OPENING SHOTS

OPENING SHOTS

The Unusual, Unexpected,
Potentially Career-Threatening
First Roles That Launched
the Careers of
70 Hollywood Stars

Damien Bona

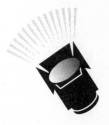

Workman Publishing, New York

Library of Congress Cataloging-in-Publication Data
Bona, Damien, 1955-
Opening shots : The unusual, unexpected, potentially career-threatening first roles that launched the careers of 70 Hollywood stars / by Damien Bona.
p. cm.
ISBN 1-56305-279-2
1. Motion picture actors and actresses—United States—Anecdotes. 2. Motion picture acting. I. Title.
PN1998.2.B66 1994
791.43′028′092273—dc20 93-21493
CIP

Illustrations by Leslie Ehlers

Workman Publishing
708 Broadway
New York, NY 10003

Manufactured in the United States of America

10 9 8 7 6 5 4 3 2 1

For Raffy
. . . and to the memory of my father

Acknowledgments

Although it is frequently said that writing is among the most solitary of endeavors, it's equally true that no book is written alone. One needs the assistance of many, many people and I thank everyone who helped out on *Opening Shots*.

My father, Arthur, who died shortly before this book was completed, and my mother, Alma, have always given me their unconditional support in all my endeavors. I have been blessed to have them as parents.

My gratitude also goes to my sister, Amy Bona, my brother-in-law Neil B. Cohen and my terrific nieces Emily, Elizabeth and Claudia Bona-Cohen. Lynn Seligman, my stalwart agent and friend was, as always, thoroughly perspicacious, encouraging and indefatigable—in short, indispensable. The enthusiasm of my frequent collaborator and dear pal, Mason Wiley, for this project kept mine from flagging, and his reassurance got me over the rough spots. I'm especially appreciative for his reading of early drafts, his insight, and his willingness to share his encyclopedic knowledge of movies.

Bill Condon and Ryan Murphy offered me their extraordinary generosity and hospitality, and plenty of laughs to boot. Joe Smith, who has a good-heartedness that knows no bounds, has provided a shoulder to lean on and a whole lot of good times for two decades.

Ed Sikov inspired me to write this book in the first place, and I acknowledge him for his strength, sly sense of humor and appreciation of small pleasures. Spencer Beckwith, Frank Pike and Kevin Dwyer all provided invaluable input early on in the proceedings and, besides, they all know from Phyllis Povah.

Thanks to my editor Sally Kovalchick and everyone at Workman Publishing, including Eddy Herch, who did a marvelous job designing the book, Carbery O'Brien, Mary Wilkinson, Barbara Perris and Peter Workman.

I would like to thank several mentors I've had over the years: Robert Anderson, Robert Cadogan, the late Dom Luke Childs, Jere Crook, David McCarthy and George Robinson.

In the course of researching and writing this book, the Billy Rose Theatre Collection of Lincoln Center's Library for the Performing Arts

became virtually a second home to me. I tip my hat to the librarians there for their graciousness, patience and unfailing sense of humor, and for treating me more like a friend than a patron: David Bartholomew, Roderick Bladel, Patricia A. Darby, Donald W. Fowle, Christopher Firth, Don Glenn, Christine Karatnytsky, Louise M. Martzinek, Brian O'Connell, Daniel C. Patri, Louis Paul, Mary Ellen Rogan, Rosalie Spar Sacks, Edward J. Sager, Betty Travitsky, Kevin Winkler and Barbara Worrell-Purdie.

Similarly, during my frequent sojourns to the Library of the Academy of Motion Picture Arts and Sciences, the staff could not have been more accommodating and cordial: Lisa Epstein, Laureen Asa-Dorian, Genevieve Brassard, Steven Garland, Rossett Herbert, Lisa Jackson, Lynne Kirste, Scott Miller, Naomi Selfman, Elaine Theilstrom, Susan Oka, Sandra Archer, and my old friend Carol Cullen.

Howard and Ron Mandelbaum and the entire staff of Photofest made photo research a pleasure instead of a chore, and the same goes for Terry Geekson and Mary Corliss of the Museum of Modern Art Still Collection. A special thanks also to Steve Gaul of Troma, Inc.

Also providing me with invaluable help, both on the personal and professional fronts, were Genie Leftwich and Dallas Murphy; Elizabeth Terhune and Mark Sullivan; Bob Montgomery; Kenneth Widener; Rob, Shelley, Shelley Jr. and Louisa Ryan; Sally Marvin; Heather Smith; Sal Nemsi; Susan Ross; Ron Fried and Lorraine Kreahling; Howard Karren and Ed Christie; Tom Phillips and Ed Davis; Ira Hozinsky; Andy Dickos; Jason Pommerance; Tom Rhoads; Bruce Finlayson; Rosanna Arce; Jane Croes; Chris Ferrone; Julia Pearlstein and Dick Beebe; Bridget Fonger; Rhoda Penmark; Nora Presutti; Yong Soon Min; Susan Wieland; Robin Miles; Paul Maggio; Susie Day; Katherine Mayfield; Eloise Eisenhardt; Marie Castro; Lee Morrow; Marjory Zaik; Rick Freyer; Kathleen Haspel; Mark Gaylord; Carl LaFong and Angie DeVito. Without them, you'd be holding a bound volume of blank pages.

And most especially, for at least a thousand different reasons, I thank Ralph Peña.

Contents

INTRODUCTION

It's axiomatic: You've got to start somewhere. *Opening Shots* shows how and where some of Hollywood's most exalted performers did just that. Sometimes the beginnings were extremely humble, such as Kevin Costner's toiling on a sleazy exercise in soft-core sex, *Sizzle Beach, U.S.A.*, or the later-to-be-distinguished Ellen Burstyn's frolicking on the sand in *For Those Who Think Young*. On other occasions, a newcomer got in there and mingled with the inhabitants of the A list, albeit in an entirely peripheral manner: A case in point is Sigourney Weaver's brief appearance in *Annie Hall*. Several actors have landed the lead role in their first picture, which sounds impressive until you realize that it was *Return to Macon County* that launched Nick Nolte and that Jack Nicholson played the *Cry Baby Killer.* Congratulations to Julie Andrews and Barbra Streisand for becoming major stars and winning Oscars their first time out of the chute, but their instant successes don't concern us here. The purview of this book is those performers who became stars *despite* their film debut, not because of it.

The one commonality shared by the actors and actresses covered in *Opening Shots* is that their first appearances on film were uncharacteristic of their later work. How many people know that Vincent Price started off as a suave, romantic leading man or that Robert Preston, musical comedy star extraordinaire, was groomed as a screen tough guy? Not all the films included in these pages are embarrassments; a few are, in fact, truly outstanding. But it comes as a surprise, for instance, that the catalysts behind the sleuthing in two great detective movies, *Kiss Me Deadly* and *Night Moves,* were, respectively, Cloris Leachman (as a femme fatale) and Melanie Griffith (who was only sixteen). And while most people remember the mysterious Boo Radley of *To Kill a Mockingbird*, few realize that the actor who created the character was Robert Duvall.

By showing many familiar performers when they were not familiar to us, I hope *Opening Shots* will create the feeling of a family photo album. Instead of exclaiming, "I can't believe Aunt Nancy was ever that young," or "Look how long Uncle Ed's hair was," you'll be making similar comments about Pia Zadora and Michael Douglas. Changes in the way the movie industry discovered new talent are also reflected here: In the days of the Three Stooges and Judy Garland, vaudeville was a fertile breeding ground

for movie performers. During the 1950s and 1960s, it seemed that no "serious" actor made it to the movies before at least one pit stop with Lee Strasberg, Stella Adler or some other acting coach for a dose of the Method. More recently, television has been the launching pad for the likes of Alec Baldwin and Debra Winger. Over the decades, however, there have been two constants: Hollywood has always looked to the New York stage for a supply of new talent, and contacts have always helped.

Each film discussed in *Opening Shots* represents the first movie an individual *appeared in,* not necessarily the first one released. The date given with the title is the year in which the actor stepped in front of the cameras, rather than the year the final film came out. Except in the case of Wallace Beery, who started out when short subjects were about the only game in town, I have included only feature films, no one- or two-reelers and no TV movies. And those few notable performers who have pornographic skeletons in the closet need not worry.

My purpose in writing *Opening Shots* was not to snicker or ridicule (all right, maybe it was a little bit). Everybody loves the story of the ugly duckling, and there are plenty of homely young mallards here. If Paul Newman and Patrick Swayze can rise from the ashes of *The Silver Chalice* and *Skatetown, U.S.A.,* respectively, anything is possible; and when Dorothy Fields wrote the lyrics, "Pick yourself up, dust yourself off, start all over again" in 1936, she was creating an anthem for Julia Roberts in *Satisfaction* five decades later. It's surprising how frequently an actor will conveniently forget his or her initial movie, insisting that he or she was in the big time from the get-go. Seems to me that Richard Gere, who fibbed onstage at the 1991 Academy Awards that his first film was *Days of Heaven,* would want to shout proudly that he actually started off in the unremembered *Report to the Commissioner.* That way he could show how far he's come, regardless of having gotten a raw deal when he was at his most professionally vulnerable. I'm a firm believer that you should always be honest and never shrink from your origins, no matter how disreputable. I speak as one who should know—I began as a lawyer.

OPENING SHOTS

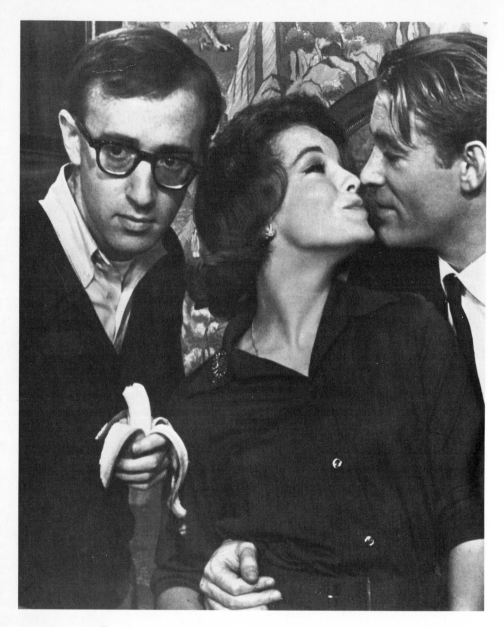

During his early days, Woody Allen's specialty was embodying the world's biggest *schlemiel.* Consequently, in *What's New, Pussycat?*— a film in which the only thing on anybody's mind is sex—Woody manages to be the one character who ends up remaining chaste (although not for lack of trying). Eating a banana next to Romy Schneider and Peter O'Toole is about the extent of his sensual pleasure in the movie.

WOODY ALLEN

······

WHAT'S NEW, PUSSYCAT?

(1964)

Born in 1935, Allen Stewart Konigsberg grew up in a lower-middle-class family in the Midwood section of Brooklyn. Papa's jobs included driving a taxi, engraving jewelry and waiting tables; Mama Nettea kept the books for a florist. For all the intellectual pretenses Woody Allen would later flaunt—not only his occasional stylistic aping of Ingmar Bergman and Federico Fellini but the throwaway references to Kierkegaard and Simone de Beauvoir—the Konigsberg boy had little predilection for learning. Bob Hope provided him with an afflatus, and as a high school student in the early 1950s he expended most of his brainpower on coming up with jokes. Buoyed by a teacher who told him, "Kid, you're funny," he began submitting one-liners and humorous anecdotes to such Broadway Beat newspapermen as Walter Winchell and Earl Wilson, who needed yuks in their columns to go along with who was doing whom.

Around this time, Allen Konigsberg decided a snappier appellation was in or-

Woody Allen's first movie was the highest-grossing comedy ever.

And still he hated it.

CAST

PETER SELLERS, PETER O'TOOLE,
ROMY SCHNEIDER, CAPUCINE,
PAULA PRENTISS, WOODY ALLEN,
URSULA ANDRESS, EDRA GALE

······

UNITED ARTISTS
DIRECTED BY CLIVE DONNER
SCREENPLAY BY WOODY ALLEN
PRODUCED BY CHARLES K. FELDMAN
CINEMATOGRAPHY BY JEAN BADAL

WOODY ALLEN'S FIRST JOKE IN A MOVIE

Referring to a pulchritudinous young woman, he says, "We played strip chess. She had me down to my shorts and I fainted from tension."

Allen's second cinematic joke occurs when he tells Peter O'Toole that he works as an assistant dresser at a strip joint and O'Toole asks what his salary is. "Twenty francs." O'Toole observes, "Not much." Allen responds, "It's all I can afford."

der. He claimed that Woody was a totally arbitrary choice, but others trying to decipher his thought processes decided it must have been an homage to his Mid*wood* neighborhood. His father had a dualistic take on the youngster's forsaking his birth name: It was either in honor of bandleader Woody Herman or a tribute to his "beloved baseball bat," whatever that means. (In my neighborhood, a "woody" was something altogether different.) Earl Wilson was the first person to use the new professional name in print: "Woody Allen says he ate at a restaurant that had OPS prices—over people's salaries." (Obviously the columnist didn't want anyone to think he had come up with this pearl himself.) From the fourth estate, Allen moved to the world of music: such unlikely *farceurs* as Guy Lombardo, Sammy Kaye and Arthur Murray spouted his wit between songs. A press agent named David Alber knew a kid ripe for exploitation when he saw one and arranged a deal in which the teenager had to come up with 250 jokes a week for 10¢ a pop. This helped gain Allen a reputation in the rarefied world of New York show business, and he was hired as a staff writer for radio star Peter Lind Hayes for $25 a week, and later for Indiana humorist Herb Shriner with a $50 raise.

Despite his budding career, Allen enrolled at New York University in 1953, only to flunk out during freshman year. Undaunted, he tried again at City University, but a few weeks later said the hell with higher education. Television now held all his attention, and he was soon contributing material for Buddy Hackett, Kaye Ballard and—the mind boggles—Pat Boone. He also became a staff writer for the *Tonight* show in the Jack Paar days. Prime time beckoned in the guise of *The Garry Moore Show,* to the tune of $1,700 a week.

Allen's manager, Jack Rollins, suggested that big-time gratification would come about only if he per-

formed his material himself rather than handing it over to Garry Moore and Durward Kirby. Allen might have wondered what kind of *meshuggener* he had entrusted his career to; the club Rollins booked him into paid him absolutely nothing. A nervous wreck with shoulders so hunched that he scarcely looked human, the comedian hugged the microphone as intensely as if it were his prom date. Nevertheless, Allen's lines (e.g., "I was caught cheating on a metaphysics examination—looking into another student's soul") scored with the audience at the Duplex. He did so well, in fact, that the club kept him on for several month—at the same salary.

With time, however, Allen moved up to joints that actually paid: the Village Vanguard, the Blue Angel and the Bitter End, where a four-month contract finally vanquished his lack of confidence. And although Allen's comedy, with its self-deprecating takes on his failed romances, sexual incompetence, lowly background ("We were a poor family. My father was a caddie at a miniature golf course"), hypochondria and lack of social graces, was steeped in a uniquely Jewish New York neurosis, he moved beyond the borders of Gotham, playing major nightclubs in major cities. He recorded a comedy album, did the talk shows and ran the gamut of variety programs from *The Judy Garland Show* to *Hootenanny*. In the early to mid-1960s, he was as hot a stand-up comic as there was. And because the history of cinema has been cluttered with vehicles for comedians from Joe Penner to Jack E. Leonard, it was only natural that Woody Allen, too, would make the transition from nightclub stage to soundstage.

■ ■ ■ ■ ■ ■

His entry into movies came about through Charles K. Feldman, the legendary Hollywood agent who founded Famous Artists and later produced such films as *A Streetcar Named Desire* and *The Seven Year Itch*. Warren Beatty had been a houseguest of Feldman's and was so busy on the phone talking to girl-

friends, potential girlfriends and other female acquaintances that, in those days before call waiting, Feldman was incommunicado with the outside world. Still, the producer got something out of the visitation. Ladies' man Beatty began every phone conversation, "What's new, pussycat?" and Feldman thought this phrase could be the basis of a Major Motion Picture. And how Pirandellian it would be to have Beatty himself star in a movie about a libertine and his equally sex-obsessed psychiatrist. The screenplay Feldman had in his possession needed work, but after Beatty's sister, Shirley MacLaine, insisted that the producer catch Woody Allen's act at the Blue Angel, he knew the person he wanted to do the rewrite. And besides creating the script, Woody Allen could also play the shrink.

What's New, Pussycat? provided Allen with a crash course in cinematic chaos. By the time the fledgling screenwriter had completed his third draft, Beatty was out of the picture because Feldman refused to have the actor's current inamorata, Leslie Caron, come on board. The male lead was assigned to Peter O'Toole, who may not have brought the same verisimilitude to the part but was a much more prestigious catch. As for his role as Dr. Fassbender, Allen discovered that Feldman had decided to give it to a comic actor with extensive film experience, Peter Sellers.

It got worse. Having painstakingly honed his screenplay through several drafts to Feldman's liking, Allen got to the set to find out that, except for the bare bones of the plot, director Clive Donner had thrown out the script. As Peter O'Toole remembered, "We began with a brilliant, sketchy Perelmanesque script by Woody Allen, who is a genius. Then things got a little neurotic, with lots of politics and infighting and general treachery and finally . . . we improvised the whole thing from start to finish." Allen was given a smaller part as Victor, the best friend and confidant of O'Toole, more or less a 1960s version of Jack Oakie's good old pal roles updated into a *schlimazel* who can't

score. As shooting continued, the character faded more and more into the background. Allen reminisced, "They would say: That scene between you and Peter Sellers or you and Peter O'Toole, we're going to let the two Peters do it." When it was all over, his reaction was, "I loathe everyone and everything concerned with it and they all loathe me. . . . They butchered my script. They wrenched it into a commercial package. It ended up in the hands of establishment people who were hep, not hip." And to think Allen had signed a three-picture contract with Charles Feldman!

When they got a look at *What's New, Pussycat?* many of the critics hated it as much as Allen did, none more so than Bosley Crowther, who, after a quarter century at the *New York Times,* had turned himself into a Savonarola railing against the Swinging Sixties: "It is actually startling and disturbing in its positive unwholesomeness. . . . it goes into a wallow in slapstick sexuality and vandalistic antagonism towards the disciplines of society." What was it that got Crowther so apoplectic? Simply a jaunty sex romp that gained notoriety because, unlike the contemporaneous Doris Day vehicles and movies based on Broadway bedroom comedies (*Sunday in New York, Come Blow Your Horn*), it wasn't at all coy about sex. The fact that ads for *What's New, Pussycat?* warned that the film was "for adult audiences only" indicates how juvenile most movies still were. (Today it would probably have a hard time earning even a PG-13.)

· · · · · ·

The film features Peter O'Toole, who, because he finds it impossible to remain faithful to girlfriend Romy Schneider, seeks help from manic psychiatrist Peter Sellers, who's even more satyric than he is. The plot's not the thing here, however. What's most memorable about *What's New, Pussycat?* is the comic interaction among a group of characters who are totally screwed up about sex but make no apologies for it.

· · · · · · · · · ·

For all his protestations about *What's New, Pussycat?*, Woody Allen must have had at least a smidgen of affection for the film—he reused his character's name, Victor Shakapopolis, in the segment of *Everything You Always Wanted to Know About Sex* titled "Are the Findings of Doctors and Clinics Who Do Sexual Research Accurate?"

Their neuroses are presented by director Donner in a cheerfully sympathetic light.

•••••••

The film winds up with an updated spin on an old-fashioned bedroom farce, as all the characters—including a gaggle of gas station attendants searching for an orgy—chase each other through the corridors of a romantic resort hotel in a superbly choreographed slapstick sequence and then somehow end up on go-carts careening through the French countryside. When all's said and done, the high spirits of the movie convey the feeling that sex is something to be celebrated, no matter how outlandish the roundelays involved or how foolish the mortals involved. That was a fairly revolutionary point of view for a mid-60s film, but today it makes *What's New, Pussycat?* seem very sweet.

Woody Allen was sixth-billed, and ads prefaced his

CRITICAL POINTS / CRITICAL ANGLES

What's New, Pussycat? was a *cause célèbre* in the summer of 1965, with critics choosing sides on whether the movie was simply an enjoyable, outrageous comedy or signaled the end of civilization as we know It.

On the pro side:

"*What's New, Pussycat?* is about as far out as you can go in the comedy field and still stay in the solar system. It is the wildest, wackiest comedy to come along in memory."
—George H. Jackson, *Los Angeles Herald-Examiner*

"Sex and psychoanalysis have been satirized in movies before, but neither has in a long time taken a drubbing delivered with quite the same ferocity and lack of let-up that they get without mercy in *What's New, Pussycat?* The result is one of the most hilarious pictures to hit the screen in recent years. . . . Not even Jean-Luc Godard in his wildest flights of fancy has matched many of the comic twists and turns."
—Richard Gertner, *Motion Picture Daily*

name with "and least but not last." He is an integral participant in the slapstick finale, but through most of the film his Victor is only a peripheral presence. When he does get screen time, Allen essentially transposes to the screen his stand-up persona of a lovable bumbler. The first time we see him, he is playing chess with a comely young woman at a Parisian café, cheating by tossing away pieces when his opponent is distracted. His initial screen line is delivered to O'Toole: "Michael James, meet Tempest O'Brien. She adores me." He wins his biggest laugh in a brief scene that he would expand in *Annie Hall:* Trying to impress a woman he's wooing, he gets behind the wheel of a sports car . . . and ends up driving on the sidewalk. Allen has only one extended scene with Sellers, an odd bit in which, clad in a tuxedo, he sets up a table on a deserted plaza for a formal dinner for one, which is interrupted by Sellers's suicide attempt. Curiously, there is little rap-

"If you want to go ape, this is the surest way I know."
—Phillip K. Scheuer, *Los Angeles Times*

On the con side:

"The smarmiest smirk of the year . . . a shrieking, reeking conglomeration of dirty jokes, dreary camp and blatant ambisexuality wrapped around a tediously plodding plot and stale comedy routines."
—Judith Crist, *New York Herald-Tribune*

"The slickness of this movie cannot cover its identity as an adolescent sexual daydream."
— *Women's Wear Daily*

port between the two comics, and this exchange is the dullest bit in the movie. Although in one draft of the script Allen had given himself 50% of screen time, in the final product he comes across as almost an afterthought, and his characterization seems to be merely a dry run for his later movies.

･ ･ ･ ･ ･ ･

P robably because it was as close as the average person in 1965 was going to get to the sexual revolution, *What's New, Pussycat?* made a fortune, becoming the highest-grossing comedy yet. But if anything, its success seemed only to confirm to Woody Allen that this is a world of philistines. "I could have made it twice as funny," he lamented, "but it would have only made half as much money." Except for giving him the opportunity to explore Paris, *What's New, Pussycat?* was a disheartening experience for Allen, and he told anyone who would listen that the final film bore not even a passing resemblance to what he had written. Still, he was fascinated by the filmmaking process, and soon his stand-up comedy career would be a thing of the past. In 1966, Allen's next film project was released: *What's Up, Tiger Lily?*, in which he took a terrible Japanese spy movie and redubbed it into an absurd comedy. He also wrote a moderately successful Broadway comedy that year, *Don't Drink the Water.* The next year saw the release of his second film for Charles Feldman, the unsuccessful all-star spoof of James Bond, *Casino Royale*, in which he played 007's nephew. Feldman's death in 1968 spared Allen the third film he was contracted to make for the producer. In 1969, the comedian finally made his directorial debut with *Take the Money and Run*, and *What's New, Pussycat?* became just a bad memory.

ALEC BALDWIN

......

FOREVER, LULU
(1986)

Born in 1958, the Long Island native didn't have stardust in his eyes while growing up. It wasn't, in fact, until after Baldwin spent three years studying political science at George Washington University that the idea of becoming an actor occurred to him. To that end, he transferred to New York University so that, while still pursuing poli-sci as a major, he could take acting classes at the Lee Strasberg Institute. A Manhattan health club proved to be Baldwin's Schwab's drugstore; in between doing her laps, a beguiled swimmer ambled up to his lifeguard stand and urged him to call a soap opera casting director with whom she was personally acquainted. This wasn't just a come-on, and before Baldwin had gotten his NYU diploma, he was cast in the perennially low-rated *The Doctors*. People who pay attention to such matters believed that an exciting new presence had arrived in daytime drama. As *Soap Opera Digest* had it, "The last actor to play Billy Aldrich, a confused and

Alec Baldwin did it backwards.

CAST

HANNA SCHYGULLA,
DEBORAH HARRY, ALEC BALDWIN,
ANNIE GOLDEN, PAUL GLEASON,
DR. RUTH WESTHEIMER,
RAYMOND SERRA, AMOS KOLLEK,
CHARLES LUDLAM

......

TRI-STAR
DIRECTED, WRITTEN AND
PRODUCED BY AMOS KOLLEK
CINEMATOGRAPHY BY LISA RINZLER

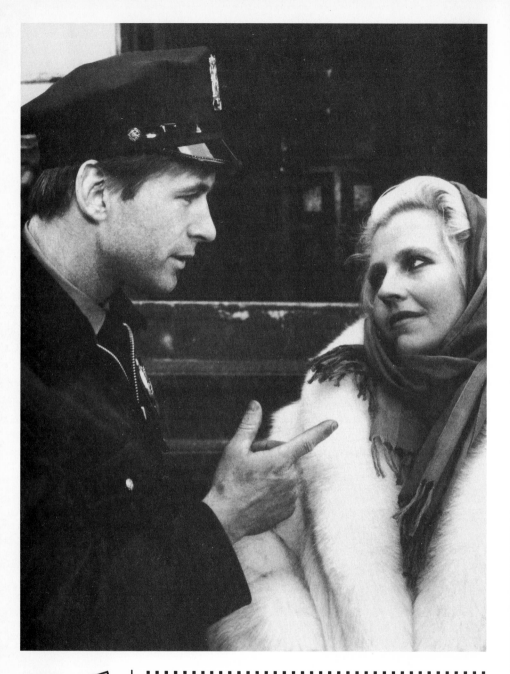

Having proved his mettle as a bad guy on television, Alec Baldwin was cast as the hero of *Forever, Lulu,* with little to do other than hang out. Here he mills about with leading lady Hanna Schygulla; romantic sparks between the two are nonexistent.

diabolical character with his whisper of a voice and subtle sensuality, Alec transferred the character into a fascinating snake." Despite his best efforts, the show remained mired at the bottom of the Nielsens, and two years later *The Doctors* flatlined.

Having created somewhat of a stir in the afternoon, Baldwin was primed for prime time. *Cutter to Houston*, however, was to evenings what *The Doctors* was to daytime, a medical show in the ratings junkpile, and it expired after seven episodes. Still, Baldwin seemed to have that certain "it" that spells TV stardom, and in 1984 he was signed to help replenish the cast of *Knots Landing*. He played the kind of ludicrously drawn character that could only exist on a nighttime soap: the reprobate son of Julie Harris who finds a lucrative career as a television evangelist, a position which enables him to spread heartache, pain and misery until he eventually kills himself. The middle of the Reagan era was the apex of these serials' popularity, and Baldwin's mixture of boyish handsomeness, antisocial behavior and mystery captivated a sizable part of the populace. As a result, in 1985, he landed the leading role in the miniseries adaptation of the best-selling *Dress Gray*.

Then, abruptly, this hot television commodity played hob with Hollywood's expectations: He moved back to New York. His motivation? "I realized that if I continued to live in Los Angeles, I would fold. Because how often can you say no to $30,000, $40,000, *$50,000* a week in a TV series? It was like getting sucked into the Bermuda Triangle." Besides, a network honcho had promised he could make Baldwin into "the next Bill Bixby," and with all due respect to the personable star of *My Favorite Martian* and *The Incredible Hulk*, that wasn't what Baldwin had had in mind when he decided to give up political science.

Although he wasn't nearly as well known in the New York theatrical community as he had been among TV executives, Baldwin landed a part in a Broadway show a mere three weeks after his December 1985 re-

■ ■ ■ ■ ■ ■ ■ ■ ■ ■

Alec Baldwin is one of an elite group of actors (Clint Eastwood, Steve McQueen, Goldie Hawn, Robin Williams, Eddie Murphy) who successfully made the leap from television stardom to movies. Others who tried but were not as fortunate:

Robert Blake
(*Baretta*)

James Brolin
(*Marcus Welby, M.D.*)

Richard Chamberlain
(*Dr. Kildare*)

Bill Cosby
(*I Spy, Cosby*)

Farrah Fawcett
(*Charlie's Angels*)

Mary Tyler Moore
(*The Dick Van Dyke Show, The Mary Tyler Moore Show*)

Joe Piscopo
(*Saturday Night Live*)

John Ritter
(*Three's Company*)

Dick Van Dyke
(*The Dick Van Dyke Show*)

Henry Winkler
(*Happy Days*)

location. The black humor of British playwright Joe Orton was enjoying a renaissance at the time, and a well-thought-of repertory revival of his *Loot* was being transferred from Off Broadway to Times Square. Kevin Bacon had a movie deal, so he couldn't make the crosstown move, but Baldwin was ready to take his place as an inept young thug trying to recover a stash of cash from a coffin. He took to the stage as effortlessly as he had to television, receiving a Theatre World Award as one of the season's most promising newcomers.

I n the normal course of things, an actor takes a role in a low-budget movie hoping it will be noticed and lead to bigger and better things . . . like a nighttime soap opera. Baldwin, however, ventured into *cinema cheapo* territory as another means of getting away from his earlier success. Between performances of *Loot*, the actor filmed *Forever, Lulu*, an unfortunate comedy vehicle for German actress Hanna Schygulla. Set on the Lower East Side during the mid-1980s—when the formerly déclassé area was the epicenter of all things cool in New York—*Forever, Lulu* follows the travails of a struggling German writer in Manhattan who makes a living selling toilet seats and inadvertently gets involved with the Mafia after stumbling across $50,000 in drug money.

When shooting *Forever, Lulu*, Alec Baldwin was asked by *USA Today*'s Stephen Schaefer, "Why a low-budget movie?" Answer: "I hadn't done a film, and I was beginning to think that Harrison Ford and Jeff Bridges were going to do all the movies I would be considered for." That still doesn't seem reason enough for any actor serious about his craft to play the hero in *Forever, Lulu*, a role notable only because there's no there there; you must surmise that to have taken such a thankless role Baldwin was getting no other film offers. Although he's third-billed, he doesn't appear until 28 minutes into the film and then has only another five

brief scenes. He plays a cop who inexplicably conceives a passion for the (here) grating Schygulla after seeing her around the neighborhood. Because this was a film designed for the downtown crowd and not the outer boroughs, it's made clear that he's only keeping his awful job as a policeman until he can get his master's degree in English. Baldwin has nothing to do except occasionally chat with Schygulla and, in the climax, rescue her from the gangsters who are about to deep-six her at the Fulton Fish Market. There, among the dead Mafia bodies and the dead fish, they make love.

■ ■ ■ ■ ■ ■

Baldwin is exceedingly charming, but *Forever, Lulu* itself is a cloddish and not even faintly amusing comedy, especially annoying because of its hip posturing and pathetic attempts to be outrageous. (This is a movie that respectfully features sex therapist Dr. Ruth Westheimer, so how cool could it be?) Baldwin escaped any mention from most of the press, although Vincent Canby of the *New York Times* said he gave a "decent performance."

■ ■ ■ ■ ■ ■

After this inauspicious beginning, Alec Baldwin the film actor slowly matched and then surpassed the level of fame he had attained on television. He gave strong supporting performances in a number of well-received films over the next couple of years, including *Beetlejuice, Married to the Mob, Working Girl* and *Talk Radio,* until Hollywood finally woke up to the fact that a guy with both looks and talent was leading-man material. Despite being dated and dull, *The Hunt for Red October* became a major box-office success in 1990, and Baldwin joined the top echelon of movie stars. But within the year, he alienated many of Hollywood's powers-in-residence by vilifying *The Marrying Man,* the Neil Simon comedy in which he was stuck for Disney, even before production was

Israeli director Amos Kollek chafed when people suggested that *Forever, Lulu* was a rip-off of the previous year's Lower East Side mistaken identity farce, *Desperately Seeking Susan.* Kollek maintained that *Forever, Lulu* was "inspired by my own life. Except it's about a woman and I wasn't a struggling writer and I certainly never went through the bizarre circumstances this character does."

finished. Then he priced himself out of the *Red October* follow-up, the equally dull and not as successful *Patriot Games,* in which Harrison Ford took his place. Baldwin happily headed back to Broadway to do a new take on Stanley Kowalski in *A Streetcar Named Desire.* Hollywood still hasn't figured out what he's all about, but then again, in the past the actor has enjoyed confounding expectations.

WARREN BEATTY, SANDY DENNIS AND PHYLLIS DILLER

······

SPLENDOR IN THE GRASS
(1960)

Shirley MacLaine's little brother was born in 1937, and while sis was pitching woo with Jerry Lewis in *Artists and Models*, Warren Beatty studied speech at Northwestern. A year of that was enough, and after a brief stint as a construction worker, he went to New York City to study acting with Stella Adler. Within a year of his move to Manhattan, small parts in television plays had come his way, and in June 1957 he costarred with Raymond Massey in an episode of *Kraft Theatre*.

Maybe Broadway wasn't clamoring for his services, but Fort Lee, New Jersey, was. God knows why, but Pulitzer Prize-winning playwright William Inge and Tony Award-winning director Joshua Logan crossed the George Washington Bridge and caught Beatty as one of the thrill killers in *Compulsion*, Mayer Levin's drama about Leopold and Loeb. Each of the two theater veterans im-

CAST

NATALIE WOOD, WARREN BEATTY,
PAT HINGLE, AUDREY CHRISTIE,
BARBARA LODEN,
ZOHRA LAMPERT, FRED STEWART,
JOANNA ROOS, JAN NORRIS,

······

WARNER BROTHERS
DIRECTED AND PRODUCED BY ELIA KAZAN
SCREENPLAY BY WILLIAM INGE
CINEMATOGRAPHY BY BORIS KAUFMAN

············

Hollywood's dominant Don Juan, the 1960s' memorable queen of sniffling neuroses and the cackling madcap all started out together. Quite a triumvirate.

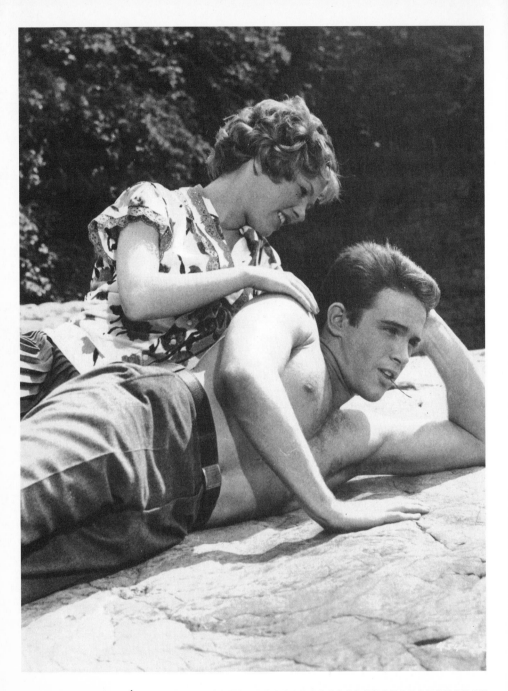

Warren Beatty's character, Bud, is about to lose his virginity to the town's "bad girl," Jan Norris (underneath a waterfall, no less). This was also Beatty's cinematic "loss of virtue," the first of his zillion on-screen sexual conquests.

mediately came up with his own agenda for the young actor.

Logan leaped into action first. He arranged a screen test with his goddaughter, Jane Fonda, which led to an MGM contract for Beatty. The 22-year-old unknown got a load of what the studio had in mind for him—something called *Strike Heaven in the Face*—and decided to kiss Leo the Lion goodbye. Borrowing money to do so, Beatty bought out his contract, and Metro executives probably heaved a sigh of relief that they wouldn't have to put up with this smart aleck who thought he knew more about movies than they did. (The actor did hang around Hollywood long enough to make several appearances as rich boy Milton Armitage on TV's *The Many Loves of Dobie Gillis*.)

Now William Inge could step in. He was planning an original film script called *Splendor in the Grass* that Elia Kazan was going to direct, and would Beatty like to star as its troubled high schooler? Beatty would, but before the handshakes could be completed, the film was postponed. Not to worry—Inge had another script up his sleeve, this one a play that also called for a handsome actor who could play a young man with little on his mind but sex. Star Shirley Booth quit *A Loss of Roses* during its tryout run, unable to cope with Beatty's exigent ways and with Inge's unwaveringly taking the young man's side. The play, which ended the string of theatrical successes by the author of *Picnic* and *Bus Stop*, lasted only 25 performances, but Beatty nonetheless managed to snag a Tony nomination. (He lost the award to Roddy McDowall.)

• • • • • •

Born a month after Warren Beatty, Sandy Dennis also had a connection to William Inge. The Nebraska native cut her sizable teeth at a community theater in Lincoln. She said that as a child she wanted to be Margaret O'Brien, as an adolescent Gloria Grahame. But now that she was approaching

• • • • • • • • • •

Warren Beatty was nominated for a Golden Globe as Best Actor—Drama for *Splendor in the Grass*, losing to Maximilian Schell in *Judgment at Nuremberg*. Beatty did fare better with the Hollywood Foreign Press Association in another category: Actor Most Likely to Achieve Prominence During the Coming Year. He shared this award with Richard Beymer and Bobby Darin; the two losing candidates were George Chakiris and George C. Scott.

SANDY DENNIS'S RECOLLECTIONS OF MAKING HER FIRST MOVIE

"We got up at 5:30. And we had the most delicious box lunches—fried chicken, roast ham, hard-boiled eggs, tomatoes.

"It was wonderful working for Mr. Kazan. He made us do a scene until it was perfect. When I don't do a scene well I feel like I've cheated everyone, the audience, myself. Not that I contemplate going out and killing myself. But I do like to do a good job."

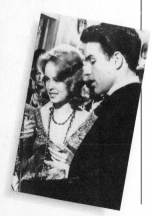

her twenties, a Plain Jane like Julie Harris offered more inspiration. Dennis made up her mind to go where Harris plied her craft, arriving in New York around the same time as Warren Beatty. She got a job as a 13-year-old in a 1956 Off-Broadway revival of Ibsen's *The Lady from the Sea* and was seen by an agent, who promptly sent her a long way out of town. Dennis appeared in a Palm Beach production of Inge's *Bus Stop* and then replaced Tuesday Weld as an understudy in the Broadway production of the playwright's *The Dark at the Top of the Stairs*, directed by Elia Kazan; showing up at the Music Box Theatre before the show to see whether she was going on, she would ask, "Dennis, anyone?" Even when the answer was negative, the actress had to hang around in the dressing room because 2 hours and 15 minutes into the play, she provided an offstage voice. Dennis eventually got to appear onstage, playing the ingenue role when the show hit the road, and after that there were two short-lived Broadway plays.

Phyllis Diller hadn't had any contact with William Inge, other than that she probably saw the film version of *Picnic*. As a young mother in California in the 1940s, she endured a precarious financial existence, thanks to a husband who flitted from job to job. With a mortgage foreclosure looming, she helped the Diller exchequer by turning to writing, first as a shopping columnist giving the lowdown on all the supermarket news about town for the *San Leandro News-Observer*. After having her fill of comparing the price of lima beans at different groceries, she went on to extol the virtues of Kahn's Department Store as an advertising copywriter for that Oakland emporium, and then wrote jokes for a pair of radio personalities. Finally she worked as a "merchandising manager" for a San Francisco radio station. I'm not sure what that position entailed, but Diller says it kept her rolling in

money; still, despite all those years of impecuniosity, she gave up her well-paying job.

Whenever Sherwood Diller saw a comedian on TV, he'd nudge his wife and say, "He's not as funny as you." Phyllis thought he was just saying it because he loved her, but deep down she did have an inkling that she was humorous: "I knew I had the kind of face that people laughed at. My mother convinced me of that when I was a little girl. She told me when I was very young that I would never be pretty like other little girls, and that I ought to take advantage of anything else I had. So she used to teach me jokes." Sherwood Diller insisted that if Red Buttons could become rich and famous by being funny, so could his wife.

Phyllis eventually acceded, but she started small: Her first public appearance was at a benefit for the Red Cross. The favorable response there (and at PTA meetings, where she would interrupt heated discussions about the quality of the school cafeteria's tuna noodle casserole to crack a joke), coupled with the encouragement and self-confidence she gained from reading an inspirational book called *The Magic of Believing*, led her to sally forth. She hosted a local television show called *Phyllis Diller, the Homely Friendmaker*, a spoof of programs oriented to housewives: "I'd make toaster covers out of hubby's new suit, things like that." The owner of San Francisco's Purple Onion then gave her a tryout, and on March 7, 1955, Phyllis Diller made her nightclub debut.

Her act consisted of outrageous takeoffs of the florid song stylings of Eartha Kitt and Yma Sumac, topical jokes and some business with a zither. Audience response was tepid, but the club let her stay on for a two-week run, after which she honed her act. She began to emphasize the persona of a put-upon housewife, with a hopeless husband ("Fang") and hateful in-laws, arming herself with self-deprecating put-downs and punctuating her jokes with an otherworldly cachinnation.

"Hello, suckers!" Phyllis Diller greets her audience as nightclub legend Texas Guinan. Because the director of *Splendor in the Grass*, Elia Kazan, was a master of Method acting, it would have been interesting to be there when Diller asked him, "What's my motivation?" The comedian had a relatively subdued look at the time; the riotous hairdo was still a few years down the pike.

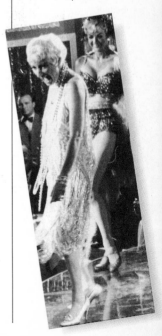

When Diller had a second booking at the Purple Onion, she stayed for 89 weeks. Within a few years she had collected a large following, appearing in major nightclubs. Thanks to numerous appearances on Jack Paar's show (and later Ed Sullivan's), Phyllis Diller became a household name.

• • • • • •

In the spring of 1960, *Splendor in the Grass* was ready to roll and Warren Beatty, Sandy Dennis and Phyllis Diller converged. Elia Kazan had suggested that William Inge write directly for the movies, and the playwright had responded by handing him a novella, which Kazan then transformed into a screenplay and handed back to Inge for rewriting and editing. Set in the small-town Kansas of Inge's youth, *Splendor in the Grass* tells a story of young love thwarted and turned hysterical. Beatty plays Bud, the son of the community's wealthiest nabob and in love with Deanie (Natalie Wood), daughter of an unambitious shopkeeper. A high school senior, Bud wants only to go to agricultural school, marry Deanie and settle down on a ranch, but his oilman father (Pat Hingle) has other plans: Yale and a business career in the East. Because they are unable to consummate their love, Deanie goes bonkers and Bud becomes a low-life. All the Inge standbys appear: middle-aged wives who have unwillingly developed into repressed Penelopes because of their husbands' lack of interest; pathetically romantic spinsters; lascivious young women whose uncontrolled desires leave them dispirited, dehumanized and dead; fathers whose dominant trait is fecklessness; prying busybodies of both sexes; and soulful protagonists who are too gentle—and good-looking—to deserve the slings and arrows.

Despite its award-winning writer and director, *Splendor in the Grass* is essentially a big, self-consciously serious, "high-class" movie about not much more than two teens with raging hormones.

Beatty, whom ads called "a very special star!," is visibly feeling his way as he goes. He's remarkably callow-looking; with his large lips trembling, his ears sticking out and his legs poking from a pair of unflattering knickers, he comes across as a big galoot. His is an unseasoned, erratic performance; Bud's confused innocence is incompatible with Beatty's nascent narcissism. Unconvincing in delivering with such lines as "I feel like I'm going nuts sometimes," he resembles his contemporary George Hamilton doing a James Dean imitation. Given his libidinous reputation, it's appropriate that in his first-ever scene on film, Beatty is on Natalie Wood, necking in the front seat of a car with heavy breathing permeating the soundtrack. His first piece of dialogue is "Deanie . . . please." Although an engaging presence, Natalie Wood was a limited actress who never quite reached the requisite dramatic heights, and consequently the scenes between them resonate only ever so slightly.

The 13th-billed Sandy Dennis recollected, "I played Natalie Wood's nasty girlfriend," but in truth her character is not particularly mean. In fact, Kay isn't much of anything—just one of the girls in Deanie's class. In her six scenes she gossips, laughs and cheers on the basketball team and, to be honest, the actress makes very little impression.

Listed in the credits four slots down from Dennis, Phyllis Diller is even more peripheral to the story. She plays the legendary Jazz Age nightclub hostess Texas Guinan (whom another raucous comic actress, Betty Hutton, had played in the 1945 musical *Incendiary Blonde*). Diller enters an hour and 41 minutes into the film, right after the stock market crash, when Pat Hingle has taken Beatty into her nightclub. At the time, Diller was still in her earliest incarnation, with close-cropped hair rather than the unholy mess we're accustomed to seeing, and a long sharp nose that gave her something of the look of an ostrich. She announces her arrival on the nightclub stage by blowing a whistle,

- - - - - - - - - - -

In the 1961 voting by exhibitors for the "Stars of Tomorrow," Warren Beatty just made the cut. The lineup:

1. Hayley Mills
2. Nancy Kwan
3. Horst Buchholtz
4. Carol Lynley
5. Dolores Hart
6. Paula Prentiss
7. Jim Hutton
8. Juliet Prowse
9. Connie Stevens
10. Warren Beatty

Horst Bucholtz.

holding her arms up and letting loose with that unmistakable laugh. Then, grabbing a bald man's head, she jokes, "They all look the same from the top." She bellows Texas Guinan's trademark, "Hello, suckers!" and gibes, "I'm glad you didn't let a little thing like the stock market crash keep you from coming out tonight!" By my count Diller has a total of 42 seconds of screen time, but she makes the most of it, and her raucous personality energizes a film that by this point is becoming increasingly gloomy.

• • • • • •

The reviews of *Splendor in the Grass* were mixed, with the naysayers objecting that it was meretricious much ado about nothing. Bosley Crowther of the *New York Times*, for one, was shocked by the goings-on in the film, which he called "a frank and ferocious social drama that makes the eyes pop and the modest cheek burn. Petting is not simply petting in this embarrassingly intimate film. It is wrestling and chewing and punching that ends with clothes torn and participants spent." *Splendor in the Grass* was a box-office bonanza, partly due to the ad campaign that played up the film's "controversial" aspects (as a press release put it, the issue was "whether Hollywood should deal with such subject matter, with which some recent European imports have been concerned") but mostly because of what had transpired during filming. Unlike the characters they played, Warren Beatty and Natalie Wood did not try abstinence, and their love affair broke up her supposedly idyllic marriage to Robert Wagner; as scandals of the period went, it was second only to the Liz Taylor/Eddie Fisher/Debbie Reynolds escapade. Director Kazan recalled, "All of a sudden [Beatty] and Natalie were lovers. When did it happen? When I wasn't looking. I wasn't sorry; it helped their love scenes. My only regret was the pain it was causing R.J. His sexual humiliation was public."

• • • • • •

A fter *Splendor in the Grass*, Beatty was rather more appropriately cast, playing an Italian gigolo in *The Roman Spring of Mrs. Stone*. Perhaps because there was no hint of off-camera hanky panky with the actor and his co-stars, Vivien Leigh and Lotte Lenya, the public was profoundly disinterested in the film. Despite the media predictions of impending superstardom, Beatty waited for 1967's *Bonnie and Clyde* to reach that plateau. Until that point, he was much more vivid to the public for the randy adventures of his personal life than for his spotty career as a leading man. As things developed, Sandy Dennis won widespread acclaim sooner than the leading man of *Splendor in the Grass,* first on the Broadway stage— where she received back-to-back Tony Awards—and then for her Oscar-winning performance as Honey when she returned to movies in 1966's *Who's Afraid of Virginia Woolf? Holiday* magazine wrote of her in 1965, "Miss Dennis has filled, in the hearts of small and large boys everywhere, the aching void left by the demise of Santa Claus." But as she made more movies, a fickle press delighted in making fun of her acting, taking pot shots at her "whiny" voice, nervous, broken-up line readings and manic timorousness, and the public followed suit. By the beginning of the 1970s, Dennis's career had become second-tier. Phyllis Diller did not use her experience with Elia Kazan as a stepping stone for other film work, but she nevertheless became more and more popular throughout the 1960s, achieving a level of fame that no other female stand-up comedian had. When she did returned to films it was in a decidedly less prestigious work than *Splendor in the Grass*— she co-starred with insult comic Jack E. Leonard in *The Fat Spy,* and then became Bob Hope's sidekick in a trio of films. She also had a reunion with William Inge, starring in a touring company of *The Dark at the Top of the Stairs.*

"Warren Beatty is too inexperienced to be able to project *anything.* I am told Hollywood hopes to make him a star, but his face, at least in this picture, is on the weak side, and doesn't always photograph well."
—*Films in Review*

"A nice-enough-looking lad except for a loose mouth. . . . I prefer his sister, Shirley MacLaine."
—*Esquire*

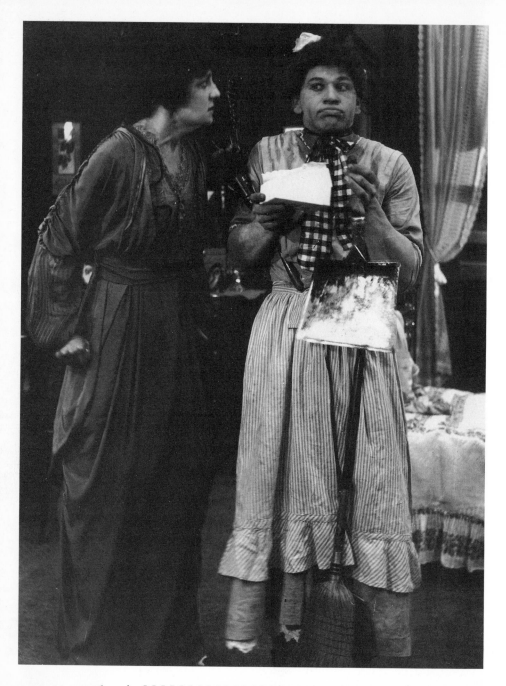

Seventy-five years before *Paris Is Burning*, Wallace Beery struts his stuff as he lets the world knows he enjoys being a girl. For his motif, Beery chose the Swedish Cleaning Woman look.

WALLACE BEERY

······

SWEEDIE THE SWATTER
(1914)

Big, brawny Wallace Beery a drag queen?

rowing up in Kansas City in the 1890s, Beery was burly even as a youngster, and being christened "Jumbo" by his classmates was one reason he dropped out of school in the fifth grade. A fascination with trains was another. He went to work in a roundhouse; that he received no pay for his first job is a testament to his obsession with trains or maybe just an indication that he wasn't the brightest kid in Kansas City. Following his brother William, he landed in a circus and, perhaps thanks to a subconscious rapport based on his nickname, Beery became a first-rate elephant trainer. So great was his renown in this singular métier that Ringling Brothers hired him away from his small Missouri troupe; a half-century later, in its obituary of Beery, the Associated Press reported that "in his teens, he became one of the best elephant men in the business."

Having shared the spotlight with pachyderms, Beery was ready to deal with human beings, and he landed a stint with a local theatrical company; when another brother, Noah, made

SWEEDIE THE SWATTER WAS MADE IN CHICAGO BY THE ESSANAY COMPANY. OTHER THAN FOR BEERY'S STARRING ROLE, NO CREDITS FOR THE FILM EXIST TODAY.

······

NOTABLE CROSS-DRESSERS

Wallace Beery was one of the earliest filmic cross-dressers. Since then, there have been literally hundreds more. Among the most prominent:

Fatty Arbuckle in *Miss Fatty's Seaside Loves* (1915) and *Fatty in Coney Island* (1917)

Helmut Berger in *The Damned* (1969) (imitating Marlene Dietrich)

Kevin Bacon, Tommy Lee Jones and Joe Pesci in *JFK* (1991)

Lionel Barrymore in *The Devil Doll* (1935)

William Bendix and Dennis O'Keefe in *Abroad With Two Yanks* (1944)

Jack Benny in *Charley's Aunt* (1941)

Ray Bolger in *Where's Charley?* (1952)

The Bowery Boys (Leo Gorcey, Huntz Hall, Gil Stratton, Jr., David Gorcey and Bennie Bartlett) in *Hold That Line* (1952)

Edd Byrnes in *Beach Ball* (1965)

Jeff Bridges in *Thunderbolt and Lightfoot* (1974)

Joe E. Brown in *A Midsummer Night's Dream* (1935), *Shut My Big Mouth* (1942) and *The Daring Young Man* (1942)

Michael Caine in *Dressed to Kill* (1980)

Eddie Cantor in *Palmy Days* (1931) and *Ali Baba Goes to Town* (1937)

Walter Catlett, Sterling Holloway and Arthur Treacher in *Star Spangled Rhythm* (1942) (as Dorothy Lamour, Veronica Lake and Paulette Goddard)

Lon Chaney in *The Unholy Three* (1925 and 1930 versions)

Charlie Chaplin in *A Woman* (1915)

Lee J. Cobb in *In Like Flint* (1967)

James Coco in *The Wild Party* (1974)

Jerry Colonna in *Garden of the Moon* (1938)

Robbie Coltrane and Eric Idle in *Nuns on the Run* (1990) (in nuns' habits)

Tim Conway and Don Knotts in *The Apple Dumpling Gang Rides Again* (1979)

Peter Cook and Dudley Moore in *Bedazzled* (1968) (in nuns' habits)

Lou Costello in *Lost in a Harem* (1944), *Here Come the Co-Eds* (1945) and *Mexican Hayride* (1948)

Bing Crosby in *High Time* (1960)

Tim Curry in *The Rocky Horror Picture Show* (1975)

Tony Curtis and Jack Lemmon in *Some Like It Hot* (1959)

Rodney Dangerfield in *Ladybugs* (1992)

Dom DeLuise in *The Twelve Chairs* (1970) and *Haunted Honeymoon* (1986)

Billy De Wolfe in *Isn't It Romantic?* (1948)

Melvyn Douglas in *The Amazing Mr. Williams* (1939)

Divine in *Multiple Maniacs* (1971), *Pink Flamingoes* (1973), *Polyester* (1981), *Lust in the Dust* (1985), *Hairspray* (1988), et al.

Jimmy Durante and Phil Silvers in *You're in the Army Now* (1941)

Hector Elizondo in *Young Doctors in Love* (1982)

W.C. Fields in *You Can't Cheat an Honest Man* (1939)

Harvey Fierstein in *Torch Song Trilogy* (1988)

Preston Foster in *Up the River* (1938)

Jack Gilford and Phil Silvers in *A Funny Thing Happened on the Way to the Forum* (1966)

Cary Grant in *I Was a Male War Bride* (1949)

Alec Guinness in *Kind Hearts and Coronets* (1949) and *The Comedians* (1967)

Jack Haley and Jack Oakie in *Navy Blues* (1941)

Oliver Hardy in *Twice Two* (1933)

Dustin Hoffman in *Tootsie* (1982)

Bob Hope in *The Princess and the Pirate* (1944), *The Lemon Drop Kid* (1951) and *Casanova's Big Night* (1953)

William Hurt in *Kiss of the Spider Woman* (1985)

Lou Jacobi in *Everything You Always Wanted to Know About Sex (But Were Afraid to Ask)* (1972)

Allyn Joslyn in *Titanic* (1953) (so he could get into a lifeboat)

Danny Kaye in *On the Double* (1961) (imitating Marlene Dietrich)

Buster Keaton in *Sherlock Jr.* (1924)

Don Knotts in *The Shakiest Gun in the West* (1968)

Harvey Korman in *Americathon* (1979)

Arthur "Dagwood" Lake in *Blondie Goes Latin* (1941)

Stan Laurel in *Duck Soup* (1927), *That's My Wife* (1929), *Another Fine Mess* (1930), *Twice Two* (1933), *Babes in Toyland* (1934), *A Chump at Oxford* (1940), *Jitterbugs* (1943) and *The Dancing Masters* (1943)

Jerry Lewis in *At War With the Army* (1950), *Money From Home* (1953) and *Three on a Couch* (1966)

John Lithgow in *The World According to Garp* (1982)

Craig Lucas in *Outrageous!* (1977) and *Too Outrageous!* (1987)

Paul Lynde in *The Glass Bottom Boat* (1966)

Fred MacMurray in *Sing You Sinners* (1936)

Steve Martin in *Dead Men Don't Wear Plaid* (1982)

Walter Matthau in *House Calls* (1978)

J. Carrol Naish in *King of Alcatraz* (1938)

Anthony Perkins in *Psycho* (1960)

Christopher Plummer in *The Silent Partner* (1978)

William Powell in *Love Crazy* (1941)

Robert Preston in *Victor/Victoria* (1982)

Tony Randall in *The 7 Faces of Dr. Lao* (1964) (as Medusa)

Mickey Rooney in *Love Finds Andy Hardy* (1938) and *Babes on Broadway* (1941) (imitating Carmen Miranda)

George Sanders in *The Kremlin Letter* (1970)

Peter Sellers in *The Mouse That Roared* (1958)

Michel Serrault in *La Cage Aux Folles* (1979)

Dick Shawn in *What Did You Do in the War, Daddy?* (1966)

Alastair Sim in *Blue Murder at St. Trinian's* (1958)

Red Skelton in *A Southern Yankee* (1948)

Dean Stockwell in *Blue Velvet* (1986)

The Three Stooges in *Nutty But Nice* (1940)

Carl "Alfalfa" Switzer in *Our Gang Follies of 1936* (1936), *Rushin' Ballet* (1937) and *Mail and Female* (1937)

Robert Vaughn in *S.O.B.* (1981)

Ray Walston in *South Pacific* (1958) and *Caprice* (1967)

Henry Winkler in *The One and Only* (1978)

it to Broadway, he summoned Wallace to join him in 1907. Familiar as we are with the raspy quality of Beery's speaking voice, what do we make of the fact that he made his mark on the New York stage singing in operettas? And given the unkempt persona he cultivated in movies, it's hard to believe that, around Gotham during the time of the Taft Administration, the actor's offstage image was that of a coxcomb of the first order.

Rather than return east when a musical in which he was touring closed in Chicago, Beery signed on with a local movie outfit called Essanay. The mini-moguls of the studio decided that the ideal role for the bulky, dandified musical performer would be as a Swedish cleaning woman who was a bit slow on the uptake. Starting with *Sweedie the Swatter* in 1914, Beery appeared in a new Sweedie adventure every two weeks or so. No attempt was made for the 6'1", 250-pound actor to resemble an actual woman—under the wig and housedress there obviously lurked a large man. The humor in these silent shorts stemmed from having men come on to Sweedie, oblivious to the obvious hermaphroditic qualities of the character; the Sweedie shorts were also filled with pratfalls and chases that kept audiences of the Woodrow Wilson era chortling.

The contents of these shorts were revealed by their titles: *Sweedie Goes to College*, *Sweedie Learns to Swim*, and so on. Although Beery's character was a dolt, she always won out in the end—which made good business sense because, in Beery's words, "Remember always that it's the maids just off the boat who go to pictures. Society folks don't." The brains behind many of these comedies was none other than Louella Parsons, who, two decades before becoming Hearst's Hollywood harridan, eked out a living as a scenarist at the Essanay studio. Beery codirected a lot of the films, and he didn't tone down the excesses of the star—already the actor was developing the habit of mugging that would turn him into a shameless scene stealer for the next three decades. When Beery played Sweedie, he simply got

into costume without any psychological inquiries into what it meant to be a woman.

The *Sweedie* series lasted through 1915, and Beery also appeared in and directed other shorts. But scandal threatened when a couple complained to the studio that the star had done more than just sign an autograph for their jail-bait daughter. Fearing the vice squad, the head of the company, cowboy star Bronco Billy Anderson, whisked the actor to Niles, California, to manage Essanay's new West Coast studio. Beery's business acumen proved as sharp as his selection of whom to romance—the studio went bust after three months of his stewardship.

He ambled down to Hollywood and signed a contract with Universal—which wasn't as big a deal as it may sound, because in 1915 Universal was eons away from being a major studio. (As Ethan Mordden points out in his book *The Hollywood Studios,* other companies had Chaplin, Pickford, Fairbanks and Lillian Gish under contract. Universal's "stars" were the likes of Mother Benson, Myrtle Gonzales, Billy Human, Little Clara Horton and Fatty Voss.) Beery then went to Mack Sennett's Keystone but was fired when he eloped with 19-year-old contract player Gloria Swanson, whom he knew from her work in a *Sweedie* film. The marriage lasted all of two years, but by the time it was over, Beery was on his way to becoming a well-regarded supporting actor in feature films, including such classics as *The Four Horsemen of the Apocalypse* and *Robin Hood,* in which he played Richard the Lion-Hearted, the performance he would always consider his finest.

It wasn't until talkies, however, that Beery perfected his gruff-but-lovable characterizations. He joined MGM in 1930, and although he was far from the most glamorous star at the studio, he was one of the most popular. Beery "aw, shucks"-ed his way to five appearances on the poll of Top 10 Box-Office Attractions, an Academy Award for *The Champ* and continued top billing until his death in 1949.

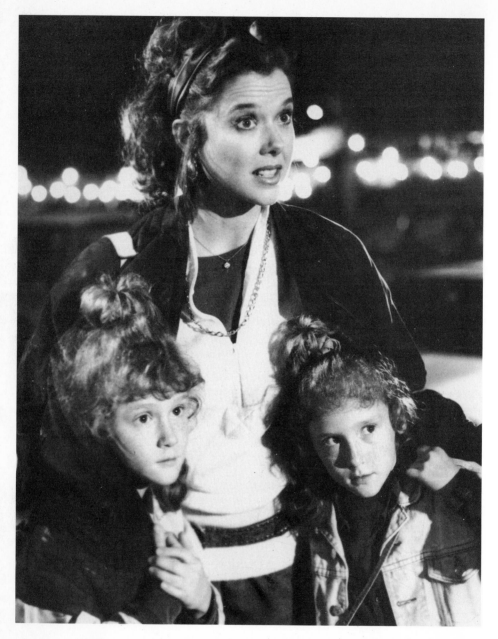

Before giving birth to Kathlyn Beatty, Annette Bening had a dry run with these twin girls, Hilary and Rebecca Gordon. Having to pretend she was in love with Dan Aykroyd in a truly horrid comedy, *The Great Outdoors,* was quite a comedown for an actress who had arrived in Hollywood with the pedigree of a Tony Award nomination.

ANNETTE BENING

······

THE GREAT OUTDOORS
(1987)

Born in Topeka, Kansas, in 1958, Annette Bening spent the first seven years of her life in Wichita. Her father was a "teacher" for Dale Carnegie, lecturing not on Carnegie's greatest hit, *How to Win Friends and Influence People,* but rather on "5 Great Rules of Selling." Figuring that he'd have a more receptive clientele elsewhere, Mr. Bening moved the family to the world's center of self-help movements, quasi-religions, cults (spiritual and otherwise) and quackery in all its various degrees and manners, Southern California. Annette grew up in San Diego, spent a year between high school and college as a cook on a charter scuba boat and received a B.A. in theater arts from San Francisco State University. After graduation, she remained in San Francisco, spending five years at the American Conservatory Theatre and marrying a student in the directing program. Husband and wife then spent a season at the Denver Theatre Center (where she

It was a sign of the times.

CAST

DAN AYKROYD, JOHN CANDY, STEPHANIE FARACY, ANNETTE BENING, CHRIS YOUNG, IAN GIATTI, HILLARY GORDON, REBECCA GORDON, ROBERT PROSKY

······

UNIVERSAL
DIRECTED BY HOWARD DEUTCH
SCREENPLAY BY JOHN HUGHES
PRODUCED BY ARNE L. SCHMIDT
EXECUTIVE PRODUCER: JOHN HUGHES
CINEMATOGRAPHY BY RIC WAITE

■ ■ ■ ■ ■ ■ ■ ■ ■ ■

So far in her career, there has been a distinctly dichotomous quality to the roles Annette Bening has played.

Dutiful Wives

The Great Outdoors (1988)

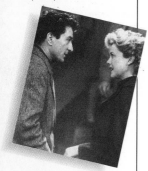

Guilty by Suspicion (1991; above)

Regarding Henry (1991)

Vamps

Valmont (1989)

Postcards from the Edge (1990)

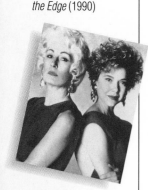

The Grifters (1990; above)

Bugsy (1991)

picked up a Best Actress citation from the local theater reviewers), and then Bening, *sans* spouse, moved on to New York.

Landing a part in an Off-Broadway show is not too unusual for a young actress, but when the play is so successful that it moves to Broadway, that's impressive. In Tina Howe's bittersweet *Coastal Disturbances*, Bening played a young woman nursing a broken heart at a New England resort town and received a Tony nomination as Best Featured Actress in a Play. She lost that prize, but did win the Clarence Derwert Award, given to "the most promising female actor on the metropolitan scene." And the movies beckoned.

After the acclaim she had received for her Broadway debut, it was only natural to expect that Bening would be given a juicy dramatic role in a prestigious motion picture. It may have worked that way in the 1930s and even in the 1970s, but this being the 1980s, she ended up playing Dan Aykroyd's wife in a lame slapstick comedy called *The Great Outdoors*, directed by John Hughes protégé Howard Deutch. John Candy plays a nice, simple, middle-class guy whose dream of an idyllic week of bonding with his wife and two sons in the north woods is shattered when brother-in-law Dan Aykroyd (a wealthy, loudmouthed braggart) and family show up unannounced at his lakeside cabin.

Fourth-billed, Bening has an almost nonexistent character to work with. Her role essentially consists of laughing hysterically at Aykroyd's unfunny wisecracks, and she has an unappetizingly surly air about her. As written (by John Hughes), Bening's Kate, like the two leads, lacks a defined personality, maternal at one point, horny at another—whatever seems to fit within the contours of an individual scene. Bening was fortunate that most critics were so busy knocking the movie's overall ineptitude and the shaggy-dog shenanigans of Aykroyd and Candy that they generally overlooked her. In the *New York Post*, however, V. A. Musetto aptly commented, "Annette Bening seems lost as Aykroyd's mate."

Having gotten through this foozle, Bening found herself back on the New York stage, costarring with Kate Nelligan in Michael Weller's *Spoils of War*. This time, though, when the show transferred to Broadway, the actress couldn't travel with it—she had journeyed to Europe to film *Valmont,* Milos Forman's unsuccessful rendering of *Les Liaisons Dangereuses.* But when Steven Frears, the director of the *acclaimed* version of that French novel, got hold of her, she became a film star. Bening received a Supporting Actress Oscar nomination for *The Grifters* (1990) and had Pauline Kael cooing that she was "a sex fantasy come to luscious life. She's irrepressible—a real tootsie." Bening's real burst of fame, however, came not from a movie but a real-life occurrence in the summer of 1991, after she co-starred with Warren Beatty in *Bugsy.* No one could believe the news that the 54-year-old Beatty would be experiencing parenthood for the first time. As a headline writer for the *New York Post* put it, "Oh, Baby!" Even more amazing, in early 1992, the actor finally gave up his bachelorhood—and Kathlyn Beatty's mom, Annette Bening, became Mrs. Warren Beatty.

Some of the lines Annette Bening had to utter in *The Great Outdoors* are so crude that we can only look on the actress with pity.

Mentioning that husband Dan Aykroyd is so busy with his financial deals that they sometimes go a month without sleeping together, Bening says, "Sometimes I think the only way I'll get any pleasure is by leaning against the washer during the spin cycle." John Candy's wide-eyed wife (Stephanie Faracy) asks, "Does that really work?" Bening: "Have you ever seen whiter whites?"

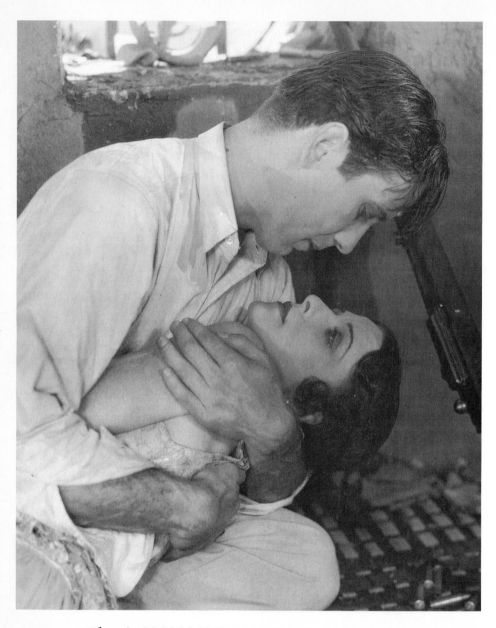

It sure isn't Duke Mantee (*The Petrified Forest*), Baby Face Martin (*Dead End*) or Rocks Valentine (*The Amazing Dr. Clitterhouse*). Nope, Humphrey Bogart, who by the end of the 1930s would be established as one of the screen's most menacing gangsters, saw the cinematic light of day as a young romantic of the Rudolph Valentino school. Here he succumbs to the vamping of Mona Maris. He would have a better time of it 14 years later with Lauren Bacall.

HUMPHREY BOGART

······

A DEVIL WITH WOMEN
(1930)

It was a far cry from Sam Spade.

When you see Humphrey Bogart, it's doubtful you have an urge to burst into "You Must Have Been a Beautiful Baby." But he was, and his commercial artist mother wanted the world to know. At the age of one, little Humphrey's smiling face, as sketched by Maud Humphrey Bogart, adorned the labels of a leading baby food manufacturer and also showed up in print advertisements for other companies; he was well known to readers of women's magazines as "the Maud Humphrey baby." His father was a prominent surgeon, and the Bogarts lived an upper-middle-class existence on New York's Upper West Side.

But the elder Bogarts were cold and distant—except in each other's company, when they argued incessantly like Jiggs and Maggie. When Humphrey flunked out of Phillips Andover, he decided he'd rather face Kaiser Wilhelm's boys than his parents and enlisted in the Navy in 1917. Warner Brothers publicity would later maintain that Bogart

CAST

VICTOR MCLAGLEN, MONA MARIS,
HUMPHREY BOGART,
LUANNA ALEANIZ,
MICHAEL VAVITCH,
MRS. JIMINEZ, MONA RICO

······

FOX
DIRECTED BY IRVING CUMMINGS
SCREENPLAY BY DUDLEY NICHOLS AND
HENRY M. JOHNSON
CINEMATOGRAPHY BY ARTHUR TODD
AND AL BRICK

THE CRITICS ON HUMPHREY BOGART

"There is an irritating friend with his trick of getting the last laugh, whether it be martial or amorous adventure. This last is Humphrey Bogart, who makes his debut and gives an ingratiating performance. Mr. Bogart is both good-looking and intelligent."
—Mordaunt Hall, *New York Times*

"Bogart is from the stage, but seems to have been miscast opposite McLaglen, for their so-called comedy stuff doesn't hardly sputter."
—*Film Daily*

"Both Bogart and McLaglen [are] okay, but the action given Bogart is silly. He's supposed to be the nephew of the richest power in the

acquired the trademark scar on his lip—and resultant slight lisp—when the troopship on which he was stationed was torpedoed. In actuality, a pair of handcuffs did the deed; on escort duty, Bogart got smacked by a prisoner trying to escape. (No matter; he still suffered the injury in service to his country.)

After the Armistice, Bogart got a job as a runner for a Wall Street investment company and then worked as an office boy for his next-door neighbor, William Brady, a theatrical producer who was branching into motion pictures. One day Brady fired the director of a Rod LaRocque movie and, with no better alternative, assigned Bogart to finish it. "I did a fine job," the actor laughed decades after the fact. "There were some beautiful shots of people walking along the streets, with me in the window making wild gestures. There was an automobile chase scene in which a car ran into itself. So Mr. Brady stepped in and directed the rest himself." Brady also determined that perhaps the young man would do less damage elsewhere and sent him off as stage manager of a touring show.

• • • • • •

Bogart's initial acting appearance came about after one of the players in that road show heard him scoff that actors were "soft." The thespian, miffed at the insult, dared the stage manager to perform a role for one performance. Looking back on the occasion, Bogart said that in a scene in which another actor lost his temper, "I thought he was really mad; he scared the hell out of me." A little later, when he calculated his salary as a stage manager against the wages of the actors, he decided to forget his vow never to act again, and he made his Broadway debut in 1922. His recollection of his first opening night : "I got so scared I had to walk off the stage to get a glass of water, leaving Hale Hamilton twiddling his thumbs. He was rather upset. So were the critics." From the beginning, Bogart was typecast onstage as a Jazz Age Romeo, and of his

performance in his second play (something called *Swifty*), the critic Alexander Woollcott wrote, "The young man who embodies the sprig is what is usually and mercifully described as inadequate." Despite that estimation, Bogart worked constantly in romantic comedies through the 1920s, averaging a Broadway play every season.

The actor's first encounter with movie acting came in 1923, when he had a screen test for the role of Lillian Gish's leading man in *The White Sister*. He lost the role to an obscure actor named Ronald Colman, who promptly became a star. Bogart had to wait for sound to come to the movies before he actually got to make one, appearing with Broadway luminary Helen Hayes in *The Dancing Town,* a two-reeler shot in Astoria in 1928. His second was also a short subject made in New York, *Broadway's Like That,* in which he played a sharpie who ate with singer Ruth Etting in a chop-suey joint and put the moves on her. While he was playing yet another juvenile onstage, a scout from Fox saw him and thought he'd be dandy in an upcoming movie called *The Man Who Came Back*. Bogart signed for $400 a week, but when he arrived in Hollywood he met two other new Fox contract players, each of whom informed him that *he* had been promised the starring role in *The Man Who Came Back*. In the end, the studio hedged its bets and cast its number one male star, Charles Farrell (whom you probably know not as a matinee idol but as Vern Albright on *My Little Margie*).

Bogart instead got the second lead in a Victor McLaglen vehicle. McLaglen was best known for *What Price Glory?* and its popular sequels, in which he and Edmund Lowe played Marine officers Flagg and Quirt, good buddies who brawled incessantly over a woman or a bottle of whiskey or whatever. Bogart, hair slicked back, essentially played a younger version of Quirt in *A Devil with Women,* a raucous comedy-adventure set in an unnamed banana republic, with McLaglen a soldier of fortune on the trail of a local bandit leader and

country and walks through jungle spots and other mysterious country as a lark, just to nag McLaglen."

—*Variety*

Bogart the unlikely playboy nephew of an American industrialist. The movie also includes two beautiful señoritas who are actually gun smugglers for the local bandit and a third woman, Mona Maris, for whose hand they become rivals. But youth wins out, and when the *bandito* pulls a gun on our two heroes, Mona steps in front of Bogart, thus signifying to McLaglen that he has lost out to his younger, more handsome competitor. You wonder what is that the woman sees in Bogart, for the actor is an unprepossessing mixture of overenthusiastic emoting (from his stage experience) and a wooden physical presence (due largely to the stilted nature of most early talkies). The character he played undoubtedly would have been more at home in a drawing room comedy than mixing it up with Latino bandits.

A Devil with Women came and went with little fanfare. *Film Daily* summarized the production this way: "Mild offering with Central American setting has a rambling story that gives McLaglen little chance. . . . It is one of those pictures that leaves so little impression that it is hard to recall even the highlights." Bogart remained at Fox for a year with no highlights, and he couldn't help noticing that his roles were getting progressively smaller. Billed third in his debut, he was given fourth standing in his next picture. He again shared a soundstage with Victor McLaglen in his fifth movie, *Women of All Nations,* but this time it was a genuine Flagg and Quirt movie costarring Edmund Lowe, and Bogart was in ninth billing. After his unhappy tour of duty at Fox, which culminated in the studio's sticking him in a cowboy movie, Bogart returned to New York. A single, undistinguished Broadway appearance was the only thing to be had on the East Coast, so he returned to Hollywood, making out no better than the first time. It was back to New York, where, after the actor was seen in a handful of pedestrian productions, the backer of the allegorical play *The Petrified Forest* thought of Bogart to play a killer who holds a group of

people hostage at a roadside café. No way, said play-wright Robert Sherwood. "It's my money," retorted producer Arthur Hopkins, and the role of Duke Mantee was Bogart's. The hit show changed his image and made him a star. There would be more transfor-mations in his acting persona over the years, but never again would Humphrey Bogart be the callow youth of *A Devil with Women.*

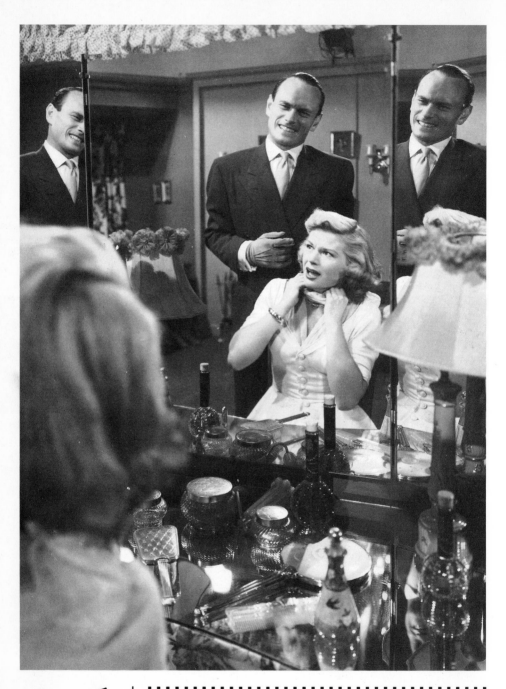

 Yul Brynner played the kind of fellow you shouldn't cross, as K.T. Stevens found out the hard way. The triptych mirror gives a nice three-way view of what Brynner looked like with hair.

YUL BRYNNER

······

PORT OF NEW YORK
(1949)

E ven before he became a star, Yul Brynner delighted in confounding reporters with wonderfully contradictory accounts of his background, starting with his birth. He preferred his natal date to be 1920, but it could just as well have been 1915 or 1917. Although Brynner—whose actual first name was Youl—was born in Vladivostok, a seaport in southeastern Russia, he often claimed he had first seen the light of day on an island off the coast of Siberia. Sometimes his mother was a Romanian gypsy, other times a Russian who had died in childbirth. In truth, his Russian mother lived many years after giving birth. She and his Mongolian father separated in 1925, and Mother Brynner took Youl and his sister to Manchuria, and later to Paris.

CAST

SCOTT BRADY, RICHARD ROBER,
K.T. STEVENS, YUL BRYNNER,
ARTHUR BLAKE, LYNN CARTER

■ ■ ■ ■ ■ ■

EAGLE-LION
DIRECTED BY LASLO BENEDEK
SCREENPLAY BY EUGENE LING,
ADDITIONAL DIALOGUE BY
LEO TOWNSEND, STORY BY
ARTHUR A. MOSS
PRODUCED BY AUBREY SCHENCK
CINEMATOGRAPHY BY GEORGE E. DISKANT

Brynner's first brush with performing occurred after he dropped out of a Paris boarding school— he later claimed to have a master's equivalency degree from the Sorbonne—and joined a traveling circus troupe. A serious fall convinced him that dangling

············

If his first film had not been a cheap little crime melodrama, Yul Brynner might never have played the King of Siam.

Brynner's predilection for making up stories about his early years nearly got him in serious trouble in the early 1950s. The American Legion, ever diligent against pinkos during the McCarthy era, published in its magazine Brynner's claim that he had driven a truck for the Loyalists during the Spanish Civil War (even though he had never been in Spain); this was, of course, the *wrong* side in the eyes of the Red hunters, and it made the actor clearly suspect. The Legion further reported that Brynner had been captured by Franco's forces and suffered such trauma from his two-month imprisonment that he "thereby lost his hair."

from a trapeze was not the life for him, and his next incarnation was as a singer and guitarist. Brynner would have had you believe that he became the rage of Parisian nightlife, but a more objective observer might tell you that he managed to get by. Meanwhile, he apprenticed in an acting troupe run by a couple of White Russians who had settled in Paris.

With France gearing up for war, the peripatetic performer headed for New York in 1940. On hearing that another Russian expatriate, Michael Chekov, was running an acting studio in the wilds of Ridgefield, Connecticut, Brynner made up his mind to attend. That he didn't speak English didn't faze him, and as for the fact that he didn't have tuition money, well, it was taradiddle time once again. Some days he'd hit up acquaintances for quick cash to send to a grandmother who was mortally ill; other times there was dear Papa, who was starving in China. Brynner's first role with Chekov was *Twelfth Night*'s Fabian, a part he learned phonetically. When the company's production of *King Lear* stopped off at Columbia University, a *Spectator* reviewer wrote that as Cornwall, Brynner sounded like a "cross between Charlie Chan and Charles Boyer." Even more than acting, Brynner served an invaluable function for Chekov's company: He drove the tour bus.

Brynner's next assignment was with the Office of War Information; afterwards he ended up on an embryonic television program called *Mr. Jones and His Neighbors*. This being the early '40s, there were only a smattering of television sets in the country, so just a select few got to see six episodes of Brynner singing and clowning around. The actor made it to Broadway in 1943 with a minuscule part in the short-lived *The Moon Vine*, playing, of all things, a gentleman of the Old South; his only notice came from a critic who made fun of his inept Southern accent. With no other roles materializing, Brynner revived his *chanteur* bit, warbling French folk songs at the Blue Angel and other nightspots.

Brynner's big break came when he was cast opposite Mary Martin in the Broadway show *Lute Song*, an adaptation of a Chinese folk tale. The show was only moderately successful, running five months, but Brynner, spelling his name Yul for the first time, won the Donaldson Award as the most promising actor of the 1945–46 theater season. The new Broadway star toured with the show for a year and also reprised his role in London.

Enter Judy Garland, who saw *Lute Song* at its last performance in Los Angeles. According to Brynner's son Roc, "That night, when he met her after the show, Yul fell in love with Judy, and they began their short, secret romance." Too bad for them that Brynner had to go with the show to Chicago. The enterprising Garland hatched a plan to keep their love alive: She convinced the powers at MGM that *Lute Song* was the Garland vehicle her fans were waiting for and that this new fellow Brynner would make a marvelous costar. MGM flew Brynner to Hollywood for a screen test and for off-screen libidinal bliss in Garland's arms. The studio decided to pass on *Lute Song*, so Brynner returned to his wife, actress Virginia Gilmore, while Garland went back (briefly) to Vincente Minnelli.

In New York, Brynner managed to latch on to yet another career: television director at CBS. (One of his assistants was the young Sidney Lumet.) And there he might have remained if it hadn't been for that *Lute Song* test. Director Laslo Benedek had made only a single film at MGM, but since that movie was the Frank Sinatra fiasco *The Kissing Bandit*, Benedek was shown the door at Culver City. Talk about a fall from grace—when Benedek went packing he didn't land at Paramount or 20th Century-Fox or even Republic. He ended up, instead, at an outfit called Eagle-Lion, which wasn't even as adept at B pictures as Monogram. Before exiting MGM, however, Benedek took a gander at the *Lute Song* test and made a mental note.

Port of New York is not the only film in which Yul Brynner has hair. He donned wigs in the following movies.

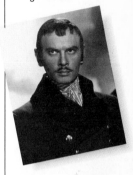

The Buccaneer (1958)

The Sound and the Fury (1959)

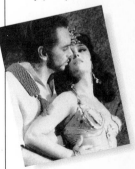

Solomon and Sheba (1959)

"Yul Brynner, a recruit from the legit stage, through his performance in this pic as the top dope smuggler brings a new and different type of personality to the screen. Unless this reviewer is a bad guesser, you'll be seeing plenty of him after this film breaks."

—*Variety*

(Bad guess. Brynner wasn't seen on-screen again until the film version of *The King and I* seven years later.)

For Eagle-Lion, Benedek was making a crime melodrama to be shot entirely on location in New York. Brynner was temporarily suspended by CBS because of attitudinal problems, so when Benedek asked him to appear as the villain in *Port of New York* he signed on, receiving fourth billing. *Port of New York* is a late example of a species that flourished after World War II: the semidocumentary crime film. Every studio had a go at this genre, but 20th Century-Fox was the champion, with such entries as *The House on 92nd Street* and *Call Northside 777*. These melodramas qualified as partial documentaries simply because they included some footage shot behind the scenes at a government bureaucracy like the Treasury Department at a time when audiences were excited by such things (*Port of New York* features *two* government agencies— the Customs Bureau and the Bureau of Narcotics); they were supposedly based on actual case histories, and they featured pompous narration to make everything sound on the square.

Suave, soft-spoken and sardonic, Brynner cuts a memorable swath as the kingpin of a band of highjackers who have stolen a shipment of medicinal drugs; he's a sadistic yet debonair heavy, complete with bowler hat and walking stick. When we first see him, his moll (K. T. Stevens) is whining about an accomplice whom Brynner had ordered killed: "You told me the person would be taken care of. You didn't say it would be with a knife." With just the slightest trace of contempt, Brynner replies, "You have such a repulsive way of putting things, darling." She starts squawking about wanting to get away from it all, and his coolly understated response, "This hysterical attitude of yours, I don't care for at all," seals her fate. The good guys triumph, of course, though not until Customs man Scott Brady is offed while under cover. Just as Brynner is about to have Narcotics investigator Richard Rober done in, the Coast Guard comes to his rescue and the

villain is arrested with a memorable look of perplexed anguish on his face.

Port of New York quickly came and went as part of a double bill with *Riders in the Sky*, starring Gene Autry. Brynner made up with his bosses at CBS and returned to his $1,000-a-week directing job. Ironically, if *Port of New York* had been made by a major studio and received a publicity push, Brynner might very likely have emerged a star, as Richard Widmark did two years earlier when he debuted as a psycho in Fox's *Kiss of Death*. Under a long-term Hollywood contract, Brynner would not have been available when he got the call to appear in *The King and I* on Broadway in 1951. It would have been a whole different career.

Brynner has hair in *Port of New York*, although you'd be hard pressed to call it a full head. His receding hairline led the costume designer of *The King and I* to badger him until he finally followed her suggestion and shaved off what little remained. Sounding the call for bald men everywhere, Brynner created a new look that set him apart from every other leading man and made him a sensation. Women swooned over his hairless pate, and chrome domes everywhere suddenly felt better about themselves. And you may say it was just a coincidence, but there's no denying that in the two presidential elections of the 1950s each party rallied around a bald man as its candidate.

Port of New York is particularly fascinating today for its on-site New York City location shooting; on view are such long-gone sights as the old Penn Station, the Canal Street El station, and Columbus Circle before the New York Coliseum imposed its ugly bulk on the area. With its stylish film noir black-and-white photography, *Port of New York* represents the dark underside of *On the Town*, which was shot in New York at the same time.

Crime boss apprehended in *Port of New York*.

Well, shut her mouth. Ellen Burstyn learns that her dirty-minded suspicions are way off the mark. Woody Woodbury reveals that stripper Tina Louise's off-hour activities consist of tutoring college boys in math and nothing else. That's the type of movie *For Those Who Think Young* is.

ELLEN BURSTYN

•••••

FOR THOSE WHO THINK YOUNG
(1964)

E dna Rae Gillooly was born in Detroit in 1932. Lacking two chemistry credits for her high school diploma, she left school to become a model and to act in community theater. Wanderlust eventually took her from the Motor City to Dallas, where she dropped the Gillooly and not only mod-eled for a couturiere but served as a commenta-tor on local telecasts of fashion shows. Next she showed up in Montreal dancing in a nightclub, now billing herself as Kerri Flynn. She had also married an auto salesman who thought he should be writing poetry. The cou-ple moved to New York, where she took the mon-iker Erica Dean. While her husband stayed at home, communicating with the Muses, Erica Dean put food on the table by pos-ing for illustrators of paper-back novels. Her husband eventually returned to De-troit, but she stayed on in

CAST

JAMES DARREN, PAMELA TIFFIN,
WOODY WOODBURY, PAUL LYNDE,
TINA LOUISE, NANCY SINATRA,
BOB DENVER, CLAUDIA MARTIN,
ROBERT MIDDLETON,
ELLEN MCRAE (BURSTYN),
JACK LARUE, ALLEN JENKINS,
ROBERT ARMSTRONG,

•••••

UNITED ARTISTS
DIRECTED BY LESLIE H. MARTINSON
SCREENPLAY BY JAMES O'HANLON
AND DAN BEAUMONT
FROM A STORY BY BEAUMONT
PRODUCED BY HUGH BENSON
EXECUTIVE PRODUCERS: AUBREY
SCHENCK AND HOWARD W. KOCH
CINEMATOGRAPHY BY HAROLD E. STINE

By the time she first appeared on a soundstage, Ellen Burstyn had managed to go from being the toast of Broadway to to being a total unknown. And when she finally made it big in movies, she had gone through half a dozen incarnations.

Gotham, and in 1955 got her best job yet: as one of Jackie Gleason's Glea Girls, young women who were hired ostensibly to serve as announcers, but mostly to look pretty.

Deciding that she could handle challenges greater than intoning "And away we go" when the Great One was about to appear, she sought to conquer Broadway. Although she had no training or experience, she managed to land an audition for a comedy through a friend of a friend who was a secretary at the William Morris Agency. The play, called *Fair Game,* was one of those "saucy" sex comedies that were mainstays of Broadway in the 1950s and '60s. As the actress later recalled, her audition was smashing: "I felt powerful and joyous. It was like singing. It was like being carried by the current of a river. Like sparkles on the water. Like reflections and shadows and bird songs."

A vehicle for Sam Levene, *Fair Game* told the story of a woman who comes to New York and takes a job in the Garment District, where, because she's a divorcée (i.e., not a virgin), she's considered "fair game" for the wolves of Seventh Avenue. Although the middle-aged men who constituted the New York theater critics generally considered the show fluff, they were enchanted by its unknown leading lady, who, by the way, was now calling herself Ellen McRae. The "willowy young Detroiter is the most refreshing and attractive ingenue to come to Broadway in quite a spell," raved John Chapman of the *Daily News,* who then alerted his fellow would-be roués, "And wait until you see Miss McRae in her slinky black gown in the third act!" Richard Watts, Jr., of the *Post* maintained, "She is bound to be the latest rage, and desperate measures should be taken to keep her from being spirited away to the movies." Then there was one Irving W. Cahn writing for a New York City tourist handout named *The Host.* Describing the play as a "howl about a guy on the prowl for a fowl," Cahn simply referred to the actress as a "doll."

A star was born, but her success did not bring her happiness, and she called the show "an experience that was to give me nightmares for eight years." It seems there were "two crazy people in the cast. No, I guess one crazy person; the other was just mean." Her analysis of the situation was that "the cast resented me, a lead without any training. That's understandable, but they didn't have to be as nasty as they were."

Besides glowing reviews and the animosity of her fellow cast members, McRae got two other things from her Broadway debut: a new husband in the person of the show's original director, who was fired when it was still on the road, and interest from Hollywood. One profile reported that she "is now receiving innumerable scripts and has offers from three film companies." *Fair Game* ran for six months, but despite all the hoopla, Ellen McRae did not make another acting appearance for half a decade. Unsure whether she had any talent beyond sheer pluck, she followed up *Fair Game* by studying with Stella Adler; her classes were curtailed when her husband decided he'd find better directorial opportunities in Los Angeles and she tagged along.

On the West Coast, McRae busied herself with two pursuits, going to Jeff Corey's acting classes and being a housewife; soon, however, she had a different husband, Neil Burstyn, a writer who would later help create the TV show *The Monkees*. Finally gaining a measure of self-confidence, McRae boldly set forth and played guest roles on such television shows as *Dr. Kildare* and its rival, *Ben Casey*. And then, six years after originally being inundated with film scripts, Ellen McRae was finally ready to try the big screen. Only now she wasn't being welcomed by Tinseltown as a hot property from back east. She was, thanks to show business's short memory, an unknown again.

It would be nice to think that her film debut gave her the success that had seemed hers for the asking several years earlier. Unfortunately, a movie with the

Harriet Lake
　　—*Ann Sothern*

Charles Locher and
Lloyd Crane
　　—*Jon Hall*

Dolly Loehr
　　—*Diana Lynn*

George Lutz
　　—*George
Montgomery*

Van Mattimore
　　—*Richard Arlen*

Lily Norwood
　　—*Cyd Charisse*
　　(although her real
name is Tula Finklea)

Dawn O'Day
　　—*Anne Shirley*
(after the character she
played in *Anne of
Green Gables*)

Eunice Quedens
　　—*Eve Arden*

John Peter Richmond
　　—*John Carradine*

Joe Yule, Jr., and
Mickey McGuire
　　—*Mickey Rooney*

- - - - - - - - - -

As bad as *For Those Who Think Young* is—and it is terrible—it has several notable aspects. For students of popular culture, the movie is of import as the first time that Bob Denver (playing Darren's sidekick and essentially redoing Maynard G. Krebs) and Tina Louise (as a combination of Einstein and Ann Corio) appeared together, several months before debuting as Gilligan and Ginger on *Gilligan's Island*. True, they have only one group scene together, but still somehow you can't help feeling that you're present at the creation. The movie may have been an attempt to inaugurate a second-generation, gender-bending Rat Pack because Frank and Dean's daughters, Nancy

title *For Those Who Think Young* is unlikely to be a vehicle for personal acclaim and stardom. *For Those Who Think Young* was one of the many *Beach Party* wannabes of the mid-1960s; if, having been produced by veteran Howard W. Koch, it's somewhat more polished than the likes of *Beach Ball* and *Wild on the Beach*, it's just as inane. It was also the most flagrant example to date of a cinematic tie-in to a commercial product, in this case Pepsi-Cola. Not only do all the kids in the film say "Pepsi, please," but the very title of the movie was Pepsi's slogan at the time.

The plot of *For Those Who Think Young* focuses on whether true love—in this case between college students James Darren and Pamela Tiffin—can overcome class distinctions. He's the scion of an upper-crust family; she's an orphan raised rather improbably by two vaudevillian uncles, Paul Lynde and Woody Woodbury.

As for conflict, the college, egged on by its chief benefactor, who also happens to be Darren's snobbish grandfather (Robert Middleton), moves to shut down the club where Woodbury performs so that Tiffin won't be able to afford tuition and will have to leave dear old Oceancrest College and Darren behind. This is where the ninth-billed Ellen McRae comes in. Playing a prudish sociology professor, she's assigned to gather incriminating evidence against the place as a corrupter of youthful morals. Woodbury manages to convince her that the place is no more disreputable than a malt shop—no liquor is sold to underage kids; the club's stripper spends her off-hours tutoring a student in math, etc.—and, wouldn't you know it, Burstyn falls in love with him. A happy ending is provided by an old newsreel that reveals that Grandfather actually made his money as a gangster. Found out, the old man drops his opposition to his grandson's romance and the nightclub is free to prosper. It's a stupid *deus ex machina*, but you don't at all mind because it gets the movie over with.

Since Ellen McRae had studied with Stella Adler,

The Critics on Ellen McRae (Ellen Burstyn)

"Ellen McRae is very good as a straitlaced teacher who comes unlaced."

—*Hollywood Reporter*

"A delightful sociology professor."

—*Variety*

"Competent enough."

—*New York Times*

and Claudia, show up as Pamela Tiffin's sorority sisters; more likely, Howard W. Koch was just doing their dads a favor, since he produced their *Sergeants 3* and *Robin and the Seven Hoods.* Lada Edmund, Jr., who shortly would achieve renown as the nation's preeminent go-go dancer via *Hullabaloo,* also has a small part, fittingly playing one of the students who does nothing but dance on the beach.

she must have felt right at home—stars James Darren and Pamela Tiffin had both taken classes with Adler, although you'd hardly want their performances in a recruiting film for her classes. McRae is quite pleasant and is as believable in her transformation from spinster to "modern woman" as the broadly written character allows. While it's not surprising that McRae was less than thrilled at being directed by *For Those Who Think Young*'s Lesley Martinson, whose *oeuvre* included the likes of *Hot Rod Girl* and *Hot Rod Rumble,* you'd think that working with one of the screen's greatest directors, Vincente Minnelli, on her next film would be ample compensation. *Au contraire.* She hated working on *Goodbye, Charlie* (which admittedly is not one of the director's choicer works). Years later, she had a standardized recitation about her experience on *Goodbye Charlie:* "I was wearing Shirley MacLaine's old wig. I had been dressed by the wardrobe department, made up by the makeup department, I was put together by the assembly line. Vincente Minnelli did my part for me and then had me copy him. He even said my lines with me as I rehearsed so that I could get his rhythm exactly."

Chances are you've never heard of Woody Woodbury, but he was an oily night-club comedian and game-show host who was "introduced" here to film audiences. Although his jokes—which concentrate on drunks and sexual innuendos—are of the "take my wife" school of humor, Woodbury has 'em rolling in the aisles and becomes the rage of all the local college kids, sort of an unhip Lenny Bruce.

The would-be Serious Actress lamented, "I thought 'I don't like this career at all.'"

With her third marriage ending, McRae packed up her kid and moved back to New York, where she found a starets in Lee Strasberg at the Actors Studio; he "made it clear that the path to my soul was my commitment to 'the work.'" As for paying jobs, McRae had costarring roles in the soap opera *The Doctors* and, returning to Hollywood, in a Dale Robertson Western series, *The Iron Horse*. After one last film, a cheap 1969 race car movie called *Pit Stop*, Ellen McRae was no more: "McRae had an acting reputation based on a previous dimension. And as I continued to learn how to act, I was saddled with the reputation of the one who didn't know how to act. By the time I was ready to do the work, I was stuck with her parts."

And so Ellen Burstyn was born. Burstyn showed up first in the 1970 film version of Henry Miller's *Tropic of Cancer* and then in Paul Mazursky's *Alex in Wonderland*. Although neither movie was successful, Burstyn drew attention for her work, and in 1971 she hit the big time, winning critics' prizes and an Oscar nomination for *The Last Picture Show*. With *The Exorcist* in 1973, Burstyn was front and center in a worldwide phenomenon, but the apex of her career came in the spring of 1975, when she won both the Oscar (for *Alice Doesn't Live Here Anymore*) and the Tony (for *Same Time, Next Year*). Burstyn had established herself as the most acclaimed American film actress of the 1970s, challenged only at the close of the decade by Jane Fonda. It would seem that her days of name changing are over, but who knows? Stay tuned.

RICHARD BURTON

••••••

THE LAST DAYS OF DOLWYN
(1948)

Richard Burton, the actor who would become the very symbol of celebrity excess in the 1960s and who would go through an estimated $80 million before he was done, had extremely lowly beginnings. Christened Richard Jenkins and born in the coal town of Pontrhydfen, Wales, in 1925, he was the 12th of 13 children; his father was a miner and his mother died when Richard was two years old. The first step on his road to profligacy occurred when the adolescent Richard caught the eye of a local drama teacher, Philip Burton. Recognizing that, with his flair for oratory, the boy showed promise for endeavors other than coal mining, the teacher convinced the teenager's father to let him have a go at the youth and Richard moved in. Philip became Richard's legal guardian in 1942, and the sixteen-year-old took his mentor's surname.

Life with the academician was not just afternoon tea and games of

CAST

DAME EDITH EVANS,
EMLYN WILLIAMS,
RICHARD BURTON,
ANTHONY JAMES,
BARBARA COUPER,
ALAN AYNESWORTH, ANDREA LEA,
HUGH GRIFFITH

••••••

LONDON FILMS
DIRECTED AND WRITTEN BY
EMLYN WILLIAMS
PRODUCED BY ANATOLE DE GRUNWALD
CINEMATOGRAPHY BY OTTO HELLER
AND GUS DRISSE

••••••••••••

Long before there was Liz and Dick, there was Dick and Dame Edith Evans.

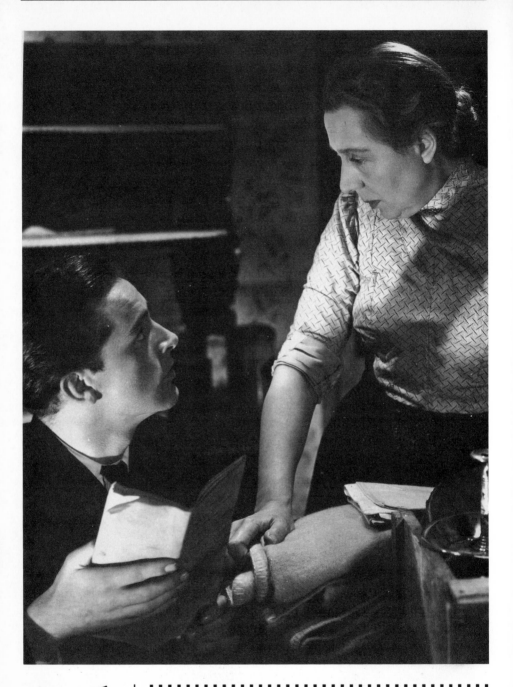

This young bloke hardly looks like the sort who would provide fodder for tabloids and the less respectable movie magazines for years. In 1948, Richard Burton was simply an unknown Welsh actor playing a sensitive fellow held back by that old British bugaboo, the class system.

cribbage. Philip Burton was determined to play Henry Higgins to Richard's Eliza Doolitle, teaching him to modulate his heavy Welsh accent and getting it through his head that stage dialogue need not be shouted to be heard in the back row. Despite his own modest background, Philip Burton was an accomplished enough master that his student was able to make his stage debut at the age of 17 in a play called *Druid's Rest*. Written by Wales's favorite son, Emlyn Williams (author of *Night Must Fall* and *The Corn Is Green*), the drama opened in Liverpool and a year later played London; after three months in the West End production, Richard left to study at Oxford. His stay at university was scarcely longer than his run with the play, for just as he was getting started with Oxford's Dramatic Society, King and Country scooped him up for the Royal Air Force. Despite the brevity of his school term, Burton made enough of an impression for one professor to jot down, "This boy is a genius and will be a great actor."

Jump cut to 1947 and Burton's release from the RAF. He considered returning to Oxford but realized that with so many young men picking up their lives after war service his opportunities at the school would be limited—not where dramatic studies were concerned, but on the playing field. There was no point in attending Oxford if he couldn't be on the rugby team, and with a multitude of veterans flooding the school, Burton knew he wouldn't make the cut. So off to London he went, signing on with a theatrical producing organization as a contract player, on call for any production in which he might be needed. Meanwhile, Emlyn Williams was again about to give a boost to Burton's career. The actor and playwright whose own ascent had begun when a sympathetic teacher had intervened to save him from a life as a Welsh coal miner—sound familiar?—was making like Orson Welles, writing, directing and starring in a movie, and he created a character with the young actor from *Druid's Rest* in mind.

Besides being Burton's first motion picture, *The Last Days of Dolwyn* was responsible for his first marriage. An 18-year-old actress named Sybil Williams had a bit part as a villager, and as far as Burton's brother Graham Jenkins was concerned, her casting "was more of a tribute to Emlyn Williams's generosity than to her raw talent." Whatever her limitations as an actress, she captivated Burton, and they wed in February 1949.

• • • • • • • • • •

Throughout his illustrious career, Richard Burton was routinely referred to as an English actor, even though he was actually Welsh. Additional actors hailing from U.K. countries other than England include:

Wales

Stanley Baker
Timothy Dalton
Hugh Griffith
Edmund Gwenn
Anthony Hopkins
Mervyn Johns
Roger Livesey
Ray Milland
Harry Secombe
Emelyn Williams
Rhys Williams

Ireland

Stephen Boyd
Kenneth Branagh
George Brent
Pierce Brosnan
Richard Harris
Dan O'Herlihy
Milo O'Shea
Peter O'Toole
Richard Todd

Set in the 1890s, *The Last Days of Dolwyn* tells the story of the small Welsh village of Dolwyn, whose inhabitants are poor but (did you doubt it?) unswervingly cheerful. The town's leaseholders are offered an unprecedented chance at the good life: A certain lord wants to buy the village in order to flood it for a reservoir project, and not only will he pay them for their land, he'll transfer them to a swell housing project in Liverpool. Merri (Edith Evans) has never been out of Dolwyn and has no desire to do so now, but being a poor, simple widow without land holdings, she has no say about the village's fate. She is axiomatically a Good Woman because a) she works as the chapel's caretaker and b) after the death of her own little boy, she adopted two other sons, one addlebrained (Anthony James), the other handsome, brooding and sensitive (Burton). Emlyn Williams himself plays the lord's agent in unmitigated hiss-the-villain fashion, and he is so unrepentingly evil that Burton has to have it out with him before the film runs its course. When the lord decides to spare the hamlet (because, I kid you not, Evans has cured his rheumatism), a foiled Williams endeavors to burn down the place. Caught in the act, he is knocked out by Burton, rolls into flames and burns to death. Burton gets away with murder because his resourceful mother opens the floodgates to the local dam, which means not only that the miscreant's body is swept away but also that the picturesque village is permanently submerged.

Burton is extremely effective as a young man who dreams of a better life yet is painfully aware of the limitations imposed on him by a rigid social system; he captures both the fierce pride and the wistfulness that define his character. It's a little odd now to see the latter-day Lothario looking this green, but despite his youth he was no innocent, at least according to Emlyn Williams. Filming the scene in which Burton watches his beloved as she dances, the director struggled to get the actor to convey ingenuousness. To no avail: "It

wasn't in his range, it wasn't in his nature. He did the rest of it marvelously, but that shot he couldn't do." Burton's voice has a slightly higher timbre than we're accustomed to, yet its beauty and melodiousness still are indescribably moving. Burton even sings a few bars of a folk song and carries it off liltingly; his vocalizing here is nothing like his talk-singing in *Camelot*.

The Last Days of Dolwyn premiered in London in 1949 and, called simply *Dolwyn*, played New York later that year. *Variety* referred to the movie as "a sincere attempt to tell simply and movingly a story of the ordinary folk of a tiny Welsh village . . . it is a film without romance or glamour." In discussing the performances, most reviewers concentrated on panning Williams and praising the somewhat fussy Edith Evans, who would be runner-up to *The Heiress*'s Olivia de Havilland for the New York Film Critics Best Actress award. Burton was mentioned in passing several times; the *New York Herald Tribune* called him "good," the *Times*, "volatile." Two decades later the actor cringed when shown a clip from *The Last Days of Dolwyn* during a television interview. He critiqued his performance as "febrile" and "lamentable," expounding, "Thank God I never have to live through that again, to live through those terrible years of puerility, of idiocy."

The movie didn't get to Los Angeles until 1951, now bearing the title *Woman of Dolwyn*. (Insofar as foreign films of that period usually promised a certain raciness, undoubtedly a lot of ticket-buyers were disappointed to find out that the title character was Edith Evans and not a Diana Dors type.) In the *Los Angeles Times* Philip K. Scheuer lamented, "Williams has crowded enough plots for three pictures," but he did allow that "Richard Burton and Andrea Lea as the young lovers . . . are excellent in support." By this time, Burton's reputation was soaring, thanks to his performance in Christopher Fry's *The Lady's Not for Burning*, which he performed in London in 1949 and New York in 1950. Hollywood beckoned in 1952, and the actor

Scotland

Ian Bannen

Jack Buchanan

Sean Connery

Gordon Jackson

David McCallum

David Niven

Alastair Sim

Nicol Williamson

earned back-to-back Oscar nominations for *My Cousin Rachel* and *The Robe*.

Throughout the 1950s, Burton made movies on both sides of the Atlantic, as well as continuing to tread the boards. However, it was *Camelot* in 1960 (or, more specifically, the original cast album, which seemed to echo from every home in America) that made him a major star. And then came *Cleopatra* and the Elizabethan years. When he died in 1984, obituaries mourned Burton's "unfulfilled gifts" and a "career madly thrown away." Seeing him in *The Last Days of Dolwyn*, all of that seems a long, long time ago.

GERALDINE CHAPLIN

······

LIMELIGHT
(1952)

Around the time that Geraldine Chaplin was beginning to dance with the Marquis de Cuevas company in Paris in the early 1960s, Charlie Chaplin's 1952 movie *Limelight* was revived in New York. In the first scene of the film, a cute little girl and boy come running down a London street to see an organ-grinder. Director Chaplin cuts from this exuberance to Claire Bloom, passed out in her room after having turned on the gas in a suicide attempt. Back to the children, joined by a second, smaller girl; all three watch the street entertainer. Behind them stumbles a drunken Chaplin, who tries to get his key into a lock. We see the kids watching him, stoned-faced in their fascination. After he mugs through his souse shtick a little longer, the elder girl shouts—almost inaudibly— "Mrs. Alsop's not home!"

Alert members of the audience recognized that this was the very same girl who, now grown up, was getting her face plastered across magazine pages; she was Charlie Chaplin's daughter, venturing forth

CAST

CHARLIE CHAPLIN, CLAIRE BLOOM, SYDNEY CHAPLIN, NIGEL BRUCE, BUSTER KEATON, MARJORIE BENNETT, ANDRE EGLEVSKY

······

UNITED ARTISTS
DIRECTED, WRITTEN AND PRODUCED BY CHARLIE CHAPLIN
CINEMATOGRAPHY BY KARL STRUSS

············

When the eldest of Charlie Chaplin's eight children by Oona O'Neill was emerging publicly—first as a ballet dancer and then as a leading lady of the mid-1960s—the press was teeming with tales about her father's opposition to her show-business career. Well, he started it.

Charlie Chaplin's seven-and-a-half-year-old daughter opens *Limelight* with her siblings Michael, six, and Josephine, three. They amuse themselves by watching an organ-grinder and then exit the picture as the mawkishness begins.

in the world of ballet. The articles were sure to include a quotation from Geraldine about her career choice, such as her acknowledgment to *Life* that "Pappy's a dictator and wouldn't hear of it."

Not only Geraldine was pressed into service in *Limelight:* the seven-and-a-half-year-old's two companions were Michael Chaplin, six, and Josephine Chaplin, three.

These four shots make up the entirety of the children's work in the film; they got out while the getting was good. In true Chaplin fashion, *Limelight* is one of the more maudlin and self-indulgent productions you'll ever see, with the writer-director-producer-composer playing a once-great music-hall-clown-done-in-by-drink who takes pity on would-be ballerina Claire Bloom and practically wills her into becoming a great and acclaimed dancer. By the time the mawkish 2 hours and 24 minutes are finally over, the ballerina has become an international star and has caught the fancy of a young composer (another Chaplin child, Sydney). Meanwhile, Chaplin, as the clown Calvero, scores a magnificent personal triumph at a gala tribute and, hearing the cheers of the crowd one last time, promptly dies.

■ ■ ■ ■ ■ ■

Unlikely as it sounds, this overblown bouquet of hearts and flowers was one of the most controversial movies of its day. The American Legion didn't like Charlie Chaplin's left-leaning politics (he was a member of the National Council of American-Russian Friendship, for example), and there were also rumblings about his sexual life (right-wing columnist Westbrook Pegler snickered that Chaplin was a "menace to young girls"). The Legion also fumed that the British-born Chaplin—a proponent of a "One World" philosophy—had never bothered to become an American citizen, despite having made a fortune in the United States. Up went the picket signs outside theaters showing *Limelight*. In Hollywood, the Motion Picture Alli-

ALL GROWN UP

Geraldine Chaplin in
Nashville (1975).

ance for the Preservation of American Ideals (Ward Bond, president) also joined in the protest, and the three Los Angeles theaters—including Graumann's Chinese—scheduled to exhibit the movie chickened out. (*Limelight* did not premiere in the Big Orange until 1972, at which time it won the now exonerated Chaplin an Oscar for Best Musical Score.) Meanwhile, when Chaplin and his family were on the *Queen Elizabeth* heading for England to promote the movie, Harry Truman's Attorney General pulled a fast one: He denied the once-beloved comic a reentry visa to the United States on the grounds that he was of "unsavory character." "Good riddance to bad company!" cackled a charter member of the Motion Picture Alliance for American Ideals, gossip-monger Hedda Hopper.

With her father barred from their Los Angeles home, Geraldine Chaplin grew up in Switzerland. At seventeen, she moved to London to study with the Royal Ballet School; she later danced as a mouse in a Paris production of *Cinderella*, unhappily ending up on front pages and receiving more attention than any chorus member in history ("Only one of twenty little dancers . . . but you'd have thought I was Pavlova," she moaned). She gave up ballet shortly thereafter, explaining, "I started too late. I soon realized that I could never catch up and become a truly great dancer, so I started thinking about acting." Geraldine made a French movie called *A Lovely Summer*, and then it was the big time, which, ironically, came about because of all that blasted publicity. In the midst of preproduction for *Doctor Zhivago* and having some casting problems, director David Lean happened to see a French magazine spotlighting the dancing *fille de Charlot*. He had found his Tonya.

KEVIN COSTNER

······

SIZZLE BEACH, U.S.A.

(1978)

ostner's father was one of the innumerable "Okies" who lost their farms in the middle of the Depression and moved to California. For the Costner patriarch, the accoutrements of a middle-class life were gained through a job as a lineman for Southern California Edison. The down side of this gainful employment was that Costner père periodically had to pick up and move his family all over the state. This peripatetic existence was especially hard on the younger son, Kevin; shy to begin with, he constantly had to make new friends in another strange town. But when the boy was feeling down, there was always the cinema: "I'd lose myself in the movies. I had a very active fantasy life. I can remember as a 10-year-old watching *How the West Was Won* and certain moments made me tingle with the magic of it."

Despite his love of films, Costner never considered an acting career as he was growing up. "I come from a pretty practical background," he said, so "I always figured that people on the stage were intended to be there. Acting was something other

CAST

TERRY CONGIE, LESLIE BRANDER, ROSELYN ROYCE, ROBERT ACEY, KEVIN COSTNER, LARRY DEGRAW

······

TROMA
DIRECTED BY RICHARD BRANDE
SCREENPLAY BY CRAIG KUSABA
PRODUCED BY ERIC LOUZIL
CINEMATOGRAPHY BY JOHN SPRUNG

············

Kevin Costner had probably forgotten about his first film when his newfound fame caused it to be resurrected.

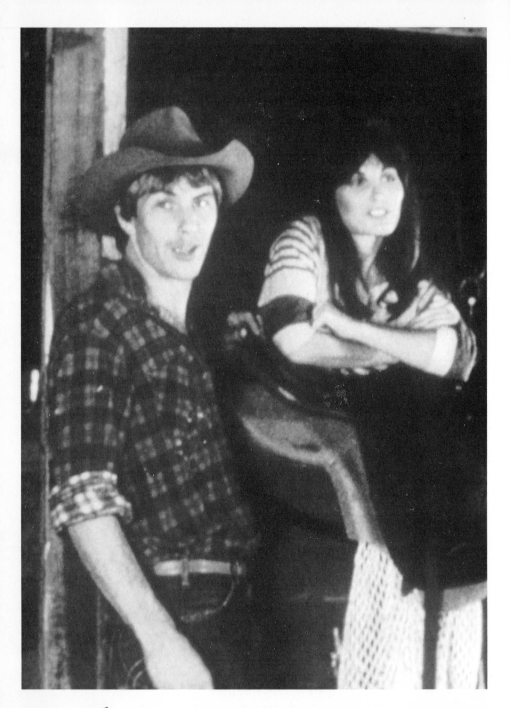

In his first film, Kevin Costner hones his persona as a Nice Guy. And unlike many of his co-stars in *Sizzle Beach, U.S.A.*, he keeps his clothes on.

people did." Because he was a better-than-average athlete, life as a baseball player seemed a more tenable proposition. In college (California State University, Fullerton), Costner appeared to be the quintessential frat boy, treating school as a last big party before adulthood, and giving only a passing nod to academia. Yet he was living a secret life. No one else at the Delta Chi house had an inkling that business major Costner was feeling strange desires. Although he tried hard, he could no longer repress his true feelings when, in senior year, he saw an ad for a school production of *Rumpelstiltskin*. At that moment he finally admitted to himself that he just had to be an actor and decided he would make a wonderful prince. He didn't get the part, but that failure was irrelevant next to the profound sense of identity he felt. Once he had this revelation, "I never looked back. I never breathed an easier breath. I relaxed. Then all I had to do was learn." Costner's next step came when, unbeknownst to his fraternity brothers, he joined a local community theater, the South Coast Actors' Co-Op, and had a great time with the other artists, exchanging ideas about acting and dramaturgy and appearing in works by Odets and Miller. As he remembered the experience, "With acting, I was on fire."

This invigorating period of theatrical self-discovery was shattered when the real world intruded in the form of college graduation. Steeped in the work ethic, Costner dutifully took a job in marketing at a construction company in Pomona. But the art of numbers-crunching was so dispiriting to a young man who had sampled the arts that "I started listening to my inner voice and said, 'You'd better do it, man.' The one voice says: 'Grow up'; the other says, 'Do the most ridiculous thing possible.'" He went with the latter and, thirty days after he began, he left his job.

Costner decided that Los Angeles and not Pomona was where he belonged. Fortunately, he was blessed with a supportive ally in his wife, Cindy, who also

knew the joy of performing—she had had a summer job dressing up as Snow White at Disneyland. Cindy was willing to become the breadwinner, with a job at Delta Air Lines, while Kevin worked as a stage manager for a small film company. He also acted in workshops and studied, and one of his teachers advised him he could get him a role in a movie. Even though it was clearly a cheap exploitation film, Costner reckoned the experience would be invaluable, so he signed on.

· · · · · ·

*S*izzle Beach, U.S.A. is a particularly negligible example of a negligible subgenre that flourished in the waning days of drive-in movies in the mid to late 1970s: the soft-core "T&A" film. (*The Pom-Pom Girls* and *Coach* are among the more seminal of these works.) The film is a cheesy reworking of *Three Coins in the Fountain*, with a trio of nubile young women coming to Malibu instead of Rome looking for love and success. Cheryl wants to be part of the exciting world of high school physical education, Dit is a would-be actress with a Bette Davis fixation, and Janice is a guitar-strumming singer-songwriter whose lyrics ("Will the creation die of cancer?") hark back to the worst of Melanie. But most of all, the three of them want to take off the tops of their bikinis, which they do with military precision every few minutes.

Costner, whom Dit falls for, plays the owner of a horse ranch. With his bangs, baby face and sheepish manner, he resembles Richard Thomas without the mole. For someone just starting out, the actor's performance here is surprisingly close to those later in his career. If you were in a charitable mood you'd call him "stolid"; if not, "wooden." In the world of *Sizzle Beach, U.S.A.*, men are divided into two camps: randy but nice guys and total jerks who treat women as possessions. Costner's John Logan is one of the former. This is apparent not only because of his gentle ways with Dit but because, when Janice enters an amateur singing

contest, he and his midget sidekick hold up her chief rival at gunpoint so that Janice will be sure to win. The bulk of the movie consists of sexual innuendo and weak satire (including a jab at Method acting in which the members of an acting class have to pretend they're bananas), and lots of close-ups of rear ends and breasts. Except that it contains no shots of genitalia and has a snickering attitude rather than a documentary one during the sex scenes, *Sizzle Beach, U.S.A.* possesses the look, feel and production values of a hard-core porno movie.

Costner and his fellow thespians spent a year's worth of weekends making their film. Once *Sizzle Beach, U.S.A.* was completed, however, it went straight to the shelf, where it festered until 1986. By that time, thanks to *Silverado*, Costner had a modicum of fame, and the ever-resourceful people at Troma—the company that hit pay dirt with *Re-Animator* and *The Toxic Avenger*—thought some lucre could be gained by presenting *Sizzle Beach* as a new Costner vehicle. The credits now read "Special Guest Star Kevin Costner." The company unveiled the movie at the 1986 Cannes Film Festival—decidedly out of competition. *Variety* took a look and reported that Costner gave the "only passable performance in the film," while the rest of the acting "ranges from amateur to atrocious." In the summer of 1989, after *The Untouchables, No Way Out, Bull Durham* and *Field of Dreams* had made Costner one of the biggest stars in the country, Troma released *Sizzle Beach,U.S.A.* on video, which at least showed the world that this new golden boy had paid his dues. For some reason, many film reference books date the movie as being made in 1974 (and Costner himself has been purposefully evasive about the production's time frame). The hideously wide lapels, halter tops and Farrah Fawcett-Majors tresses, however, firmly place the movie in the latter part of the decade. If that's not enough, seen on a desk at one point is the grinning visage of President Jimmy Carter.

Justifiably disappointed when he got a look at the

The enterprising film company Troma unearthed *Sizzle Beach, U.S.A.* after Costner had made a name for himself. In a clever bit of revisionism, the film was then advertised as a Kevin Costner starring vehicle.

finished product, Costner held *Sizzle Beach, U.S.A.* in contempt. "While it completely turned me off the business," he later said, "it taught me a valuable lesson. It changed me, not so much because of the low budget, but because of the filmmakers' low-budget thinking." Meanwhile, he and a group of friends formed a theater workshop, a place for actors, writers and directors to experiment and get the kinks out with nobody watching. A couple of years passed before Costner once more appeared before film cameras, though again in less than auspicious circumstances, with small roles in *Shadows Run Black* (1981) and *Night Shift* (1982). There were also roles in more prestigious films, including a bit in *Frances* in 1982 (in which he was incongruously cast as Yiddish actor Luther Adler) and a supporting part in 1983's *Testament*. Costner's big break came, ironically, through a film from which all his scenes were cut. Having cast Costner as the fallen comrade mourned in *The Big Chill*, director Lawrence Kasdan decided, two weeks before the release date, to forgo the film's flashback scenes. Costner's fate on the picture made his a well-known name in Hollywood circles, and Kasdan promised to make amends by putting him in his next movie. Although the western *Silverado* was a high-profile failure, Costner's raucous performance—annoying to some observers, charming to others—was hard to miss. He was billed third in *Silverado*; from then on, his name would go first.

BILLY CRYSTAL

······

RABBIT TEST
(1977)

Bronx-born Billy Crystal moved to Long Island as a two-year-old and 15 years later was voted "Best Personality of the Class of '65" at Long Beach High; this commendation was due partly to his writing, directing and acting in the school's variety shows and partly to his buttonholing fellow high school scholars in the hall and regaling them with impersonations and anecdotes. After high school came Nassau Community College and later New York University, where Crystal studied cinema and had Martin Scorsese as a professor.

An atypical film school graduate, Crystal didn't use his cinematic training as a springboard for making a murky-looking independent film about how lousy it is to be alive, or publishing a treatise on the art of director Reginald LeBorg, or working as an office temp. Instead, he joined up with two other guys and formed a com-

CAST

BILLY CRYSTAL, JOAN PRATHER,
ALEX ROCCO, DORIS ROBERTS,
IMOGENE COCA, RICHARD DEACON,
NORMAN FELL, ALICE GHOSTLEY,
GEORGE GOBEL, ROOSEVELT GRIER,
PAUL LYNDE, PETER MARSHALL,
RODDY MCDOWALL,
SHEREE NORTH, TOM POSTON,
CHARLOTTE RAE, JIMMIE WALKER

······

AVCO EMBASSY
DIRECTED BY JOAN RIVERS
SCREENPLAY BY JOAN RIVERS
AND JAY REDACK
PRODUCED BY EDGAR ROSENBERG
CINEMATOGRAPHY BY LUCIEN BALLARD

············

Comedian Billy Crystal began in films by playing a straight man, or at least as straight as a pregnant man could be.

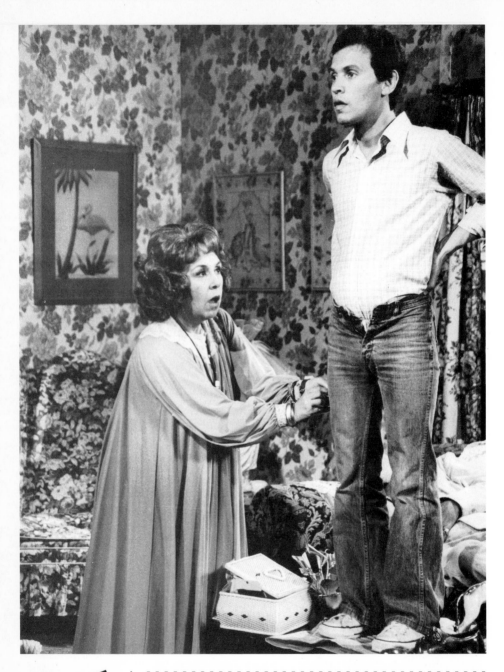

It's not enough that Billy Crystal is the world's first pregnant man; he's also nagged mercilessly by an archetypal Jewish mother in the form off Doris Roberts. In addition, Crystal has to make do as the straight man, the calm in the middle of all the craziness Joan Rivers can concoct.

edy troupe they christened 3's Company. (This was half a decade before Suzanne Sommers.) When not appearing with the act, Crystal made pocket money as a substitute teacher, though it was his wife's job as a guidance counselor that paid the bills. Crystal's manager took him aside and told him he was the talented one and he should drop the two other schmoes; so much for a Three Stooges redux on Long Island. Crystal set off on a solo career and, after playing the requisite number of dives, began making a name for himself as an up-and-coming young comedian. He earned an appearance on *The Tonight Show*, although he tarnished his image a bit by showing up on *Saturday Night Live with Howard Cosell*, the variety series that became one of TV's legendary fiascoes. Crystal also had a run-in with the other, successful *Saturday Night Live*. The show made stars of Chevy Chase, John Belushi et al.; Crystal got canned after the premiere episode. Appearing at the Comedy Store in Los Angeles, he was seen by Norman Lear, and a guest spot on *All in the Family* in 1976 marked his first job as an actor.

• • • • • •

While Crystal was busy making a decent living on the comedy circuit, a comedian from the previous generation was about to follow in the footsteps of D.W. Griffith. Inspiration came to Joan Rivers as she sat meditatively under a hair dryer and read a movie magazine headline: "Is Elliott Gould pregnant?" The need to bring to the screen the story of a man who gives birth became so overpowering that when money for *Rabbit Test* was not forthcoming from the grand pooh-bahs of Tinseltown, Rivers mortgaged her Beverly Hills home and convinced her doctor father to take a second mortgage on his residence in Larchmont, New York. Rivers also made like a politician and hosted some 200 fund-raising dinners, glad-handing regular folks and giving them the chance to glamorize their lives by investing in an honest-to-goodness Hollywood

movie. Her biggest angel was Indiana shopping center magnate and would-be movie mogul Melvin Simon, who anted up $400,000. Noting that she had directed student productions while at Barnard College, Rivers acknowledged that directing is "something every bad actor wants to do."

Rivers cowrote the script with a producer of *The Hollywood Squares* and, since they had a budget of only $1 million, they got a lot of their friends and veterans of the game show (Paul Lynde, Roddy McDowall, Fannie Flagg, George Gobel, Jimmie "J.J." Walker, as well as the program's host, Peter Marshall) to work for scale. The lead role of the expectant father went to a television actor named Dennis Dugan. (Anybody remember *Richie Brockelman, Private Eye*? Me neither.) Dugan left the project because of that old bugaboo creative differences, and Billy Crystal was in.

• • • • • •

Rabbit Test is essentially a collection of one-liners and set pieces played as blackout sketches, with the arc of the script following the transformation of Crystal's Lionel Carpenter from virgin mama's boy to self-effacing public curio to money-grubbing muckamuck. Rivers bragged that her film had "something to offend just about every ethnic group except the Eskimos." The movie employs a take-no-prisoners approach, with jokes focusing on Helen Keller, lesbians, Polish people, the Pope, colons, midgets, pimples, immigrants, Kate Smith and urine. A typical line: "The nice thing about sleeping with the orphans is that they can never tell their folks on you." Like most comedians, Rivers is a sentimentalist at heart, so when the world turns on Lionel for contributing to overpopulation and he loses fame and fortune, he doesn't become embittered but instead reverts to his sweet original self, giving birth to a daughter and settling down with his gypsy wife.

• • • • • • • • • •

Despite his movie career, Billy Crystal has probably received his greatest acclaim for his appearances on the Academy Awards, which he first hosted in 1989. Others have also had multiple stints as Oscar hosts or co-hosts:

19 Appearances
Bob Hope

5 Appearances
Johnny Carson

4 Appearances
Jack Lemmon

The film is populated with outrageous comic characters, the funniest of which is Alec Rocco's parody of a crazed Vietnam vet (a staple of movies and TV cop shows until the Vietnam memorial got people thinking) and Imogene Coca's gypsy fortune-teller, who goes out on a limb and predicts that a sailor will take a long ocean trip. Crystal functions as straight man, a calm, steady foil to the craziness going on around him; he accomplishes this pleasantly enough, if not with an overabundance of charisma or warmth.

Kevin Thomas of the *Los Angeles Times* lambasted *Rabbit Test* as "among the world's worst" and questioned "how a lady as witty and talented as Miss Rivers . . . could come up with something so crass and unfunny." At the *New York Times* Janet Maslin scoffed that "a movie this visually crude" belonged on television. Rivers had a friend in the *Hollywood Reporter*'s Arthur Knight, who wrote, "if the humor is often raucous and grating, it still affords ample evidence of a fresh and eager, albeit as yet undisciplined, talent. I hope that like [Woody] Allen, she continues to work in this medium." Unfortunately, she hasn't, but at least *Rabbit Test*, with the ad line "Inconceivably Funny," did well with ticket-buyers, grossing more than twelve times its cost, and Joan's dad got to keep his house.

After *Rabbit Test* was completed, but before its release, Billy Crystal became a household name in the controversial comedy series *Soap*. His portrayal of the gay Jodie brought complaints from some gay groups and jeers from homophobes when they ran into the comic at airports and other public places. Despite this notoriety, when *Rabbit Test* opened at the Lido, a theater Crystal used to hang out at as a kid, the marquee proudly proclaimed, "Long Beach's own Billy Cryptal!" He didn't make another feature film until 1986, but he did appear in several TV movies, including *S.S.T.— Death Flight,* in which he got to ride the Concorde with Lorne Greene, Tina Louise, Robert Reed and Bert Convy.

3 Appearances
Jane Fonda
Jerry Lewis
Conrad Nagel
David Niven
Frank Sinatra

2 Appearances
Fred Astaire
Jack Benny
Frank Capra
Chevy Chase
Sammy Davis, Jr.
William DeMille
Goldie Hawn
Walter Matthau
Richard Pryor
James Stewart

It was Crystal's return to *Saturday Night Live* in the post–Eddie Murphy era of the mid 1980s that served to reinvigorate his career and position him as the second coming of Bob Hope. But all those baby boomers who were so moved when he delivered a calf in *City Slickers* should be aware that the scene has an antecedent: More than 10 years earlier in *Rabbit Test*, Crystal helped a woman give birth. His smug, self-congratulatory reaction was the same.

RODNEY DANGERFIELD

• • • • • •

THE PROJECTIONIST
(1969)

First there was Jacob Cohen, a poor boy in a middle-class section of Queens who had to work as a delivery boy, carrying groceries into the homes of his well-to-do classmates. Then, in 1939, he became Jack Roy, a name chosen by the 17-year-old would-be comedian because "Jacob Cohen" sounded more like a rabbinical student. After a couple of years doing amateur nights at Queens theaters, he got his first booking, at a resort in the Catskills. Jack Roy the comedian toughed it out for a dozen years, plying his trade in lesser Borscht Belt venues and such jerkwater places as the High Hat Club in Bayonne, New Jersey, and the Diamond Mirror in Passaic. Danger-field would later joke about his bookings during his Jack Roy incarnation, "I worked so far out in the woods, I was reviewed by *Field and Stream*." But there comes a time in every comic's life when he has to take stock; his came in 1952 when, at age 30, he had not only an ailing checkbook but a wife to support. So he bid adieu to the world of smoky

CAST

CHUCK McCANN, INA BALIN,
RODNEY DANGERFIELD,
JARA KOHOUT, HARRY HURWITZ,
ROBERT STAATS

• • • • • •

MARON
DIRECTED, WRITTEN AND PRODUCED BY
HARRY HURWITZ
CINEMATOGRAPHY BY
VICTOR PETRASHEVIC

• • • • • • • • • • •

By the time he was ready for his first close-up, Rodney Dangerfield had had three different identities and two distinct whirls around the show-business dance floor.

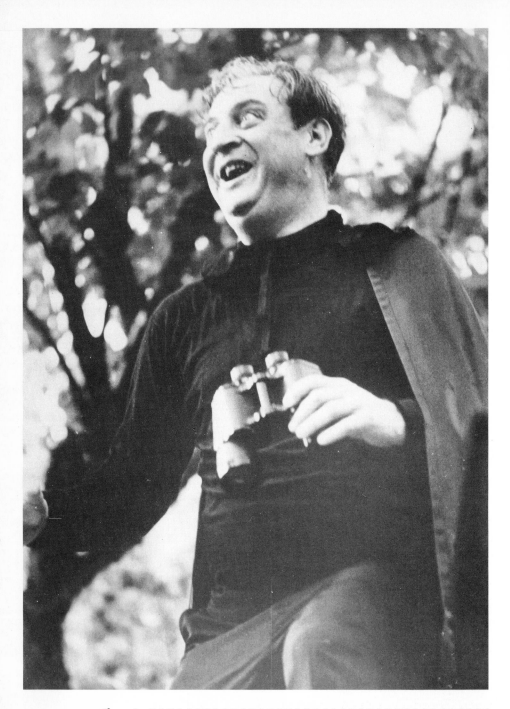

Portraying the evil Bat, nemesis of our heroic Projectionist, Rodney Dangerfield looks less like the I Don't Get No Respect man than a Wild and Crazy Guy.

dives and drunken audiences and got respectable.

For the next dozen years, salesman Jack Roy supported his family by hawking paint and other combustibles; fatefully, his sales route took him to many of the same areas he had covered as a comedian, and driving by an old haunt like Vinnie's Boom Boom Room, he would get to thinking wistfully of what might have been. By the early 1960s, he was inching back to the biz by writing jokes in his spare time and selling them to the likes of Joey Bishop and Jackie Mason. And then, at age 40, he had not a midlife crisis but a rejuvenation: He ventured back onto a nightclub stage.

Not only that, but the first club he'd be playing was not some hole in the wall across the Hudson but was actually in Manhattan. All right, so the Homestead was all the way up north in Washington Heights, but that's still technically within the borders of the city. The comedian was somewhat self-conscious about starting over, so he asked the owner of the club to come up with a new moniker. ("I would've been embarrassed in front of my friends from before, y'know. I didn't wanna have to explain why I was going back," he explained.) "Rodney Dangerfield" went up on the Homestead's marquee. The response of the audience to such lines as "My wife's so ugly . . . she makes onions cry" was enthusiastic. Dangerfield still peddled his industrial wares Monday through Friday; on weekends, he basked in the sound of laughter. Even though he was only playing joints like the Polish Falcon, Dangerfield knew that performing stand-up comedy was his calling in life, and he resigned from his sales position to pursue show business full time.

Six months later Dangerfield and his family might have questioned the wisdom of this career change: Thanks to travel expenses, publicity and nonpaying bookings, he was $20,000 in the hole. Still he persevered, becoming a mainstay at the Greenwich Village nightspot the Duplex, where other regulars included Joan Rivers, Dick Cavett and Linda Lavin (as well as

Dangerfield spends most of the "real life" portions of *The Projectionist* hectoring the staff of his movie theater.

To the Projectionist: "Just once I'd like to meet you when you're not in the union."

To the Kindly Candy Concessionaire, on hearing that soft drink sales are down: "Tomorrow you put more salt in the popcorn. You'll sell more soda."

On seeing white specks on an usher's shoulders: "Dandruff means dismissal!"

dozens of other people who remained unknowns and have since found other lines of work). Slowly Dangerfield moved up the pecking order of New York nightspots, as quips like "Even a hooker makes me say please" found more and more takers. Then came the realization of a dream shared by every performer of the mid-20th century, from Leontyne Price to Renaldo and His Spinning Plates: Dangerfield got a booking on *The Ed Sullivan Show*. Even that came about in true Rodney Dangerfield fashion: Sullivan always had an extra performer show up at the Sunday afternoon rehearsals just in case the scheduled acts finished in less than the allocated hour. Dangerfield sat there, eyes fixed on his watch, and saw sixty minutes tick away with no time left for him. Five months later, though, Sullivan got around to remembering him, and on March 5, 1967, Dangerfield faced the cameras. Soon after, Merv Griffin and Joey Bishop extended invitations, and Rodney Dangerfield became a nationally known comedian.

The success he had long worked for had its down side. Though he was thrilled at getting an offer to open for Judy Garland in her 1967 return to the Palace, Dangerfield's enthusiasm soured when he saw his dressing room, a tiny hovel six flights up. Even worse was all the time spent on the road away from his family. This, at least, he could do something about—in the fall of 1969 he opened his own night club in Manhattan, with the imaginative name Dangerfield's. He held court there, and if he felt like a night off he'd spotlight new talent. Although the $7 cover was double the going rate, the place was a huge success. Newspaper profiles of the comedian at this time were invariably headlined "Finally, Dangerfield Gets Some Respect."

• • • • • •

Being stationed in New York was also convenient for the comedian's film debut. For all his recent success, however, Dangerfield would be taking

a back seat to another comic. In the 1960s, Chuck McCann was—along with Sandy Becker—one of the glories of New York children's television. A heavyset, sweet-faced man who would act out the day's funny pages, even to the extent of putting white cardboard circles in his eyes while recounting the adventures of Little Orphan Annie, McCann was a gifted mimic who exuded a lovable craziness. He gave a memorable performance as a simple-minded deaf-mute in the 1968 adaptation of Carson McCullers's *The Heart Is a Lonely Hunter*, but was probably best known to the general public for a long-running deodorant commercial in which he shared a medicine cabinet with his next-door neighbor. *The Projectionist* was McCann's initial starring vehicle, a $160,000 independent labor of love made by a young man named Harry Hurwitz, which took nearly five years from its inception to its release in 1971.

A unique film, *The Projectionist* features McCann as one of those solitary figures who inhabit every city, men you see by themselves in movie theaters and coffee shops and at hockey games, nice guys with a couple of buddies but not much to do with their lives other than hang out. Chuck works as a projectionist in a second-rate New York theater, but he spends most of his time fantasizing about old films and movie stars, inter-acting—through Hurwitz's use of film clips—with the likes of Fred and Ginger and the cast of *Casablanca*. He has also concocted a girlfriend (Ina Balin) in a black-and-white movie of his imagination and regales his friend, the Friendly Usher (played by director Hurwitz), with tales of what it's like to be in love. In one of the more intriguing set pieces, Chuck actually attends the world premiere of *The Projectionist*, besieged by ador-ing fans.

Rodney Dangerfield plays Rinaldi, the martinet manager of the movie house who relishes browbeating his staff—which he does in his very first screen line, after finding the Friendly Usher in Chuck's projection

THE CRITICS ON RODNEY DANGERFIELD

"Rodney Dangerfield is just dandy."
—Judith Crist, *New York*

"Dangerfield (who is a New York nitery owner) is a wonderful deadpan heel."
—*Variety*

"Dangerfield is mediocre as 'the Bat' but delightfully churlish as the theater manager who bullies ushers."
—*Christian Science Monitor*

"A funny, nervous menace."
—*Box Office*

booth: "I caught you, huh? What is this . . . a pool room? You hang out here? . . . Just for this, tomorrow night when they change the marquee, you're gonna stay late, and polish every bulb." When the refreshment stand doesn't meet his punctilious standards of neatness, he threatens the Kindly Candy Concessionaire with "I'll send you back to the Old Country." As Rinaldi, Dangerfield is unexpectedly soft-spoken and gives a slyly comic performance, nicely combining a dyspeptic contempt for the world with a buffoonish self-importance. The familiar Dangerfield characteristics—the bobbing up and down, the mobile head and neck, the sweating—are all here, although in a much more subdued fashion than we're accustomed to, as if he were just beginning to feel his way through his mannerisms.

Dangerfield plays a second role, the Bat, the malfactor of the serial in Chuck's mind, in which the projectionist is the valiant though only marginally competent Captain Flash, who gambols instead of flying. Through the intercutting of clips, our hero is aided by Humphrey Bogart (in *Across the Pacific*), John Wayne (in *Fort Apache*), and others, while the Bat receives assistance from the Ku Klux Klan of *The Birth of a Nation* and Adolf Hitler. These sequences are coy and overly broad and Dangerfield, mugging vigorously, is much less effective than in his "real life" scenes.

The Projectionist did not give much of a career boost to any of its principals, and despite his nice personal notices, it would be almost a decade before Dangerfield did another movie. But his return in 1980's *Caddyshack* made him, as he approached his sixties, one of the top three or four comedians in the country, with an improbably devout following among people under 25. (This for a man who had once been dubbed "The Voice of the Silent Majority.") His cinematic career has been fitful, but *Back to School* did so well that in 1986 he came in as the number four movie star in America in the annual Exhibitors' Poll of Box-Office Attractions.

BETTE DAVIS

......

BAD SISTER
(1931)

Peripatetic best describes Bette Davis's child-hood, at least from the time her parents divorced in 1918, when she was 10. Florida; East Orange, New Jersey; Newton, Massachusetts; Harlem—Betty (as her name was then spelled) got a Cook's tour of the East Coast with her mother and younger sister. (Her own estimation was that the trio had 75 different residences in less than a decade.) Bette—the name was changed when a neighbor in New York read Balzac's *Cousine Bette* and insist-ed that the French spell-ing was so much more *provocant*, although no one around was fluent enough to realize that the "te" should be silent—had her first encounter with the arts when her mother, Ruthie, latched on to photography as a means of expressing herself. The malleable Bette, who could go from bright-eyed and vivacious to funereal at a moment's notice, was her mother's favorite model. There was also a succession of places

CAST

CONRAD NAGEL, SIDNEY FOX, BETTE DAVIS, ZASU PITTS, SLIM SUMMERVILLE, CHARLES WINNINGER, EMMA DUNN, HUMPHREY BOGART, BERT ROACH, DAVID DURAND

......

UNIVERSAL
DIRECTED BY HOBART HENLEY
SCREENPLAY BY RAYMOND L. SCHROCK
AND TOM REED, ADDITIONAL DIALOGUE
BY EDWIN KNOPPF
PRODUCED BY CARL LAEMMLE, JR
CINEMATOGRAPHY BY KARL FREUND

..........

The first time she saw herself onscreen, Bette Davis left in the middle of the movie, crying and ruing her decision to leave the stage for Hollywood.

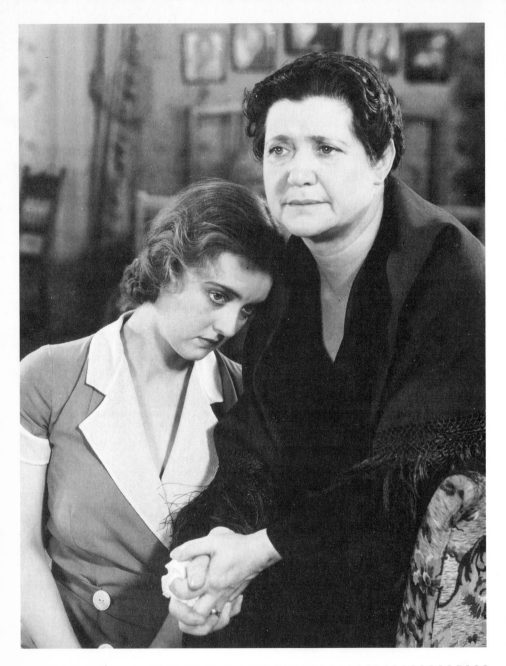

Emma Dunn consoles her daughter, Bette Davis, who's having love problems. Off-camera Davis's travails were that she was under contract to a studio that didn't know what to do with her and that she was stuck in an insipid part, as the "good sister" in a film in which her malevolent sibling had the title role.

of learning for the girl, varying from a stint at a Dickensian institution called the Northfield Seminary for Young Ladies to studying modern dance tinged by Burmese and Indian influences with a woman who called herself Roshanara (but whose birth certificate read "Jane Craddock").

Although she had appeared in high school productions, Bette Davis did not possess anything approaching a passion for the theater until her senior year of high school. It was then, in 1926, that she saw a Boston production of Ibsen's *The Wild Duck* starring Blanche Yurka and Peg Entwhistle. Yurka was a highly admired classical actress of the day, best known today for the 1935 version of *A Tale of Two Cities*, wherein, as Madame Defarge, she rolls around the floor with Edna May Oliver and gets killed. Entwhistle later becomes notorious as the unsuccessful film actress who killed herself by jumping off the Hollywood sign. Something about the combination of actresses and their material enthralled Bette, and she badgered her mother, insisting she just *had* to be an actress. That was fine with Ruthie, whose artistic pretensions weren't being completely gratified by her attempts at creating photographic mood pieces. She brought her daughter to New York for an audition to study with the most prestigious acting teacher around, Eva Le Gallienne.

There are conflicting accounts as to whether Le Gallienne—who by all reports was an exceptionally mean woman—curtly dismissed Davis after hearing her flub a reading, or whether her secretary—who apparently was of the same temperament as her boss— kicked Davis out of the office without her even seeing *la grande dame* because she didn't like the girl's attitude. In any case, it is undisputed that Davis spent the next few weeks moping around the house. This wouldn't do, so Ruthie again accompanied her from Massachusetts to New York, this time for a tryout at the second most prestigious school, John Murray Anderson's place; here Davis was accepted and was soon studying with British

HUMPHREY BOGART ON BETTE DAVIS

The paths of *Bad Sister*'s featured players, Bette Davis and Humphrey Bogart, would cross frequently over the years as they became two of Warner Brothers' biggest assets. They never cared for each other, personally or professionally. While filming *Bad Sister,* Bogie cracked to costar Conrad Nagel, "That dame is too uptight. What she needs is a good screw from a man who knows how to do it." After she became successful, Bette Davis delighted in recounting that, after seeing her for the first time, Carl Laemmle, Jr., the head of Universal, purportedly said, "She has about as much sex appeal as

actor George Arliss and dance legend Martha Graham.

Using a combination of her contacts and her training, Davis was able to parlay her schooling into employment in summer stock, including a stint in Rochester under the tutelage of director George Cukor, whose career in films would be almost as long as hers. Davis's New York debut occurred in a 1929 play called *The Earth Between* at Greenwich Village's Provincetown Playhouse, where Eugene O'Neill had made his mark. The play, which delt with incest, was not successful, but Davis received some kind words from the critics, including Brooks Atkinson of the *Times,* who called her "an entrancing creature." And then it was kismet. Blanche Yurka wanted her to take the Peg Entwhistle role (Hedvig) in the very production that had so bewitched Davis in the first place—*The Wild Duck,* which Yurka was now mounting for a road tour. In city after city, Davis received splendid reviews. After another season of summer stock, the actress made her first Broadway appearance in a slight situation comedy called *Broken Dishes* in which she helped her milquetoast father "become a Man"; minor though the play was, it was popular, and again, although not the focus of the show, Davis won approbation.

· · · · · ·

This was when movies came into the picture. Now that it was clear that sound was here to stay and that precise diction would be imperative, anyone at all who appeared on the New York stage was fair game for motion pictures. One of Sam Goldwyn's assistants arranged a screen test for Davis to have a chance at being Ronald Colman's leading lady. She blew it by tensing up as the camera started rolling. The story goes that when Goldwyn took a look at the test he was infuriated that film had been wasted on her. His measured opinion was "She's a dog!" Davis didn't much care because, like many of her stage colleagues, she denigrated the movies as commerce; the theater was art,

though you'd have a hard time convincing anybody of that who saw her next play. *Solid South,* a plantation farce, was a vehicle for Richard Bennett (father of Constance and Joan), who spent most of its one-month run making a raging shambles out of things by ad-libbing and stepping out of character to talk to the audience. In the midst of this tomfoolery, Davis was impressive enough to be given another try at a screen test. This time it was for Universal; the studio wanted someone who could utter Preston Sturges's urbanities in the film version of his hit play *Strictly Dishonorable.* A scout signed her, although with the less than ringing endorsement, "They'll fix you up to look better out there. You're not the most sexy or glamorous girl I've sent out west, but you've got *intensity.*"

Davis was a reluctant traveler, heading to Hollywood because she hadn't been able to land a part in another play; since she was only offered a three-month contract (at $300 a week), her mother convinced her that she had little to lose and should give it a shot. Legend has it that Bette and Ruthie waited in vain for someone from the studio to meet them at the train station; the representative claimed, "I didn't see anyone who looked like a movie star so I left." Likewise, studio executives couldn't figure out what that East Coast talent scout had had in mind when he signed Davis. Universal head Carl Laemmle, Jr.—the company founder's doltish son, who received the reins of the studio as a 21st birthday present—didn't even bother giving Davis his customary greeting for new actresses on the lot: After taking a look at her, he decided not to invite her to a "conference" on his office couch.

Still, the studio was giving her a weekly paycheck, so something had to be done with her. After a few weeks of posing for publicity photos and sitting in on the screen tests of other young hopefuls, Davis was put into a small-town soap opera, *Bad Sister.* Given her later performances as malevolent siblings in such films as *In This Our Life* and *What Ever Happened to Baby*

Slim Summerville!" referring to a popular hayseed comic actor at the studio. One look at the rube shows why this was such an insult.

Jane?, you might assume that the title role in *Bad Sister* was Davis's, but that part went to Sidney Fox, another recent Broadway transplant who had the advantage of being invited back for additional sessions on Junior Laemmle's divan. Davis was the bland and drab good sister, which was a pretty fair indication of the studio's assessment of her. Although she received third billing, she had very little to do.

Based on a Booth Tarkington novel, *Bad Sister* concerns a flirtatious young woman (Sidney Fox), her dull older sister (Davis), the eligible doctor (Conrad Nagel) beloved by the good sister, and a sophisticated stranger (Humphrey Bogart). The movie was unimaginative pap, blandly presented in 68 minutes, but it served its purpose of helping to fill out Universal's quota of movies for the year. Ads promised "The Story of a Girl Who Wanted *Everything!*" and warned "She Took What She Wanted and Made Them Like It!" but audiences weren't biting. One way of praising Davis's performance is to acknowledge that her character is supposed to be lackluster and the actress fits the bill nicely. (She does have one scene in which she shows the soon-to-be-familiar Davis feistiness, slapping Sidney Fox when her sister shouts, "You're a failure—a failure!") Watching the film, Junior Laemmle's father looked nonplussed and said of Bette Davis, "Can you picture some poor guy going through hell and high water and end up with *her* at the fade-out?" Davis herself seemed to concur in "Uncle Carl's" estimation. Mortified after seeing herself onscreen, she lit into her mother for convincing her to give up her budding stage career for *this*.

Still, Universal's publicists did their duty and wrote glowing press releases about the new contract player. They referred to her as "one of the newest glorious young girls on the screen" and told the bald-faced lie that "Carl Laemmle, Jr., has every hope that the unique personality and deep emotional ability which she has evidenced will win a high place for her as soon

as *Bad Sister* makes its appearance." The studio system being what it was, even though both Laemmle Sr. and Laemmle Jr. thought the actress had no future, they gave her small roles in negligible films and happily loaned her to other studios. She had specifically come to Hollywood to star in *Strictly Dishonorable*, but that film went to Junior Laemmle's inamorata, bad sister Sidney Fox.

Davis was relieved at the end of 1931 when, after having renewed her contract several times—because cinematographer Karl Freund had argued that she had "lovely eyes"—the studio decided not to pick up her option. She was cheerfully making plans to head back east when her one-time teacher, George Arliss, now a huge box-office draw, got in touch with her. He was interested in having her appear in his latest movie, *The Man Who Played God*, which meant not merely that she would be performing with the most venerated film actor of the day, but that she would have a contract with a more prestigious studio, Warner Brothers. Within five years, Bette Davis would be the undisputed Queen of the Lot.

THE CRITICS ON BETTE DAVIS

"Miss Davis's interpretation of Laura is too lugubrious and tends to destroy the sympathy the audience is supposed to feel for the young woman."
—*New York Times*

"Bette Davis holds much promise in her handling of Laura, sweet, simple, and the very essence of repression."
—*Variety*

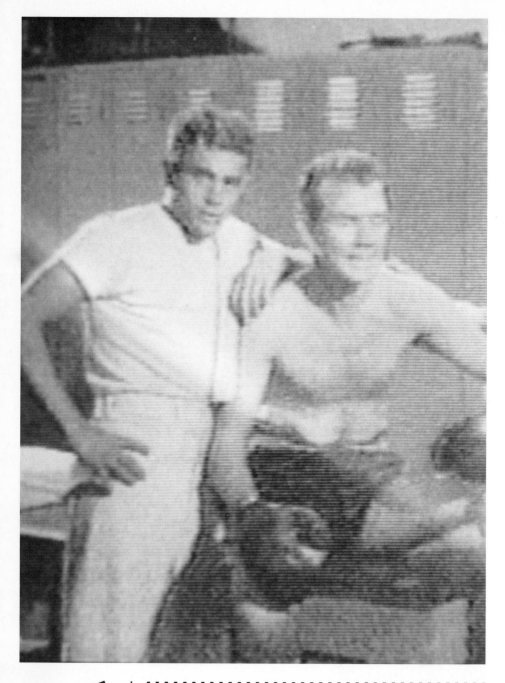

What a break! James Dean begins his film career by getting to share the screen with the two hottest actors in America—Dean Martin and Jerry Lewis.

JAMES DEAN

· · · · · ·

SAILOR BEWARE
(1951)

James Dean was born in Marion, Indiana, on February 8, 1931. His father, a dental technician in veterans' hospitals, once said of him as a little boy: "You'd try to order him to do or not to do something and he'd just sit there with his little face all screwed up and closed. It didn't take you long to realize that you weren't going to get anywhere with him. Spankings didn't help. And you couldn't bribe him. But you could always reason with him, or appeal to his better instincts."

When Jimmy was five, his father was transferred to a hospital in Southern California and the family relocated to Santa Monica. But his mother died in 1940 and, at the urging of the family, his father sent him back to Iowa to live on a farm with his aunt and uncle. By all accounts it was an unremarkable boyhood in the heartland. Jimmy hurried home after school to do his chores and work on 4-H projects — raising chicks, growing a garden—so, as one relative pointed out, "He

Before he was an American icon, he was simply Jimmy Dean, struggling actor.

CAST

DEAN MARTIN, JERRY LEWIS,
CORINNE CALVET,
MARION MARSHALL,
ROBERT STRAUSS, DON WILSON,
VINCENT EDWARDS,

· · · · · ·

PARAMOUNT
DIRECTED BY HAL WALKER
SCREENPLAY BY JAMES ALLARDICE
AND MARTIN RACKIN
PRODUCED BY HAL B. WALLIS
CINEMATOGRAPHY BY DANIEL L. FAPP

.

James Dean's death in a car crash on September 30, 1955, is probably the most striking instance of a movie star struck down in his prime. Other actors who died in accidents include:

Automobile Accident

Larry Blyden

Brandon de Wilde

Janet Gaynor

Bernard Gorcey

Kirby Grant

Ernie Kovacs

Plane Crash

Phillips Holmes

Leslie Howard

Carole Lombard

Audie Murphy

Will Rogers

Hit by Car

Percy Kilbride

Fire

Jack Cassidy

Linda Darnell

Maria Ouspenskaya

Drowning

Eric Fleming

Maria Montez

Natalie Wood

didn't have many friends, but then again, he didn't have many enemies."

The boy's first brush with the arts came in the form of dramatic readings at his Aunt Ortense's Women's Christian Temperance Union meetings. As a seventh-grader, he entered a competition sponsored by the Union, reciting a monologue in which he portrayed a man about to face the gallows because he had killed another in a tavern brawl. "Oh, if only I had spent that night at home with my loving wife and darling little ones. . . ." The teetotaling Christian ladies found three other actors preferable and Jimmy didn't win, place or show. Dean was a high school track star, and he also appeared in a number of drama club productions, but his greatest triumphs came in the arena of public debate: He was the 1949 Iowa champion of the National Forensic League (but lost the national tournament in Colorado).

In the summer of 1949, Dean headed back to California, where he attended Santa Monica City College as a prelaw major. His father had convinced him his debate skills would be put to their best use in the legal field, although Jimmy thought dramatic arts made more sense. The most significant fact about the college as regards Dean was that much of *Rebel Without a Cause* would be filmed on its campus. While it made for a perfect movie set, the school didn't have much of a theater department and so was less than educationally ideal for the freshman. For sophomore year, Dean transferred to UCLA, where dramatics played an integral part in school life. Acceding to his father's wishes, he remained prelaw but his report card spoke volumes: A's and B's in speech and drama courses, C's and D's in prelaw classes. He appeared in a campus production of *Macbeth,* and although the snotty kid reviewing the play for the college paper sneered that his "Malcolm failed to show any growth and would have made a hollow king," an agent in the audience strongly disagreed and called Dean in for a meeting. The upshot: As soon as he

had head shots made, she would take him on as a client. From that point, his academic career was a lost cause.

James Dean's first professional acting assignment came in the form of a pair of Pepsi ads, one featuring a pack of fresh-faced kids—including Nick Adams, a future *Rebel Without a Cause* costar—and filmed at Griffith Park, an integral *Rebel* locale. Dean was next cast as St. John the Apostle in an Easter TV special that likened the plight of a group of soldiers in battle to Jesus's crucifixion. The actor had only a handful of lines, but he did enough with them to make an impression, at least on one group of people. Ordered by the nuns to watch the show during Easter break, the girls of Los Angeles' Immaculate Heart High School clearly had other things on their minds than the Resurrection, for they promptly organized the James Dean Appreciation Society (his first fan club) and had the actor over for a spot of tea.

Between his inconsequential acting roles, Dean earned his living as an usher at CBS and a parking lot attendant, sometimes sleeping in his beat-up car because he had no rent money. That all changed when he crossed paths with a radio and television director 15 years his senior named Rogers Brackett. In the Hollywood milieu, Brackett was the type of person euphemistically referred to as "cultured" or "refined." When Dean's agent clucked her disapproval on hearing that he was moving in with Brackett, Dean protested, "He has twin beds." Rogers Brackett had some minor contacts, which he was able to parlay into minor acting jobs for Dean. First there were secondary roles on radio dramas, and then, in 1951, James Dean walked, invited, through the famous front gate of the Paramount lot. Jimmy Dean of Fairmount, ~~Iowa~~, was now a movie actor.

<div align="center">. INDIANA</div>

James Dean's first film would turn out to be one of the highest-grossing of 1952, but he had nothing to do with the success of *Sailor Beware*. The team

of Dean Martin and Jerry Lewis was the hottest thing in movies and would be voted the nation's number one box-office draw of the year. Seeing how much money the duo made when they were *At War with the Army*, Paramount now set them on the Navy, where they—but of course—run afoul of their immediate superior, Petty Officer Robert Straus. The main "plot" has their entire brigade getting the misconception that women find Jerry irresistible and betting all their wages that he'll be able to get movie star Corinne Calvet to kiss him. (In the play on which *Sailor Beware* is based, the wager was about getting more than just a smooch.) The story line is merely there to allow Dean Martin to croon some tunes and, especially, to let his costar engage in shenanigans: Jerry eats a thermometer ("I thought it was a peppermint stick!"); Jerry gets stuck on the deck of a submarine as the vessel descends, forcing him to cling to the periscope (meaning a distorted close-up of his face is all that can be seen from down below); Jerry ends up chained to a torpedo; and, in Hawaii, Jerry indulges in comic stereotyping by wearing a coolie hat, pulling a rickshaw and squawking, "Chop-chop!" But his big moment comes when he is forced into a lop-sided boxing match. Naturally he is victorious; he knocks out the other boxer, after being smashed against the ropes, by bouncing back and hitting him in the stomach with his head.

This prizefighting scene is where James Dean makes his appearance. He plays a corner man for Jerry's two opponents: Dean is in the locker room with the sailor Lewis scheduled to fight in a grudge match, until the man chickens out after hearing Jerry sound off like a real boxer ("The toughest fight I ever had was Gene Tierney"). James Dean gets his one and only line, "That guy's a professional," and has 56 seconds of camera time. During the actual match, when the coward's brother fights in his stead, Dean can be seen in the ring before the fight, outside the mat during it and back inside dragging away his fallen man, for an additional

minute and 22 seconds, bringing his onscreen total to 2 minutes and 18 seconds. *Sailor Beware* was Martin and Lewis's biggest hit yet.

James Dean had roles in three more movies, each of them about as meaty as his characterization in *Sailor Beware*. Rogers Brackett then informed Dean that he was leaving L.A. for assignments in Chicago and then New York. Brackett's mother told him she'd caught Jimmy sobbing uncontrollably over his departure, so Brackett took him along. Because Dean was bored and restless in Chicago, his mentor sent him ahead to New York. In a matter of months, Dean would become a member in good standing of the Actors Studio and eventually garner attention in two Broadway plays; he caught the eye of Elia Kazan, who was looking for a Cal for *East of Eden*.

That all probably seemed a millennium away, though, when Dean arrived in the city in September 1951, where "for the first few weeks I was so confused that I stayed only a couple of blocks from my hotel off Times Square. I would see three movies a day in an attempt to escape from my loneliness and depression. I spent a hundred and fifty dollars of my limited funds just on seeing movies." If he had ambled over to the Paramount a few months later, he could have caught *Sailor Beware*, as had Bosley Crowther of the *Times*, who reported, "The audiences seem to adore it. We don't get it, that's all."

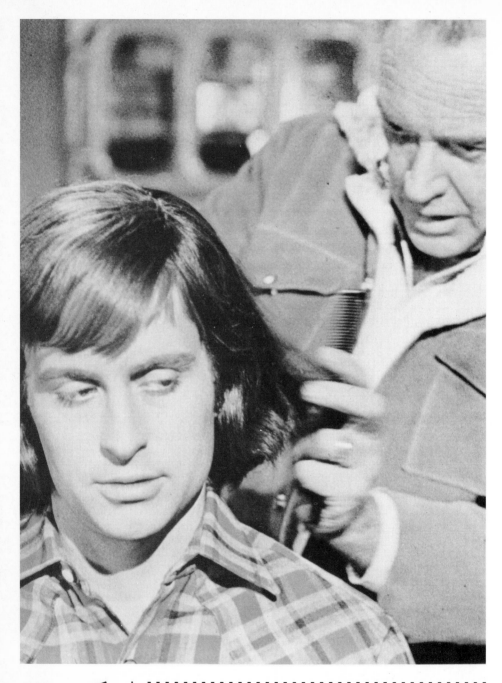

Arthur Kennedy thinks there's nothing wrong with the American youth of the Vietnam era that a good old-fashioned haircut won't cure, but unfortunately Michael Douglas's performance was equally bad pre- and post-shearing.

MICHAEL DOUGLAS

······

HAIL, HERO!

(1969)

Douglas was born in New Brunswick, New Jersey, in 1944, two years before father Kirk made *his* film debut (in *The Strange Love of Martha Ivers*). After his parents' marriage ended in 1950, Michael grew up with his mother in Connecticut and prepped at Choate. His college career was at the University of California at Santa Barbara, where he had a unique dormitory, a commune of student artists and writers on a mountain. "We smoked a lot of pot and dropped a lot of LSD. I took quite a lot of both. I liked it," he recalled while doing publicity for his first movie. Even though "it was pleasant enough sitting around naked by a pool and cramming drugs down your throat," Douglas eventually decided this was too vegetative an existence, so he came down off the mountain to take drama classes.

Not long after graduation he got his first professional acting gig, playing

CAST

MICHAEL DOUGLAS,
ARTHUR KENNEDY,
TERESA WRIGHT, JOHN LARCH,
CHARLES DRAKE,
MERCER HARRIS,
DEBORAH WINTERS,
PETER STRAUSS,
LOUISE LATHAM, JOHN QUALEN

······

NATIONAL GENERAL.
DIRECTED BY DAVID MILLER
SCREENPLAY BY DAVID MANBER
PRODUCED BY HAROLD D. COHEN
CINEMATOGRAPHY BY ROBERT HAUSER

············

Michael Douglas's first film foray is so bad that, in retrospect, it's not only surprising that he became a major star, but that he was allowed to make any additional movies at all.

The misguided makers of *Hail, Hero!* intended Douglas's character, Carl Dixon, to be a spokesperson for young America. Here are some of the choice things this inane channeler for the antiwar movement had to say:

"From sweet bones, the sweet flowers grow. That's why the world is now carpeted with the most beautiful, sweetest flowers ever known."

"What would happen if every soldier on both sides would just try to love instead of hate?"

"Don't you see? This business of fighting for ideals is nothing but a goddamned muscle twitch." (To which his father, Arthur Kennedy, responds, "I'll show you a muscle twitch of my own later.")

a "hippie scientist" (don't ask, it was the sixties) in *The Experiment*, an original drama for *CBS Playhouse* that aired in February 1969. Around the same time, he appeared in an Off-Broadway flop, *City Scene*, and auditioned for a movie called *Hail, Hero!*, a character study about an antiwar college student. Douglas's first job in films had been assisting the editor on *Lonely Are the Brave*, an attempt at an existentialist cowboy movie starring his father and directed by David Miller. It happened that this same David Miller was the director of *Hail, Hero!*, and lo and behold, of the 100 actors trying out for the role, young Douglas snagged it. Miller swore that during auditions he had had no idea that Michael was Kirk Douglas's son.

Michael Douglas said, "When I read the script, I flipped out," but in retrospect, being cast in *Hail, Hero!* was not such a great career move. A press release for the movie bragged that it was "the first motion picture to deal with the sensitive issues of the Vietnam War and its relationship to the Generation Gap." But this supposedly controversial movie was so namby-pamby that it played at Radio City Music Hall at a time when nobody went there except tourists. Its relevance to the issues of the Vietnam War was about on par with such other 1969 Radio City attractions as *If It's Tuesday, This Must Be Belgium* and *The Love Bug*.

Douglas plays a free-spirited young man who, though he opposes the war, enlists in the Army and goes home to his parents' ranch to give them the news. He whiles away the day arguing with various family members, attempting to engage a pair of house painters in a philosophical disscussion while they're trying to work, skinny-dipping with a pair of teeny-boppers and, best of all, stumbling across a crazy dope-smoking old lady who lives among her mementos in a hidden cave. This zonked-out version of Miss Havisham adds to the film's high level of discourse when she inquires of Douglas, "What do you use to clean your private parts?" and recommends "sour goat's

cream with a little meal, it does wonders." She also presents Douglas with her prized possession—a mummified Indian baby with its head bashed in. The impish Douglas then ruins his brother's birthday party by giving him the grotesque mummy as a present. One thing Douglas's character never does get around to is explaining why he joined the military.

Hail, Hero! is a model of incoherent filmmaking, boasting dialogue so artificial and situations so pointless that the mind reels. Yet it's directed by David Miller with a placid sobriety and total lack of irony or wit, as if this were the most naturalistic material imaginable. In addition, the film only deals with its supposed issues in the most perfunctory ways. Douglas's character is against the Vietnam War because people get killed—or, as he eloquently puts it, "all wars just stink"—not specifically because he thinks that the United States was fighting to prop up a corrupt government during a country's civil war. As a result, the movie is as profound as the old "War Is Not Healthy for Children and Other Living Things" poster. The *Los Angeles Free Press* sneered that *Hail, Hero!* is "not a sixties film at all, but a forties film got up, as it were, in sixties drag." Of all the naysayers, though, Joseph Morgenstern of *Newsweek* best captured the unique qualities of this cockamamie movie: "It makes no sense whatsoever, and in that sense becomes a fascinating display of imbecility, an incessantly talking picture in which words have finally been purged of all meaning."

Michael Douglas is every bit as bad as his material allows him to be. As written, his character comes across as spoiled and self-indulgent, and the actor aggravates matters with an oddly fey presence and a high-pitched voice that would have been more suitable coming from a cartoon rodent. As Douglas's brother, Peter Strauss, also making *his* debut, seemed more poised for stardom. Six-time Oscar nominee Arthur Kennedy (who played Kirk Douglas's brother in 1949's *Champion*) does nothing but bluster as the father, and even the

We keep having wars one after the other and they don't seem to change anything . . . don't all wars just stink?"

"I read somewhere that a son must kill his father in order to become a man. . . . They got it all screwed up. It's the fathers that kill sons. They call it war."

"Everybody's so worried about how long hair is. Nobody seems to care how long wars last."

Douglas addresses other subjects as well. Remembering his first crush: "At school I used to share my lunch with her. She never ate peanut butter, said she preferred cow manure. I loved her for it."

THE CRITICS ON MICHAEL DOUGLAS

"It's not an especially memorable performance, but it's an energetic one, and without Douglas, *Hail, Hero!* would not even be tolerable."

—Vincent Canby,
New York Times

He "plays the hero with ingratiating charm even if he isn't quite strong enough to carry an entire picture."

—Kathleen Carroll,
New York Daily News

"It should be noted that throughout this film he sounds as if he were whiffing helium before each take."

—*Hollywood Reporter*

great Teresa Wright, as accomplished an actress as the movies have ever seen, can't make the character of the mother remotely believable.

Hail, Hero! died ignominiously at the box office. Nevertheless, Douglas hung in there and starred in two more youth movies that young people avoided in droves (*Adam at 6 A.M.* and *Summertree*) before switching gears in 1972. That year he appeared in *Napoleon and Samantha,* a Disney picture about two kids and a runaway lion, which introduced Jodie Foster to film audiences (see page 145). He also took a supporting role in a television crime series, *The Streets of San Francisco,* notable for being a cop show in which the leads were played by dyed-in-the-wool Hollywood liberals. (Rather than looking back at his four-year run on the series as slumming, Douglas maintained that working with Karl Malden and playing a character so unlike himself was the best acting training he could have had.) Michael Douglas inched his way onto Hollywood's A list by producing *One Flew Over the Cuckoo's Nest* in 1975, but it would be another decade before he got any respect for his film acting. If, after *Hail, Hero!* came out in 1969, you had predicted that in 1988 its young star would be an Oscar winner and would be voted number two in the Exhibitors' Poll of Box-Office Attractions, you would have been pegged as the type of person who shells out ten bucks for dope and ends up with a dime bag of oregano.

Faye Dunaway

······

The Happening

(1966)

In early 1966, columnist Earl Wilson flashed, "So look who's going to be America's answer to Oscar-winner Julie Christie—a former waitress. Faye Dunaway, a lovely, leggy brunette from Tallahassee, Florida, who had five waitressing jobs a day on her summers off from college, and won more scholarships than she could use, is producer Sam Spiegel's nominee." That the legendary producer of *On the Waterfront* and *The Bridge on the River Kwai* would pick this unknown for future stardom was par for the course. Everything always seemed to go her way.

The Army brat was born in 1941, growing up all over the United States and Europe. Her good fortune took hold immediately after graduation from the Boston University School of Fine Arts; three weeks after receiving her diploma she was signed to take over the role of St.

CAST

ANTHONY QUINN,
GEORGE MAHARIS,
MICHAEL PARKS,
ROBERT WALKER, JR.,
MARTHA HYER, FAYE DUNAWAY,
MILTON BERLE, OSCAR HOMOLKA,
JACK KRUSCHEN,
CLIFTON JAMES

······

COLUMBIA.
DIRECTED BY ELLIOT SILVERSTEIN
SCREENPLAY BY FRANK R. PIERSON,
JAMES D. BUCHANAN AND
RONALD AUSTIN, STORY BY BUCHANAN
AND AUSTIN
PRODUCED BY JUD KINBERG
EXECUTIVE PRODUCER: SAM SPIEGEL
CINEMATOGRAPHY BY PHILIP LATHROP

············

For a supposed golden girl, Faye Dunaway certainly got off to a shaky start.

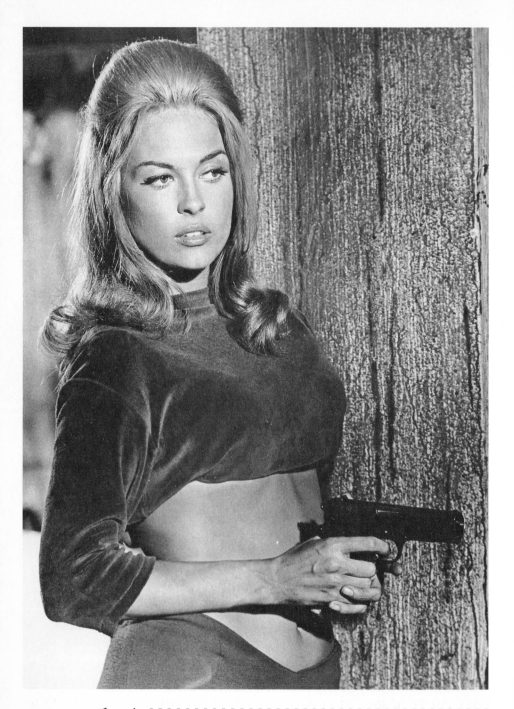

This is what chic looked like in the mid-1960s. Except for the gun, Faye Dunaway is the most unlikely-looking kidnapper in history.

Thomas More's daughter in Broadway's *A Man for All Seasons*. Right after that, Dunaway won a Fulbright scholarship to study at London's Royal Academy, an opportunity she passed up, opting instead to study at the new Lincoln Center Repertory company headed by Elia Kazan. So it was days at Kazan's and nights as St. Thomas More's daughter, not a bad way for a 21-year-old actress to be spending her time. Her charmed career continued when, in 1965, she got the lead in a drama called *Hogan's Goat*, which turned into the biggest Off-Broadway play in years. Producer Joyce Selznick got a load of her in the play and was on the horn with director Elliot Silverstein, fresh from his sleeper hit *Cat Ballou*. Director and actress met, and Dunaway said Silverstein "just looked at me across the table and said I was just what he wanted." This is where Dunaway's career hit a speed bump.

■ ■ ■ ■ ■ ■

The movie in which Dunaway would make her debut was to be called *The Innocent*. Scratch that, it's *Mr. Innocent*. On the other hand, *It's What's Happening* would probably appeal to the kids. Finally the film ended up as *The Happening*. Three title changes are never a good sign, and the fact that the movie sat on the shelf for nearly a year was even more ominous. In fact, the second film Dunaway made, Otto Preminger's *Hurry Sundown*, opened several months before *The Happening*. The portents were all borne out: *The Happening* was a disaster.

The film is an asinine reworking of *The Ransom of Red Chief* in which Dunaway and her fellow nihilistic "swingers," Michael Parks, George Maharis and Robert Walker, Jr. (the unsettlingly sylphlike son of Jennifer Jones), kidnap ex-Mafioso Anthony Quinn only to discover that nobody wants him back. Insulted, Quinn takes charge of the kidnapping to implicate his wife, Martha Hyer, and her lover, Milton Berle, in the abduction. But the plot is merely an excuse for a lot of

THE CRITICS ON FAYE DUNAWAY

"The hippies are played with grotesque ineptitude by George Maharis, Michael Parks, Robert Walker, Jr., and Faye Dunaway."
—Brendan Gill, *New Yorker*

Newcomer Fay [sic] Dunaway, though stunning to view and essaying her role with élan, is too womanly seductive for a teenybopper role."
—*Variety*

"A carbon copy of Jane Fonda."
—Bosley Crowther, *New York Times*

"[Dunaway's] rib cage looks marvelous in this film."
—*Los Angeles Herald-Examiner*

■ ■ ■ ■ ■ ■ ■ ■ ■ ■

One thing can be said about Faye Dunaway's career: It has certainly contained more than its fair share of turkeys, starting right at the beginning. Besides *The Happening*, her *oeuvre* includes:

The Extraordinary Seaman (1969)
A Place for Lovers (1969)
Doc (1971)
The Deadly Trap (1971)
Oklahoma Crude (1973)
Voyage of the Damned (1976)
The Champ (1979)
The Wicked Lady (1983)
Ordeal by Innocence (1984)

Supergirl (1984; above)
Burning Secret (1988)
Midnight Crossing (1988)
Double Edge (1992)
The Temp (1993)

would-be existentialist prattle about the Meaning of Life.

A crazy quilt of wildly variant tones and styles, with *de rigueur* mid-sixties jump cuts and purposelessly delirious camera angles, *The Happening* is a complete mess. In the last of his 28 years at the *New York Times*, poor Bosley Crowther just didn't get Hollywood any-more—in fact, his later cursory dismissal of *Bonnie and Clyde* led to his dismissal. No one could blame him, however, for failing to figure out *The Happening*, which he wrote "leaps and wobbles and screeches as though it were on some sort of hallucinatory binge." Kathleen Carroll of the *New York Daily News* aptly relegated the movie to "a limbo reserved for square pictures with pre-tensions of being hip."

Fortunately for Faye Dunaway, *Bonnie and Clyde* opened three months after *The Happening* and quickly established itself as a movie landmark, finally giving Dunaway her predicted stardom. George Maharis and Michael Parks weren't as lucky: Neither would again appear in an A-budget movie. Parks at least gained some measure of popularity in the 1969 TV "road" series *Then Came Bronson*, which was essentially Maharis's earlier *Route 66* with one guy on a motorcycle instead of two in a Corvette. Anthony Quinn, of course, kept rolling on. The career of *The Happening*'s female lead, however, would be a yo-yo, as Faye Dunaway experi-enced the highs of *Chinatown* and her Oscar-winning *Network* as well as the lows of *The Extraordinary Seaman* and *The Wicked Lady*.

ROBERT DUVALL

······

TO KILL A MOCKINGBIRD
(1962)

How's this for a rebellious streak? Your father's a career Navy man (eventually making it to the rank of rear admiral) and he and your mother have it all planned out: You'll attend Annapolis and go on to enjoy the good times of a Navy lifer. So what do you do? After high school you join the Army. Following *his* military service, Robert Duvall floundered for a spell until he ended up at Principia College in Illinois. Actually he floundered a bit there, too. But when a professor informed his parents that their Bobby was no great shakes as a social studies major, they—recalling his childhood talent for mimicry—urged him to give the theater department a shot. An A in a drama class convinced him this was the way to go: "My first A since the eighth grade. Then I found myself as Harlequin in a school pantomime, dancing around to music by Ravel and Stravinsky."

With minimal screen time and no dialogue, Robert Duvall created an indelible impression.

CAST

GREGORY PECK, MARY BADHAM,
PHILIP ALFORD, JOHN MEGNA,
FRANK OVERTON,
ROSEMARY MURPHY,
RUTH WHITE, BROCK PETERS,
ESTELLE EVANS, PAUL FIX,
COLLIN WILCOX,
JAMES ANDERSON,
ALICE GHOSTLEY, ROBERT DUVALL,
WILLIAM WINDOM

······

UNIVERSAL
DIRECTED BY RICHARD MULLIGAN
SCREENPLAY BY HORTON FOOTE
PRODUCED BY ALAN J. PAKULA
CINEMATOGRAPHY BY RUSSELL HARLAN

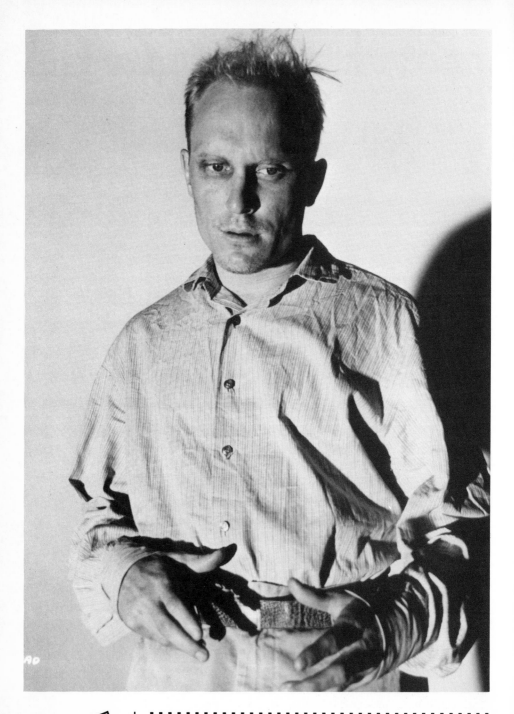

In keeping with the retiring ways of Boo Radley, Robert Duvall refuses to look at the camera.

In 1955, with a diploma hot off the press, Duvall headed to New York, studied at the Neighborhood Playhouse (thanks to the GI Bill) and shared an apartment with another struggling thespian, Robert Morse, although his best pal was Gene Hackman. The roll call of positions Duvall took to pay the rent included mail sorter, clerk at Macy's, messenger and dishwasher. Two years after arriving in New York, Duvall won his first role outside the Neighborhood Playhouse. It was way off Broadway, out in Bellport, Long Island, and it wasn't much of a run—a one-night-only performance of Arthur Miller's *A View from the Bridge*. But the playwright himself was in the audience, and, playing the lead, Duvall made the kind of contacts an unknown dreams of. A year after this professional debut he appeared on the New York stage for the first time, in a revival of Shaw's *Mrs. Warren's Profession*; he also—in an era when a considerable number of television shows were produced in New York—showed up on the small screen several times, beginning with a *Naked City* episode in which he played a rooftop sniper.

A contact that predated Duvall's performance in *A View from the Bridge* led to his entrance into films. Producer Alan J. Pakula was planning a film adaptation of Harper Lee's *To Kill a Mockingbird*, a book which, although only a year old, was already beloved. Pakula explained that he and director Robert Mulligan "wanted to retain that sense of discovery, which is so important in the novel. We didn't want familiar faces that everyone in the audience would recognize—so, aside from Gregory Peck, we're using Broadway actors who are not too well known to motion picture audiences, and completely unknown children." To transform the tale from page to screen, Pakula hired playwright Horton Foote—a godsend for Robert Duvall. The writer remembered an unsung young actor he had seen in a production of one of his plays at the Neighborhood Playhouse, and told Pakula this fellow had the right quality to play the small but pivotal role

A major concern of Robert Mulligan's work is the conflict between the public and private self, the image the world has of a person and what he himself feels is his true identity. Robert Duvall's character is the film's prime embodiment of this motif.

Despite his unques-
tionable talent,
Robert Duvall never
became a movie star
of the first order,
which is perhaps
due to one over-
riding factor—he's
bald. And unlike
such cowards as
Charlton Heston,
Burt Reynolds and
John Wayne (to
say nothing of Ida
Lupino), Duvall
hasn't tried to cover
the truth. A number
of actors have had
long careers without
having to spend
much time in hair-
dressing, although
admittedly, except
for Yul Brynner and
Sean Connery,
they've generally
made do as charac-
ter actors or come-
dians rather than
romantic leads.

F. Murray Abraham
Edward Asner
Martin Balsam
Peter Boyle
Roscoe Lee Browne
Fred Clark
James Coco

of Boo Radley. (You might hesitate to call this recom-
mendation a compliment, since the character is men-
tally retarded.)

· · · · · ·

To most observers, the film version of *To Kill a Mockingbird* more than does justice to its Pulitzer Prize-winning source. It is, of course, the leisurely, episodic account of 18 months in a family's life in Depression-era Alabama, as filtered through the mem-ory of a woman who was a first-grader at the time. Although the centerpiece of the movie is a trial in which her widowed father, Atticus Finch (Gregory Peck), defends a black man on a trumped-up charge of raping a white woman, the essence—and the over-whelming achievement—of the film is the masterful way it captures the world seen from the perspective of the children Jem and Scout (Phillip Alford and Mary Badham), encompassing events both mysterious and mundane.

Boo Radley, who lives a hermetic existence two houses down from the Finches, is a mysterious figure in the town of Maycomb, about whom everyone makes the darkest assumptions. As Jem tells the young visitor Dill (John Megna), "Boo only comes out at night when you're asleep and it's pitch dark. . . . Judging from his tracks, he's about six and a half feet tall. He eats raw squirrels and all the cats he can catch." And Dill's aunt (the irrepressible Alice Ghostley) warns her nephew, "There's a maniac that lives there and he's dangerous." Boo inexplicably leaves small items such as a pocket watch and a penknife in the knothole of a tree (which Jem collects) and remains an enigmatic figure to the audience as well, for he doesn't appear until 2 hours and 13 minutes into the film.

At that point, Jem and Scout, walking home late at night, are attacked by Ewell, the malevolent father of the woman who claimed to be raped. A few minutes earlier, narrator Kim Stanley (the voice of the grown-

up Scout) had remarked, "I still looked for Boo every time I went by the Radley place." Since this is the first mention of the character since early in the picture, we are led to think that the figure mauling the children might be Boo. But a hand comes into the frame, then feet, and from Scout's point of view we finally see Boo, carrying the injured Jem to the Finch house. We view Robert Duvall's face for the first time shortly thereafter; he is standing behind the door in Jem's bedroom, hollow eyes cast downward, his blond hair disheveled, body pressed against the wall. When the door is pushed away Boo comes out of the shadows, both literally and figuratively. Scout stares at him, then hesitatingly smiles and offers, "Hey, Boo," but Atticus makes a proper introduction: "Miss Jean Louise, Mr. Arthur Radley." She also beckons him to Jem's bedside, telling him, "You can pet him, Mr. Arthur. He's asleep. You couldn't if he was awake, though. He wouldn't let you." Boo touches Jem's hair and then takes Scout's hand, and the two of them sit on the porch swing together. Boo has killed Ewell to save the children, but the sheriff insists on keeping silent about his heroism because "it would be a sin to drag him with his shy ways into the limelight." As Scout walks Boo home, Kim Stanley's voice says, "Neighbors bring food with death and flowers with sickness and little things in between. Boo was our neighbor. He gave us two soap dolls, a broken watch and chain, a knife, and our lives."

Duvall is onscreen for three and a half minutes, and he doesn't speak. But with his haunted look and hulking presence, he creates an indelible impression. Boo Radley resonates in the memory of every child who has ever seen *To Kill a Mockingbird*, a metaphor for the fears of childhood that we ultimately overcome. A bunch of English musicians were so affected by the character that, a quarter of a century after the film was made, they named their pop band "The Boo Radleys."

Having finished his time as Boo Radley, Robert Duvall went back to New York for an Off-Broadway

Richard Deacon
Danny DeVito
Charles S. Dutton
Hector Elizondo
Leon Errol
John Fiedler
Lou Gossett, Jr.
Sidney Greenstreet
Ed Harris
Percy Helton
Bob Hoskins
Edgar Kennedy
Guy Kibbee
Ben Kingsley
John Malkovich
Donald Meek
Robert Middleton
Bob Newhart
Edward C. Platt
Telly Savalas
Woody Strode
Grady Sutton
Erich von Stroheim
Eli Wallach
Paul Winfield
Hank Worden

play called *The Days and Nights of Beebee Fenstermaker,* which was more successful than its title would indicate. He then had an 18-month sojourn in Hollywood, which brought a lot of television work but only one new film. Duvall had another strong secondary role as a character with a mental problem in a Gregory Peck vehicle, this time an Air Force officer treated for a nervous breakdown by the eponymous Air Force psychiatrist, *Captain Newman, M.D.* In New York, a triumphant 1965 return engagement in *A View from the Bridge*—still Off Broadway, but at least in Manhattan—that made Robert Duvall, if not a household name, at least a name on the tips of casting agents' tongues. And on the subject of names, throughout the years Duvall christened several of his dogs "Boo Radley."

SALLY FIELD

······

THE WAY WEST
(1966)

Imagine, if you can, Gidget on a wagon train.

Sometimes it seems that there never was a time when Sally Field wasn't part of our lives. Although she was only eighteen when she first encroached upon our collective consciousness, Field would have really, really liked to have been around long before that. In the 1950s, she'd see Patty McCormack or Lauren Chapin performing and wish that she too were a glamorous star, but Stepfather knew best, and Jock Mahoney (TV's *Yancy Derringer*) said there'd be no kid actors in his Encino household. So little Sally dutifully went to school just like a regular girl and dreamed of appearing in the pages of *Photoplay*.

But hooray for Hollywood: While on summer vacation from Valley State College, Field attended Columbia Studios' Film Industries Workshop. Studio casting director Eddie Foy III told the acting teachers to be on the lookout for "a petite, bite-size bundle of joy"; in other words, no longer retaining box-office appeal, the *Gidget*

CAST

KIRK DOUGLAS, ROBERT MITCHUM,
RICHARD WIDMARK,
LOLA ALBRIGHT, MICHAEL WITNEY,
STUBBY KAYE, SALLY FIELD,
KATHERINE JUSTICE,
MICHAEL MCGREEVEY,
HARRY CAREY, JR.

······

UNITED ARTISTS
DIRECTED BY ANDREW V. MCLAGLEN
SCREENPLAY BY BEN MADDOW AND
MITCH LINDEMANN
CINEMATOGRAPHY BY
WILLIAM H. CLOTHIER

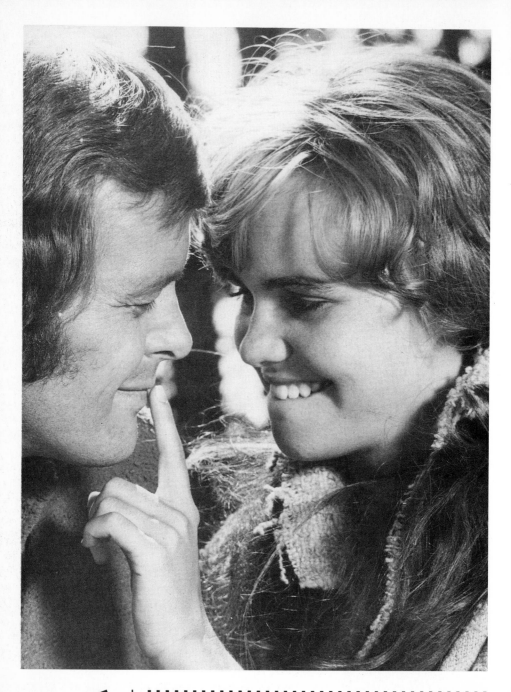

 This is Sally Field's way of playing sexy as Mercy McBee, a hot-to-trot teenager looking for kicks on a wagon train. Poor Michael Witney falls for it, and for his troubles ends up strung from a tree.

movies were being turned into a TV series. Before you could say, "You're going out a youngster but you've got to come back a star," a professor reported that Field would be perfect as that crazy Southern California beach kid (even if she had never surfed in her life). Still, that was only one man's opinion. Field had to go up against more than a hundred other girls, and "They were all gorgeous and had portfolios of pictures of themselves in things they'd done. I'd never done anything. All I had was a wallet full of pictures of my girlfriends."

Despite her lack of experience, Field got the part. The network wasn't surprised when the series got roasted by reviewers (although one teen magazine did rave that Sally was "a gear, absolutely fab Gidget"), but they were shaken by the fact that the targeted kid audience wasn't tuning in. At the end of the 1965–66 television season, *Gidget* was kaput. The actress's mother conducted a postmortem on the flop: "Sally has grown up a lot in the past year. She knows where she's going. But she has to learn that everybody's not a hero—she's been hurt a few times because she thought that everybody loved her."

• • • • • •

Field decided that since TV audiences weren't appreciative, she would offer her talents to a more sophisticated clientele—the moviegoing public. In the summer of 1966, while *Gidget* was petering out in reruns, she began filming *The Way West*. This adaptation of A. B. Guthrie, Jr.'s Pulitzer Prize novel about settlers on a wagon trek to Oregon was produced by Harold Hecht (*Birdman of Alcatraz, Cat Ballou*) and starred three of the best postwar American film actors, Kirk Douglas, Robert Mitchum and Richard Widmark. Yet despite its genealogy, *The Way West* stands as probably the worst-reviewed Western of the 1960s.

Douglas portrays Tadlock, the captain of the wagon train, a man given to severe mood swings and so driven that he comes off as a frontier Captain Queeg. Mitchum

is a laconic Indian scout and Widmark the toughest of the pioneers. The film, directed by Andrew McLaglen (son of Victor, with *Shenandoah* and *Monkeys Go Home!* among his credits), touches all the usual bases: stampedes, Injuns, raging rivers, disease. To give the movie what they hoped would be a contemporary spin, the filmmakers cast Field as one Mercy McBee, a teenager whose personality is entirely defined by her sex drive. When Field first comes onscreen, we see only her bare legs, suggestively spread apart as she rides on the back of her parents' wagon. At the time, she said of her characterization, "My role in *The Way West* is a gutsy, dramatic one and naturally I put some of myself into it, otherwise it wouldn't be real. But I'm not actually the sexy type so I had to do a lot of acting." Her way of conveying concupiscence is by constantly doing things with her mouth, a roll of the tongue here, a biting of the lower lip there. And in case the audience doesn't get it, the character's father comments that if "we don't get that girl hitched 'fore we get to Oregon, she's gonna run off and marry the nearest buffalo." Instead, in a plot development that's more *Peyton Place* than *The Covered Wagon,* she gets involved with a man saddled with a frigid wife and has an affair that causes a lot of bother.

The movie's clichés, overwrought acting and undeveloped subplots provoked the wrath of the critics. Pauline Kael sneered, "*The Way West* is about as bad an epic Western as I've ever seen. . . . It's a jerk's idea of an epic," and to Hollis Alpert of the *Saturday Review* it was "about as flabby a Western adventure as has come along." The only people who liked *The Way West* were the Daughters of the American Revolution; those haughty ladies selected it as "The Picture of the Year." Sally Field's acting was generally ignored by the reviewers, but she is dreadful. The shrill, unmodulated quality of her voice is aggravated here by her thick, corn-pone accent, and her performance is all mannerisms and superfluous gestures.

The Way West did nothing to improve the standing of any of its participants; Field's nascent film career had already received a blow when the only thing that resulted from her screen test for *The Graduate* was that Katharine Ross ended up with the role of Elaine Robinson; this really hurt because the thought of working with Mike Nichols "got me so excited I could hardly stand it." So three months after *The Way West* premiered, Field was back on television, playing Sister Bertrille on *The Flying Nun*. She confided to *Hollywood Screen Guide* that she was fretting, "Am I good enough for this role?" Clarifying her concern, she explained, "I didn't mean 'good' in terms of my acting abilities. I have worked hard at that, and it shows, and if it sounds vainglorious, I'm sorry." Rather, "The thought constantly haunts me that I'm not nice enough to be doing what I am—playing a fine idealistic young nun." *The Flying Nun* was a successful show and kept Field in the public eye. Screen Gems head Jackie Cooper was so pleased with the actress's work that he surprised her with a Ferrari. And in November, Cooper also threw her a 21st-birthday party at West Hollywood's trendy Factory. Reported *TV Guide*: "She wore a bright orange, cut velvet Rudi Gernreich mini-dress, had her first legal drink (Kahúla and cream) and frugged the night away with Davy Jones (of the Monkees), her sometime escort. 'I just couldn't believe it,' said the Flying Nun. 'There was little me where all the big stars are.'"

Sounds like a nice dénouement. But in actuality, although Field was pulling down $4,000 a week and appearing on magazine covers, "People hurt me when I worked in *The Flying Nun* . . . I was a continual put-down, a national joke, a running gag." Self-respect for this actress, who always wore her television roots like an albatross, didn't come until nearly two decades after *The Way West,* when the Academy tossed a pair of Oscars her way for *Norma Rae* and *Places in the Heart.*

Although critics neglected Field's performance, they took full stock of her character and decided that this anachronistic sexpot was the worst aspect of the movie. Newsweek headlined its review "Lolita Goes West" and called Mercy McBee "a sort of wayward Girl Scout," while Pauline Kael found the character "grotesquely avid for sex."

Memorable Oscar Acceptances

At the time of *The Way West,* the thought of Sally Field's winning two Academy Awards would have been unfathomable. Now, however, the actress will be forever linked with the acceptance speech she gave when she was named Best Actress of 1984 for *Places in the Heart:* "I can't deny the fact you like me—right now, you *like* me!" Field's may be the most famous, but there are plenty of other memorable Oscar quips, comments and speeches:

"I honestly never expected to win one of these. There are too many good actors in this business. But I feel as happy as a kid and a little foolish they picked me." —Clark Gable, Best Actor, 1934 (for *It Happened One Night*)

"Well, thanks, even if it isn't gold . . . but if you have a gold one left over, I'd like to have it." —Charlie McCarthy, recipient of a special, miniature wooden Oscar in 1937

"Mr. Sturges isn't here this evening, but I will be happy to accept the award for him." —Preston Sturges, Best Original Screenplay, 1940 (for *The Great McGinty*)

"There has been so much niceness here tonight that I am happy to say that I am entirely—and solely—responsible for the success of *The Philadelphia Story.*" —Donald Ogden Stewart, Best Screenplay, 1940

"Awards are nice, but I'd much rather have a job." —Jane Darwell, Best Supporting Actress, 1940 (for *The Grapes of Wrath*)

"I will share this award in spirit with my friends at the Royal Theatre of Athens. I hope they are still alive, but I doubt it." —Katina Paxinou, Best Supporting Actress, 1943 (for *For Whom The Bell Tolls*)

"I think I may have the baby right here." —Eva Marie Saint, Best Supporting Actress, 1954 (for *On the Waterfront*)

"I'm so loaded down with good-luck charms, I could hardly make it up the stairs." —David Niven, Best Actor, 1958 (for *Separate Tables*)

"I feel like thanking the first secretary who let me sneak into a Broadway casting call." —Charlton Heston, Best Actor, 1959 (for *Ben-Hur*)

"Having been educated in English schools, we were taught for at least fifteen years of our lives how to lose gracefully, and I've been preparing myself for that all afternoon . . . Now I don't quite know what to say." —Peter Ustinov, Best Supporting Actor, 1960 (for *Spartacus*)

"Thank you so much, you lovely, discerning people." —Billy Wilder, Best Director, 1960 (for *The Apartment*)

"Martinis for everybody!" —Johnny Mercer, Best Song, 1960 (for "Moon River")

"Deepest appreciation to all the Baby Janes, wherever you are." —Norma Koch, Best Costume Design (Black-and-White), 1962 (for *Whatever Happened to Baby Jane?*)

"I wish I could take the lady [presenter Angie Dickinson] home with me rather than this little Oscar." —Emil Kosa, Jr., Best Special Effects, 1963 (for *Cleopatra*)

"I know you Americans are famous for your hospitality, but this is really ridiculous." —Julie Andrews, Best Actress, 1964 (for *Mary Poppins*)

"I think one-half of this belongs to some horse somewhere in the Valley." —Lee Marvin, Best Actor, 1965 (for *Cat Ballou*)

"I'll just say what's in my heart—ba-bump, ba-bump, ba-bump." —Mel Brooks, Best Original Screenplay, 1968 (for *The Producers*)

"Oh, all the charming ghosts I feel around me who should share this." —Lillian Gish, Honorary Lifetime Achievement Award, 1970

"This couldn't have happened to a nicer fella." —Ben Johnson, Best Supporting Actor, 1971 (for *The Last Picture Show*)

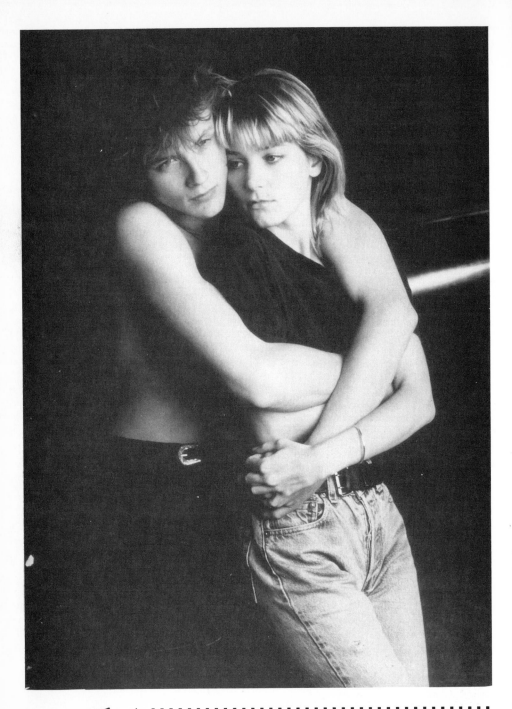

Henry Fonda's granddaughter just had to look beautiful, take her clothes off, make love and keep her mouth shut. All of which she did admirably.

BRIDGET FONDA

· · · · · ·

ARIA
(1986)

Looking back on the entirety of film history, a movie producer named Don Boyd realized there was one type of motion picture that had never been made: a collection of dramatic vignettes, each accompanied by an operatic aria on the soundtrack. Perhaps he should have stopped and considered that there was probably a good reason why this genre was nonexistent. But a man with a vision—no matter how dopey—cannot be denied, at least not if he has some money. To execute his dream, Boyd contacted a gaggle of internationally renowned directors (and a couple of marginal figures of dubious talent) and made the following challenge: "Find an operatic aria and, within the constraints of the budget [$80,000 apiece] and time available, make a short film visualizing your interpretation of the music, independent of its literal operatic story line." In other words, he was looking for a string of music videos set to Verdi and Puccini rather than Axl Rose.

Among the filmmakers accepting the solicitation

CAST

BRIDGET FONDA,
JAMES MATHERS

· · · · · ·

MIRAMAX
PRODUCED BY DON BOYD
"TRISTAN UND ISOLDE" SEQUENCE
DIRECTED AND WRITTEN
BY FRANC RODDAM
CINEMATOGRAPHY BY
FREDERICK ELMES
MUSIC BY RICHARD WAGNER
SUNG BY LEONTYNE PRICE

· · · · · · · · · · · ·

Bridget Fonda cruised in a car, made love and died. All in less than seven minutes.

was Franc Roddam, who had made the smashing Who-inspired musical drama *Quadrophenia* in 1978 but nothing of note since (unless you were impressed by Sting as Dr. Frankenstein). Here is Roddam articulating his artistic ethos: Youth "is a period when you have freedom without responsibility. It's a great moment with wonderful potential. After that, compromise. Compromise offends me, so I have my characters kick out against it." To illuminate this vision for *Aria*, he chose the "Liebestod" from Wagner's *Tristan und Isolde*. Then he had to round up a couple of youths. For his Tristan, he selected painter James Mathers; as leading lady, a 22-year-old New York University graduate who happened to have a world-famous grandfather, aunt and father. One of Bridget Fonda's first appearances in the media came when, interviewing Peter Fonda in the late 1960s, Rex Reed noted that his young daughter was running around naked. She also appeared without a stitch through much of her segment in *Aria*.

■ ■ ■ ■ ■ ■

"Liebestod" begins with Fonda and Mathers driving through the desert; then Roddam cuts from this beautifully arid landscape to the glitz of Las Vegas. All the expected targets are hit: a quickie wedding chapel, pathetic-looking old people dropping coins into slot machines, the ludicrous expenditure of electricity for massive signs advertising such banalities as bargain breakfasts and third-rate lounge singers. The city is intended to look more crass than normal because it is juxtaposed against the aural beauty of Leontyne Price belting out one of the most sublime pieces of music ever written. Next, Fonda and Mathers are in a cheap, wood-paneled hotel room, standing across from each other, naked; she walks toward him; they embrace, kiss and fall to the bed making love, exterior neon lights flashing various hues into the room. A glass breaks and the pair is now in the

bathtub, not because they're trying a new sexual variation but because it's a romantic place to slit their wrists. They do so in close-up. Back outside, an elderly woman leaves a casino in the early morning, the city looking even more grotesque in sunlight. The entire sequence has taken six minutes and forty seconds.

Shallow and pointless, the piece is nevertheless one of the better entries in *Aria*. It's an undeniably erotic sequence (though Wagner's "Liebestod" is so inherently sensuous that Roddam could have shown Fonda and Mathers doing laundry and they would still have prurient appeal), and the actors make a great-looking couple. On the other hand, the contrast between the purity of the young lovers and the vulgarity of Vegas is much too obvious a conceit to merit even a passing thought, and having the characters "kick out against compromise" by commiting suicide is a no-brainer. Reaction to "Liebestod" ran the gamut. In the *Los Angeles Times*, Martin Bernheimer complained that "Roddam cheapens the ethereal myth and mystery of Wagner's 'Liebestod' with a sordid mini-melodrama depicting teenage sex in Las Vegas." Taking the middle ground was Jerry Talmer of the *New York Post*, who opined of the episode, "Kitsch, but somehow touching." *Variety*, on the other hand, wrote that the film's "most striking clash of images is achieved by Roddam" and Amy Taubin of the *Village Voice* threw caution to the wind to proclaim "Liebestod" "the most merrily brilliant bit of filmmaking since *Blue Velvet*."

Presumably because she doesn't have any dialogue, Fonda's performance was not commented on by critics. the *Voice*'s Taubin, however, gushed that she and Mathers are "a pair of achingly handsome California kids."

After Aria, Fonda made the sex comedy *You Can't Hurry Love*. Though of an entirely different order than *Aria*, it was another piece of trash. But at least she got to speak in it.

Bernard Gorcey and Leo Gorcey

Helen Hayes and James MacArthur

Tippi Hedren and Melanie Griffith

Jim Hutton and Timothy Hutton

Marjorie Lord and Anne Archer

John Mills and Hayley Mills

Raymond Massey and Daniel Massey and Anna Massey

Robert Montgomery and Elizabeth Montgomery

Vic Morrow and Jennifer Jason Leigh

Ryan O'Neal and Tatum O'Neal

Maureen O'Sullivan and Mia Farrow

Osgood Perkins and Tony Perkins

Martin Sheen and Emilio Estevez and Charlie Sheen

Donald Sutherland and Kiefer Sutherland

Danny Thomas and Marlo Thomas

Ed Wynn and Keenan Wynn

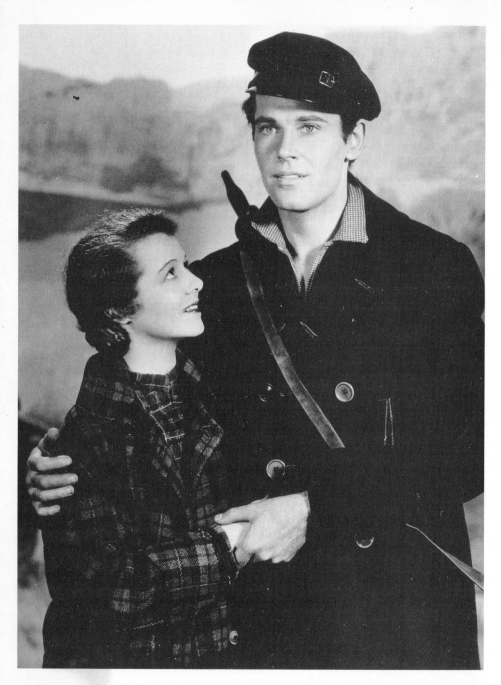

Henry Fonda looks as if he can't believe his good fortune: getting to reprise his stage role in *The Farmer Takes a Wife* instead of watching it go to an established movie star, and co-starring with top box-office drawer Janet Gaynor to boot.

Henry Fonda

· · · · · ·

THE FARMER TAKES A WIFE
(1935)

When Henry Fonda was 10 years old, a newspaper in suburban Omaha published a story he had written. That settled his career choice right then and there. Eight years later, in 1923, he arrived at the University of Minnesota to study journalism, while also working as athletic director at a settlement house to earn money for tuition. Two years down the line, this combination of academic toil and athletic moil finally proved too exhausting, and Fonda went home. Unable to get newspaper work, he mostly hung around—until Mrs. Dorothy Brando, having seen her son Marlon through his first year of life, returned to her duties at the Omaha Community Playhouse.

Needing a youthful actor for the playhouse's latest production, Do Brando thought of her friend Herberta Fonda's son, even if he was just about the shyest boy in town. In fact, Fonda had no interest in acting; he

CAST

JANET GAYNOR, HENRY FONDA,
CHARLES BICKFORD,
SLIM SUMMERVILLE,
ANDY DEVINE, ROGER IMHOF,
JANE WITHERS,
MARGARET HAMILTON,
SIEGFRIED RUMANN,
JOHN QUALEN

· · · · · ·

FOX
DIRECTED BY VICTOR FLEMING
SCREENPLAY BY EDWIN BURKE
PRODUCED BY WINFIELD B. SHEEHAN
CINEMATOGRAPHY BY JOHN F. SEITZ

THE CRITICS ON HENRY FONDA

"Mr. Fonda, in his film debut, is the bright particular star of the occasion. As the virtuous farm boy, he plays with an immensely winning simplicity which will quickly make him one of our most attractive screen actors."

—Andre Senwald,
New York Times

"Henry Fonda, as the farmer, is youthfully manly and shows nice personality, but he is made to dress as no New York state farmer ever did."

—*Variety*

"New heart throb seems to be on the way in Henry Fonda, who turns in a quiet but highly effective performance."

—*Daily Variety*

"Henry Fonda's day dawns. . . . He emerges from his

was simply too timid to decline the offer. It turned out that Do Brando knew more about Henry than Henry did—he loved being onstage. Although he received no stipend, Fonda stayed on at the playhouse, doing backstage chores and acting in small roles while simultaneously working twelve hours a day as a filing clerk for a finance company. To his great surprise, he was offered the lead role in the theater's production of *Merton of the Movies*, and the thrill of being the main attraction was such that on opening night, "The short hair on the back of my neck felt like live wires and my skin tingled."

A wealthy local woman hired Fonda to drive her son home from Princeton, throwing in a week's stay in New York City as a bonus; he used his time there to see nine plays. Watching the big boys do it convinced him more than ever that he was destined to be a disciple of Thespis. Back home again, he became assistant to the playhouse's director. A vaudevillian who made his living entertaining people by impersonating Abraham Lincoln hired Fonda to join him on his one-night stands, playing Lincoln's secretary. He got a position as chauffeur, driving a dowager from Nebraska to Cape Cod, and then remained on the Cape to seek work in summer stock. He eventually met a group called the University Players, made up of young hopefuls from Princeton and Harvard; Fonda wasn't an Ivy Leaguer, but they let him into their club nonetheless. During Fonda's five summers and one winter with the gang, other Players included Joshua Logan, James Stewart, Margaret Sullavan and Mildred Natwick. His first professional exposure came in 1929 at the National Junior Theatre in Washington, D.C., and later that year he finally walked onto a Broadway stage—though that's all he did, his being a nonspeaking role. He wasn't ignoring his personal life, however. On Christmas Day 1931, he married Margaret Sullavan. In February 1932, they split up. And so did the University Players.

Fonda did a pair of unsuccessful Broadway plays and worked in a few stock companies, both on and

behind the stage, before hitting a dry spell that forced him to work for a florist. But Fonda's breakthrough came soon after his floral interlude. An inexperienced producer named Leonard Sillman figured out a way to put up a show on the cheap. He would stage a revue with a cast made up entirely of unknowns, and rather than trying to disguise the fact that theatergoers weren't going to be getting any star power for their bucks, he made that the selling point—audiences would feel as if *they* were discovering untapped talent—and boasted of it in the very title, *New Faces*. The collection of comedy sketches and songs pleased the critics, who singled out Fonda and Imogene Coca, and the show had a respectable run. (Other than these two performers, the rest of the cast grew into old faces without ever becoming familiar faces.) Leland Hayward thought there was money to be made on this young fellow, so in addition to sparkling reviews, Fonda also ended up with an agent, and a highly influential one at that.

Hayward persistently worked on convincing his new client that the theater was small potatoes compared to motion pictures, but Fonda was happily ensconced playing stock in Mount Kisco, New York. Finally, with the agent offering to pay for a trip to Hollywood to meet producer Walter Wanger, Fonda agreed to go, reasoning that once he did Hayward would finally shut up and he could proceed with his theater work in peace. And he also knew how to get Walter Wanger off his back. When the producer asked him how much money he wanted, the actor—who had a $100 offer waiting for him in New York—would give the outrageously exorbitant price tag of $350 a week. But Wanger never asked him his salary demand. Instead, he told him $1,000 a week. Fonda signed.

• • • • • •

Wanger didn't have anything ready to go before the cameras, so he allowed his contractee to return to Mount Kisco. A stage actress named

film debut with a certain film success and one of the really important contributions of stage and screen within the past few seasons."
—*New York American*

"Young Fonda, a find, resembling young Abraham Lincoln, is sincere, repressed and strong in what it takes."
—*Motion Picture Daily*

June Walker happened to see him perform there and thought he'd be grand for a Broadway play she was doing later that year. With *The Farmer Takes a Wife*, Henry Fonda went from new face to romantic idol. As one of the two title roles in the drama, set in the Mohawk Valley of the 1850s, when the rough-hewn workers on the Erie Canal were at odds with farmers in the area, Fonda enchanted the critics. The most important of the scribes, the *Times*'s Brooks Atkinson, deemed his "a manly, modest performance in a style of captivating simplicity." The play ran for only three months, but that was just fine by the Fox Film Corporation, which paid the not inconsiderable sum of $65,000 for screen rights. While MGM specialized in the world of the elegant rich, Warner Brothers in the urban working class, and Paramount in Continental sharpies, Fox's particular métier was rural America and the simple folk who lived there, and *The Farmer Takes a Wife* fit into the studio's agenda quite nicely.

■ ■ ■ ■ ■ ■

Discussion at the Fox lot: Who better than Gary Cooper to embody the quiet farmer? Unavailable? No problem, Joel McCrea is our preference, anyway—not as stiff an actor. Whaddya mean we can't get him either? At this point Walter Wanger stepped in with the suggestion that the studio simply use the youthful actor who had caused such a stir with the piece in the first place. Thus was Henry Fonda summoned to Hollywood. The studio paid Wanger $5,000 a week for Fonda's services. He turned around, took $2,000 of that money and increased the actor's salary to $3,000, thus giving Fonda the same amount of cash he himself was pocketing on the deal. (Wanger was that rarity among movie moguls—a good egg.)

The Farmer Takes a Wife was a big deal. Fonda would be launching his screen career by costarring with Janet Gaynor, whom exhibitors had voted 1934's top female box-office draw (although she was about to be dethroned

as queen of the Fox lot by Shirley Temple, age seven). Director Victor Fleming was strictly A list, and although he was a bigot, an anti-Semite and a right-wing zealot—and therefore the antithesis of everything Henry Fonda stood for—the actor was forever indebted to him. On the first day of filming, Fonda nearly blew out the sound recorder's ears, projecting all the way to an imaginary second balcony, as well as making facial gestures so broad they could be seen clear across Pico Boulevard. Fleming took him aside and said, "Hank, you're hamming it," explaining that because his image would be on a huge screen, restraint was the key. "That's the biggest message I ever got in Hollywood," Fonda recollected. "I just pulled it back to reality because the lens and that microphone are doing all the projection you need." It was obviously a lesson well learned, because Henry Fonda overacting is an oxymoron.

Fonda was ideally cast in *The Farmer Takes a Wife*, a film whose modest but genuine pleasures lie in its nostalgic evocation of its time and place. He plays an idealistic young man working as a pilot of an Erie Canal barge, there only to save up enough dough to return to the country and buy a farm. Fonda captures the fancy of Janet Gaynor, a cook on the vessel owned by the truculent Charles Bickford, even though she generally thinks of farm people as flaccid dullards and has always preferred the rampageous men of the canal. He falls for her, too, and when Bickford drunkenly abuses her, Fonda hires her for the boat he has conveniently won in a lottery. There's a problem in this relationship, though. To Fonda's character, the agrarian is the ideal life, but feisty Gaynor won't even consider forsaking the excitement of the waterfront. A drunken Bickford challenges Fonda to a fight, and the farm boy does what any gentle soul would do in the situation: He gets the hell out of there. Since sensitive males are in short supply in upstate New York at the time, everyone has a fine old time teasing Gaynor that her fella is a coward. Not that she had to be told; she's got eyes of her own.

"Mr. Fonda is that rarity of the drama, a young man who can present naive charm and ingratiating simplicity in a characterization and yet never fail to seem both manly and in possession of his full senses. His is a delightful portrayal in a role that might easily have seemed the type of thing that 'Buddy' Rogers used to strive for haplessly."
—Richard Watts, Jr., *New York Post*

Bringing shame on his beloved will never do, so the lanky Fonda returns to meet the enemy and somewhat improbably licks the sturdy Bickford. If he's capable of *that*, then Gaynor reckons it's worth having to muck it up with the cows and pigs if that's what it takes to be with him.

The Farmer Takes a Wife, which premiered at Radio City Music Hall, pleased most of the reviewers, with the press declaring that in Henry Fonda a star was born. Fonda slips right into the type of role that would become his signature: the soft-spoken man of principle, a bit gangly and awkward, perhaps, but that was part of his appeal. His Dan Harrow in this film is in many ways a dry run for his magnificent work in *Young Mr. Lincoln* four years later.

The actor had naively assumed that his Hollywood career would peacefully coexist with his life in the theater back east. Wrong. He returned to Broadway only once in the next thirteen years. Fonda didn't get an extended break from Hollywood until 1943, and that wasn't to tread the boards in New York. It was because he had enlisted in the Navy.

JANE FONDA

······

TALL STORY
(1959)

Henry Fonda's daughter did her first professional acting at age 17 after graduating from finishing school in 1955; she had a small part in an Omaha Community Theatre production of *The Country Girl* that starred her father and family friend Dorothy McGuire. After that, it was off to Vassar and then another minor role in another summer stock show starring Henry Fonda, *The Male Animal*, in Cape Cod. Bored with college, Jane left after her sophomore year, saying Vassar had "too many women." For a couple of years, she became the consummate dabbler, trying out painting in Paris and at New York's Art Students League, taking courses in French and Italian, going highbrow by apprenticing with George Plimpton at the *Paris Review*, and working as a script girl for Warner LeRoy (when he harbored illusions of filmmaking rather than serving food in New York tourist spots like Tavern on the Green). Modeling was also part of Fonda's life in the late '50s, and considering she ended up on the covers of *Vogue*

What if Jane Fonda's godfather had been Alfred Hitchcock?

CAST

ANTHONY PERKINS, JANE FONDA,
RAY WALSTON, MARC CONNELLY,
ANNE JACKSON,
MURRAY HAMILTON,
ELIZABETH PATTERSON,
GARY LOCKWOOD, TOM LAUGHLIN

······

WARNER BROTHERS
DIRECTED AND PRODUCED BY
JOSHUA LOGAN
SCREENPLAY BY JULIUS J. EPSTEIN
CINEMATOGRAPHY BY
ELLSWORTH FREDERICKS

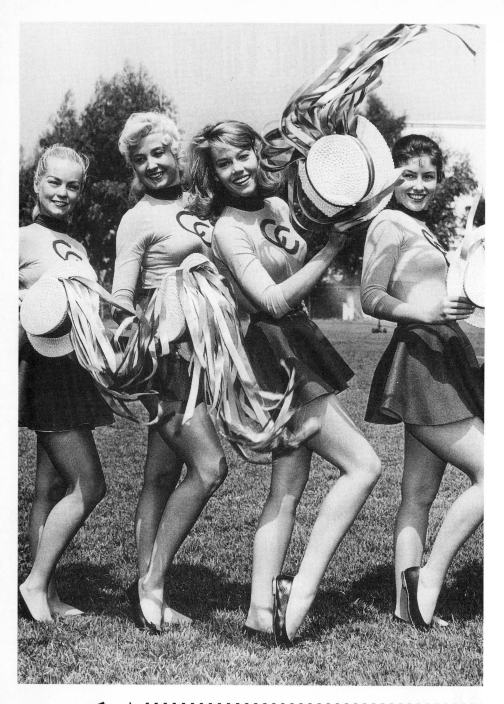

At age 21, Jane Fonda goes through a dry run for her career as America's Queen of Aerobics two decades later.

and *Glamour,* it's fair to say that in this field she went beyond dabbling. Not that she had pursued modeling as a profession, mind you: "I wasn't looking for a job, but the head of one of the big agencies talked me into it. I was fascinated by the amount of money that might be made; I like to pay my own way."

Still, she was bored. Her pal Susan Strasberg, who had just costarred with Jane's dad in *Stage Struck,* egged her on to try acting, so Jane signed up with Susan's dad, Lee, and began classes at the Actors Studio. Years later, Jane rhapsodized, "Lee Strasberg told me I had talent. *Real* talent. It was the first time that anyone, except my father—who *had* to say so—told me I was good. At anything. It was a turning point in my life." Jane decided that there'd be no more diddling around. Acting had become her life.

Lee Strasberg might have been her guru but her fairy godfather was her real-life godfather, Joshua Logan. The producer and director announced that Jane would star in his film version of *Tall Story,* an inconsequential Broadway comedy that had run for only four months. Despite the decline of the studio system, Warner Brothers gave her a full buildup, going so far as to issue an advance poster for *Tall Story* that completely ignored the film's star, Tony Perkins (who had starred with Fonda *père* in 1957's *The Tin Star*). Instead, there were four pictures of Jane, in one clad in negligee and in another with her arms provocatively positioned behind her head; the copy referred to her as "that fabulous new screen find." The actress told the *New York Mirror,* "Girls generally don't get a part like this until they've had lots and lots of experience. And I know I wouldn't have got it if I didn't have the father I have, and if Josh Logan hadn't known me all my life."

• • • • • •

Released in April 1960, *Tall Story* was a less than auspicious way to launch a career. The obnoxious comedy begins with coed June (Fonda), a home ec

• • • • • • • • • • •

Although *Tall Story* was her first movie and she was undoubtedly on her best behavior for her godfather, it's hard to believe that even in 1959 Jane Fonda would have uttered this particular line of dialogue: Her character gleefully admits that she didn't go to school for an education but for "the same reason that every girl, if she's honest with herself, comes to college—to get married."

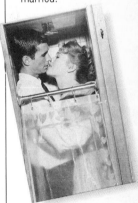

The next time that Tony Perkins got into a shower with an actress, it was with Janet Leigh, and she ended up with much more than a smooch.

Although the anti-war activist dubbed "Hanoi Jane" by angry critics was a lifetime away from the ingenue of *Tall Story*, the film was nevertheless affected by her politics. In 1973, Dallas television station WFAA "indefinitely post-poned" the telecast of the basketball romance. Explained station manager Ward Huey, "We had a very signifi-cant reaction to it—very significant—because of Miss Fonda's appearance in it." (The Vietnam War was officially over at this point, but Fonda had accused returning soldiers of lying about the hardships they endured in North Vietnamese prison camps—hence the uproar.)

major setting her sights on Ray (Perkins), Custer College's basketball phenom as well as its top scholar. She gets her man with remarkable speed and minimum conflict, and with that done, Fonda, who dominates the first section of the movie, recedes into the background. The final two-thirds of *Tall Story* deal with Ray's dilemma over being offered a bribe to throw a basketball game against a visiting Russian team—money that would pay for the trailer he and June dream of calling home. In the finale, Ray has been barred from playing in the big game for flunking a midterm and then, after a change of heart, must convince his professor (Ray Walston) that he failed on purpose for fear of having his sports integrity compromised by any association with tainted money. It all gets very convoluted and improbable, but suffice it to say that our hero wins the game for Custer, gets to keep the bribe money (with the consent of the local D.A., no less) and lives happily ever after with June in their trailer.

It was the type of smarmy film that was advertised with the catch line, "STUDENTS: If you want to go to college, don't let your parents see this picture!" The critics were not kind. The *Los Angeles Mirror-News* fretted that scenes in which the two stars lead up to a first kiss by talking about nymphomaniac elephants or squeeze into a half-sized shower together "will take no prizes for good taste," but concluded, with a sigh of relief, "*Tall Story* is such a crashing bore it will likely put you to sleep before it can offend you." *Time* said, "The lines are stupefyingly cute, the sight gags franti-cally unfunny, the climax about as exciting as a soggy sweat sock."

Film audiences got their first glimpse of Jane Fonda as she sped along on a bicycle and crashed into two pro-fessors. Although she comes across as too intelligent a presence for her bubble-headed character, the actress is eminently appealing and gives her character a charm that is lacking in the script. Joshua Logan later said, "I should have known better than to get involved in *Tall*

Story," but added, "With the exception of Marilyn Monroe, I have never worked with a more talented actress than Jane Fonda." A month before *Tall Story* opened, Broadway had a look at her in a drama called *There Was a Little Girl*, also directed by Logan; the play, too, was a flop, but Fonda did receive a Tony nomination and won the New York Drama Critics and Theatre World awards as the year's most promising actress.

And so appeared the first public persona of Jane Fonda, that of a talented ingenue. Over the years that image would give way to European sex kitten, antiwar activist, leading Hollywood dramatic actress, exercise queen, Mrs. Ted Turner and so on. On the subject of image, *Tall Story* was Tony Perkins's last film before *Psycho*. As the movie ends, he and Jane Fonda drive off in their trailer into (get it?) a tunnel. The next time audiences would see Perkins, it was as Norman Bates, and the engaging all-American boy was gone forever.

Even though *Tall Story* was not a box-office success, film exhibitors around the country still had high hopes for its female star. The results of their 1960 survey on the "Stars of Tomorrow":

 1. Jane Fonda
 2. Stephen Boyd
 3. John Gavin
 4. Susan Kohner
 5. Troy Donahue
 6. Angie Dickinson
 7. Tuesday Weld
 8. Fabian
 9. James Darren
10. George Hamilton

A mere seven years after this photograph, Peter Fonda would personify the counter-culture as Captain America in *Easy Rider*. Being forced to play bland young men in such pieces of tripe as *Tammy and the Doctor* would have made anyone rebel. Besides, Fonda had a much better rapport with Dennis Hopper than he did with Sandra Dee.

PETER FONDA

......

TAMMY AND THE DOCTOR
(1962)

Two years younger than his sister, Jane, Peter Fonda was born in 1939. When he was beginning to establish himself as an actor, Louella Parsons did her best imitation of Sigmund Freud and announced, "It's obvious that Peter's restlessness and inner turmoil stem from his unhappy childhood," and it is true that his formative years did not reflect a traditional upbringing. With father Henry usually off acting someplace and his mother often institutionalized (before committing suicide when Peter was eleven), from a very early age he was stuck in boarding schools or with relatives in Connecticut. Although he delighted in claiming that he didn't consider acting as a profession until the last minute, when college graduation loomed and "the family was beginning to worry about me becoming a sports car nut or a suicidal maniac," Peter had performed in prep school and at the University of Omaha. After matricula-

>
> Peter Fonda
> had a singular
> reaction to
> his first movie—
> he threw up.

CAST

SANDRA DEE, PETER FONDA,
MACDONALD CAREY,
MARGARET LINDSAY,
BEULAH BONDI, REGINALD OWEN,
ALICE PEARCE, ADAM WEST,
JOAN MARSHALL,
STANLEY CLEMENTS,
DOODLES WEAVER

......

UNIVERSAL
DIRECTED BY HARRY KELLER
SCREENPLAY BY OSCAR BRODNEY
PRODUCED BY ROSS HUNTER
CINEMATOGRAPHY BY RUSSELL METTY

tion, he followed in the footsteps of his father and sister by spending the summer at the Omaha Community Playhouse.

His emergence on Broadway came much more quickly than the rest of the family's (of course, he had both of their reputations to help him along). In the autumn of 1961, Peter starred in a military comedy written by future Oscar winners James and William Goldman, called *Blood, Sweat and Stanley Poole.* (His understudy was James Caan.) The play ran for only two and a half months, but it won for Peter a Theatre World award as one of the year's most promising stage personalities (two years after Jane had received hers) and brought about a movie deal. Producer Ross Hunter, who always had an eye out for handsome young men, came backstage and talked Peter into signing a personal contract. The following summer, Peter was on the soundstages at Universal, the first member of the clan ever to work for that studio.

• • • • • •

*T*ammy and the Doctor was the third movie about the backwoods country gal who charms everyone around her with her guileless ways and hayseed perspicacity. Debbie Reynolds originated the role in 1957's *Tammy and the Bachelor;* Sandra Dee took over four years later with *Tammy, Tell Me True* and reappeared for this final installment. Here, heart problems plague the rich old biddy played by Beulah Bondi, who in the previous film and for reasons known only to her, gave up her mansion to live with Tammy in a shack down by the riverside. MacDonald Carey is apparently the only doctor in the country who can treat Bondi's palpitations, and Tammy accompanies her to Dr. Carey's Los Angeles hospital—where she discovers his assistant, Peter Fonda.

A movie more dimwitted than *Tammy and the Doctor* is hard to imagine (even within the context of this book). It's an extremely odd mixture of the crass

THE CRITICS ON PETER FONDA

"Peter Fonda, sprig of Henry who resembles a cross between his dad and Fred Astaire, makes his screen bow. It's an unfortunately inane role for a debut, and young Fonda responds, sad to relate, with a self-conscious, artificial performance."

—*Variety*

and the profane: Peppered with bathroom humor and other lowbrowisms, the movie also features Tammy citing Scripture every chance she gets. Sandra Dee's way of communicating the supposed innocence of this flibbertigibbet is by bugging her eyes out until she looks like a thyroid case. (Debbie Reynolds at least brought some warmth to her rendition of Tammy.) The character herself is insufferable, yet everyone falls over himself to declare how charming she is. Poor Peter Fonda has the worst of it—he has to act as if he's fallen in love with her. He's not terribly convincing, but then again, even his father would probably have been stymied by a line like "You know, Tammy, you're amazing. You've lived away from the world half your life and yet there's so much worldly wisdom in that uncluttered mind of yours." So thin as to border on the anorexic, Fonda has a sylphlike quality, except when he speaks, and then he's merely stilted; he also seems much too young to have completed medical school—and what is this heart specialist doing lighting up a cigarette every few minutes? It's no wonder that, having been stuck in dross like *Tammy and the Doctor,* Fonda rebelled against conventional Hollywood moviemaking through *Easy Rider.* Thankfully, this was the last *Tammy* movie, although a 1965 television spin-off lasted one season, and in turn was reedited into a feature film.

By the late 1960s, when he was established as a Hollywood rebel, Peter Fonda claimed he vomited after seeing *Tammy and the Doctor.* Earlier in the decade, however, when he was still a young aspiring actor around town, he proffered a more measured assessment—whenever an interviewer mentioned the movie, Fonda simply changed the subject.

It wasn't long after *Tammy and the Doctor* that he ceased coming across as just another male ingenue. First there was some messy business when his best buddy was found dead of a gunshot wound, and although Fonda was exonerated of any complicity in his death, tongues wagged. As Lawrence J. Quirk put it in *Hollywood*

"He is a nice young actor, with presence and charm."
—*Hollywood Reporter*

"Fonda is lean and lanky, handsome, has boyish charm and has mastered some acting techniques. But, unless he gets more polish from more difficult films, he won't measure up to sister Jane's success."
—*Los Angeles Herald-Examiner*

"Peter Fonda as the young intern is rather colorless."
—*Films and Filming*

■ ■ ■ ■ ■ ■ ■ ■ ■ ■

Despite the less
than rapturous
reception accorded
Fonda, he never-
theless turned up in
second place in the
1963 exhibitors' poll
of the "Stars of
Tomorrow." (It was,
admittedly, not one
of the exhibitors'
more stellar lists.)

1. George Chakiris
2. Peter Fonda
3. Stella Stevens
4. Diane McBain
5. Pamela Tiffin
6. Pat Wayne
7. Dorothy Provine
8. Barbara Eden
9. Ursula Andress
10. Tony Bill

Screen Parade, Fonda "admitted that he and McDonald had cared deeply for each other, and that he had loved him as much as his wife, but in a different way." Then there was a marijuana bust—charges were later dropped—at a time when that was a big deal. Fonda was also a tireless proselytizer for the therapeutic wonders of LSD. His participation in such seminal late-60s works as *The Wild Angels, The Trip* and, of course, *Easy Rider* meant that he had embraced a Hollywood far different from his father's. One journalist reported, "Talking to Peter Fonda is like tuning in on the soundtrack of an LSD experience." You never would have guessed from *Tammy and the Doctor.*

John Forsythe

······

DESTINATION TOKYO
(1943)

John Forsythe, whose real name is John Lincoln Freund, was the son of a successful stockbroker whom he describes as "very Republican, very straitlaced, very Wall Street." (Forsythe would later recall, "Happily, my father lived long enough to see me do some rather good things, and he was very proud of me. But still, I'm the only actor in our family—and, I daresay, the only Democrat.") Intending to pursue a career in sportswriting, Forsythe studied journalism at the University of North Carolina. He dropped out after auditioning for and winning the job of stadium announcer at Ebbets Field during that wonderful (to this Giants fan) time when the Dodgers were not yet a force to reckon with. His unmistakable voice was first heard by soap opera fans some forty years before *Dynasty* when he landed jobs on such radio programs as *Stella Dallas* and *Helen Trent*. Discarding his earlier interest in the fourth estate, Forsythe decided

> You never can predict whom the public is going to embrace, and John Forsythe's first film and enduring subsequent career are a case in point.

CAST

CARY GRANT, JOHN GARFIELD, ALAN HALE, JOHN RIDGELY, DANE CLARK, WARNER ANDERSON, WILLIAM PRINCE, ROBERT HUTTON, TOM TULLY, PETER WHITNEY, WARREN DOUGLAS

······

WARNER BROTHERS
DIRECTED BY DELMER DAVES
SCREENPLAY BY DELMER DAVES
AND ALBERT MALTZ
STORY BY STEVE FISHER
CINEMATOGRAPHY BERT GLENNON

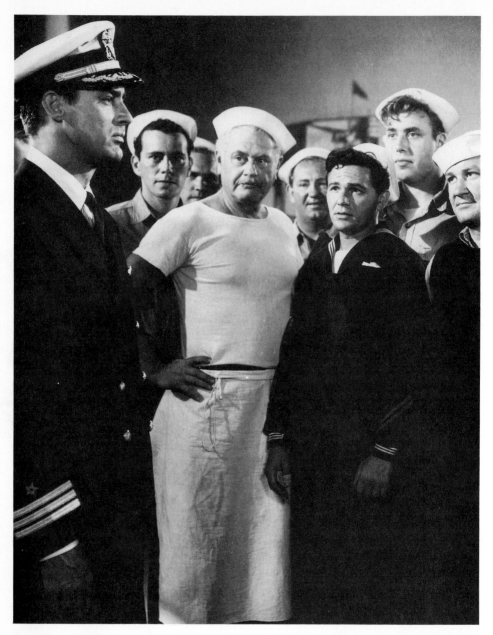

Destination Tokyo's director Delmer Daves probably told John Forsythe (second from the left) to get out of the way and stay in the background, since he was no Cary Grant or John Garfield. Nor was he one of the two other newcomers Warner Brothers was grooming for stardom. But how many people today can identify Robert Hutton or William Prince?

to pursue an acting career, even if it did mean that, between engagements, he was supporting his wife and himself by waiting tables at Schrafft's, modeling and operating an elevator.

Forsythe's first theatrical work was with a touring outfit by the name of Clare Tree Major's Children's Theatre, in a 1939 production of *Dick Whittington and His Cat* in Chappaqua, New York. It wasn't until three years later that his career took him 45 miles south to Broadway, where he briefly served as a replacement in a wartime farce called *Vickie*. During the days of the studio system, there was nothing uncommon about an actor getting a Hollywood contract after performing in a hit New York show, but Forsythe did it the hard way: He was signed by Warner Brothers after appearing in a flop that lasted three weeks (a comedy titled *Yankee Point*, in which he played a coast guard sailor).

The year 1943 was a great one for Forsythe. He had a movie contract and he became the father of a son, Dall (who would grow up to be one of the best professors I had at Columbia). At Burbank, the 25-year-old actor's first assignment was *Destination Tokyo*, another of the myriad movies made during World War II in which actors who—for whatever reason—were not in the war showed audiences the gallantry of the men who were. The film details the mission of the first submarine to infiltrate Tokyo harbor, where it must drop off three men to gather vital data the Navy needs in order to bomb the area. *Destination Tokyo* is one of the more distinguished of its genre, by and large eschewing the usual phony heroics and clichéd dialogue and, to some extent, doing away with stereotyped characters. (Still there is an off-putting piece of propaganda when Captain Cary Grant "explains" Japanese culture to a crew member: "Females are useful there only to work or to have children. The Japs don't understand the love we have for our women.")

To the critics, *Destination Tokyo* (which also starred John Garfield and Alan Hale) stood far above most other

· · · · · · · · · ·

Five pictures of Forsythe as a leading man, one from each decade from the '50s through the '90s.

Bachelor Father

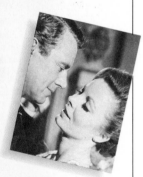

To Rome With Love

And Justice for All

films about the war. The *New York Daily Mirror*'s Lee Mortimer advised, "When you see this picture, when you live with the crew aboard the sub, when you feel the impact of undersea war at close hand, you will undergo an emotional experience which the theatre never surpassed." Philip K. Schuer of the *Los Angeles Times* was so giddy with excitement, he opined that debuting director Delmer Daves "comes through with the most brilliant and effortless directorial 'first' since Orson Welles electrified us with *Citizen Kane*." (There was no way Schuer could have known that the man he was panegyrizing would eventually make the camp classics *A Summer Place, Susan Slade* and *Youngblood Hawke*.)

Forsythe, billed 13th, plays Sparks, the sub's radio operator. Unfortunately for the actor's budding career, his screen time is kept to a minimum—whenever the other men are interacting, Sparks always seems to be perched at his radio in another area of the vessel. And while the higher-billed actors all have at least one big scene, Forsythe rarely gets a chance to say two lines in succession. Even when he engages in derring-do as part of the trio that goes ashore, it's Garfield who makes the perilous rendezvous back to the sub. Forsythe is stuck in a cave, guarding his precious radio equipment.

Much more prominent are two other actors making their film debuts, both of whom, as opposed to Forsythe, Warner Brothers was already grooming for stardom. Baby-faced, pouty-lipped Robert Hutton was cast as *Destination Tokyo*'s one walking cliché, a naive and scared young recruit named Tommy who, you know from the moment he first appears, will "become a man" in the course of the movie. He's the one whose wallet photo of a young woman turns out to be that of his sister. Hutton is so sincere it hurts. As Pills, the sub's pharmacist, William Prince gets to flex his acting muscles when, unaccustomed as he is, he must operate on the hapless Tommy, who gets appendicitis while the boat is at the bottom of Tokyo harbor. Not only is the surgery a success, but by the time it's over the atheistic

Pills has found religion. Poor Forsythe—how could talking into a radio compete with this stuff? He went without mention in the reviews, but Jack Warner must have smiled broadly when he opened the *Hollywood Reporter* and read that the names of his two new stars in the making, Hutton and Prince, "will go up in lights as a result of the hits they score in their screen debuts."

Dynasty

Forsythe made one more appearance in a Warner Brothers version of the war, Raoul Walsh's *Northern Pursuit*, and then it was on to get a look at the real thing—he was drafted into the Army Air Corps. His military experience wasn't totally removed from his previous life, however, since he ended up in *Winged Victory*, Moss Hart's traveling air corps show. He also worked with Army psychologists, helping shell-shocked soldiers who had lost their voices. Robert Hutton, meanwhile, proved popular with bobby-soxers in several wartime trifles, while William Prince was second-billed to Errol Flynn in *Objective, Burma* and also played a romantic lead to Barbara Stanwyck. After the War, Forsythe asked Jack Warner to release him from his contract; the mogul was only too happy to oblige. The actor headed back to New York, where he appeared regularly on the stage and also became a charter member of the Actors Studio. Back in Hollywood, Hutton's callow persona didn't cut it with post-war audiences, and the cerebral Prince never truly connected as a leading man; neither of their contracts was renewed by Warners.

The Powers That Be

Replacing Henry Fonda as *Mr. Roberts* in 1950 propelled Forsythe into the New York spotlight, and once again the movies beckoned, albeit not with anything too distinguished (*The Glass Web, It Happens Every Thursday*). Forsythe's heart remained with the stage, and he scored his greatest theatrical success in the 1953 Tony winner, John Patrick's service comedy, *The Teahouse of the August Moon*. Forsythe's best movie opportunity came when he starred in Hitchcock's *The Trouble with Harry* in 1955 and the following year showed up in the exhibitors' poll as one of the top 10

"Stars of Tomorrow"—only 13 years after his debut. He had appeared in live television drama as early as 1950, and in 1957 starred in his first series, the long-running *Bachelor Father*. By this time, Robert Hutton had been reduced to supporting roles in cheap horror films such as *The Colossus of New York* and producing and directing *The Slime People*. William Prince left films after William Castle's schlocky *Macabre* in 1958 and concentrated on afternoon soaps (although he took on supporting character roles in several movies of the 1970s).

John Forsythe, little more than just another body in the first movie all three made, kept on going. With five additional series after *Bachelor Father*—including his emergence as a 60-year-old sex symbol in the Reagan-era phenomenon *Dynasty*—and occasional film roles, the actor's eminent likability has served him well. He has said, "I try to be realistic about my talents. I know I'm not a great actor. I am a good journeyman actor and I always do my best, but I'm not jealous of Henry Fonda or George C. Scott or Brando because they have 'touched-by-the-hand-of-God' talent and I don't." But he is overly modest; you don't to win the favor of audiences in six decades just by being a journeyman. Robert Hutton and William Prince could attest to that.

JODIE FOSTER

••••••

NAPOLEON AND SAMANTHA
(1971)

Although Jodie has two older sisters, her brother, Buddy, was the only Foster child to precede her in show business, and it was he who, inadvertently, was responsible for her entrance into the arts. In 1966, Buddy was up for a Coppertone suntan lotion commercial and, because a three-year-old couldn't be left home alone, Jodie was dragged along to the interview. As seems to happen so often in the parturient stage of success stories, it was the unwitting Jodie who got the job. (Weep not for Buddy; he did more than his share of TV ads and appeared for three years as Ken Berry's kid on *Mayberry R.F.D.*) Thus Jodie Foster's first appearance on film consisted of having her panties pulled down by a dog. (This was also the way Patty McCormack, the inimitable Rhoda Penmark of *The Bad Seed*, started out.) Over the next five years, Foster made 57 commercials and showed up in 65 television programs.

When Jodie was eight, her mother, Brandy, laid

Jodie Foster had to compete for attention with animals, another kid performer and a second-generation Hollywood actor whose career was going nowhere.

CAST

MICHAEL DOUGLAS, WILL GEER,
ARCH JOHNSON, JOHNNY WHITAKER,
JODIE FOSTER, HENRY JONES,
MAJOR THE LION, VITO SCOTTI,
JOHN CRAWFORD, MARY WICKES,
ELLEN CORBY

••••••

BUENA VISTA
DIRECTED BY BERNARD MCEVEETY
SCREENPLAY BY STEWART RAFFILL
PRODUCED BY WINSTON HIBLER
CINEMATOGRAPHY BY MONROE P. ASKINS

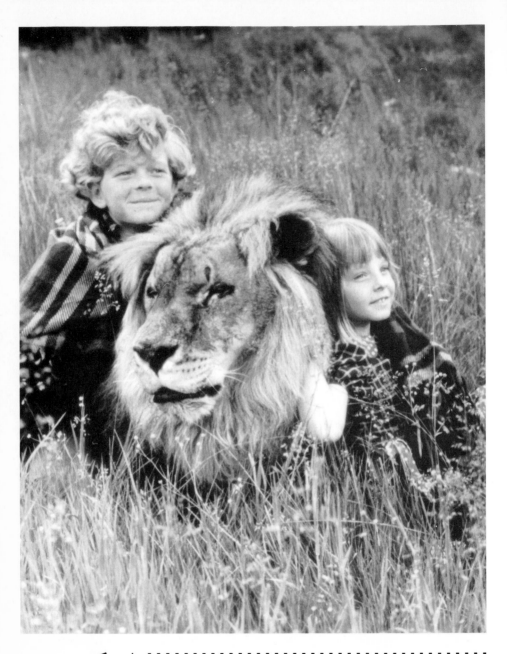

Someday Jodie Foster would costar with the likes of Robert De Niro and Peter O'Toole, but she had to start off with *Family Affair*'s Johnny Whitaker and a lion named Major. Whitaker, who would leave show business for religion in a few years, was fine to work with. The lion, on the other hand, was a very temperamental performer.

down the law: No more commercials and no more bit parts—her daughter was too good for that. She also showed she was a tough customer when it came to Jodie's finances: "I asked that she be paid $1,000 a week. In those days they were paying children $420 a week. When Jodie was offered that for a series called *Nanny and the Professor*, I said 'Absolutely not.'" Although Brandy Foster got a lot of static from the agents ("They thought I was crazy") Jodie worked steadily after the ultimatum: guest shots on *The Partridge Family* and small recurring roles on *The Courtship of Eddie's Father* and *My Three Sons*. There was also an episode of *The Wonderful World of Disney*, "Menace on the Mountain," which heralded a long affiliation between the actress and the Disney studio.

· · · · · ·

The top brass at Disney took a look at a second episode of the *Wonderful World* show featuring Foster and concluded they weren't going to waste this one on people who just sat around at home and got their entertainment for free. And so it came to pass that *Napoleon and Samantha* was presented to moviegoers. (That this mediocrity was judged to be of theatrical quality bears witness to how pitiful most entries of the *Walt Disney* anthology program were.)

Napoleon and Samantha is another in the long line of preposterous Disney movies involving animals, this one focusing on a lion, with a major supporting role played by a rooster. Johnny Whitaker (coming off a five-year run as Jody on *Family Affair)* plays Napoleon, who, because a clown wants to move to Europe unencumbered, ends up with a retired circus lion named Major as a pet. The orphaned Napoleon lives with his grandfather (a pre-*Waltons* Will Geer) and, carrying out the Disney tradition of terrifying and depressing young audiences, Grandpa keels over. Afraid of being stuck in an orphanage and having his lion put to sleep, Napoleon turns to his friend Danny (Michael Doug-

· · · · · · · · · ·

Jodie Foster remained loyal to the company that gave her her first film role. Even after she startled everyone by playing a teenage prostitute in *Taxi Driver* and receiving an Oscar nomination in 1976, she returned to Disney. As the actress said at the time, "I need children's films in my career. There's not a Martin Scorsese around every corner."

Besides *Napoleon and Samantha,* her Disney films are:

One Little Indian (1973)
Freaky Friday (1977)
Candleshoe (1978)

As genial as Major the Lion seems in *Napoleon and Samantha*, off-screen was a different story. The animal scooped Jodie up in his mouth, leaving her with a couple of prominent scars on her abdomen. Jodie's mother joked that the pair of marks "guarantees she'll never pose for pinups."

las), a reclusive "hippie" who takes care of sheep while studying for a master's degree in political science. (Having played counterculture types in failed movies aimed at his own generation—*Hail, Hero!* (page 97) and *Summertree*, Douglas was now reduced to enacting the same for kids.) Ignoring the precepts of the local health and sanitation departments, Danny agrees to bury Grandpa out in the country. But later, when the locals get to thinking that they haven't seen the old geezer around for a while, Napoleon panics and runs away with Major to hang out in Danny's lair. Afraid he won't make it on his own, Napoleon's tomboyish pal Samantha (Foster) and *her* animal friend Doodle-Do-the-Rooster accompany him.

On their way to Danny's place, they encounter the usual perils: unfriendly wild animals and a treacherous terrain. But after all their travails, Napoleon and Samantha learn that Danny doesn't want to be saddled with a couple of kids. Following some nonsense with an escapee from the local mental hospital, Samantha is returned home, Major becomes a ward of the state, and Napoleon is thrown into the dreaded orphanage. Talk about a happy ending.

Napoleon and Samantha is another of those aggressively cute, artificial and condescending movies to which children have been subjected for years. It's no surprise that screenwriter Stewart Raffill's background was as an animal trainer because, on the evidence here, he has little grasp of how human beings function. (Actually, the behavior of the animals in the film also far exceeds the bounds of believability. Raffill later became a director, but such works as *Adventures of the Wilderness Family* and *Mannequin Two: On the Move* indicate that he never did get a handle on people.) If the movie is noteworthy for anything, it's the decidedly minor fact that Michael Douglas's character marks the first time in a Disney movie in which a long-haired—relatively speaking—youth is presented in a positive light instead of being caricatured for supposed comic effect; in fact,

although you never believe his odd amalgam of character traits, Douglas is quite ingratiating. The film also contains a number of first-rate character actors (Henry Jones, Mary Wickes, and Ellen "Grandma Walton" Corby) all of whom, unfortunately, are stymied by the stock roles they play.

The best thing about *Napoleon and Samantha* is its two young stars: Both Jodie Foster and Johnny Whitaker have a gravity of purpose that goes far beyond their years. They are those rare creatures, child actors who seem like real children, even as their characters are behaving in a way no actual kids ever did. Foster especially, with her solemn demeanor, conveys a maturity and intelligence that seem positively prescient in a nine-year-old, and she uncannily communicates the fact that, although children's problems may seem trivial to adults, they are very weighty to the ones experiencing them. Her initial piece of dialogue is "Ouch, I bumped my knee," in a scene where she's playing Indians with Whitaker, and in the course of the film she also gets to administer her first screen kiss—a peck on the cheek to which her leading man is not terribly responsive. One's heart goes out to Foster because she has to make the Incredible Journey to Danny's place, not in sensible jeans but in a party dress. The moment that best vaticinates the no-nonsense quality that would become a Foster trademark occurs after Whitaker waxes poetic about Life and Death, i.e., "My Grandpa's free to do what he wants to now . . . nobody ever really dies because the thing that's real inside of you goes on and on forever and ever." To which Jodie off-handedly responds, "I think that's very beautiful Napoleon," before hitting him with "But who's gonna look after you?"

Jodie Foster later had reunions at the Oscars with her two leading men from *Napoleon and Samantha*. She and Johnny Whitaker—with whom she also costarred in a musical version of *Tom Sawyer*—sang a nominated song from Disney's *Robin Hood* cartoon at the 1973

Napoleon and Samantha, surprisingly enough, has a place in the records of the Academy Awards. For reasons known only to the members of the Academy's music branch, Buddy Baker's insistently perky music was nominated as the Best Original Dramatic Score of 1972. (It lost to the score of Charlie Chaplin's *Limelight.*)

THE CRITICS ON JODIE FOSTER

"Jodie Foster is appealing as Samantha."

—*Variety*

"For my dough Miss Foster could steal a scene from a happening train wreck. She's a quizzical delight."

—Charles Champlin, *Los Angeles Times*

awards. Eighteen years later, Michael Douglas handed Foster the statuette when she won her second Academy Award for *The Silence of the Lambs.*

After *Napoleon and Samantha,* Jodie Foster spent her childhood and adolescence in a wide assortment of television and cinematic endeavors. One of her more curious roles was in a Saturday-morning cartoon version of the *Addams Family:* She provided the voice, not of Wednesday, but of Pugsley. In 1974, Foster appeared in a TV version of *Paper Moon.* The general consensus was that she was no Tatum O'Neal. How little we knew.

JUDY GARLAND

PIGSKIN PARADE
(1936)

She was born Frances Ethel Gumm in 1922. Her parents were small-time vaudevillians, and though their names were Frank and Ethel Gumm and they came from Midwestern stock, they toured as Jack and Virginia Lee, Sweet Southern Singers. The two older Gumm girls, Mary Jane and Virginia (seven and five years older than Frances), were put into an act of their own, and they kept at it even after their parents gave up on passing for Dixie minstrels so that Mr. Gumm could run a theater in Grand Rapids. Judy Garland frequently told her version of her theatrical debut: Impishly running onstage during her sisters' act, she burst into "the only song I knew, 'Jingle Bells.' I sang five choruses before Daddy carried me offstage, kicking and squealing." Her spontaneity makes for a good story, but that's all it is—in actuality, her premiere

CAST

STUART ERWIN, PATSY KELLY,
JACK HALEY, JOHNNY DOWNS,
BETTY GRABLE, ARLINE JUDGE,
DIXIE DUNBAR, JUDY GARLAND,
ANTHONY [TONY] MARTIN,
FRED KOHLER, JR.,
ELISHA COOK, JR., EDDIE NUGENT,
GRADY SUTTON,
THE YACHT CLUB BOYS

• • • • • •

20TH CENTURY-FOX
DIRECTED BY DAVID BUTLER
SCREENPLAY BY HARRY TUGEND,
JACK YELLEN AND WILLIAM CONSELMAN
STORY BY ARTHUR SHEEKMAN,
NAT PERRIN AND MARK KELLY
PRODUCED BY BOGART ROGERS
CINEMATOGRAPHY BY ARTHUR MILLER

Louis B. Mayer liked another kid better.

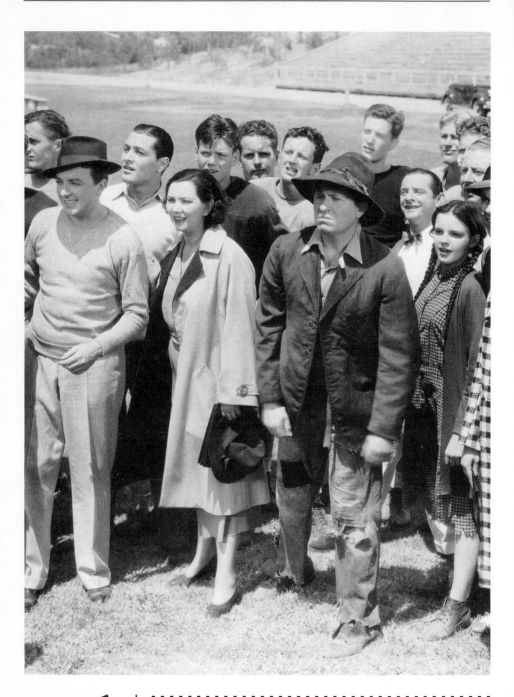

Judy Garland seems fascinated by football practice, as do Jack Haley, Patsy Kelly and Stuart Erwin. Judy's braids, torn gingham dress and lack of socks indicate her character's hillbilly origins.

appearance had been heralded a few days earlier in a newspaper advertisement announcing the program's bill.

The family upped and moved to Lancaster, California, in 1927, where the Gumm patriarch operated a movie theater. The two older girls enrolled in school, but Baby Frances went to work, joining a traveling bevy of child performers called the Meglin Kiddies; the five-year-old's solo number with the troupe was "I Can't Give You Anything but Love, Baby." A theatrical agent was impressed by her rendition and thought her sisters must be equally talented. He urged the parents to yank the girls from school and put them on the road again. Originally, Mary Jane and Virginia joined Frances in the Meglin group—with which they appeared in occasional film shorts—but then the trio branched out on its own. Their official stage name was the Gumm Sisters Kiddie Act, with Frances receiving special billing as "the little girl with the great big voice"; she also occasionally made the rounds as a solo act.

Then there was the matter of that name. This is another instance of Garland's either having a faulty memory or just concocting a tall tale. Her version was that the marquee of a Chicago theater advertised them as The Glum Sisters. The tearful girls protested to George Jessel, who was also on the bill. He said Gumm wasn't much of an improvement, but, remarking to Frances that she was "as pretty as a garland of flowers," suggested they take that as a surname. The truth: In his book *Rainbow,* Christopher Finch quotes Virginia explaining that as a last-minute replacement at Chicago's Oriental Theater, they weren't even on the marquee. Inside the auditorium,

> Jessel introduced us as the Gumm Sisters and the audience broke up. We got a big laugh. I think he thought we were a comedy act, because he really punched the name. Well we came on and we weren't funny—but we stopped the show. . . . [Jessel] was horrified because he had introduced us and gotten a laugh, and he said, "You have to change your name." Heck—Gumm wasn't funny to us! We said, "To

Judy Garland, on attending a preview and seeing herself in *Pigskin Parade:* "It was the most awful moment in my life. I was frightful. I was fat—a fat little pig. My acting was terrible."

what?" And he said, "I don't know. I'll do it." Between shows he got a long-distance call from [drama critic] Robert Garland. We were standing in the wings for the third show and he introduced us as the Garland Sisters. . . . And it didn't get a laugh, so we just kept it.

Finch also points out that the Glum Sisters incident *did* occur, but it happened in Milwaukee, not Chicago, and after they had already determined that they would change the name of the act. And, "far from being horrified, they thought this was a wonderful joke and even took a photograph—since lost—to commemorate the occasion." The girls' act became more polished, and audience response improved accordingly; although vaudeville was pretty much dead by this point, movie palaces often had live shows to accompany film showings, and the Garland Sisters played many important venues. A year after the rechristening, the act was reviewed by *Variety*, whose critic said, "As a trio, it means nothing, but with the youngest Frances, 13, featured it hops into class entertainment; for if such a thing is possible, the girl is a combination of Helen Morgan and Fuzzy Knight [a cowboy sidekick whose forte was comedic stuttering] . . . gets every note and word over with a personality which hits audiences. Nothing slow about her hot stuff, and to top it off she hoofs. Other two sisters merely form a background." The writing was on the wall, and Mary Jane and Virginia didn't need a seeing-eye dog; fortunately, two fiancés showed up on the scene, allowing them to bow out gracefully. Before leaving, however, all three girls appeared in a swan-song movie short, *La Fiesta de Santa Barbara*, which was nominated for an Academy Award in a category that no longer exists, Best Color Short Subject. Having changed her first name as well, Judy Garland was now on her own.

The period between becoming a solo act and getting a movie contract was brief but unhappy for Garland. She sometimes grew so fearful of adverse audience reaction that she'd stand trembling in the wings unable

to move, with Mrs. Gumm chewing her out in front of everyone. Strolling down Memory Lane years later, Garland said, "My mother was truly a stage mother, a mean one. . . . If I didn't feel good she'd say, 'You go out there and sing or I'll wrap you round the bedpost.'"

There are at least two dozen different accounts of the way Judy Garland ended up at MGM. This much is known: Somebody (producer Joseph L. Mankiewicz? agent Al Rosen? songwriter Harry Akst? songwriter Lew Brown? arranger Roger Edens?) saw her performing somewhere (a Lake Tahoe club? a Hollywood theater?) and, duly impressed, called somebody at Metro (producer Arthur Freed? Roger Edens? Ida Koverman, Louis B. Mayer's executive secretary? music publisher Jack Robbins? a combination of the above?), who grudgingly agreed to have her come in. Once the mystery host heard the girl, he or she pestered Mayer to take a listen. Garland sang "Zing Went the Strings of My Heart" to the studio head, and although he much preferred operetta to swing, he was so impressed that he either (a) agreed to give her a screen test, which was successful, or (b) agreed to sign her right there and then.

In whatever way it happened, on September 27, 1935, 13-year-old Judy Garland signed a contract with MGM. For months, though, the studio didn't seem to know what to do with her other than have her make radio appearances and perform at industry functions. A year later, when her second contract renewal was up for consideration, Mayer told the head of his short subject department to put together a one-reeler so that he could at least see how Garland came across on screen. And Mayer told the producer that while he was at it, he should also throw in another singing 14-year-old who was idling at the studio, Deanna Durbin. The end result was *Every Sunday,* in which the two girls sing a duet at a small-town bandstand, Garland singing hep, Durbin trilling away like a crazed, pint-sized Jeanette MacDonald. Mayer liked Garland, but he loved Durbin and was roiled to learn that before the lawyers had

ALL GROWN UP

Judy Garland in her final film, *I Could Go On Singing* (1963).

gotten around to renewing her contract, she had bolted
for Universal. Needing a musical teenager on call, MGM
had no choice but to keep Garland. There was still the
question of how to use her services, but before an an-
swer could be found, another company came looking for
her. Thus Judy Garland began her feature film career at
20th Century-Fox, not MGM.

Garland may not have been the most sophisticated
girl in Hollywood, but playing a goofy young hillbilly
was a bit extreme. Darryl F. Zanuck, the head of Fox,
had two weaknesses when planning his production
slate: movies about horses and college musicals. *Pigskin
Parade* did not have steeplechases. The ads promised
"Merrier than *Thanks a Million*! Swingier than *Sing
Baby Sing*!," so 1936 audiences had fair warning that
they weren't going to be getting another *The Informer*.
How's this for a plot: Looking for a football opponent
who will be a draw at the gate but whom the Bulldogs
can beat—and thus boost their confidence for that all-
important upcoming Harvard game—the Yale admin-
istration decides on the University of Texas. A clerical
error results in the invitation going to Texas State
University, an institute of higher learning so podunk
that even its new coach, Jack Haley (hired because he
steered a Flushing, Queens, high school to a successful
season), had never heard of the school. (Somebody at
Fox didn't know much about Yale—women are shown
going to classes at a time when that would have been a
sacrilege.) TSU takes up the challenge, but then the
coach's wife, Patsy Kelly, has to go and get drunk at a
pep rally, tackles the quarterback and breaks his leg.
(Remember when inebriation was considered a prime
source of hilarity?) A dire situation has become hope-
less, until Kelly stumbles across a hayseed (Stuart
Erwin) with the gift of being able to throw watermel-
ons ninety yards. Despite his illiteracy, he is made a
student in good standing, with his sister (Judy
Garland) joining him on campus. Erwin learns the
finer points of the gridiron while Garland shakes off

some of her country bumpkin ways by soaking up the comparatively cosmopolitan environment of the TSU campus.

Garland's contribution to *Pigskin Parade* is secondary, a small role in which her lack of guile provides comic moments, as well as occasional simple-hearted sagacity. Also thrown in are a couple of college romances, between Johnny Downs and Arline Judge, and Tony Martin and a prestardom Betty Grable. There are nine songs, which I doubt anyone has heard outside of the confines of this movie in close to 60 years. (Several are performed by an outfit called the Yacht Club Boys, who, joined by Alan Ladd, vocalize about the joys of spending six years in freshman class and come across as precursors to those marvelously bland '50s pop groups like the Four Preps, the Four Freshmen and the Four Aces). Everything leads up to the game in New Haven, and since there were many more Americans who could relate to a rural rube than to elite Ivy Leaguers, Erwin leads the team to victory. Directed by David Butler, an unobtrusive assembly-line moviemaker whose greatest asset was bringing his projects in on time and on budget, *Pigskin Parade* is thoroughly nonsensical, but in its cheerful silliness it's more entertaining than it has any right to be. As the *New York Times*'s Frank S. Nugent enthused, the film "moves down the entertainment field with gusto and eclat, emerging as a genuinely funny burlesque . . . one of the season's most entertaining contributions."

Judy Garland's Arkansas yokel-ese is laid on a bit thick, and it sometimes comes and goes. If Garland's backwoods accent is somewhat overdone, so was her physical appearance: She was unflatteringly coiffed with braids, costumed in a ratty gingham dress and made to go barefoot, and the Fox makeup department thought it could turn her into more of a hick by covering her face with painted freckles. The actress is unseasoned, rough around the edges and on the slightly pudgy side. Nevertheless, Garland does have an undeniable sweet-

THE CRITICS ON JUDY GARLAND

Garland's "striking personality is brightly projected in song and scores for an exceptionally interesting comedy character in the role of Stuart Erwin's country sister."
—*Daily Variety*

". . . Judy Garland, about 12 or 13 now, about whom the West Coast has been enthusing as a vocal find. The [film] has now crystallized all the promise in definitely catapulting this youngster to the fore. She's a cute, not too pretty but pleasingly fetching personality, who certainly knows how to sell a pop song."
—*Weekly Variety*

ness and a winning enthusiasm, especially when singing her three songs, one ballad ("It's Love I'm After," addressed to Tony Martin, which was no "The Boy Next Door") and two upbeat numbers ("The Balboa" and "The Texas Tornado," neither of which would ever be mistaken for "The Trolley Song" or "On the Atchison, Topeka and Santa Fe"). When Garland is vocalizing, all traces of hillbilly speech disappear.

While Judy Garland was killing time in *Pigskin Parade,* Deanna Durbin starred in an extraordinarily popular movie called *Three Smart Girls.* The girl that got away from MGM was credited for almost single-handedly rescuing Universal from bankruptcy. Louis B. Mayer must have been kicking himself.

RICHARD GERE

······

REPORT TO THE COMMISSIONER
(1974)

Richard Gere is one of those charmed actors whose early career was a rising curve as, due to luck, talent and looks, he steadily ascended from college shows to repertory theater to the New York stage and then to movies. A philosophy major who acted in campus productions at the University of Massachusetts, Gere dropped out after his sophomore year. His first professional theatrical work was at the Provincetown Playhouse, where he spent a summer performing in six plays that ran two weeks each; his salary was $28.70 a week, which even in 1969 dollars was not a hell of a lot. The director of the playhouse also designed sets at the Seattle Rep, and thanks to his letter of introduction Gere left school and spent a season in the Pacific Northwest.

Heading back east, Gere eschewed acting to perform in a rock band in Vermont; he was quoted as saying (though later denied it) that with hair

Richard Gere's first motion picture effectively killed a budding film career.

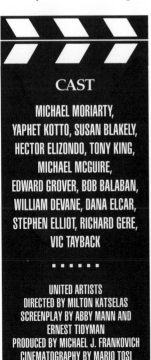

CAST

MICHAEL MORIARTY, YAPHET KOTTO, SUSAN BLAKELY, HECTOR ELIZONDO, TONY KING, MICHAEL MCGUIRE, EDWARD GROVER, BOB BALABAN, WILLIAM DEVANE, DANA ELCAR, STEPHEN ELLIOT, RICHARD GERE, VIC TAYBACK

······

UNITED ARTISTS
DIRECTED BY MILTON KATSELAS
SCREENPLAY BY ABBY MANN AND ERNEST TIDYMAN
PRODUCED BY MICHAEL J. FRANKOVICH
CINEMATOGRAPHY BY MARIO TOSI

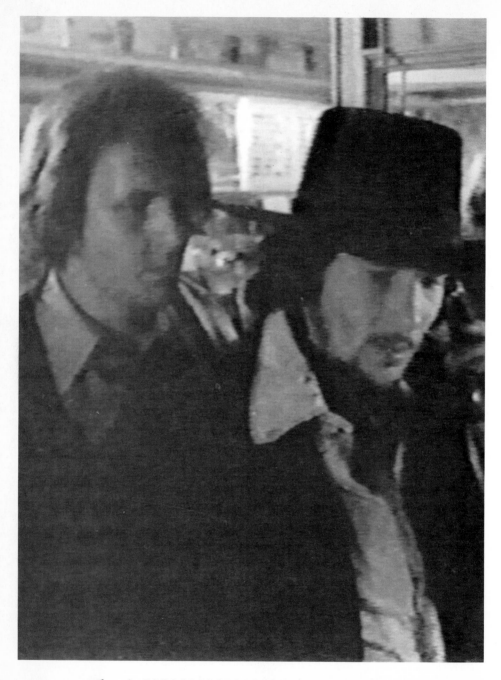

Although Richard Gere only had three scenes in *Report to the Commissioner,* he got the last laugh. He's had a long and successful film career; the movie's star, Michael Moriarty, has not.

below his shoulders, he looked like Rita Hayworth. New York was next, and although he was quickly cast in a Broadway show, he hardly took Broadway by storm. Up through the mid-1970s, producers doggedly tried to duplicate the runaway success of 1968's "American tribal love-rock musical," *Hair,* and by the time it was all over, Broadway was littered with the carcasses of *Dude, Via Galactica* and, most ludicrously, *Rockabye Hamlet.* Gere's encounter with the "rock opera" genre was in *Soon,* a Mickey-and-Judy update about some kids coming to New York to make it as musicians. Opening in January 1971, it hung around for only three performances; also enduring this fiasco were Peter Allen, Barry Bostwick, Nell Carter and Vickie Sue Robinson, who, although she wouldn't have much of a career, did achieve disco immortality five years later with "Turn the Beat Around." That same year, Gere appeared in an Off-Broadway tribute to dead folksinger and writer Richard Farina, and in 1973 he played the lead role in the London production of *Grease.*

· · · · · ·

I n 1974, Gere signed for his first film; not yet a star but a respected and frequently employed theater actor, he would have only a small role in *Report to the Commissioner.* The movie was intended to showcase an actor who had already conquered Broadway—Michael Moriarty, poor guy. Having first attracted media attention—although not much of an audience—in 1973's baseball weepie *Bang the Drum Slowly,* Moriarty won stupendous reviews and a 1974 Tony Award (defeating Jason Robards, Zero Mostel, Nicol Williamson and George C. Scott) as a hustler involved with a married man in *Find Your Way Home.* Now it was time to make Moriarty a movie star. Moriarty, however, chose unwisely for his post–toast of Broadway showcase vehicle.

Report to the Commissioner was one of the last and least of the 1970s cycle of cop movies that flooded the

• • • • • • • • • •

Sex for money has played a prominent part in Richard Gere's career. A pimp in his movie debut, he portrayed a hustler in his first successful star vehicle, *American Gigolo,* and played a john in his biggest hit, *Pretty Woman.* Prostitution has been his good-luck charm (or maybe it's actor Hector Elizondo, who's appeared in all three of these films).

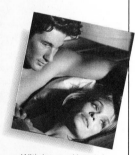

With Lauren Hutton in
American Gigolo.

With Julia Roberts in
Pretty Woman.

marketplace after *The French Connection.* (Besides *Serpico,* there were such now-forgotten titles as *Busting, The Seven-Ups* and *Badge 373.*) The baby faced Moriarty portrays the most naive cop in the history of the NYPD, delivering his Dead End Kid accent in such a laid-back manner that he seems either stoned or catatonic. In a plot that relies on each character's behaving in the stupidest manner imaginable, Richard Gere, 12th-billed (right above Vic Tayback) and appearing in three scenes, emerged unscathed as a Times Square pimp named Billy. Decked out in an open silk shirt, medallions, a suede jacket that has swaths of leather on the upper back and a gaucho hat, and sporting a goatee and mustache, Gere oozes sleaze. In his first scene, he's sitting in a coffee shop with several of his "girls" and is approached by Moriarty, who, looking for an undercover cop he thinks is a young runaway, asks, "Excuse me. Can I talk with you?" To which Gere sneers, "Very well," and then snorts with derision. As written, it's a standard pimp role—a prevalent cliché at the time, although one usually played by a black actor—but Gere does a nice job of imbuing the pimp with a subtle haughtiness that shows a smug self-satisfaction at being the king of his own little world. He maintains his contemptuousness when he gets Moriarty to shell out for a hooker, claiming she's the woman the cop is seeking, and remains unperturbed even when Moriarty pulls a gun on him. Only when the enraged policeman pulverizes the pimp does Gere allow the arrogance to crumble from the character. After that, he's out of the picture. Given the small size of his part, Gere hardly figured in reviews of *Report to the Commissioner,* but *Variety* did mention "Richard Gere very good as a smalltime pimp."

Gere's next movie, *Baby Blue Marine* (in which the lead, Jan-Michael Vincent, was again a "promising young actor" who never quite met expectations), found him with a completely different look; he portrayed a discharged World War II soldier who, because of shell

shock, has a head of completely white hair. It wasn't until he played one of Diane Keaton's pickups in his third released film, *Looking for Mr. Goodbar,* that Gere was declared an exciting new film personality and a bona fide sex symbol.

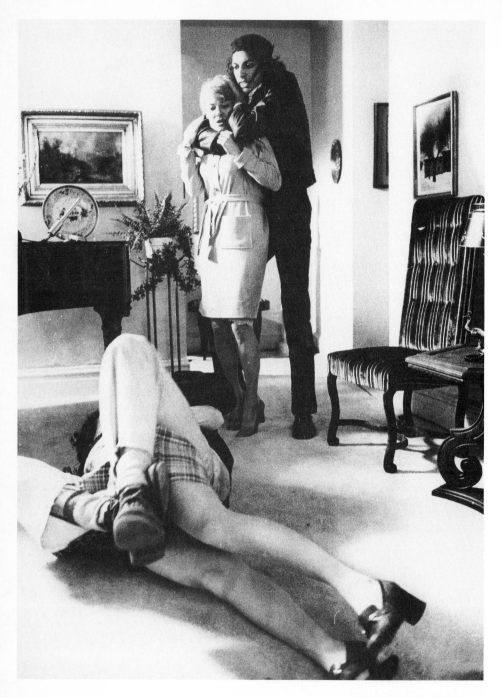

In one of the most unpleasant screen debuts ever, Jeff Goldblum goes through his paces robbing, raping, sodomizing and murdering.

JEFF GOLDBLUM

......

DEATH WISH
(1974)

Jeff Goldblum's performing career came about so effortlessly that he can serve as inspiration for aspiring young actors. The closest the Pittsburgh native got to college was a session in the Carnegie Mellon University drama program, which he attended instead of taking a summer job. With his parents' blessing, he headed to New York immediately after high school in 1970 and studied with Sanford Meisner at the Neighborhood Playhouse. Within a year, he had his first stage role, appearing in the musical version of *Two Gentlemen of Verona* at the New York Shakespeare Festival. Granted, he only played a guard, and by his own admission probably was cast simply because he was tall, but still, there he was at age 18 working for Joseph Papp. The actor's next appearance was as a high-strung piano player in *El Grande de Coca Cola,* a hit musical revue set in a banana republic nightclub.

CAST

CHARLES BRONSON, HOPE LANGE,
VINCENT GARDENIA,
STEVEN KEATS, WILLIAM REDFIELD,
STUART MARGOLIN,
STEPHEN ELLIOTT,
KATHLEEN TOLAN,
OLYMPIA DUKAKIS

......

PARAMOUNT
DIRECTED BY MICHAEL WINNER
SCREENPLAY BY WENDELL MAYES
PRODUCED BY HAL LANDERS,
BOBBY ROBERTS AND MICHAEL WINNER
EXECUTIVE PRODUCER:
DINO DE LAURENTIIS
CINEMATOGRAPHY BY ARTHUR J. ORNITZ

Jeff Goldblum could easily have been typecast as the kind of person who enjoys kicking the hell out of nice, middle-aged white ladies.

A casting agent thought Goldblum's manic energy befitted a psychopathic killer and invited him to audition to play same. And so Jeff Goldblum was cast in the first movie he ever auditioned for.

Death Wish was a *cause célèbre* in 1974 (*Newsweek* called it "the most controversial movie since *The Exorcist*"). A film taking the view that American cities would again belong to "decent people" if only urban dwellers stopped being such wimps and fought back against muggers was bound to engender discussion. If nothing else, *Death Wish* is notable for being the only Charles Bronson movie to become a topic of conversation at New York cocktail parties.

Goldblum is one of the three baddies who sets things in motion, playing a character listed in the credits as Freak Number 1. Sporting the type of beanie favored by the young Leo Gorcey, he first turns up in a D'Agostino's supermarket, engaging in monkey business like opening a bag of chips while Hope Lange, as Bronson's wife, and her daughter, Kathleen Tolan, go about their shopping. Goldblum and his two pals get the women's address from a delivery slip and enter their Riverside Drive building through the service entrance. Goldblum's first screen line is "Shit, man. Got business," admonishing one of his buddies, who is spray-painting the stairwell wall. Once inside the apartment, their crime is much more serious than shoplifting at the supermarket. In a genuinely unpleasant scene, Goldblum, enraged because the women only have $7.25 between them, slaps and then kicks Lange, growling "Goddamn rich cunts! I kill rich cunts!" And he makes good on his word. Goldblum forces the daughter to perform oral sex; to that end, the actor joins the elite circle of actors who moon the audience in their first film. The three goons turn tail, leaving behind one corpse and one vegetable. That's it for Goldblum in the film, as he checks out with a little over five minutes of screen time. It's a thoroughly frightening performance, although less so today, now that we know this monster

is in reality the affable Jeff Goldblum and not some actual lowlife the casting director found on the sidewalks of New York.

Strong pro- and anti-*Death Wish* camps stood up to be counted, treating it not as a movie but as a social statement. Only Molly Haskell at the *Village Voice* and her husband and fellow *Voice* critic, Andrew Sarris, stayed cool enough to assess the movie for what it was. Haskell chuckled in print, "If it were even remotely realistic it would be intolerable but . . . [it] is so patently unconvincing as to make the payoff an irresistibly entertaining exercise in backlash titillation." Sarris made note of "the central credibility problem in *Death Wish*—the casting of Charles Bronson in anything but a primitive form of life on this planet."

Reviewers did not specifically cite Jeff Goldblum, or any of the actors playing his fellow villains, other than to note that the filmmakers took pains to have a cross section of white, black and Latino muggers, lest they be accused of racism. Even before *Death Wish* was released, Goldblum scored another career boost when, because of a blizzard, Robert Altman couldn't travel from his hotel to the Broadway show for which he had tickets, and instead walked across the street to the Plaza Hotel, where *El Grande de Coca Cola* was ensconced. Impressed by Goldblum's performance, he offered him a part in *California Suite,* which in turn led to a more important role in a more important Altman movie—the mysterious silent motorcyclist in *Nashville.*

In 1976's *St. Ives,* Goldblum again played a hood in a Charles Bronson movie, but then he emerged with an altogether different persona. Paul Mazursky's *Next Stop, Greenwich Village* that same year and 1977's *Between the Lines* and *Annie Hall* (in which, as a party guest, he had one unforgettable line: "I forgot my mantra!") earned him cult status as an expert interpreter of neurotic intellectualism. He attempted to shuck that image by buddying with Ben Vereen in a 1980 cop show, but *Tenspeed and Brownshoe,* lasted only 13 weeks and

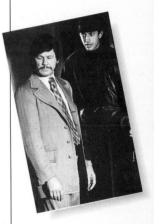

Jeff Goldblum was in a temporary career rut—here it is two years after *Death Wish* and he's still playing a creep in a Charles Bronson film, *St. Ives* (1976).

slowed down his career momentum. Then in 1983, the one-two punch of *The Big Chill* and *The Right Stuff* made Goldblum the leading character actor of the moment, and David Cronenberg's 1986 remake of *The Fly* turned him into a star. More often than not, however, Goldblum has used his leading-man status to make almost defiantly noncommercial films, as if he had a death wish for his career: None of his starring roles in *Fathers and Sons, Mister Frost, The Tall Guy* and *The Favor, the Watch and the Very Big Fish* had nearly the impact of his five minutes in *Death Wish*.

MELANIE GRIFFITH

······

NIGHT MOVES
(1973)

Born in 1957, Melanie Griffith is the daughter of Tippi Hedren, the model who gained a permanent place in the pantheon of film when Alfred Hitchcock selected her to star in *The Birds* and *Marnie*. For Griffith, the down side of having a mother who was a movie star was that Mom's mentor had a perverse take on the world: When Griffith turned six, she opened a birthday present from Hitchcock and instead of a doll found a likeness of her mother in a miniature coffin. The up side was that when Griffith as a teenager visited her mother on the set of a movie, she met a really cute guy who was in the picture, and he liked her, too. Doing publicity during her first year in films, Melanie made sure everyone knew she had lost her virginity at age 14 to Tippi Hedren's 22-year-old costar in *The Harrad Experiment*, Don Johnson. In the mid-1970s, it was *de rigueur* to reveal these things, so it was perfectly natural for Johnson, whom she moved in

CAST

GENE HACKMAN,
JENNIFER WARREN,
SUSAN CLARK, EDWARD BINNS,
HARRIS YULIN, KENNETH MARS,
JANET WARD, JAMES WOODS,
ANTHONY COSTELLO,
MELANIE GRIFFITH

······

WARNER BROTHERS
DIRECTED BY ARTHUR PENN
SCREENPLAY BY ALAN SHARP
PRODUCED BY ROBERT M. SHERMAN
CINEMATOGRAPHY BY BRUCE SURTEES

············

When we first saw Melanie Griffith, she was a little teenage sexpot.

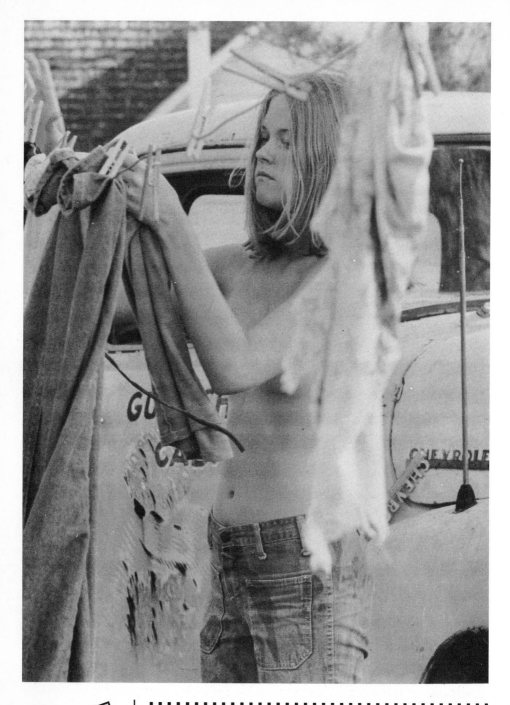

A topless, sixteen-year-old Melanie Griffith is about to catch the attention of detective Gene Hackman and the audience.

with at 15, to tattle to *People,* "Melanie assures me she was one of the last of her group to experience, shall we say, all the joys of life."

Griffith was all of nine months old when she acted in her first television commercial. She was 16 when she finally experienced the joys of feature films, and that only came about because of a misunderstanding. Having taken up modeling, she received a call from Warner Brothers and figured it was for some kind of fashion shoot at the studio. As she told David Galligan of *Drama-Logue,* "I went there and they said, 'This is for a lead in a movie.' And I said, 'Thank you very much but no thank you. I'm going to get out of here.' They said, 'Wait, wait, Arthur Penn wants to meet you.' So I went home and Don said, 'What? Are you crazy? You're not going to meet Arthur Penn? Are you out of your mind?'"

Griffith, who had been recommended by a friend, returned and won the part of Delly in *Night Moves,* a precociously sexual Beverly Hills teenager who runs away from her indifferent, alcoholic mother (an ex-starlet who married well), going from man to man until she ends up in her stepfather's bed. Gene Hackman stars as Harry Moseby, a former football pro who is now a private eye hired to retrieve her. This being detective fiction, much more was involved than scooting a teen back to her home, and Moseby unearths a ring of smugglers shipping priceless pre-Columbian art from Mexico. This being an Arthur Penn movie, much more was involved than a labyrinthine mystery plot; the director of *Bonnie and Clyde* and *Alice's Restaurant* was capable of capturing the wounded American psyche of the 1960s and '70s as incisively as any filmmaker. Accordingly, although the plot does hold our interest, it is as a mood piece drenched in melancholia that *Night Moves* is particularly riveting. It is a resonant, heartbreaking movie about disillusionment and lost dreams and hopes, easily one of the most important works of the 1970s.

In Melanie Griffith's Delly, actress and character combine into a provocative mixture of wide-eyed inno-

In her initial appearance in *Night Moves,* Melanie Griffith matter-of-factly showed her breasts, which was part of the reason that the National Catholic Conference (formerly the Legion of Decency) slapped its once-feared, by-now-toothless Condemned rating on the film. Old habits are hard to break, and in more than half of her movies since then, Griffith has been similarly exposed:

Smile (1974)

Joyride (1977)

Body Double (1984)

Fear City (1985)

Something Wild (1987)

Stormy Monday (1988)

Working Girl (1988)

Shining Through (1992)

cence and raw carnality, as expressed physically by the actress's chubby-cheeked little girl's face on a woman's body. Griffith enters *Night Moves* 33 minutes into the film, and the first time we see her she glances across the yard to see whether Moseby, this man she doesn't know, is checking her out as she changes shirts, taking a clean one off the clothesline to cover her breasts. "Hi," is her first line, and after Harry answers in kind, she continues with a stream-of-consciousness monologue: "Been down here before? Pretty funky. There's been some great storms. Feels like everything's gonna blow away. I really like that feeling, you know." She later tries to seduce Moseby, and yet she also needs him as a father figure. But when he tries to comfort her after a particularly traumatic experience, the best he can muster is "Listen, Delly, I know its doesn't make much sense when you're 16. Don't worry. When you're 40, it isn't any better." That's the movie in a nutshell. Griffith's performance may not be a great piece of acting—her voice is too tremulous and self-consciously hesitant—yet she's ideally cast and convincing in the role of a girl who, though precocious, tragically is not nearly as sophisticated and knowing as she thinks.

Night Moves wrapped shooting a couple of days after Christmas 1973, but once postproduction was completed, it inexplicably sat on the shelf for a year. The movie played at L.A.'s Filmex festival in the spring of 1975 but wasn't released until June, unluckily opening the same day as *Nashville,* a rather more heavy-handed exploration of many of the themes of *Night Moves,* whose publicity juggernaut cut down everything in its path. Much of the press was confused because *Night Moves* didn't tidily wrap up its mysteries, and then there were those like Vincent Canby of the *New York Times,* who complained, "Harry is much more interesting and truly complex than the mystery he sets out to solve." A few observers caught on that this was what was intended.

While her debut movie was gathering dust, Melanie Griffith appeared in two more films. She played

Miss Simi Valley in *Smile,* the noisome "satire" about beauty pageants (another film that did time on the shelf) and appeared as another nymphet in another detective movie, *The Drowning Pool.* Thanks to the vagaries of film releasing, all three opened within weeks of each other and Griffith received a flurry of publicity, including a profile in *Newsweek* that revealed she had a tattoo of a pear on her rear end (that fruit being her nickname for Johnson, to whom she was married, briefly, in 1976). Despite the prognostications of stardom, Griffith became mired in B movies and televised drivel, largely due, she would later admit, to her twin addictions to drugs and alcohol. At age 23, she stumbled into the path of a car on Sunset Boulevard and was almost killed. After a long recuperation, she became more resolute about her career, moved to New York and studied with Stella Adler. Her work for Brian De-Palma in 1984's *Body Double* brought her a Supporting Actress award from the National Society of Critics, and Jonathan Demme's 1987 cult favorite *Something Wild* cemented her critical reputation. Griffith topped off her resurrection with Mike Nichols's *Working Girl* in 1988, complete with Academy Award nomination. And further harking back to the time when stardom was first predicted for her, she remarried Don Johnson.

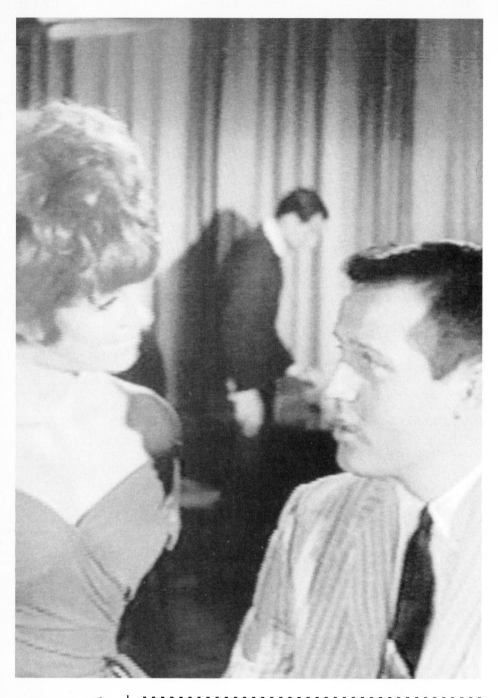

The callow Charles Grodin is about to find out about "sex and the college girl" from co-ed Julie Sommars.

CHARLES GRODIN

·······

SEX AND THE COLLEGE GIRL
(1964)

Grodin went to college to study acting and stayed for one whole semester; as he later put it, "I attended the University of Miami (briefly but honorably)." He returned to his hometown to continue his study; he claims, "I never could get it together at the Pittsburgh Playhouse. I was the only person there who wasn't allowed to direct a student one-act play and I was never in a student production! I suppose hearing people say over and over that 'We don't want you' was all I needed to keep on." The year was 1956, and he went to New York for such quintessentially out-of-work-actor's jobs as driving a cab, working in the post office and doing time as a Pinkerton guard, in charge of protecting an empty warehouse on the graveyard shift. He took classes with the *corps d'élite* of acting teachers, Uta Hagen and Lee Strasberg, and by 1961 was working Off Broadway, in summer stock, with comedy improvisation groups and on television. Grodin also had a stint as a writer and

···········

Charles Grodin is so embarrassed by his first movie that he wrote a 308-page autobiography and didn't refer to it even in passing.

CAST

JOHN GABRIEL, LUANA ANDERS, CHARLES GRODIN, JULIE SOMMARS, RICHARD ARLEN, VALORA NOLAND, VICTOR SANTINI

······

AURA FILMS
DIRECTED BY JOSEPH ADLER
SCREENPLAY BY WARREN SPECTOR, WILLIAM A. BAIRN AND JOSEPH ADLER
PRODUCED BY BEN PARKER AND ROBERT LANGWORTHY
CINEMATOGRAPHY BY FLOYD CROSBY

Charles Grodin
called his mem-
oirs—the book with
not a single mention
of *Sex and the
College Girl*—"It
Would Be So Nice If
You Weren't Here."
Although some per-
formers have cho-
sen bland titles for
their autobiogra-
phies ("My Life" by
Henry Fonda; "June
Allyson" by June
Allyson), many
others have, like
Grodin, gone for
more color:

"Three Phases of Eve"
　　—*Eve Arden*

"The Raw Pearl"
　　—*Pearl Bailey*

"Little Girl Lost"
　　—*Drew Barrymore*

"Knock Wood"
　　—*Candice Bergen*

"B.S. I Love You"
　　—*Milton Berle*

"Bulls, Balls, Bicycles
and Actors"
　　—*Charles Bickford*

"Life Is a Cucumber"
　　—*Peter Bull*

"Where Have I Been?"
　　—*Sid Caesar*

"What's It All About?"
　　—*Michael Caine*

director with *Candid Camera,* and although he only lasted two months there, he believed that was a relatively long spell for someone who had to put up with Allen Funt.

Grodin's success on Broadway happened fairly rapidly. He was only 27 when, playing a young twit, he completed the cast of the successful three-character romantic comedy, *Tchin-Tchin;* the two other high-powered members of this 1962 triumvirate were Anthony Quinn and Margaret Leighton. Two seasons later Grodin was back on the boards in the not as successful *Absence of a Cello.*

Between these Broadway shows, Grodin heard the siren call of the cinema. He would have you believe that he started off prestigiously in movies with Roman Polanski's *Rosemary's Baby* in 1968, but four years earlier there was *Sex and the College Girl*. In 1964, the 29-year-old actor wasn't so reticent about how he broke into movies. He filled out a publicist's questionnaire about his background for *Absence of a Cello* and, under the heading "Movies," eagerly expounded on *"The Fun Lovers* (a starring role) (a downbeat color picture) (my first feature picture). To be released later this year—shot on location in San Juan, Puerto Rico."

C ontrary to Grodin's expectations, *Sex and the College Girl* (the title was changed from *The Fun Lovers* to evoke some of Helen Gurley Brown's aura) wasn't released in the next few months or even the next few years. It didn't see the light of day until 1970, when for some reason it played in Chicago, and it's every bit as bad as its checkered history would lead you to believe. When the first thing you see on the screen is the proud boast "Filmed entirely on location in San Juan, Puerto Rico," it's not a good sign.

Costing all of $200,000, *Sex and the College Girl* seems to have been intended as a dark version of a *Beach Party* movie, and it has a strangely somber feel.

Frankie and Annette filled their days with fun and sun, surfing and dancing, and an innocent misunderstanding that inevitably ended with a fade-out clinch. By contrast, Larry, the protagonist of this movie, is an unregenerate sleaze whose idea of a good time is to emotionally abuse his girlfriend, Susan (Luana Anders), when she comes to San Juan for a weekend visit. Larry (played by one John Gabriel, an actor who somehow manages to resemble both Dean Martin and Jerry Lewis) is a college dropout who lives off his wealthy father, spending his time gambling and trying to make it big as a singer and songwriter; unfortunately for the audience, when he breaks into song, John Gabriel sounds like nothing more than a poor man's Buddy Greco.

As for the third-billed Grodin, he does an embryonic riff on his later *schlemiel* characters, playing Larry's buddy, Chuck, an earnest goofball who is the flip side of Larry's supposedly charming heel. His hairline already receding at age 29, Grodin walks through the proceedings with sloped shoulders and a dopey expression on his face. And while John Gabriel is quick to show off his physique, when Grodin comes out of the water after a swim, he hurriedly covers up the flabby contours of his upper torso.

Similarly, while Larry's girlfriend, Susan, is supposed to epitomize the modern, sophisticated college girl circa 1964, Chuck's weekend date, Gwen (Julie Sommars), is a pure ditz who's got only one thing on her mind—losing her virginity. Chuck obliges her. This being 1964, the way we know Gwen's mission has been accomplished is that Chuck brings her back to his hotel room and then the next time we see them, she's lying in bed and he's standing up putting his jacket on. From the sour expression on his face, he's got a bad case of postcoital depression, while she describes the encounter as "the craziest thing I could have done." Some people maintain that the most erotic movies are not hard-core films but those that are merely suggestive and leave things to the imagination. Anyone of that

"Has Corinne Been a Good Girl?"
—Corinne Calvet

"Past Imperfect"
—Joan Collins

"Vanity Will Get You Somewhere"
—Joseph Cotten

"The Lonely Life"
—Bette Davis

"See You at the Movies"
—Melvyn Douglas

"My Heart Belongs"
—Mary Martin

"The Quality of Mercy"
—Mercedes McCambridge

"Wide-Eyed in Babylon"
—Ray Milland

"Tops in Taps"
—Ann Miller

"Where's the Rest of Me?"
—Ronald Reagan

"Make Room for Danny"
—Danny Thomas

"Dear Me"
—Peter Ustinov

And the all-time best title:

"The Memoirs of an Amnesiac"
—Oscar Levant

opinion hasn't seen *Sex and the College Girl*. The next day, Chuck apologizes to Gwen for "taking advantage" of her, offering her the aphorism, "It was nice, it's just not . . . it's just not worth it if it's that hard for you to live with." And then they're at it again in the bushes, followed by more remorse. The future of their relationship is unclear. Chuck caps their weekend of erratic passion by telling Gwen, "It was nice meeting you." He does, however, promise to write.

After making *Sex and the College Girl*, Grodin did many guest appearances in TV series, was a regular in a long-forgotten soap opera called *The Young Marrieds* and, in 1966, cowrote and directed an Off-Broadway revue, *Hooray!—It's a Wonderful Day*, which lasted a month. It looked like the big time when Mike Nichols offered him the lead in *The Graduate*, but Grodin and his agent agreed that he shouldn't play Benjamin since the insulting $500 weekly salary was half as much as he could nab for an episode of *The Guns of Will Sonnett*. Grodin recovered from that boner to direct plays and appear in *Rosemary's Baby* and Mike Nichols's *Catch-22*.

In 1972, Nichols's ex-partner Elaine May gave Grodin his star-making opportunity with *The Heartbreak Kid*. The role of a jerk who falls in love on his honeymoon—but not with his wife—made the actor a household name and won him a Golden Globe. If Grodin's subsequent film career didn't quite meet expectations after *The Heartbreak Kid*, it was partly because the Renaissance man was as interested in writing and directing for the stage as appearing in movies. In any case, his success in films has been much greater than anyone could have guessed on the basis of *Sex and the College Girl*.

TOM HANKS

······

HE KNOWS YOU'RE ALONE
(1980)

Born in 1956, Tom Hanks grew up in Oakland and first acted in a high school production of *The Night of the Iguana*. It wasn't acting that lured him to the theater, however, but rather the pure joy of hammering and sawing. He set off to study stage carpentry at Chabot College in Hayward, California, where his handiwork landed him a scholarship to California State University, Sacramento. But once in Sacramento, Hanks realized that appearing before the footlights was immeasurably more glamorous than behind-the-scenes artisanship, so he switched his major to acting. After graduation, he spent three summers at the Great Lakes Shakespeare Festival in Cleveland and then moved on to New York City's Riverside Shakespeare Company. Later, after he became a movie star, the actor claimed he would have felt totally fulfilled if his career had continued in this vein. "I was hoping to build a career in regional

Not every actor can say his first film was shot entirely on Staten Island.

CAST

DON SCARDINO,
CAITLIN O'HEANEY,
ELIZABETH KEMP, TOM ROLFING,
LEWIS ARLT, PATSY PEASE,
JAMES REBHORN, TOM HANKS

······

MGM/UNITED ARTISTS
DIRECTED BY ARMAND MASTROIANNI
SCREENPLAY BY SCOTT PARKER
PRODUCED BY GEORGE MANASSE,
ROBERT DIMILLA AND NAN PEARLMAN
EXECUTIVE PRODUCER: EDGAR LANSBURY
CINEMATOGRAPHY BY GERALD FEIL

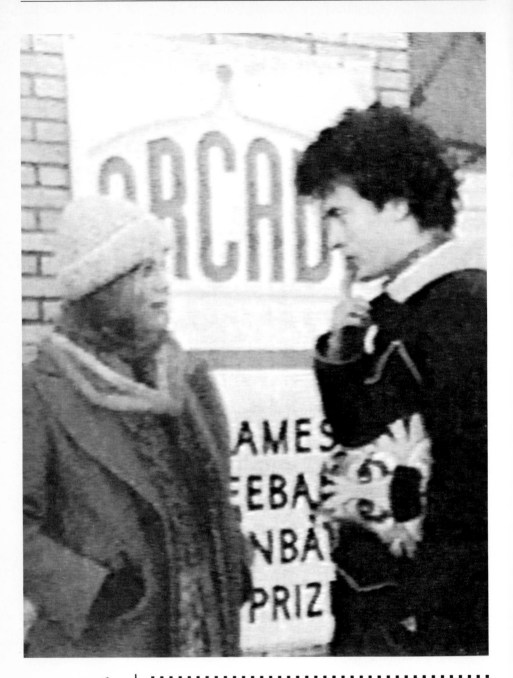

Even though his first film was entitled *He Knows You're Alone*, Tom Hanks didn't get to participate in any killings. Nor did he face the psycho killer himself. He simply went on a date to a rinky-dink Staten Island amusement park with a couple of young women who would end up victimized by the murderer.

theater," he said. "I was willing to drift around, from Cleveland to Chicago to Minneapolis, wherever the jobs were going to take me."

That noble sentiment didn't prevent him from auditioning for a part in a low-budget slasher movie. The director of *He Knows You're Alone* was one Armand Mastroianni, who claimed to be related to Marcello Mastroianni. If so, the talent genes in that family were distributed with cruel unevenness. Armand Mastroianni's dreary, tedious film is so incompetent that it can't even live up to its simple premise: a knife-wielding psycho, jilted by his girlfriend, kills young women who are about to be married. As the film unfolds, the body count features only one such betrothed; the other victims include a cop, the proprietor of a bridal salon and a college professor. *He Knows You're Alone* isn't even true to its title—two of the victims are in bed together when they are knocked off. The plot concentrates on one fiancée, Amy (played by a doughy-faced actress named Caitlin O'Heaney), and the movie essentially consists of Amy's visiting various places in Staten Island, as psycho-alert music swells for what generally turn out to be false alarms.

As for the seventh-billed Hanks, his role is totally superfluous to the carryings-on. If an actor is going to bother being in a cheap horror movie, he might as well have some fun and either be slaughtered onscreen or do a bit of bloodletting himself. But in Hanks's own recollection, "I just played a guy . . . I just come in and say, 'How do you do?'" That's pretty accurate, though he does have a few more snippets of dialogue, such as, "Want a Goober?" The first time audiences see Hanks onscreen he's jogging in the woods wearing a blue wool hat. Then, resting against a log, he trips Amy's friend Nancy when she jogs by so that he can spew out a come-on line. Hanks's first piece of cinematic dialogue: "I'm too tired to scream from the pain you just caused me," a statement that, like most of his dialogue, he handles with a goofy, overemphatic line reading.

LOVE IS IN THE AIR

Tom Hanks met his future wife, actress Rita Wilson, when they co-starred in 1985's *Volunteers*. Relationships that began on a movie set and led to marriage are a time-honored Hollywood tradition, as the following will attest.

Lola Albright and Jack Carson in *The Good Humor Man* (1950)
Julie Andrews and director Blake Edwards, *Darling Lili* (1970)
Annabella and Tyrone Power in *Suez* (1938)
Desi Arnaz and Lucille Ball in *Too Many Girls* (1940)
Elizabeth Ashley and George Peppard in *The Carpetbaggers* (1964)
Lew Ayres and Ginger Rogers in *Don't Bet on Love* (1933)
Lauren Bacall and Humphrey Bogart in *To Have and Have Not* (1944)
Alec Baldwin and Kim Bassinger in *The Marrying Man* (1991)
Ellen Barkin and Gabriel Byrne in *Siesta* (1987)
Anne Baxter and John Hodiak in *Sunday Dinner for a Soldier* (1944)
Warren Beatty and Annette Bening in *Bugsy* (1991)
Constance Bennett and Gilbert Roland in *Our Betters* (1933)
Ingrid Bergman and director Roberto Rossellini, *Stromboli* (1949)
Joan Blondell and Gilbert Roland in *Gold Diggers of 1933* (1933)
Ernest Borgnine and Katy Jurado in *The Badlanders* (1958)
George Brent and Ruth Chatterton in *The Rich Are Always With Us* (1932)
George Brent and Ann Sheridan in *Honeymoon for Three* (1941)
Richard Burton and Elizabeth Taylor in *Cleopatra* (1963)
Madeline Carroll and Sterling Hayden in *Virginia* (1941)
Cyd Charisse and Tony Martin in *Till the Clouds Roll By* (1946)
Joan Crawford and Franchot Tone in *Today We Live* (1933)
Geena Davis and Jeff Goldblum in *The Fly* (1986)
Frances Dee and Joel McCrea in *The Silver Cord* (1933)
Troy Donahue and Suzanne Pleshette in *Rome Adventure* (1962)
Betsy Drake and Cary Grant in *Every Girl Should Be Married* (1948)
Joanne Dru and John Ireland in *All the King's Men* (1949)
Howard Duff and Ida Lupino in *Women in Hiding* (1950)

Dale Evans and Roy Rogers in *The Cowboy and the Senorita*
(1944)

Alice Faye and Tony Martin in *Sing, Baby, Sing* (1936)
Errol Flynn and Patricia Wymore in *Rocky Mountain* (1950)
Judy Garland and director Vincente Minnelli, *The Clock* (1945)
Greer Garson and Richard Ney (who played her son) in *Mrs. Miniver* (1942)

Betty Grable and Harry James in *Springtime in the Rockies*
(1942)

Stewart Granger and Jean Simmons in *Adam and Evelyn* (1949)
Rex Harrison and Kay Kendall in *The Constant Husband* (1955)
Laurence Harvey and Margaret Leighton in *The Good Die Young* (1954)

Miriam Hopkins and director Anatole Litvak, *The Woman I Love*
(1937)

Nancy Kelly and Edmond O'Brien in *Parachute Battalion* (1941)
Evelyn Keyes and director Charles Vidor, *Lady in Question*
(1940)

Fernando Lamas and Esther Williams in *The Magic Fountain*
(1961)

Hope Lange and Don Murray in *Bus Stop* (1956)
Vivien Leigh and Laurence Olivier in *Fire Over England* (1937)
Viveca Lindfors and director Don Siegel, *Night Unto Night*
(1949)

Carole Lombard and William Powell in *Man of the World* (1931)
Lyle Lovett and Julia Roberts in *The Player* (1992)
Malcolm McDowell and Mary Steenburgen in *Time After Time*
(1979)

Merle Oberon and director Alexander Korda, *The Private Life of Henry VIII* (1933)

Geraldine Page and Rip Torn in *Sweet Bird of Youth* (1962)
Dennis Quaid and Meg Ryan in *Innerspace* (1987)
Ronald Reagan and Jane Wyman in *Brother Rat* (1938)
Jean Simmons and director Richard Brooks, *Elmer Gantry*
(1960)

Alexis Smith and Craig Stevens in *Affectionately Yours* (1941)
Ann Sothern and Robert Sterling in *Ringside Maisie* (1941)
Barbara Stanwyck and Robert Taylor in *His Brother's Wife*
(1936)

Hanks's character, Elliot, joins the two women who, even though several friends and acquaintances have been murdered, decide to spend a carefree afternoon at an amusement park. As a freshman psychology major, he feels compelled to analyze Amy's contention that she is being followed ("definitely sexual"). He and Nancy make plans to get together later that night, and that's the last we see of him because Nancy goes home, smokes a joint and is hacked to death. Hanks's total screen time is approximately three and a half minutes. You could praise his performance by noting that he is convincingly nerdy. His fellow actors, however, seem to have been picked up at the New Dorp Community Theater.

He Knows You're Alone received unanimous critical raspberries ("no more than just another by-the-numbers piece of sickening trash," said the *Los Angeles Times*). And despite director Mastroianni's contention that he was leading filmgoers "on a trip where they have not been taken before," audiences didn't care to make the journey; the film's grosses came nowhere near those of *Halloween* or *Friday the 13th*. The only faintly amusing thing about the whole enterprise was that among those receiving "Special Thanks" in the end credits was the Hoffritz cutlery company.

Fortunately for Hanks, by the time *He Knows You're Alone* opened, he was already shooting his cross-dressing television series, *Bosom Buddies*, a *succès d'estime* that would pave the way for his star-making role in *Splash*.

ETHAN HAWKE AND RIVER PHOENIX

· · · · · ·

EXPLORERS
(1984)

Born November 6, 1970, in Austin, Texas, Ethan Hawke grew up in Princeton, New Jersey, living a normal boy's life for a dozen years. Then at age 13, with the only acting he had ever done being a small role in *Saint Joan* at Princeton's McCarter Theatre, "I just kind of decided to audition for a couple of movies in New York. I can't even remember why." Hawke's parents weren't thrilled with his escapade but let him do it anyway because "they just thought, 'He'll go, it'll be awful and he won't do it again.'" To both his and his parents' surprise, he got a part and in October found himself on the Paramount lot.

If starring in a movie was unusual for Ethan Hawke, it was probably the most normal thing that had happened to River Phoenix in his entire life. Two and a half months older than Hawke, he pulled an Abraham Lincoln by being born in a log cabin. River's name came about because his parents had just finished Herman

· · · · · · · · · · · ·

Two boys sharing a spaceship, their backgrounds couldn't have been more dissimilar.

CAST

ETHAN HAWKE, RIVER PHOENIX, JASON PRESSON, AMANDA PETERSON, DICK MILLER, ROBERT PICARDO, DANA IVEY, MARY KAY PLACE

· · · · · ·

PARAMOUNT
DIRECTED BY JOE DANTE
SCREENPLAY BY ERIC LUKE
PRODUCED BY EDWARD S. FELDMAN AND DAVID BOMBYK
EXECUTIVE PRODUCER: MICHAEL FINNELL
CINEMATOGRAPHY BY JOHN HORA

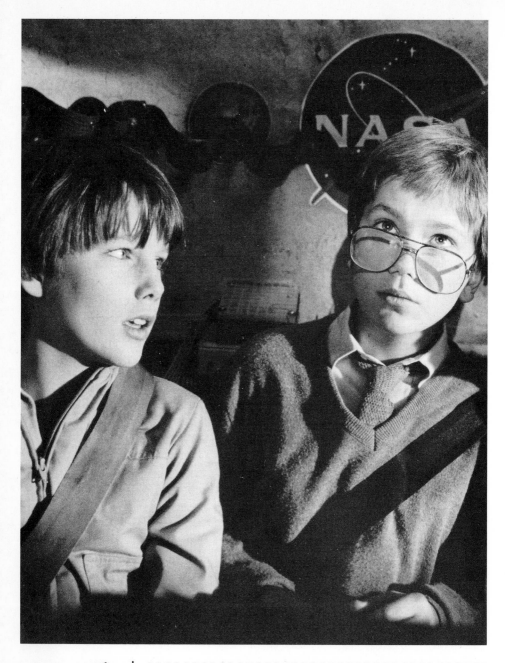

For the next several years after taking a trip to the galaxies together, Ethan Hawke and River Phoenix followed extremely different career paths. Phoenix never stopped working and became a teen idol and Academy Award nominee; Hawke went back to being a regular kid.

Hesse's *Siddhartha.* (Imagine if they had been reading *The Wind in the Willows.*) When he was three, his parents packed the car and moved River and his three younger siblings—to Venezuela. There, while working with street kids, they also preached the gospel of a group called the Children of God. To help make ends meet, River and his sister Rainbow came up with a singing act, harmonizing on street corners for coins. The family did their missionary and social work in Trinidad and Mexico, as well. In 1977, the Phoenixes became disillusioned with the religious cult and gave up their lives as Jesus freaks. They moved to Florida and then California, where River's mother found employment as a secretary at NBC; his father was unable to work because of an injury from a car accident. It seemed like old times because, as River remembered, "We were desperately poor," so he and his sister "would go to Westwood and sing on the streets to make people happy and to get some money."

The amount of money the performers around her at NBC were pulling down wasn't lost on Arlyn Phoenix, and she and her husband thought their kids could do better than relying on spare change and the kindness of strangers. While she took dictation in Burbank, her husband took the four little Phoenixes on auditions. River made five commercials, but at age 10, he decided no more ad work: "I wasn't sure of anything then, but I guess what I was zeroing in on was that performing was more about telling the truth through a different character's eyes. I felt that the constant lying, the smiling on cue and the product naming was going to drive me crazy or numb me to a not-yet-developed craft that I was beginning to feel staring me in the face." The next stop on the road to his artistic fulfillment was reuniting with Rainbow in a pilot for a TV show called *Real Kids*—their role was to warm up the audience before taping. Then River got to appear *on* TV as one of the title characters in an unsuccessful series, *Seven Brides for Seven Brothers.* That only lasted

• • • • • • • • • •

Although this was
but his first film
role, River Phoenix
attacked his
assignment with
the gusto of a
seasoned performer.
Since Phoenix
himself was a hip
rock-and-roll type,
playing a science
nerd was quite a
stretch. So the
untrained actor did
his own version of
the Method: "You
must figure out how
Wolfgang would
live, what kind of
things he would do,
how he would act.
So I thought about
what his financial
situation is . . . what
kind of clothes he
wears . . . if he likes
girls. . . . You know,
I just tried to keep
his character. . . .
Wolfgang's a really
neat character, but
I'm really not too
much like him
except for my
appearance. And I
have some of the
same speech
patterns."

for 22 episodes from 1982 to 1983, but Phoenix found steady employment with guest appearances on other shows. And in the summer of 1984, he showed up at the open casting call for boys aged 12 to 14 for a movie called *Explorers*.

• • • • • •

*E*xplorers was one of the innumerable science-fiction movies featuring children that proliferated for a few years in the wake of *E.T.* In this one, easily the most endearing of the bunch, three junior high students fashion a spaceship out of an old car from an amusement park ride. After tooling around town in the vessel, they are summoned to a humongous starship by aliens who turn out to be a pair of wacky, mischievous adolescent space creatures, the female, Neek, an extraterrestrial equivalent of a Valley Girl. The awesomely cool space station they are manning is actually their dad's "car," which they borrowed without permission (there's later hell to pay for that transgression). Instead of dishing out great pearls of wisdom of the Obi-Wan Kenobi school, they can only spout English learned from long-distance television broadcasts. Thus, the boy, Wak, treats the three guests to a manic riff of vocal impersonations encapsulating pop history and ranging from James Mason to Little Richard to Mr. Ed. It's a very funny payoff, though a bit of a letdown because the conventions of this genre have the audience primed for something mystical or vaguely profound. I suppose, though, that a curveball of this sort should have been anticipated in a film made by Joe Dante, an unmistakably talented director but a man who, displaying his passion for trash culture in film after film (*Gremlins*, *The 'burbs*, *Matinee*), seems to be suffering from a bad case of arrested development.

All three young lead actors are natural and ingratiating. Ethan Hawke is Ben, who with his encyclopedic knowledge of 1950s sci-fi movies (sounds suspiciously like director Dante) could have come across as a nerd.

The actor, however, imbues the character with a wide-eyed charm that makes Ben a slightly idealized but immensely likable archetypical good kid, and he convinces you that he is capable of believing in his fantastic dreams of traveling to other galaxies *and* winning the girl of his dreams. As Wolfgang, the science whiz who engineers the flight, River Phoenix expresses a seriousness of purpose that is both perfectly in keeping with the character and slyly comic in its contrast to the high-spirited silliness that surrounds him. The third actor, Jason Presson, was the only one of the trio who had been in a film previously, having starred with Robert Duvall and Glenn Close in *The Stone Boy,* a grim little drama about a kid who accidentally shoots his brother. Here the frog-voiced Presson portrays Darren, from the proverbial wrong side of the tracks, and plays him with a solemnity that's as amusing as it is unexpected. (Unlike his two costars, little has been heard from him since *Explorers*.)

Director Dante singled out Ethan Hawke for being able to hold his own with his more seasoned costars: "People frequently remarked that they couldn't believe it was Ethan's first picture. He hadn't even done any television, but he's a natural actor; he just fell into the whole attitude that Jason and River already had. We were very lucky with him."

"When *Explorers* comes out, I don't know what it's going to be like," Hawke acknowledged shortly before the film's summer release, adding that his friends in Princeton will "see the finished product of what I've been doing, and if they don't like it, I don't know, that's their problem. It'll bother me if they make a big deal about everything when I get home, if they treat me differently—which I don't really think they will." Ethan was in for a rude awakening—*Explorers* was a bomb. Years later he spoke of the trauma: "It was pretty devastating for me because I had such a great time making it. I thought, 'Well it must be my fault because Joe Dante's so talented.' Also, you're the big shot in town

All Grown Up

Hawke in *A Midnight Clear* (1992). Phoenix in *My Own Private Idaho* (1991).

before it comes out. Then it comes out and it's gone in a week and everybody's like 'Ha-ha, you thought you were such a big shot, but you're really just a geek.'" Another time he recalled that after the failure of *Explorers*, "I'd have dreams they were remaking the movie without me." Hawke disappeared from public scrutiny, but a few years later took up acting again while in high school and briefly studied theater at Carnegie Mellon University. Then in 1989, almost exactly four years after *Explorers* opened, he reappeared on movie screens, to be seen by all the people who had stayed away from his first movie, when he played the pathologically shy student in *Dead Poets Society*. Hawke has been acting nonstop in films and on the New York stage ever since, doing work that made the *Hollywood Reporter* select him as one of the "90 for the 90s," the trade paper's predictions of the people who would dominate the entertainment world during the decade.

In contrast to Ethan Hawke, River Phoenix never paused for breath after the failure of *Explorers*. Cast as the sensitive leader of a group of 1950s misfits in his next movie, the sleeper *Stand By Me*, he was acknowledged by critics as an unusually talented teenage actor. Having shed the chunkiness he carried at the time of *Explorers*, he went through a teen idol phase—in 1988, while Hawke was living in anonymity in New Jersey, Phoenix was reportedly receiving 34,000 letters a week from lovesick girls. The following year he garnered an Academy Award nomination as Best Supporting Actor for his work as the gifted son of fugitive radicals in *Running on Empty*. In 1991 he won the National Society of Film Critics Award for playing a narcoleptic gay hustler in *My Own Private Idaho;* River Phoenix was a teen actor no longer. And like his first costar, he made the *Reporter*'s "90 for the 90s." Sadly, this prediction didn't have a chance to come true—River Phoenix died suddenly on Halloween 1993 at the age of 23.

Goldie Hawn

······

The One and Only, Genuine, Original Family Band

(1967)

oldie Hawn was born to dance, and she began the beguine at the age of three. After high school, she studied drama at American University for two years, but her feet had to do their stuff, so she opened her own dance studio. It was not a success, and since those who can't teach, do, she went off seeking fame and fortune as a terpsichorean. After a brief stopover in Williamsburg, Virginia, for a stint in a Passion play, Hawn worked as a can-can dancer—not in Paris at the *Moulin Rouge*, but in the Texas Pavilion at the New York World's Fair. When the fair folded up in the autumn of 1965, Hawn found employment in a contemporary version of the *Folies Bergère:* She was a go-go dancer at the Dudes 'n' Dolls club in Manhattan.

CAST

WALTER BRENNAN, BUDDY EBSEN,
JOHN DAVIDSON,
LESLEY ANN WARREN,
JANET BLAIR, KURT RUSSELL,
STEVE HAMON, RICHARD DEACON,
WALLY COX, DEBBIE SMITH,
BOBBY RIHA, PAMELYN FERDIN

······

BUENA VISTA
DIRECTED BY MICHAEL O'HERLIHY
SCREENPLAY BY LOWELL S. HAWLEY
PRODUCED BY BILL ANDERSON
CINEMATOGRAPHY BY FRANK PHILLIPS

············

Love was in the air when Goldie Hawn made her first movie, but she was too busy to notice.

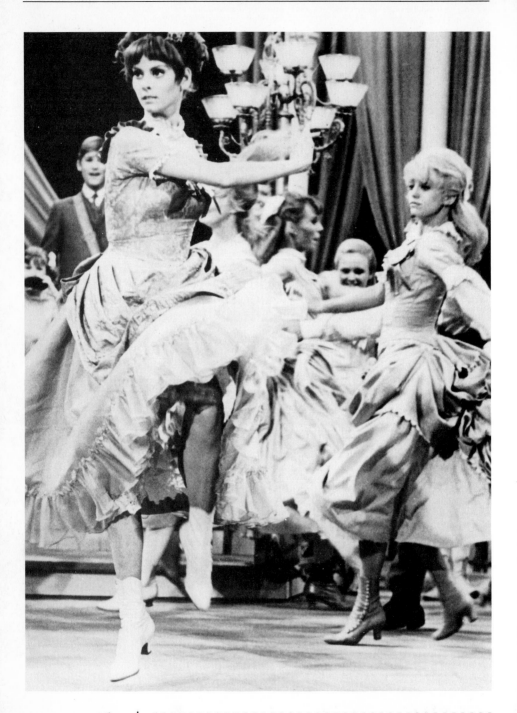

Goldie Hawn is so preoccupied with going through her paces that she doesn't see Kurt Russell on the stage. With time, that would all change.

New York proved not to be the promised land she had anticipated, but maybe Las Vegas would be her Canaan. Nope—all she ended up doing there was shaking her body for the high rollers at the Desert Inn. Appraising that stint, Hawn confessed: "I am temperamentally and morally unsuited for Las Vegas and nightclubs. It was the saddest time of my life." She continued, therefore, on her westward trek. Her first job in California was the polar opposite of her previous two gigs: She worked as a chorine in Melodyland, U.S.A., right next to Disneyland. If the 21-year-old dancer found herself staring across Harbor Boulevard and entertaining dreams of being part of the universe of Mickey and Donald and Goofy, she would soon be getting her wish. Hawn was summoned to the Disney Burbank studios to dance in a new musical.

The current Disney regime of Michael Eisner and Jeffrey Katzenbach has propagated the myth that Uncle Walt's studio has *always* been the once-and-future phantasmagoric kingdom of childhood delights, where the most glorious of fantasies constantly took flight. But Disney in the 1960s was a far cry from the studio's glory days of the 1940s. Instead of *Pinocchio* and *Dumbo*, the company served up such pips as *Follow Me, Boys!*, *A Tiger Walks* and *The Ugly Dachshund*. (All you need to know about the quality of the Disney output at the time is that the two Kings of the Lot were Fred Mac-Murray and Walter Brennan.)

Somebody got the bright idea that a dandy musical could be made against the backdrop of the 1888 presidential contest between Benjamin Harrison and the incumbent Grover Cleveland. (Since this has not exactly gone down in American history as one of the more pivotal elections, it wasn't the most obvious event on which to hinge a movie. And this being a Disney film, no mention is made of the charges of having fathered a child out of wedlock that had dogged Mr. Cleveland.)

The One and Only, Genuine, Original Family Band— a title guaranteed to bring tears to the eyes of the guy

Other performers who, like Goldie Hawn, began as dancers only to concentrate on film genres other than musicals include:

James Cagney

Leslie Caron

George Chakiris

Buddy Ebsen

Teri Garr

Valerie Harper

Audrey Hepburn

Miriam Hopkins

Van Johnson

Shirley MacLaine

Mary Tyler Moore

George Raft

Moira Shearer

Patrick Swayze

Mary Treen

Christopher Walken

Clifton Webb

who had to put the letters up on the marquee—tells the story of the trigenerational Bower family of Nebraska. Daughter Lesley Ann Warren has been carrying on a correspondence with Grand Rapids newspaperman John Davidson. (These two actors were being reunited for romantic duty a year after they first did it in *The Happiest Millionaire*.) Davidson urges the family to get a homestead in the Dakota territory so that they can have ample free land and he can have his beloved. Grandpa Brennan wants nothing to do with Davidson, and not because the young man is prettier than his granddaughter. Rather, it's that the septuagenarian is an inflexible Democrat, while Davidson supports the Republican national ticket. For that matter, Brennan doesn't get on too well with his own family because his son, Buddy Ebsen, and daughter-in-law, Janet Blair, are also Benjamin Harrison partisans, although at least Warren shares Grandpa's predilection for Grover Cleveland.

So what we have here is a musical in which the members of a family are constantly quarreling, and when they're not bickering they're bursting into song. As annoying as the squabbling is, the musical interludes are no easier on the ears, especially with Walter Brennan's wheezy croak of a singing voice. Critical reaction can be summarized by *Cue* magazine's assertion, "This formula Disney pap involves a nausea-inducing family."

• • • • • •

Into this stew Goldie Hawn brought her magic feet. Appearing in a hard-stomping dance number, she has no lines, but she giggles a bit and momentarily takes center stage by being lifted up by John Davidson. She also has a short solo in which, mouth agape, she boisterously flaps her arms, kicks her feet and spins around for the camera. If you didn't know this dancer was Goldie Hawn, you wouldn't give her a second thought, but the scene does have great significance in the grand scheme of life. There on the steps behind

her, playing Sidney, the eldest son of the Bower family, was Kurt Russell. The 16-year-old had replaced Tommy Kirk as Disney's major boy star after appearing in *Follow Me, Boys!* There was no way of knowing that this hebetudinous child actor would grow up to be a virile leading man of hard-edged action movies. Even less likely was that the sixth-billed juvenile and the tittering 21-year-old dancer listed in the credits as Goldie Jeanne Hawn would become paramours. No, she wasn't messing with jail bait offscreen—the two would meet again in 1983 when filming *Swing Shift* and fall in love. (This time she was billed above him.) They also had a laugh on realizing that their paths had crossed earlier, and a quarter of a century after first sharing soundstage space with Hawn, Russell recalled, "I remember thinking she was well built. But I didn't have a car or anything. She was beyond the realm of possibility."

After filming *The One and Only, Genuine, Original Family Band*, Goldie Hawn made the leap from dancer to actress when she landed a "kooky" role as a next-door neighbor on *Good Morning, World*, a forgotten sitcom about a pair of disc jockeys. By the time *Family Band* opened as the 1968 Easter attraction at Radio City Music Hall, the young woman in that dance number was a household name. The phenomenally successful *Rowan and Martin's Laugh-In* had premiered in January and the dopey blonde who shimmied in a bikini as the camera zoomed in on the graffiti painted on her body became the most popular cast member. The next time Goldie Hawn appeared in a movie, she was costarring with Walter Matthau and Ingrid Bergman in *Cactus Flower* and being built up as the "new Judy Holliday." She also won an Oscar, while all those actors who had had dialogue in *The One and Only, Genuine, Original Family Band* continued performing in various forms of schlock.

The second time Goldie Hawn and Kurt Russell showed up together in a movie, something happened. In the course of filming *Swing Shift* (below) in 1983, they fell in love.

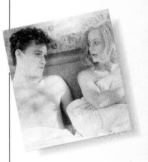

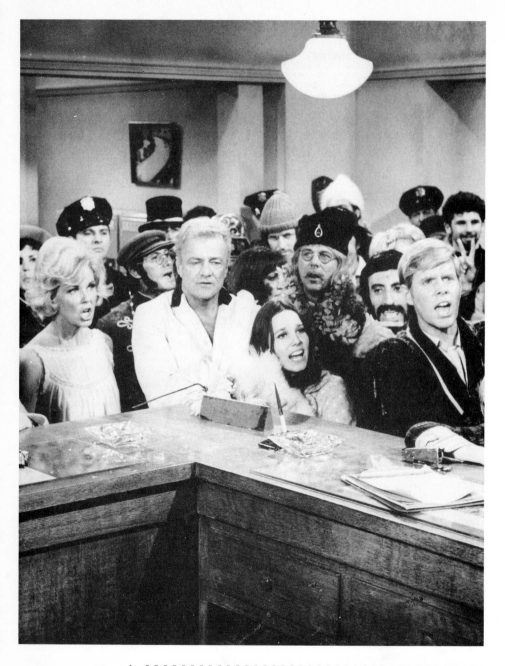

"With six you get eggroll," and with a family comedy of the 1960s you get a happy
ending. Here the warring factions of Doris Day and Brian Keith's household,
including Barbara Hershey as Keith's jealous (in a non-Oedipal sort of way)
daughter, come together over a traffic violation.

BARBARA HERSHEY

······

WITH SIX YOU GET EGGROLL
(1968)

Barbara Hershey joined the ranks of Carol Burnett, Stefanie Powers and Ricky Nelson as Hollywood High students who went on to have successful show-biz careers. In school, however, she appeared in only two productions, once as Lady Macbeth and once as Martha in *Who's Afraid of Virginia Woolf?* "I chose the nuttiest parts because I knew I'd be an ingenue for a long time," she explained. A drama teacher recommended the teenager to an agent, who signed her on and immediately changed her last name from Herzstein. Like many young actresses starting out at the time, Hershey cut her teeth on television; the producers of the *Gidget* series liked her work in a small part as one of Sally Field's girlfriends so much that they invited her back twice. She also showed up on *The Farmer's Daughter* and

CAST

DORIS DAY, BRIAN KEITH,
PAT CARROLL, BARBARA HERSHEY,
GEORGE CARLIN, ALICE GHOSTLEY,
JOHN FINDLATER, HERB VOLAND,
ALAN MELVIN, JAMIE FARR,
WILLIAM CHRISTOPHER,
VIC TAYBACK, JACKIE JOSEPH,
THE GRASSROOTS

······

NATIONAL GENERAL
DIRECTED BY HOWARD MORRIS
SCREENPLAY BY GWEN BAGNI,
PAUL DUBOV, HARVEY BULLOCK AND
R.S. ALLEN, STORY BY GWEN BAGNI AND
PAUL DUBOV
PRODUCED BY MARTIN MELCHER
CINEMATOGRAPHY BY
ELLSWORTH FREDERICKS AND
HARRY STRADLING, JR.

Before she did stints as a Hollywood flake and as a respected actress, Barbara Hershey spent time as latter-day starlet.

Bob Hope Presents The Chrysler Theatre. Then in 1966, when she was 18, came a shot at big-time success—a series of her own. And it was in *Gidget*'s old time slot! *The Monroes* was a no-go, though. America didn't care about a group of irritatingly feisty orphans in the Old West, especially since three families the public did relate to were on view at the same hour: the Graingers of *The Virginian,* the Robinsons, who were *Lost in Space,* and Jed, Granny and the other *Beverly Hillbillies.*

So it was back to guest appearances on other people's programs. Mixed in with *Daniel Boone* and *The Invaders* was an episode of *Run for Your Life* (the show in which Ben Gazzara had two years to live, but which was on the air for three years). Playing a hippie who gets busted for writing pornography was a transcendental experience for Hershey: "That really changed me. It opened me up. Oh, it didn't make me want to drop out—I've always wanted to do something—and it didn't make me pro-hippie. But it made me pro–human being, made me realize my true philosophy: That there's something religious and beautiful about doing what you want to do, about loving people if you can."

■ ■ ■ ■ ■ ■

Hershey wanted to make movies, but there was nothing beautiful about *With Six You Get Eggroll.* Given her television background, it was appropriate that her first film would have been more at home on the small screen. In fact, except for Doris Day, the entire cast consisted of people who mostly did TV, and even DoDo went right into her own series immediately after finishing the film. (Adding to its television pedigree, the movie was the initial release of Cinema Center, CBS's short-lived film company.) The premise of the picture is that when widow Day and widower Brian Keith fall in love, hilarity results from the emotional difficulties faced by their children at having a new adult in their lives. And then after the couple elopes, more merriment ensues when the kids have to deal with

their new siblings and live together in a house that wasn't designed for six. It's about as funny as it sounds.

Around the edges the film does contain intimations of a dark view of American family life: The kids learn about the marriage when Day's youngest son jumps into the conjugal bed and wakes the house, screaming, "There's a man in Mommy's bed!"; later when the kid calls, "Mommy!" Day sighs, "You know, you can grow to hate that word." But director Howard Morris, another TV veteran, is no Douglas Sirk and doesn't have the gumption to pursue any of the situation's unsavory aspects. Hanging around to crack wise in true sitcom fashion are Pat Carroll as Day's sex-obsessed sister, and housekeeper Alice Ghostley. After a good deal of tedious quarreling, the family, of course, comes together. In court, following a series of altercations with truck driver Vic Tayback, the kids magically start saying "He's my father" and "He's my brother" (and no, it's nothing like Faye Dunaway's confession in *Chinatown*).

With Six You Get Eggroll opened several months after the popular *Yours, Mine and Ours,* in which the widowed Lucille Ball and Henry Fonda wed and bring together 18 children (not to mention the kid the 57-year-old Lucy is expecting at picture's end). *Eggroll*'s sextet couldn't compete with the earlier brood, and the film opened to mass indifference.

Billed fourth, Barbara Hershey plays Daddy's little girl, who resents Day's intrusion into the nice life she's made for her father and herself (talk about Freudian intimations). It's a stock role, which the actress filled adequately. *Variety* mentioned that "Barbara Hershey is pretty (but not up to her featured billing)." She wasn't a new face to the critic for the *Christian Science Monitor*, who observed that the 20-year-old "is pretty and contemporary-looking, but much less effective than she was as the rebellious daughter in *Secrets* [a CBS Playhouse production]."

With Six You Get Eggroll would turn out to be Doris Day's final film, but Barbara Hershey was just

Barbara Hershey has long since slapped a moratorium on discussions about the Seagull Period. In 1979, in one of her last conversations on the matter, she said, "I'm not surprised that people reacted as they did. After all, some of the things I did must have seemed very odd." Pointing out that she was only 20 when she made *Last Summer,* she spoke with the wisdom of experience: "I don't apologize for anything I did. I'm just sorry I did them in public, that's all. That was silly."

getting started. The following year she appeared in *Heaven with a Gun,* a tired little Western in which she gets raped by David Carradine; in real life, they moved in together. Hershey was regarded as a prime candidate for stardom after she manifested evil in Frank Perry's acclaimed *Last Summer,* but portraying a cruel, foul-mouthed teen got to her. "Subconsciously I started becoming her. I started becoming bitchy. I started hating myself," she acknowledged. "After that, I took acting lessons for the first time in my life—because it spooked me so." Hershey's career would also be haunted by something that happened during *Last Summer.*

As she told the *New York Times* in 1972, after too many takes of a scene in which Hershey had to throw a seagull into the air, the bird's neck broke and it died. "At that moment, I felt her soul enter me. I didn't tell anybody about it for a long time. I did read *Jonathan Livingston Seagull* but really, that had nothing to do with it. I just realized, finally, that the only honest, moral thing would be to change my name." Which she did. Although, in general, Hollywood was never particularly disdainful of an idiosyncratic life-style (Clifton Webb was a beloved figure around town, even though the sixtyish actor never went anywhere without his dear mother), the town did take notice when eccentricity crossed from private life to commercial viability, and the name under which an actor is billed is a part of the latter. From being classified as a beautiful rising star, Barbara Seagull was now pegged as some sort of weirdo. In retrospect, you might wonder what all the fuss was about—it's not as if Hershey was her real name. And at least it wasn't a sperm whale that got killed.

What is more startling in the notorious *Times* interview—and so emblematic of its time—is the insouciant young woman's reminiscences of giving birth at home to her and Carradine's son, Free: "Of course, animals eat the infant's placenta, after it's born, and we'd planned to do that—it's incredibly nourishing. But, um, after we looked at it, we decided not to. Instead, we put

it in the ground and planted an apricot tree on it, so that, later, Free can eat the apricots." The actress also raised hackles when she appeared on *The Dick Cavett Show*, blithely unbuttoned her sweater and nursed Free.

The industry punished the free spirit: For the rest of the decade she got roles only in junk, both in films and on television. In 1978, director Richard Rush fought with his backers and insisted that she costar with Peter O'Toole in *The Stunt Man;* unfortunately, the movie didn't get released until two years later, and although it was critically praised, the leading lady was overshadowed by the flamboyant O'Toole and Rush's directorial flashiness. Meanwhile, she reverted to Barbara Hershey.

Her fortunes truly began to improve in 1983, when she showed up in the high-profile astronaut movie *The Right Stuff*. She had a good go of it in the '80s, appearing in such major releases as *The Natural, Hannah and Her Sisters, The Last Temptation of Christ* and *Beaches*. Hershey also won unprecedented back-to-back Best Actress awards at Cannes, for *Shy People* and *A World Apart.*

Speaking of different names, when he was nine, Free changed his name to Tom.

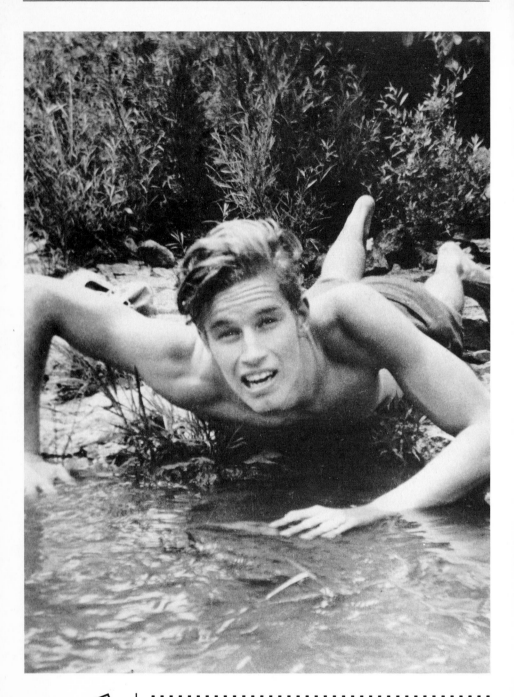

Could the pitchman for *National Review* and the National Rifle Association really ever have been this young? Playing Peer Gynt, the 17-year-old tries to look heroic in the wilds of Illinois and Wisconsin.

CHARLTON HESTON

· · · · · ·

PEER GYNT

(1941)

While Mickey Rooney and Judy Garland were saying, "Let's put on a show!" to their friends in MGM musicals, a young man named David Bradley got his gang together to make movies in and around Winnetka, Illinois. After graduating in 1938 from the same school where Orson Welles had prepped, Bradley attended Northwestern University and couldn't wait for summer vacation. Unlike his classmates, however, his eager anticipation wasn't based on warm-weather travel, the lure of a job or the rekindling of an August romance. No, come May, with classes over, Bradley would be reunited with his beloved 16mm camera, free to set down on film his interpretations of classic literature. His *oeuvre* included *Treasure Island*, *A Christmas Carol*, *Oliver Twist* and *The Emperor Jones;* his casts were comprised of friends, students, and unemployed professional actors, who, although Bradley couldn't pay them, were happy to be working on their craft.

How I spent my summer vacation.

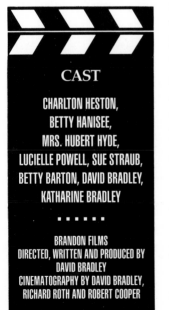

CAST

CHARLTON HESTON,
BETTY HANISEE,
MRS. HUBERT HYDE,
LUCIELLE POWELL, SUE STRAUB,
BETTY BARTON, DAVID BRADLEY,
KATHARINE BRADLEY

· · · · · ·

BRANDON FILMS
DIRECTED, WRITTEN AND PRODUCED BY
DAVID BRADLEY
CINEMATOGRAPHY BY DAVID BRADLEY,
RICHARD ROTH AND ROBERT COOPER

Bradley shot the films on location in the greater Chicago area, making do with any suitable place where the cops wouldn't go after him for trespassing.

In the spring of 1941, Bradley was in preproduction on his latest opus, an adaptation of Ibsen's *Peer Gynt*. Just like a real movie producer, he had to deal with a temperamental, unpredictable star: The chap who was set for the title role informed him that he had been offered a salaried role in summer stock, and said see ya later. The only bright spot in this hasty hegira was that it occurred around the time of year when high school drama societies were putting on their farewell productions; Bradley was therefore able to comb auditoriums throughout the area conducting a Peer review. His search ended at New Trier High in his own hometown of Winnetka: "The play was terrible, but there was a gangling six-foot, startling creature named Heston."

Charlton Heston was another of those people who gravitated toward acting because of an inferiority complex. As you learn in Psychology 101, their low self-esteem is somewhat ameliorated by the gratification of being onstage and slipping into the skin of another person totally unlike the worthless creatures they feel they are. Heston's diffidence arose largely from having grown up in a tiny, isolated village in the north woods of Michigan and then being thrown into the comparatively bustling town of Evanston, Illinois. In this new metropolis he felt alienated and skittish—especially among girls—and deficient in all the social graces that seemed to come so naturally to his classmates. In the words of the subject himself: "In those days I wasn't satisfied with being me." Bradley went backstage that night, told Heston he was impressed by his performance, and asked him whether he might be interested in starring in a movie. Heston's immediate, enthusiastic response was, "Are you a talent scout from Hollywood?" "Never mind Hollywood," Bradley huffily told him. With diminished expectations, the 17-year-old agreed to play the globetrotting Norseman, and so on

June 15, 1941, Charlton Heston stepped before a movie camera for the first time.

• • • • • •

P eer Gynt is foolishly pretentious in the unblink-ing, self-contained way that only the work of a young person can be, yet you can't help being impressed at Bradley's ability to make something this relatively grandiose with so few resources. The film also verges on the hilarious when a clip suddenly pops up, obtrusively edited in from a travelogue the film-maker borrowed from the local library. The director didn't have the money to go to a real desert, so the beach of Lake Michigan substituted for Arabian sands; similarly, who's going to know whether the woods Peer ambles through are in Norway or the Winnetka Forest Preserve? The budget for costuming was tiny, and although sheets sufficed for the robes of Moroccan sol-diers of fortune, the papier-mâché masks worn by the trolls and elves as they dance around the bound Peer before burning him at the stake turn the Hall of the Mountain King sequence into a giddy farce. *Citizen Kane* had opened several months before Bradley began shoot-ing *Peer Gynt,* and he was clearly imitating his fellow Todd School alumnus, with an odd angle here, a deep-focus shot there and frequent dissolves everywhere. The most inescapably amateur-night aspect of the produc-tion is that only a handful of scenes are accompanied by dialogue, the rest of the film making do with title cards accompanied by a recording of Grieg's *Peer Gynt* suites. Although Heston has an authentically ingenu-ous quality that's well suited to the naif he is portray-ing, by his own laughing admission he hadn't the fog-giest that Ibsen had written the play as a satire, and he was trying to enact the role as heroically as he could.

Despite the trying conditions under which he was working, Bradley finished his 100-minute movie in less than three months. *Peer Gynt* had a gala premiere in August, a charity benefit for the Winnetka Commu-

• • • • • • • • • • •

ALL GROWN UP

Charlton Heston as Cardinal Richelieu in 1974's *The Three Musketeers.*

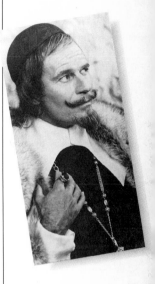

Charlton Heston once commented: "I have a theory about actors' faces. They have a tendency to fall into time periods. The great American urban face belonged to Humphrey Bogart. Bill Holden is the great modern American face. You can't cast him in the 19th century." With his high cheekbones and Romanesque nose, Heston has a puss that was destined to convey heroes of the past. That's not to say he never dons modern dress in the movies, but starting with *Peer Gynt*, he's seemed much more comfortable in the long ago:

The President's Lady (1953)
 (as Andrew Jackson)
Pony Express (1953)
 (as Buffalo Bill)
The Far Horizons (1955)
 (as the latter of the Lewis & Clark Expedition)

nity Theatre, because, as Bradley explained to the *Chicago Daily Times*, "We aren't allowed to make any money. If we did we would have to get an exhibitor's license, use union labor throughout, and what not." The Chicago dailies didn't bother with this little 16mm movie, but *American Cinematographer*, the Bible of amateur filmmakers, checked it out and reported that the "technical details, especially of photography, both exterior and interior, are remarkably good. Several of the individual sequences are excellent." Unfortunately it "is to be regretted that some of the more fanciful sequences could not have been filmed with distorting lenses, or against impressionistic sets like those used in *The Cabinet of Dr. Caligari*." As regards Heston and his fellow onscreen talent, the magazine declared the acting "decidedly commendable." Another journal of similar scope, *International Photographer*, reported that Heston's "handling of the stellar role was carefully accomplished."

After *Peer Gynt*, Heston joined David Bradley at Northwestern on a drama scholarship. He spent two years in academia, then joined the Air Force, doing time in the Aleutians. (Perhaps his failure to finish his studies explains the quality of some of those subsequent performances.) Released from service in 1947, Heston tried his luck in New York, where he had no luck at all, and ended up in Asheville, North Carolina, getting an opportunity not only to act but to direct. With this experience under his belt, Heston again ventured forth to Manhattan, finding employment in both television and the theater, including a Katharine Cornell production of *Caesar and Cleopatra*. As for motion pictures, who should come knocking but David Bradley. This time (1949) Bradley was having a go at Shakespeare and wondered whether his Peer Gynt might be available to star as Marc Antony in *Julius Caesar*. Charlton Heston thus made his second feature film appearance—costarring with another later-to-be Hollywood star, Jeffrey Hunter. Again it was an inex-

pensive but pompous 16mm film, but Heston got something out of it: He used it as the equivalent of a screen test for his infiltration of Hollywood.

Peer Gynt had a second life. The film received little exposure in 1941. But 24 years later, when its leading man had been a certified box-office draw for more than a decade, the movie was rereleased, now with the voice of Francis X. Bushman (who had appeared as the villain in the silent version of Heston's most famous movie, *Ben-Hur*) substituting for those annoying title cards. During another reissue, this one in 1978, Kevin Thomas of the *Los Angeles Times* remarked that *Peer Gynt* was "an ingenious delight." He added, "More often than not, major screen stars would like to forget their very earliest movies but David Bradley's *Peer Gynt* . . . remains among the most artistically ambitious films in which Charlton Heston has ever appeared." Not really. Sure, it's better than *Earthquake* and *Soylent Green,* but don't forget that Heston also starred in *Touch of Evil, 55 Days at Peking, Planet of the Apes* and *Will Penny;* and to be honest, the TV series *Dynasty II: The Colbys* was a lot more fun than *Peer Gynt.* In any event, Heston's career work is more prestigious than his first director's. For all his early artistic loftiness, David Bradley ended up in Hollywood directing movies with names like *Twelve to the Moon* and *Dragstrip Riot.*

The Ten Commandments (1956)
(as Moses)

The Buccaneer (1958)
(as Andrew Jackson)

Ben-Hur (1959)
(1st-century Rome)

El-Cid (1961)
(11th-century Spain)

55 Days at Peking (1963)
(China's 1900 Boxer Rebellion)

The Greatest Story Ever Told (1965)
(as John the Baptist)

The War Lord (1965)
(medieval England)

The Agony and the Ecstasy (1965)
(as Michelangelo)

Khartoum (1966)
(Africa, 1883)

Julius Caesar (1970)
(as Mark Antony)

Antony and Cleopatra (1973)
(again as Antony)

The Three Musketeers (1974) and *The Four Musketeers* (1975)
(as Cardinal Richelieu)

Crossed Swords (1977)
(as Henry VIII)

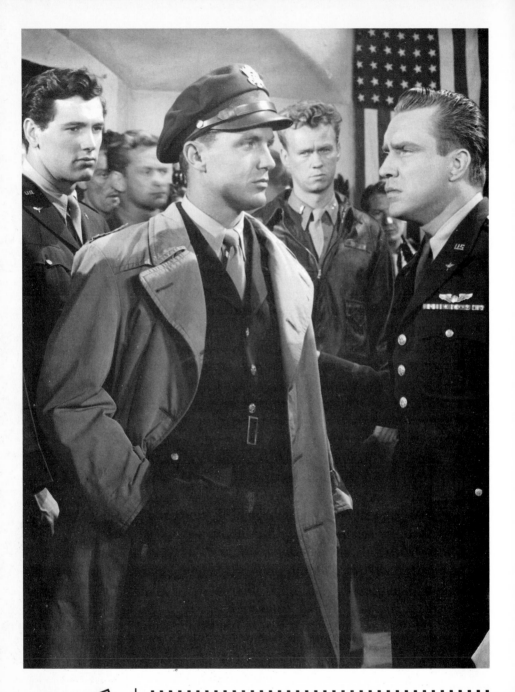

This scene pretty much sums up Rock Hudson's contribution to *Eagle Squadron:* standing around and keeping out of the main action. It's remarkable how inept he was at simply observing what was going on around him.

ROCK HUDSON

······

FIGHTER SQUADRON
(1948)

No one is born into this world with a name like Rock Hudson—but Roy Scherer, Jr., that's another story. Childhood and adolescence entailed constant run-ins with his sadistic and drunken stepfather, dealing with the stigma of being lower-middle-class in the gilded community of Winnetka, Illinois, and coping with extreme shyness. Roy's greatest joy was going to movies and plays, but despite already having leading-man looks, he was never cast in school plays because he simply couldn't remember lines. His joining the Navy immediately after graduating high school in 1944 was less an attempt to escape an unhappy home life than a simple recognition of reality: The draft board was going to get him anyway, so he might as well chose what service to enter. In the Navy, Roy was shipped to the South Pacific and given work as an airplane mechanic, but after V-J Day he was reassigned to an area where

············

Rock Hudson basically just had to stand there, and he had a hard time bringing it off.

CAST

EDMOND O'BRIEN, ROBERT STACK, JOHN RODNEY, TOM D'ANDREA, HENRY HULL, JAMES HOLDEN, WALTER REED, SHEPPERD STRUDWICK, ARTHUR SPACE

······

WARNER BROTHERS
DIRECTED BY RAOUL WALSH
SCREENPLAY BY SETON I. MILLER AND MARTIN RACKIN
PRODUCED BY SETON I. MILLER
CINEMATOGRAPHY BY SID HICKOX AND WILFRED M. CLINE

his services would be more beneficial in the postwar environment—the laundry room. (There was nothing out of the ordinary about his stint in the service, but his cousin Betty clucked that before enlisting "He liked girls. . . . It was in the Navy that he changed.")

After the war, Roy moved to California, where he got the rude awakening that, even with the GI Bill of Rights, he couldn't just walk into USC, not with his crummy high school grades. In lieu of higher education, he opted for a job as a truck driver and dreamed of breaking into the movies, something he had first fantasized about when, as a teenager, he had seen the lithe, sinewy Jon Hall dive off a mountain in some South Seas epic. The long-accepted lore about the way Roy Scherer became Rock Hudson and entered films focuses on one of the casting directors with whom he had dropped off head shots. Henry Willson was working for David O. Selznick at the time but was champing at the bit to start his own agency; he was also known around Hollywood for being on the prowl for good-looking young things, seducing them by plying them with promises of stardom. Sizing up the nervous but hunky greenhorn, Willson liked what he saw and believed the women of America might be similarly smitten. Because he found "Roy Fitzgerald" (Roy had taken his evil stepfather's surname) too long and prosaic, Willson set out to rename his find. Later he gurgled on about how he came to dream up the appellation that would beckon millions of movie fans into theaters: "I tried to think of something strong and big. Rock of Gibraltar. Hudson came from the Hudson River, for no reason. I knew that was it. Rock Hudson." (Over the years, Willson became renowned for coming up with these macho *noms de cinéma*, transforming Arthur Gelien into Tab Hunter, Carmen Orrico into John Saxon, and Merle Johnson, Jr., into Troy Donahue.)

Researching the book *Rock Hudson: His Story*, however, writer Sara Davidson determined that Willson

hadn't actually christened Rock Hudson after all. In 1947, Roy Fitzgerald was having his first serious relationship, with a well-connected radio producer named Ken Hodge. At an afternoon cocktail party before Roy had even met Henry Willson, Hodge told his guests that his young friend was looking to break into movies and invited them to create a more marquee-friendly name. Someone came up with Rock, another with Hudson. *Voilà!*

Even though Henry Willson took undue credit for the name, no one else played a more significant role in launching the career of Rock Hudson. Meeting him at a party, Willson told him to drop by his office the next day. Twenty-four hours later, Rock Hudson had an agent. Willson realized that the callow young man had a long way to go before he could be taken seriously as screen material, so he shelled out for lessons in acting and diction. The agent used his contacts to arrange screen tests at several studios, but when casting directors saw the results they thought Willson had to be kidding. Raoul Walsh, though, figured otherwise. As someone who had been directing movies since 1914, Walsh wasn't deluding himself about Hudson's thespian skills, but he did allow "He'll be good scenery."

• • • • • •

Walsh signed Hudson to a very small role in *Fighter Squadron,* a movie about Air Force fliers stationed in England. Twelve actors received onscreen billing in the film's credits; Rock Hudson was not one of them. The movie deals with conflicts arising between pilots who hanker to attempt daring, unorthodox maneuvers to pulverize the enemy and by-the-book, deskbound generals who don't have a clue. The fliers are, of course, proved right, and stars Edmond O'Brien and Robert Stack (who a decade later would be playing second leads to Hudson) are given the opportunity to engage in some pretty far-fetched aerial histrionics. Director Walsh is, as always, expert in con-

• • • • • • • • • •

In his first film, Rock Hudson did not get screen credit. He worked for director Raoul Walsh again in 1953's *The Lawless Breed.* This time, Hudson received top billing.

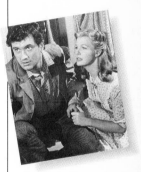

Hudson in *The Lawless Breed.*

• • • • • • • • • •

Robert Stack was the leading man in *Fighter Squadron,* with Rock Hudson providing little more than window dressing. By the time they made Douglas Sirk's *Written on the Wind* in 1956, Hudson had become a huge box-office attraction and Stack was the supporting player (although the drunken ne'er-do-well Kyle Hadley was such a potent role, it earned Stack an Academy Award nomination).

With Stack in *Written on the Wind.*

veying an acute sense of camaraderie among good-natured, fatalistic men of action, and the war scenes are expertly handled by the second unit, but essentially the movie is a mass of clichés. (Ironically, the garish color photography of *Fighter Squadron,* instead of having the intended effect of heightening realism, makes World War II look like a cheerful Technicolor fantasy: You almost expect Carmen Miranda to go zipping by in a plane.) Besides its status as Rock Hudson's first film, *Fighter Squadron* is notable only for being the first World War II movie to go into production after the war was over; it was thought that having been back home for a couple of years, all those ex-soldiers would now pay to see their heroics re-created on the screen, and a whole spate of other (more successful) such films would soon follow: *Twelve O'Clock High, Battleground,* and *Sands of Iwo Jima.*

Hudson's character doesn't have a name in the movie; he's just a guy in the squadron. Director Walsh did, however, give him a relatively large amount of screen time; although he doesn't say much, he has eight scenes, usually standing near Edmond O'Brien or Robert Stack when they're doing a bit of business. In his first onscreen moment, he wears a hangdog expression as part of a trio listening to a captain brag about his romantic exploits. Hudson's initial bit of dialogue comes a few minutes later during a crap game, when he bets against a player who needs to roll a four. Putting his wallet on a table, he bellows, "All that says he doesn't." One of Hudson's few other lines occurs when an officer is toting the squadron's aerial successes on a black-board. Hudson liked to tell the story that it took him more than three dozen takes to be able to say, "Or we're gonna need a bigger blackboard." In fact, Walsh may have thrown up his hands over the actor's ineptitude, because the dialogue is heard off-camera and was likely dubbed in later. Hudson seems sheepish throughout; flashing an inappropriate nervous grin in many scenes, he resembles an eager-to-please pup.

After filming, director Walsh signed Hudson to a personal contract. Over the course of a year, he didn't put the actor in any other films, but he did use him as a chauffeur and had him paint his house and clean his windows. In 1949, Walsh sold his contract to Universal-International, which, specializing in undemanding juvenilia featuring good-looking young people, was the perfect place for Hudson. During his first year at the studio, Hudson had small parts in half a dozen films, playing everything from an Indian named Young Bull in *Winchester '73* to an Arabian Knight in *The Desert Hawk* (typical casting at Universal in those days). A supporting role in a 1951 movie called *The Iron Man* changed everything for the actor. In the film, he had a boxing scene with star Jeff Chandler. When female audiences got a load of Hudson's torso in the ring, the volume of fan mail he received forced the studio brass to take notice. Hudson was suddenly a hot property, and there were no more supporting roles.

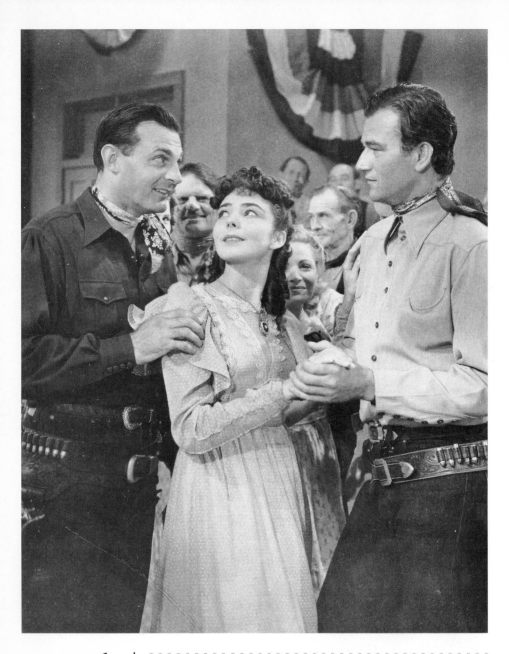

If it had been 1950, then making your first film appearance opposite John Wayne would have been a big deal— at mid-century he was the number one star in America. In 1939, however, the Duke was just another minor cowboy actor. And besides, Phylis Isley (that's Jennifer Jones to you) had dreams of being an illustrious dramatic actress, not of decorating a low-budget Western.

JENNIFER JONES

······

NEW FRONTIER
(1939)

She was born in Tulsa in 1919 as Phylis Isley. Her parents—who misspelled her first name—ran a tent show that traveled through Oklahoma and Texas. From early on, little Phylis dreamed of being an actress, but Ma and Pa figured a kid this timid didn't stand a chance. Reasoning that the only way to conquer your fears is to confront them, Phil Isley threw his daughter into the thick of things—he put her to work at the candy concession. Every once in a while, he did toss her way a walk-on part in one of their productions. Phil Isley went on to own a small chain of movie theaters, and his teen age daughter spent much of her spare time watching films. Unlike most other star-struck youngsters of the period, who doted on Joan Crawford or Constance Bennett, Phylis chose for her idol Katharine Cornell, an odd choice since the woman didn't even make movies. Eager for an acting career, Phylis wrote to Cornell, asking which would be more advantageous, college or drama school. The

CAST

JOHN WAYNE, RAY CORRIGAN, RAYMOND HATTON, PHYLIS ISLEY (JENNIFER JONES), EDDY WALTER, LEROY MASON

······

REPUBLIC
DIRECTED BY GEORGE SHERMAN
SCREENPLAY BY BETTY BURBRIDGE AND LUCI WARD
PRODUCED BY WILLIAM BERKE
CINEMATOGRAPHY BY REGGIE LANNING

great actress responded with none of the above, advocating instead a "cultural background." Yeah, and good luck, kid, finding it in Depression-era Oklahoma.

Having briefly attended Northwestern University, the Isley girl decided real culture lay in New York City, specifically at the American Academy of Dramatic Arts. After Phylis passed the admission test, her parents dropped her off at that perennial depository of nice young girls alone in the city, the Barbizon Hotel for Women. Within a year, she fell in love with another AADA student, Robert Walker, became engaged and followed his lead by dropping out of school. When the Isleys got wind of things, they came to Manhattan to investigate and were appalled that their Phylis was working at a hole-in-the-wall theater in that hotbed of bohemia and bolshevism, Greenwich Village. They hightailed it back home and, making use of their sundry contacts in the Tulsa entertainment world, procured for their daughter her very own radio show, *The Phylis Isley Radio Theatre*. Not only that, but her fiancé could be the leading man, and they'd each make $25 a week! Capping it all off, Phylis and Bob were married early in 1939. The program got canned after 13 episodes, but, undaunted, the couple figured that even though Tulsa didn't want them, there was still Hollywood. Granted, thousands of young hopefuls poured into Southern California every month, but the newlyweds had something those other kids didn't: a letter of introduction from her father, and since he was a theater owner, that should count for something.

· · · · · ·

Unfortunately, Phil Isley was an independent theater owner and therefore couldn't peddle much influence with the major studios, which possessed their own movie houses. But a small Poverty Row studio like Republic needed the Phil Isleys of the world. Republic's forte was junk—some of it amiable junk, the rest just junk—but having to choose between the

grandiose callings of her artistic muse and the growlings of her stomach, Phylis agreed to a six-month contract. Her first assignment was *New Frontier,* an entry in the Three Mesquiteers Western series. The Mesquiteers were a trio of cowboys inspired, in a half-assed way, by Alexander Dumas's characters. Although Republic had been making these films since the birth of the studio in 1935, there was no consistency or coherence to them, since the three lead actors constantly changed and the trio's personalities varied from entry to entry. *New Frontier* marked John Wayne's eighth and final appearance as a Mesquiteer, and, coming several months after John Ford's *Stagecoach* had begun to nudge his career out of the B-minus film ghetto, it would be the last out-and-out cheapie film he would make. (The only way this superpatriot became a major star, however, was by staying in Hollywood during World War II and taking leading-man roles that would otherwise have gone to actors who were off fighting.)

Like most B Westerns, *New Frontier* was intended for children and undemanding rural audiences and, as such, presents one-dimensional cardboard characters involved in an utterly simplistic plot. (These oaters did play grind houses in urban centers, although the *New York Times,* for one, didn't consider them fit to review so they never appeared in that paper of record. And the likelihood that Isley's favorite star, Katharine Cornell, would catch her first movie was nil.) Containing several fistfights, a couple of shootouts and innumerable shots of groups of people on horseback, *New Frontier* is essentially standard issue. House director George Sherman, who would still be churning them out with John Wayne 30 years later, belonged—by necessity, given the studio's mingy ways with a budget—to the "roll the cameras and print it" school of filmmaking.

Despite its insignificance, the movie does have a certain fascination because of its undercurrent of an almost reactionary distrust and anger toward govern-

Seven years after *New Frontier,* Jennifer Jones would return to the sagebrush in *Duel in the Sun* (below), in which she brought a startlingly ferocious carnality to the role of an oversexed half-caste (the film's famous nickname was "Lust in the Dust"). As narrator Orson Welles describes her, she is "Pearl, who came from down along the border, and who was like a wildflower sprung from the hard clay, quick to blossom, early to die." In contrast to her shabby debut film, *Duel in the Sun* was, at the time, the most expensive Western ever made.

ment, traits not uncommon in B Westerns. The plot has to do with the citizens of New Hope Valley, who, on the 50th anniversary of the founding of their town, learn that the state is taking possession of their land in order to turn the area into a reservoir. Outraged by this intrusion into their lives, the good people of New Hope Valley, in their righteous indignation, react by trying to kill the project's contractors and engineers. The Three Mesquiteers inform the citizenry that eminent domain is legal and, acting on advice from a slick developer, convince them to use their government checks to buy land in another valley. The Mesquiteers, however, have been hoodwinked: The supposed Promised Land is actually desert. Justice, of course, prevails as the bad guys get theirs in the end and the citizens are allowed to hang around until the new New Hope Valley is irrigated and made even more fertile than the old. Even with the happy ending, the inclusion in the scenario of crooked politicians and Big Brother government makes it seem as if the film is trying to ferment distrust of the New Deal in unformed little minds. Not to mention that the reservoir in question will be used to provide water for a *city* (read: home of people of loose morals and immigrants).

Phylis Isley plays the granddaughter of the founding father of New Hope Valley. While she is technically the leading lady, the part couldn't be called the romantic interest because these movies contained no such animal, little boys in the audience finding such things yucky. The closest Isley and John Wayne get to a romantic clinch is a short, antiseptic whirl around the dance floor at a community supper.

Variety, which complained about the "trite dialogue and transparent situations" of *New Frontier*, noted that Isley "debuts in this one but the part has little enough to give her a good chance." Lamenting that the movie "lacks the action and honesty that goes to make a western amiable entertainment," Wanda Hale of the *New York Daily News* weighed in with "Besides the Mesqui-

teers, we see Phylis Isley, a cute new girl." There is
something both touching and slightly hilarious in see-
ing this veteran of the American Academy of Dramatic
Arts gamely giving it her best shot, even though she's
stuck with a cast that, let's face it, didn't give a damn
about acting technique. As an actress, she often pos-
sessed an ethereality that would later serve her well when
playing a strange girl who has religious visions in her
Oscar-winning *The Song of Bernadette* or a dead girl
having a love affair in her best film, *Portrait of Jennie*.
On horseback, however, her gossamer quality is a little
weird, and Isley is a distinct contrast to the down-to-earth
good-time girls who usually populated these movies.

Phylis Isley made one more movie for Republic,
a serial called *Dick Tracy's G Men*, and then she and
Robert Walker—who, with three bit parts, fared even
worse than his wife—returned to New York in the fall
of 1939. Having given birth to two sons, Isley was
itching to act again, and in the summer of 1941 she
met producer David O. Selznick, the Svengali who
would change her name and change her life. Signing her
to a seven-year contract, he guided her career and, in
1949, married her. When she showed up as Jennifer
Jones in *The Song of Bernadette*, Selznick's publicity gave
her a huge buildup, presenting her as his find and
claiming that she was absolutely "new to films." Phylis
Isley was dead, buried and forgotten. To the *Brooklyn
Eagle*, "Jennifer Jones makes the most auspicious debut
in Hollywood history. . . . A bow to David O. Selznick
for her discovery." Oh, well, what's the point of having
a publicity department if it can't lie for you?

After being killed ten minutes into *Kiss Me Deadly*, Cloris Leachman makes a return engagement—on a mortuary slab. Gumshoe Ralph Meeker and mortician Percy Helton take a gander. The wonderfully porcine Helton is about to get his fingers crushed in a drawer by Meeker's Mike Hammer, who gets off on such things.

CLORIS LEACHMAN

......

KISS ME DEADLY
(1954)

When you visualize Cloris Leachman as the lonely Ruth Popper in her Oscar-winning *The Last Picture Show*, it's hard to believe this haggard-looking woman was actually one of the five finalists in the Miss America pageant. (That's movie makeup for you.) Chosen Miss Chicago of 1946, the 20-year-old dropout from Northwestern University—which she attended on an Edgar Bergen Scholarship—decided to remain on the East Coast after the Atlantic City contest. Even before she was a beauty pageant contestant, Leachman had hosted a radio program, doling out advice to Des Moines homemakers. In New York she branched out to the new medium, appearing on many early television programs, ranging from televised plays to a game show to the *Bob and Ray* program. She also studied at the Actors Studio, making her Broadway debut in a short-lived Studio production. In 1950, Leachman

By getting herself killed in her first film, Cloris Leachman set the stage for one of the most glorious cinematic achievements ever.

CAST

RALPH MEEKER, ALBERT DEKKER,
PAUL STEWART, MAXINE COOPER,
GABY ROGERS, WESLEY ADDY,
JUANO HERNANDEZ, NICK DENNIS,
CLORIS LEACHMAN,
JACK LAMBERT, JACK ELAM,
PERCY HELTON

......

UNITED ARTISTS
DIRECTED AND PRODUCED BY
ROBERT ALDRICH
SCREENPLAY BY A.I. BEZZERIDES
EXECUTIVE PRODUCER: VICTOR SAVILLE
CINEMATOGRAPHY: ERNEST LASZLO

appeared in another flop called *Story for a Sunday Afternoon,* but, like several other people in this book, won a Theatre World Award as a promising newcomer. Her stage work ranged from summer stock at the Westport Playhouse to *As You Like It* with Katharine Hepburn to commercial Broadway comedies. Referring to one of the last, the *Newark Sunday News* leered, "Patrons at *King of Hearts* drool nightly over the way she fills an evening gown."

This Pavlovian effect brought her to the attention of Robert Aldrich, the young producer-director who was having a go at Mickey Spillane. The rub, though, was that Aldrich found Spillane's Nietzschean superman of a private dick, Mike Hammer, a contemptible Neanderthal. As a result, Aldrich fashioned *Kiss Me Deadly* into a film that operates on several different levels: a debasement of the crude machismo of Spillane and Hammer, which was the stuff of dreams for millions of ineffectual postwar American males; a black comedy about American paranoia at midcentury; and a febrile political parable on the suspension of civil liberties in the McCarthy era. Moreover, Aldrich did so with amazingly kinetic visual storytelling unlike anything that had come before it. The unerring use of jump cuts, the startling camera placements and the striking imagery, which visually conveys a prodigious amount of unspoken information about the characters, had a profound effect on such French New Wave directors as Jean-Luc Godard and Claude Chabrol.

■ ■ ■ ■ ■ ■

Cloris Leachman is the movie's first—jolting—image, even before the credits roll. The whole ethos of *film noir* can be summed up in this opening tracking shot: We see the legs of a barefoot woman running on a highway at night, and the only thing we hear is her exhausted panting. People don't get any more desperate than this. A cut to her upper torso reveals that the woman is wearing only a trench coat,

and her heavy breathing is now accompanied on the soundtrack by the blaring brass of Frank DeVol's score. After two cars pass her by, she stands in the middle of the road and assumes a Christlike pose of supplication, forcing a car to stop. In the automobile is Mike Hammer (Ralph Meeker), and what is this gallant hero's response to a lady in distress? A surly "You almost wrecked my car."

Once Leachman is in the vehicle, we get the credits, which give another indication of the worldview of this film: They roll from the top of the screen to the bottom, and this inversion of the norm immediately turns our expectations upside down. (At one point the wording on the screen reads "Deadly/Kiss Me/Spillane's/Mickey"). A police blockade reveals that Leachman's character, Christina, is an escapee from a mental asylum (or, as Hammer puts it in his own incomparable way, "a fugitive from a laughing house"). Once she composes herself, Christina quietly lacerates Hammer's life-style, making fun of his need to drive a sporty Jaguar and analyzing, "You're the kind of a person who never gives in a relationship." She was named after Christina Rossetti, and the look of total disdain she gets after asking the detective if he reads poetry tells us exactly how Robert Aldrich feels about Hammer.

An automobile suddenly cuts in front of them and, to the aural accompaniment of Christina's screams, Aldrich cuts to another shot of her bare feet, but this time they are dangling off the ground because her body is skewered on a meat hook. Her corpse is then put in the Jaguar with the injured Hammer and pushed over a cliff. Leachman has just under 10 minutes on the screen, although later she shows up as a stiff in the morgue. Despite her limited screen time, she has the opportunity to cover a range of emotions—terror, cynicism and coquettishness—and she conveys all of them with a haunting quality that is hard to shake off.

Hammer spends the rest of the film tracking down Christina's killers (although in his personal "code of

Reviewers of *Kiss Me Deadly* tended to group Cloris Leachman with the two other main actresses in the film, Gaby Rogers and Maxine Cooper. In fact, in posters and advertising for the movie, all three were referred to as "The Spillane Dames."

"The femmes are well equipped for the s.a. [standard attributes] demands of their parts."
—*Variety*

"The actresses use many strange styles of diction (some of them effective), but you begin to wish that some of them would relax and talk like straight human beings."
—*Hollywood Reporter*

• • • • • • • • • • •

Kiss Me Deadly achieved some notoriety when the censor for the CBS affiliate in New York refused to allow commercials for the movie to air on his station. His reasoning was that the film "has no purpose except to incite sadism and bestiality in human beings."

honor," his pursuit derives as much out of a need for revenge over being roughed up himself and having his car wrecked as from avenging a young woman's murder). The film's dominant imagery is of staircases, which Hammer constantly climbs up and down, a Sisyphus who expends much energy but figuratively gets nowhere in his quest because he's a chump who's in over his head. Ultimately the gumshoe stupidly gets double-crossed by a oddly gaminelike femme fatale (Gaby Rogers) and discovers that the film's many killings were over "the great whatsit": a black box containing atomic material. Aldrich's ultimate joke is that Hammer's ineptitude leads to this Pandora's box being opened, blowing up a Malibu beach house and, by extension, destroying the whole world. We never even see Hammer and Velda, his absurdly devoted girl Friday (Maxine Cooper), escaping intact from the inferno. Some hero. *Kiss Me Deadly* is nonnegotiably a great movie, worthy of much more detailed discussion than I have the space for (and which it has received in numerous scholarly journals and books). American reviewers at the time had no appreciation for the film. In fact, *Kiss Me Deadly* wasn't even reviewed by the *New York Times.*

A year after *Kiss Me Deadly,* Cloris Leachman had a small role in *The Rack,* starring Paul Newman, and then, except for a tiny one-shot appearance in *The Chapman Report,* stayed away from motion pictures until *Butch Cassidy and the Sundance Kid* in 1969. In the interim, she did a couple of Broadway plays, preceded June Lockhart as Timmy's mom for one season on *Lassie* and made guest appearances on other television programs. Mostly, though, she raised her five children. Only when they were older, in the early 1970s, did the actress come into her own, with Emmys, an Oscar, her own TV series (*Phyllis*) and a seemingly endless array of motion pictures and TV movies.

MARSHA MASON

······

HOT ROD HULLABALOO
(1966)

The official biography of Marsha Mason goes something like this: Born in St. Louis in 1942 and named after film actress Marsha Hunt, she grows up mad about the movies. Sixteen years of parochial education culminate in 1964 with a B.A. from the all-woman, all-Catholic Webster College. From there it's on to New York for a career as an actress; before producers summon her, though, there are stints as a department store sales clerk and a go-go girl. Then comes work in her chosen field: roles in commercials and two Off-Broadway plays, including Israel Horowitz's successful *The Indian Wants the Bronx*. (When Mason leaves that show, her replacement is Jill Clayburgh, who a dozen years later would be one of her fellow losing nominees for the 1979 Best Actress Oscar.) There are eight months on the soap opera *Love of Life* and, finally, Broadway. Late in the run of the comedy *Cactus Flower* Mason takes over the "kook" role that Gol-

Marsha Mason likes to think it never happened.

CAST

JOHN ARNOLD,
ARLEN DEAN SNYDER,
KENDRA KERR, RON CUMMINS,
VAL BISOGLIO, MARSHA MASON,
WILLIAM HUNTER

······

ALLIED ARTISTS
DIRECTED BY WILLIAM NAUD
SCREENPLAY BY STANLEY SCHNEIDER
PRODUCED BY MARTIN L. LOW
AND WILLIAM NAUD
CINEMATOGRAPHY BY
THOMAS SPAULDING

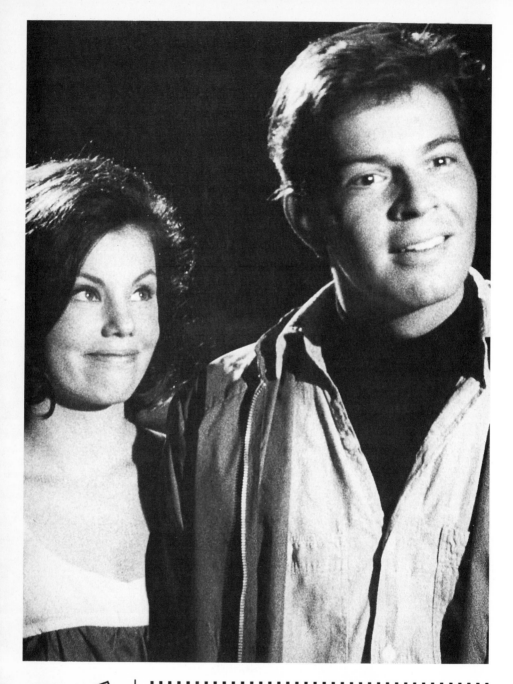

Although Marsha Mason's official biography doesn't let you know she once made a movie called *Hot Rod Hullabaloo,* she doesn't look particularly distressed by it here. In fact, she seems absolutely eupeptic about the whole enterprise.

die Hawn would play in the movie, and reprises it in the national tour.

The first whiff of official acclaim comes in the guise of a critics' poll conducted by *Variety* citing Mason as Most Promising Actress—Off-Broadway division—for Kurt Vonnegut's *Happy Birthday, Wanda June.* Any movies in her future? Could be, because she auditions for director Paul Mazursky. There's no time to worry about whether she'll get the role, however, because someone at the American Conservatory Theatre in San Francisco seems to remember that sometime somewhere she had enacted the ingenue role in Noël Coward's *Private Lives* and the company needs a last-minute replacement bad. Rather than confess that she actually has never played Sybil, Mason learns the play over the weekend and two days later slaps on the greasepaint for Francis Ford Coppola's production. Never a dull moment when you've got a life in the theater. But now, suddenly, it's going to be a life in the movies as well: Paul Mazursky gives her the smallish part she had tried out for in *Blume in Love,* and then she gets to costar with James Caan as a hooker in *Cinderella Liberty* and—can it really be true?—an Academy Award nomination for the little-known actress. Then, to complete the Cinderella story, there's a tryout for the new Neil Simon play, and she winds up not only with the role but with the playwright. And so on and so forth.

· · · · · ·

What's wrong with this picture? Only that Marsha Mason has always managed to omit one fairly significant fact about her life, namely that, before she ever stepped onto a New York stage, she appeared in a movie called *Hot Rod Hullabaloo.* And although a film with a title like that is bound to be a career embarrassment, it was the first time Mason was paid to act, so we assume that back in 1966 she was tickled pink to get it. In addition, the movie afforded her the opportunity to leave her cold-water Manhattan

· · · · · · · · · ·

During the time she was married to Neil Simon, the majority of Marsha Mason's films were written by her husband. Other actresses also had a conjugal connection with a behind-the-scenes power on at least a couple of movies.

Julie Andrews:
The Tamarind Seed, 10, S.O.B, Victor/ Victoria, and *The Man Who Loved Women* directed by Blake Edwards

Jean Arthur:
The Devil and Miss Jones and *A Lady Takes a Chance* produced by Frank Ross, and *The More the Merrier* co-written by him

Anne Bancroft:
Silent Movie written by Mel Brooks, and *The Elephant Man* and *To Be or Not to Be* produced by his company

Joan Bennett:
The House Across the Bay, Scarlet Street, Secret Beyond the Door and *The Reckless Moment* produced by Walter Wanger

flat and breathe the clear fresh air of Silver Spring, Mary-
land, where it was shot.

Made on a piddling budget, with ads holding out
the promise of "Drag Racing! Demolition Derbys!
Chicken Racing!", *Hot Rod Hullabaloo* was designed to
be unspooled at rural drive-in theaters, where the undis-
criminating young people in their cars were not there
primarily to watch a movie anyway. If any of them did
happen to look up at the screen while their dates went
to the refreshment stand or the bathroom, they wit-
nessed a whole lot of low-grade nonsense. *Hot Rod Hulla-
baloo* focuses on a group of high school students, divided
into the kids who like hot-rodding and are good and
the kids who like hot-rodding and are bad, all played
by actors looking rather aged for their assignments.
The film kicks off with one of the good kids challeng-
ing a bad kid to a game of chicken. The good kid is
killed, not by going off a cliff à la Corey Allen in *Rebel
Without a Cause*, but by a gun the bad kid has somehow
managed to rig up in his car. Our hero, Luke (John
Arnold), and his girlfriend, Cindy (Kendra Kerr), have
their hands full. Luke and his pals are worried that
they'll be forced to hang out on the street corner
because the local busybodies, who can't differentiate
the good kids from the bad, are trying to shut down
the dragstrip that's their home away from home.
Thinking that Luke is a no-good speed demon, Cindy's
dad says, "Cindy, you can't see him anymore." The bad
kid works for a bad man, a mechanic who sells Luke's
brother a lemon. The bad man apparently isn't out for
repeat business because when brother complains, he beats
him up and tries to crush him under a grease rack.

And so it goes. The bad kid gets a look at flirta-
tious Marsha Mason and tries to rape her. Her boy-
friend punishes him by . . . challenging him to another
bout of chicken. Because the "hullabaloo" of the title
was an attempt to rip off the rock-and-roll TV show,
the melodramatics are occasionally interrupted by mu-
sical numbers giving the hot-rodders a chance to frug

and do the jerk. Wanting to show Cindy's dad that he's a bit of all right, Luke studies his hardest for a scholarship test for trade school, but he's got a delicate sensibility and is so upset by all the unpleasantness caused by the bad kid that he flunks. Brother tells him not to worry, they'll build a dragster and win tuition money in a race. If Luke were more contemplative, he might be asking how, if there's a God, He could be so cruelly unjust, because, after he and brother expend buckets of sweat to create their masterpiece, the car is damaged in the time trials and they have no cash to fix it. But some other good kids donate a piece of junk for them to drive in a demolition derby so that they can win some money in order to fix their dragster, so that they can win some more money so that Luke can go to school, so that he can win over Cindy's dad. Meanwhile the bad kid is preparing for the drag race, once again installing his gun, but when another bad kid sees him . . . Oh, enough already. But you should know that the bad kid gets killed when his gun misfires after Cindy sticks a pencil in the barrel. Come to think about it, you can't blame Marsha Mason for doing her best to eradicate *Hot Rod Hullabaloo* from her personal history.

of an American Wife, and A Farewell to Arms produced by David O. Selznick

Gene Rowlands: A Child Is Waiting, Faces, Minnie and Moskowitz, A Woman Under the Influence, Opening Night and Love Streams directed by John Cassavetes

Norma Shearer: Private Lives, Strange Interlude, The Barretts of Wimpole Street and Romeo and Juliet produced by Irving G. Thalberg

Joanne Woodward: Rachel, Rachel, The Effect of Gamma Rays on Man-in-the-Moon Marigolds, Harry and Son and The Glass Menagerie directed by Paul Newman

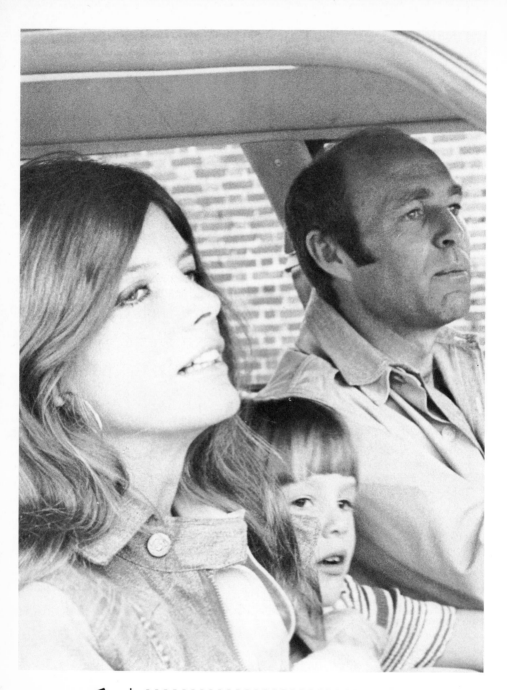

Mary Stuart Masterson goes for a spin with her screen mother, Katharine Ross, and her real-life father, Peter Masterson, who while a terrific guy in real life, was a husband from hell in *The Stepford Wives*.

MARY STUART MASTERSON

......

THE STEPFORD WIVES
(1974)

Born in 1967, Mary Stuart Masterson is the daughter of actor-writer-stage director Peter Masterson and actress Carlyn Glynn. Not until 1978, when her father cowrote and codirected, and her mother starred in and won a Tony for, the Broadway musical *The Best Little Whorehouse in Texas,* did Masterson's family get on firm ground in terms of both bankability and money in the bank. Therefore, back in 1974 when Peter Masterson got a costarring role in the film version of Ira Levin's best-seller *The Stepford Wives,* it was a gala occasion. Since his character had two young daughters, why waste time trying to find a little girl who looked as if she might have inherited some of her screen father's genes when you could have the real thing? Hiring Peter Masterson's true-life daughter made perfect sense, and seven-year-old Mary Stuart headed to Westport for filming.

Directed by Bryan Forbes, a veteran of British

CAST

KATHARINE ROSS,
PAULA PRENTISS,
PETER MASTERSON,
NANETTE NEWMAN,
PATRICK O'NEAL, TINA LOUISE,
CAROL ROSSON, WILLIAM PRINCE,
PAULA TRUEMAN,
REMAK RAMSAY, JOSEF SOMER

......

COLUMBIA
DIRECTED BY BRYAN FORBES
SCREENPLAY BY WILLIAM GOLDMAN
PRODUCED BY EDGAR J. SCHERICK
CINEMATOGRAPHY BY OWEN ROIZMAN

In 1985, the shy gamine in the Catholic boys' school comedy *Heaven Help Us* struck me as the most wonderful new face I had seen in years. How was I to know that I had laid eyes on her a decade earlier? She didn't look the same.

Introducing Mary Stuart Masterson

Mary Stuart Masterson's first screen line (other than a perfunctory "Thank you" to a doorman): "Daddy, I just saw a man carrying a naked lady."

kitchen-sink movies, *The Stepford Wives* is science fiction about a suburb where the women all behave like devoted followers of Marabel Morgan's *The Total Woman,* blissfully doing housework, cooking gourmet meals and living to please their men. Leading lady Katharine Ross and her friend Paula Prentiss, both newcomers to town, discover that the village's wives have been replaced by robots, and Ross finds out that her husband, Peter Masterson, wants in on the action. Mildly satiric, both about the women's movement and what used to be referred to as male chauvinist pigs, *The Stepford Wives* might have made a diverting episode of *The Twilight Zone,* but stretched to two hours it wears pretty thin. There's not much more to the movie than its premise, and since the town's secret was common knowledge in 1975, actually sitting through the movie became superfluous. "Something strange is happening in the Town of Stepford," said the ads, but what Frank Rich, writing in the leftie magazine *New Times,* saw was "a classic example of how Hollywood tries to exploit a 'topical' issue without ever bothering to find out its substance.

Mary Stuart Masterson, who received 22nd billing, has very little to do as Kim Eberhard: going to the supermarket with her parents, riding on the school bus, hanging out around the Fairfield County house and playing in the yard—standard little-girl things. She is basically indistinguishable from Ronny Sullivan, who plays her sister, Amy (Mary Stuart's hair is slightly longer). In fact, the two girls are so peripheral to *The Stepford Wives* that we never hear their names until more than 90 minutes into the movie; up till then they're simply referred to as "the kids," "the girls," "Sweetie" or "you guys." Mary Stuart does have two dramatic moments. One is when she can't sleep after the family has just moved to Stepford, and she says to Katherine Ross of her stuffed animal, "I think Teddy's gonna cry all night." The other is when she and her sister live every child's nightmare: walking in on an argument between the parents. "Are you two fighting ?" she inquires.

She's a cute towheaded child, but there is nothing in her performance to indicate the extraordinary actress she would grow up to be, with her seemingly thaumaturgic mixture of fragility and free-spirited toughness. But even back then the wheels were turning. During one scene, set late at night, director Forbes asked her to pep up her entrance into a room. "Why?" she inquired. "It will be better," the director explained. "We want to see your lovely face." "But it's supposed to be late at night and I'm supposed to have just woken up," protested the little actress. "I should be tired!"

After this one stint in the movies, Masterson's parents decided she would have a more grounded childhood outside the limelight, for which she was grateful. "They helped me stay on track as a person with my first priority being experience," she said. "They told me, 'You can't play a person unless you are one.'" She did perform in productions at New York's Dalton School and on Broadway at age 15 in Eva Le Gallienne's version of *Alice in Wonderland,* enacting two roles, the Four of Hearts and the Small White Rabbit. Masterson was 17 when she returned to films as Dani, the vulnerable working girl in *Heaven Help Us.* Except for an eight-month dry spell after completing the film— during which she entered New York University to study anthropology—she hasn't slowed down. She graced a number of films of varying quality (*At Close Range, Some Kind of Wonderful, Funny About Love*) that had one thing in common: Hardly anybody came to see them. As Masterson put it, "I'm lucky not to be considered box-office poison." After playing Idgie in 1991's *Fried Green Tomatoes* she was anything but.

ALL GROWN UP

Mary Stuart Masterson in *Heaven Help Us.*

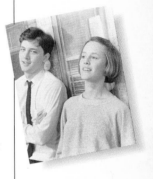

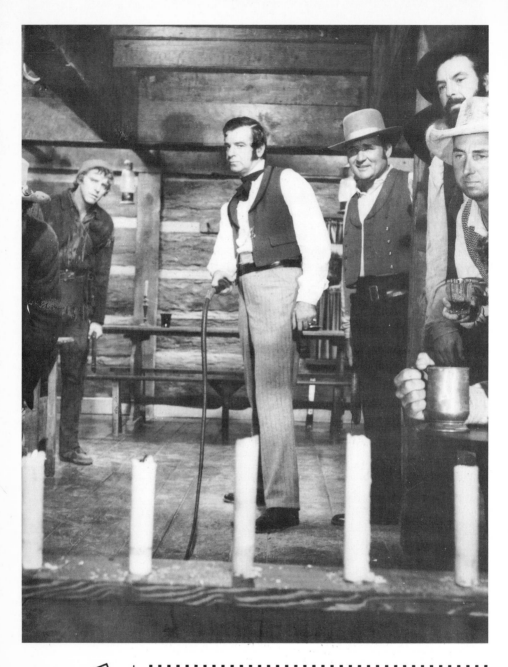

In his later career Walter Matthau would make a specialty of curmudgeonliness, but in *The Kentuckian* he was downright sadistic. Here he engaged in his favorite lesiure-time activity—whipping candles. Next to him is Burt Lancaster; Matthau later has a go at him, too.

WALTER MATTHAU

.

THE KENTUCKIAN
(1955)

A product of New York's Lower East Side, Walter Matthau said, "I learned at a very early age that we were living in a ghetto. We didn't have a quarter. I knew before anybody else that we were all waiting for Godot." Referring to that poverty-stricken childhood as "a nightmare," he recalled, "My older brother Harry and I slept in the same bed. My mother slept in the kitchen in the bathtub. The place was about 12-foot-square." He began working in refreshment stands at local Yiddish theaters at age 11, a billet that not only helped out the finances of the Matuschanskayasky family (is it any wonder he changed his name?), but also inspired him to consider a life in the theater; before he was through, he even got to perform small roles before rushing offstage at intermission to man the candy counter.

Among the positions Matthau held after his 1939 high school graduation were boxing instructor at a Police Athletic League club and factory

.

Walter Matthau did not look at home on the range.

CAST

BURT LANCASTER, DIANNE FOSTER, DIANA LYNN, DONALD MACDONALD, WALTER MATTHAU, JOHN MCINTIRE, UNA MERKEL, JOHN CARRADINE, JOHN LITEL, RHYS WILLIAMS

.

UNITED ARTISTS
DIRECTED BY BURT LANCASTER
SCREENPLAY BY A.B. GUTHRIE, JR.
PRODUCED BY HAROLD HECHT
CINEMATOGRAPHY BY ERNEST LASZLO

· · · · · · · · · ·

Walter Matthau
wasn't the first, or
last, actor with a
decidedly non-
outdoorsy persona
to find himself in a
Western. Among
the others over the
years who turned
up amid the sage-
brush and the
gunfights:

Humphrey Bogart in
The Oklahoma Kid
(1939).

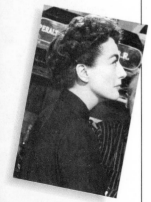

Joan Crawford in
Johnny Guitar (1954).

floor cleaner. He spent World War II as a volunteer in the Air Force, distinguishing himself as a gunner and radio operator. After the war he used the GI Bill of Rights to pursue acting lessons at the New School. (Also at the school at the time were Tony Curtis and Rod Steiger.) A couple of seasons of summer stock prefaced landing on Broadway as an understudy for *Anne of the Thousand Days,* in which he eventually got to go on as an octogenarian churchman. For the next half dozen years, Matthau moved up the theatrical hiercharchy, rising from walk-ons to small parts, then costarring roles, finally winning widespread—at least from the East River to the Hudson—acclaim in 1955 as Nathan Detroit in the first revival of *Guys and Dolls* and then scoring a triumph in the popular sex comedy *Will Success Spoil Rock Hunter?*

· · · · · ·

N o such hosannahs greeted Matthau that year, however, when moviegoers got their first look at him. If there's one thing that Walter Matthau epitomizes, with his New York-ese speaking voice, curmudgeonly attitude, weary expression and unwieldy features, it's an urban Everyman. So where did he end up? Why, the Western frontier of the 1820s, of course, when he was cast in *The Kentuckian.* The only movie directed by Burt Lancaster, *The Kentuckian* is a leisurely account of backwoodsman Lancaster and his son, who have left Kentucky to settle in Texas because "It ain't we don't like people, we like room more." Father and son barely get started before their traveling money is gone, having been used to buy freedom for Dianne Foster, a good-hearted indentured servant who also has a yen to see the Lone Star State. This lack of cash means they have to spend time working in the small frontier town Lancaster's brother calls home, where the domesticating forces of civilization (personified by Diana Lynn as a schoolmarm) compete for Lancaster's heart and mind with the freedom of the wilderness.

The Kentuckian is essentially a series of tableaux in which, unaccustomed to the ways of townfolk, Lancaster and son Donald MacDonald undergo humiliations. In fact, the film plays more like a character study and a homespun domestic drama than a Western until the end, when an ominous pair of brothers try to shoot down the hero as part of a long-standing family feud. It is a thoroughly pleasant, albeit minor, work.

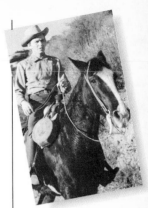

Frank Sinatra in *Johnny Concho* (1956).

Walter Matthau plays the local saloon keeper; he is not a traditional Western bad guy, but a respected businessman who happens to have an unfortunate sadistic streak. The actor makes his initial appearance engaging in a contest of extinguishing lit candles with a whip, becoming irritated at Lancaster for stepping on a creaking board and ruining his concentration. Later, because he too has eyes for Diana Lynn, Matthau delights in humbling Lancaster by exploiting his naïveté and lack of schooling. Besides psychic damage, Matthau inflicts some physical pain. When Lancaster sees Matthau egging on a local tough kid to go after his son with one of the whips that are strangely ubiquitous in this film, he proclaims, "For once you've gone too far." To which Matthau snarls, "I go where I please." Instead of engaging in gentlemanly fisticuffs, Matthau uses his bullwhip to slice up Lancaster into a bloody mess, foiled only when Dianne Foster drives a wagon wheel over his lash (this sequence so upset the sensibilities of the British censor that he deemed his countrymen—those good, brave people who had endured the Blitz—incapable of stomaching such unpleasantness and snipped the scene). Matthau gets his comeuppance when, in the true fashion of a cowardly scoundrel, he alerts the vengeful brothers of Lancaster's whereabouts but won't help them track him down; irritated by his demurral, they conk him on the head and kill him, but they, in turn, are knocked off by Lancaster and Foster.

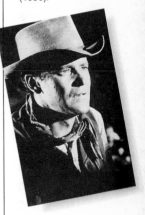

Jack Lemmon in *Cowboy* (1957).

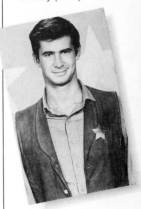

Tony Perkins in *The Tin Star* (1957).

Several years after making *The Kentuckian,* Matthau told the *New Yorker,* "It was a ridiculous part . . . I did it because I was desperately in need of money." He was

.

THE CRITICS ON WALTER MATTHAU

"One of the most insolent bullies ever seen on the screen."
—*Hollywood Reporter*

"Walter Matthau as a sneering villain is one of the old tent-show school."
—Bosley Crowther, *New York Times*

"There's too much of ten-tewnt-thirt flamboyance to Walter Matthau's portrayal of the whip cracking heavy."
—*Variety*

"As ornery a villain as ever villified."
—*Los Angeles Times*

correct about the role, but failed to mention that it's made even goofier by his miscasting and eye-rolling over-embellishments. Awkwardly dancing about as he maneuvers his whip, Matthau is a sight to behold. Thanks to the actor's subsequent history, the character is now even more absurd than he must have originally seemed—when he snarls out threats, Matthau uses the same voice as when he played Oscar Madison in *The Odd Couple.*

Curiously, considering how uncomfortable Matthau looks in his frontier duds, his second movie was also a Western, *The Indian Fighter,* starring Burt Lancaster's pal Kirk Douglas. At the time, Matthau professed that the theater was his true love and that he would only do films when there was nothing for him on Broadway or when his gambling debts so dictated, but as things worked out, he soon after became one of the screen's most popular character actors. Billy Wilder's *The Fortune Cookie* brought him an Oscar in 1966 and made him a bona fide movie star. In fact, Walter Matthau has not returned to the New York stage since starring in *The Odd Couple* in 1965.

STEVE MCQUEEN

......

SOMEBODY UP THERE LIKES ME
(1956)

Abandoned by his father shortly after his birth in 1930, Terence McQueen had a nomadic early life: He lay in his cradle in an Indianapolis suburb for several months; this was followed by a few years at a kindly great-uncle's place in Missouri, and then a stint with his mother and mean stepfather in California. Come to think of it, "mean" is too gentle a term for this bully, who habitually beat his stepson; in McQueen's words he was "a creep . . . a prime sonuvabitch—and I was no prize package myself." But after the 14-year-old threatened to kill him if he tried anything again, the authorities were notified and the youngster had yet another new address: the California Junior Boys Republic, which was a genteel pseudonym for reform school. Fortunately, he crossed paths with a counselor who was straight out of Central Casting as the compassionate yet firm authority figure, and soon the tough kid had turned from stealing hubcaps to making Christmas wreaths.

CAST

PAUL NEWMAN, PIER ANGELI,
EVERETT SLOANE, EILEEN HECKART,
SAL MINEO, HAROLD J. STONE,
JOSEPH BULOFF,
SAMMY WHITE

......

MGM
DIRECTED BY ROBERT WISE
SCREENPLAY BY ERNEST LEHMAN
PRODUCED BY CHARLES SCHNEE
CINEMATOGRAPHY BY
JOSEPH RUTTENBERG

Sometimes the least likely people become actors. Even more surprisingly, they become stars.

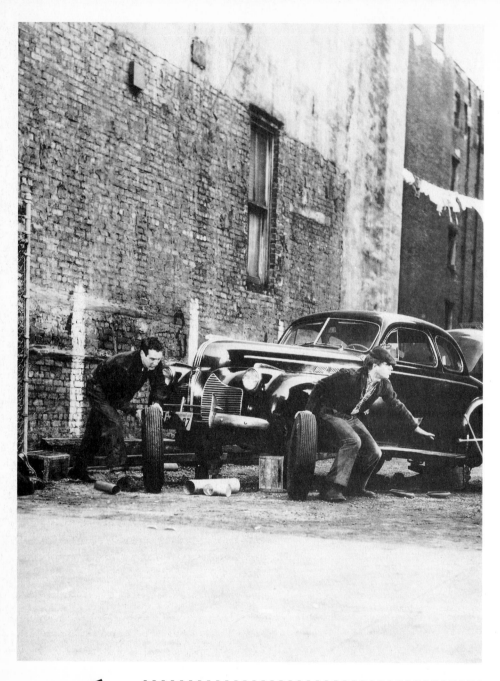

For a kid who grew up as a delinquent and had to do time in a home for wayward youths, Steve McQueen is doing what comes naturally—stealing tires. (For the upper-middle-class Paul Newman, it was more of a stretch.)

After being sprung from the Boys Republic, he
headed to New York City, where his now widowed
mother had relocated. McQueen was not geared to
family life, at least family life as it was handed to him.
To escape the cramped apartment he called home, he
pursued the romance of the open sea—which he saw
while scrubbing the decks of a decrepit Greek tanker
making its way to the West Indies. That was no picnic
either, so he jumped ship in Santo Domingo, where
he worked for a carpenter to earn passage back to the
States. McQueen spent the next two years doing every-
thing from selling trinkets with a traveling carnival to
being the towel boy in a whorehouse. And with all
these experiences under his belt, he still wasn't even 17
when he joined the Marines. His three-year tour of
duty as a tank driver was marked by a 41-day stay in
the brig—during three weeks of which he dined on
bread and water—for going AWOL and then putting
up a fuss when the MPs tried to bring him back to
base. The other highlight was being assigned to the
honor guard delivering Harry Truman from evil as he
enjoyed a spin on the presidential yacht. McQueen was
still a private when he left the service, but given his
volatile past, that he got through it without being dis-
honorably discharged was a victory of sorts.

It was 1950. McQueen was young and, with his
accumulated pay from the Marines, relatively flush.
The money didn't last long; he blew it over the course
of a wild few days in Myrtle Beach, South Carolina,
with some college students he had met in his travels.
Then he headed back to New York to make something
of himself. But what? More odd jobs (selling ballpoint
pens, making sandals) followed while he meditated on
a life choice. "One career which crossed my mind was
tile laying," McQueen recounted. "I wasn't all that hooked
on the idea but I heard these guys could earn as much
as $3.50 an hour." But a "chick I was shacking up with
at the time" was a drama student, and not only that, she
knew the high priest of the Neighborhood Playhouse,

When they were
making *Somebody
Up There Likes Me*,
Paul Newman was a
hesitatingly emerg-
ing star while Steve
McQueen was just a
two-bit New York
actor. (McQueen
wasn't even
included in cast
listings for the film.)
In 1974, when they
both signed for the
disaster epic *The
Towering Inferno*,
they were firmly in
the pantheon of
the world's most
popular movie stars.
The two men
received the same
salary: $1 million
and 7.5% of the
gross (which
ultimately meant
they saw $12
million apiece). But
McQueen balked
because Newman
had a dozen more
lines of dialogue
than he, and scripter
Stirling Silliphant
was forced to deal
with his carping.
There was also the
thorny issue of top

Sanford Meisner, personally. Meisner got McQueen a two-line part in a Yiddish play. (Connections, it's all connections.) This experience led McQueen to apply to study at the playhouse. He was accepted, and Meisner remembered that the budding actor "was an ordinary personality. Like Marilyn Monroe, he was both tough and childlike, as if he'd been through everything but still preserving a certain innocence." His voice teacher said he "was awfully short-tempered and he'd cut classes. Just not show. When he did show up he'd often fall asleep. Yet when Steve chose to put himself into a scene or a character he was absolutely compelling." His least favorite aspect of this acting business was dance class because "we had to wear a leotard—which I found damned embarrassing. Felt like a clown in those funky tights."

His first acting experience outside the confines of the Neighborhood Playhouse came in 1952 with a Fayetteville, New York, summer stock production of the sentimental chestnut (even in 1952) *Peg o' My Heart*. Margaret O'Brien, age 15, was the star, and McQueen's role was small but poorly performed. That same year he could be seen with Ethel Waters in a Rochester engagement of *The Member of the Wedding* and in the road company of a comedy starring Melvyn Douglas. His wanderlust resurfaced, and he moved from one legendary acting teacher to two others, leaving Sanford Meisner for Uta Hagen and Herbert Berghof. His next big year was 1955, when he aquired a new drama teacher (Lee Strasberg at the Actors Studio, where the story goes that McQueen was among five students chosen from 2,000 applicants) and a role on television's *Goodyear Playhouse*. And, he got his first movie.

*S*omebody Up There Likes Me is a biography of middleweight boxing champ Rocky Graziano starring Paul Newman, but in many ways it was the Steve McQueen story, with its abusive father, adolescent gang violence, reform school and even an

AWOL segment. The movie was Paul Newman's third, but, fearing that his second, *The Rack*, might be another *Silver Chalice*, MGM released this one next. Except for when comedians such as Charlie Chaplin, Jerry Lewis or Huntz Hall got in the ring, boxing movies were almost uniformly downbeat and cynical, the corrupt sport being a metaphor for the festering rottenness of the world. Not this one. *Somebody Up There Likes Me* was intended as an inspirational drama—even with Louis B. Mayer long gone, this was still MGM, and the movie's point of view is not far removed from the "there's no such thing as a bad boy" philosophy of the studio's *Boys Town* two decades earlier.

You know you're not in for another *Body and Soul* or *Champion* as soon as the credits roll and you hear none other than Perry Como crooning the title tune joined by a heavenly chorale. The film covers Graziano's early years as a punk on the streets, and then limns how he escaped this fate thanks to the intervention of "Somebody"—in the cumulative form of a sympathetic Army sergeant who encourages Rocky to put his anger to good use as a fighter in the ring, an avuncular trainer, a philosophizing candy store owner (who shows Rocky the path of righteousness by theorizing that, in life, you should "never ask for a soda unless you're willing to pay the check"), his overindulgent mother and, especially, the sweet and simple young woman he marries (Pier Angeli, who had converted Paul Newman to Christianity in *The Silver Chalice*).

The early parts of *Somebody Up There Likes Me*, in which Graziano is an incorrigible hoodlum, are much more fun than the uplifting sequences that follow, and it's in these segments that Steve McQueen appears as Fidel, another hood in Rocky's gang. In his first scene, eight minutes into the movie, he has his back to the camera, hunched over a pool table, preparing to shoot. Suddenly, from off-camera, a hand appears and pulls his cue away from him. McQueen immediately spins around, producing a switchblade from his pants so

billing, which McQueen was being prickly about. The solution: Although McQueen came first in the credits and his name appeared to the left of Newman's in print ads, the words "Paul Newman" were placed slightly higher than "Steve McQueen."

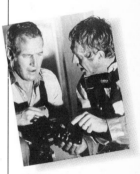

With Paul Newman in *The Towering Inferno* (1979).

quickly that by the time he's facing the camera, the knife is drawn and ready for blood. Newman (still off-camera—he may not even have been on the set for the scene) says, "What do you say, Fidel?" McQueen answers, "Rocky," and flaps his hand up and down in a meaningless gesture. Newman: "Come on." McQueen: "Hey, when'dya get out, huh?" McQueen then walks offscreen; the scene has lasted 10 seconds.

He has five brief additional scenes, as he, Newman, Sal Mineo and Michael Dante carry out their nefarious deeds: McQueen removes a tire from a parked car while Newman beats up the owner. The gang steals clothing from the back of a truck. From a rooftop, McQueen "fishes" a radio out through the opened window of an apartment. They sell stolen goods to a fence, and when Newman tells the purchaser they're going to buy new clothes with their money, McQueen, who has sniffed the $20 bill he received, pipes up with "Yeah, we don't want people to think we're no bums." Finally, the quartet has a rooftop rumble with another gang, after which Newman and Mineo are arrested. We see nothing more of Steve McQueen, although years later Graziano learns that Fidel was killed in a botched holdup. McQueen's total screen time is one minute and 50 seconds. Just about all the acting in *Somebody Up There Likes Me* is the Method run amok, as everyone tries his damnedest to approximate lower-class New Yorkers, and in his few lines McQueen jumps right into the fray with a ridiculously overdone "New Yawk-ese."

Because his part is so small, McQueen doesn't have enough time to get on your nerves. Paul Newman—a replacement for the recently deceased James Dean—is a different story. Mugging, mumbling, slouching, scratching, hemming and hawing, he turns in a mannered performance of epic proportions, and it seems impossible that *Somebody Up There Likes Me* actually made him a movie star. (Happily, the overindulgence was only a passing fancy for Newman, and as his performances became cleaner, he developed into a great movie actor.)

Somebody Up There Likes Me was popular with the press and the public, but its success did little for Steve McQueen. A month before the film opened, however, he made it to Broadway for the first and only time, replacing Ben Gazzara in the hit drug-addiction drama *A Hatful of Rain*. His reviews were so-so, and after three months McQueen left for Hollywood. No, he didn't have an offer. His wife, Neile Adams, had been signed by Robert Wise—the same man who made *Somebody Up There Likes Me*—to appear in his new film, *This Could Be the Night*. Out on the West Coast, McQueen—whose scenes in his debut film were shot in New York—made a couple of cheap movies (including *The Blob*, which is inexplicably well remembered), but it was television that brought him stardom. Premiering in 1958, the Western *Wanted: Dead or Alive*, in which he played a bounty hunter, was very popular for two years, but then CBS scheduled it against *The Price Is Right* and *Ozzie and Harriet*, and before long it was history. That was all right because it cleared the way for McQueen to take featured roles in motion pictures. By eluding the Nazis on a motorcycle in 1963's *The Great Escape*, McQueen exuded "cool" and became a movie star of the first magnitude.

For *Somebody Up There Likes Me*, Steve McQueen earned $50 a day. The next time he worked with director Robert Wise, a decade later, he was on camera considerably longer than a minute and 50 seconds. In *The Sand Pebbles*, McQueen had more than two and a half hours of screen time. And he pulled in $650,000.

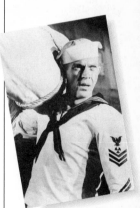

The Sand Pebbles (1966)

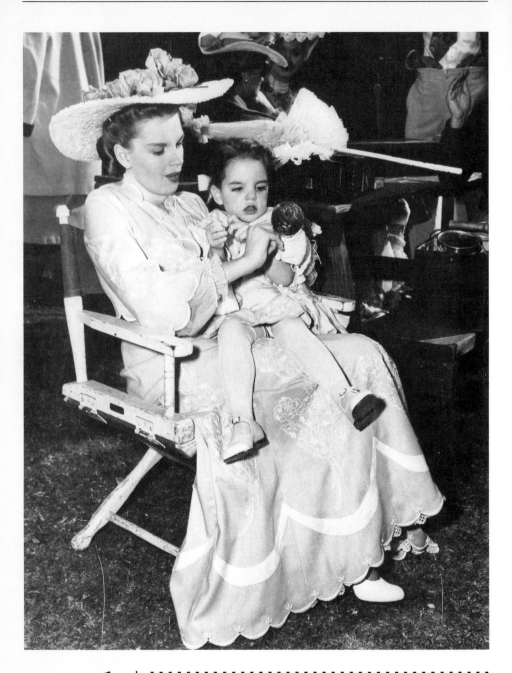

Judy Garland used to refer to her stage mother as "the real Wicked Witch of the West," but here she is prepping her own kid to step in front of the cameras. Actually, aside from Liza's 20-second appearance at age 3, Judy Garland was adamantly against her having a show business career as a child.

LIZA MINNELLI

······

IN THE GOOD OLD SUMMERTIME
(1949)

Judy Garland's latest vehicle at MGM called for a toddler to appear in the final scene. Although her daughter Liza was, at age three, a bit long in the tooth for the role, Garland and Vincente Minnelli had clout at the studio and the child got the part. *In the Good Old Summertime* is a musical remake of Ernst Lubitsch's sublime *The Shop Around the Corner* (1940), with Garland and Van Johnson in the parts originated by Margaret Sullavan and James Stewart. The setting was transposed from contemporary Budapest (although, as portrayed in the film, it was more of a Continental never-never land) to turn-of-the-century Chicago. A good deal was lost in the translation.

In the Good Old Summertime was directed by longtime Metro hack Robert Z. Leonard, but producer Joe Pasternak's personality infuses the movie. Whereas Ernst Lubitsch was without peer in conveying a knowing,

It just goes to show. It's *who* you know.

CAST

JUDY GARLAND, VAN JOHNSON, S.Z. "CUDDLES" SAKALL, SPRING BYINGTON, CLINTON SUNDBERG, BUSTER KEATON, MARCIA VAN DYKE, LILLIAN BRONSON

······

MGM.
DIRECTED BY ROBERT Z. LEONARD
SCREENPLAY BY SAMUEL RAPHAELSON,
ALBERT HACKETT, FRANCES GOODRICH
AND IVAN TORS
PRODUCED BY JOE PASTERNAK
CINEMATOGRAPHY BY
HARRY STRADLING

PARENTAL GUIDANCE

Rather than being frowned on as an example of un-seemly nepotism, the practice of an actor, director or producer getting his or her kid a part in a movie has long been a Hollywood tradition.

Barbara Merrill (a.k.a. B. D. Hyman) was the teenage next-door neighbor in *Whatever Happened to Baby Jane?* (1962). Her mother, Bette Davis, was Baby Jane.

Director John Farrow put his 13-year-old daughter, Mia, in *John Paul Jones* (1959).

When Diane Ladd played Flo in *Alice Doesn't Live Here Anymore* (1974), her seven-year-old daughter, Laura Dern, had a walk-on.

When Bing Crosby appeared in Para-mount's *Star Spangled Rhythm* (1942), he wangled his eight-year-old son, Gary, a role as himself. Three years later, when the studio tapped Der Bingle for another star-studded extra-vaganza, *Duffy's Tavern,* he not only had Gary cast, but also his three other boys, Dennis, Phillip and Lindsay.

Blake Edwards cast daughter Jennifer in *S.O.B.* (1981), as well as in *That's Life!* (1986), in which she was joined by stepsister Emma Walton. Chris Lemmon also joined his father, Jack, in the latter film.

Pat Hitchcock, Alfred's daughter, managed to get fifth billing in *Strangers on a Train* (1951).

David Ladd co-starred as a mute boy with his father, Alan, in 1958's *The Proud Rebel* (and received better reviews).

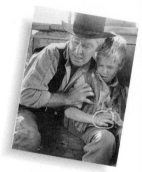

Alan Ladd and David Ladd.

Charley Boorman, the star of *The Emerald Forest* (1985), happened to be the son of its director, John Boorman.

The role of Clint Eastwood's nephew in 1982's *Honkey-tonk Man* was played by East-wood's son, Kyle. Two years later in *Tightrope,* East-

wood's daughter Alison portrayed his daughter.

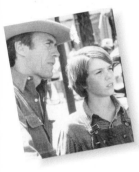

Clint Eastwood and Kyle Eastwood.

If Joel McCrea was *The First Texan* (1956), then his boy Jody—later a *Beach Party* regular—was the second.

In *The Effect of Gamma Rays on Man-in-the-Moon Marigolds,* Nell Potts portrayed Joanne Woodward's daughter. In real life she's the offspring not only of the film's star, but also of its director, Paul Newman.

Leo Gorcey had his father Bernard cast as Louie Dumbrowski in the *Bowery Boys* series (1946–55).

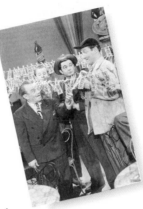

Playing the son of Bette Midler in *For the Boys* was the director Mark Rydell's son, Christopher.

Gene Lockhart portrayed Bob Cratchit in the 1938 version of *A Christmas Carol.* Daughter June was one of the Cratchit girls.

Cecil B. DeMille was one of the most powerful people in Hollywood, so if he wanted to cast his 18-year-old daughter, Katherine, in *Madame Satan* (1930), no one was going to stop him.

Leo Gorcey (center) and Bernard Gorcey (second from left).

Sean Stone, son of Oliver Stone, played Jasper Garrison, the son of Kevin Costner's character in *JFK* (1991).

And perhaps the most notoriously misguided case of cinematic nepotism: Sofia Coppola in her father Francis's *The Godfather III* (1990).

gently satirical yet sympathetic view of the way people in love behave, Pasternak was a jolly unsophisticate who reveled in wholesome, corny entertainment and thought light opera was the last word in good taste. Pasternak's idea of art was a picture with a title like *Two Girls and a Sailor* or *Two Sisters from Boston,* in which attractive young stars (e.g., June Allyson, Jane Powell, Van Johnson) engaged in by-the-numbers romances that were climaxed by José Iturbi or Lauritz Melchior bringing down the house with some extraneous classical music.

In the Good Old Summertime follows the basic plot of *The Shop Around the Corner:* A pair of pen pals who fall in love with each other through the mail are actually fellow store clerks who can't stand each other. The remake is hopelessly jejune.

While it doesn't even begin to approach its predecessor, *In the Good Old Summertime* is, on its own terms, a pleasant enough time-filler, enhanced by a nice rapport between Judy Garland and Van Johnson (although she looks distressingly thin throughout). This was not intended to be a major MGM musical; there are no big production numbers, and the score consists of such *fin de siècle* favorites as "Wait Till the Sun Shines, Nellie" and the title song, gussied up in anachronistic mid-20th-century orchestrations. (Oddly enough, despite the name of the movie, much of it takes place during the Christmas season.) The 102 minutes unfold predictably and painlessly as, despite their tiffs and a romantic rival for Van Johnson's affections in the person of a classical violinist who lives in his boardinghouse (Marcia van Dyke), Garland and Johnson are ultimately betrothed.

• • • • • •

Liza's appearance comes in a coda that serves no real purpose other than moving the film from December to July (several Julys later, actually) so that one last refrain of "In the Good Old Summer-

time" can be warbled. A dissolve takes us from a Christmas tree to flowering blossoms. The camera then pans down to Liza walking between Garland and Johnson. Moving rather unsteadily, she looks down at her feet and glances about, before her screen father lifts her up and kisses her cheek twice and her mother shakes her arm. "The End/Made in Hollywood, U.S.A. by Metro-Goldwyn-Mayer" is then superimposed on the trio. Liza's total screen time is 20 seconds. Years later, she explained that if she looked less than comfortable on screen, it was because no one in the costume department had remembered to put underwear on her.

Judy Garland had a statement for the press about her daughter's film debut. "Liza can now understand when we talk about our work at the studio," she cooed. "I think acting is a wonderful profession and I know it will bring her happiness." Quite a comment considering the constant personal turmoil Garland was experiencing and her constant run-ins with MGM head Louis B. Mayer, which would lead to her being canned the very next year. Her true attitude toward an acting career for her daughter is revealed by Liza's recollection, "My mother wouldn't let me go near work until I was 16." Liza Minnelli's second movie came when she was 18; that 1964 film was a cartoon sequel to her mother's most famous movie, with Liza providing the voice of Dorothy. But *Journey Back to Oz* was no *Wizard* and it sat on the shelf until 1974.

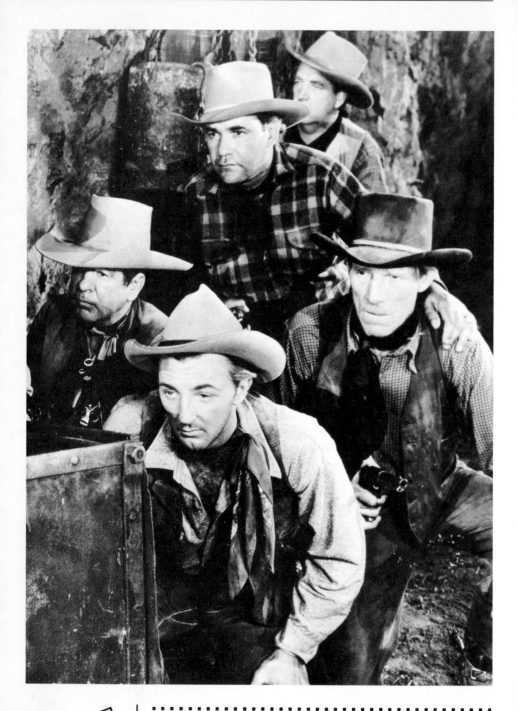

 Robert Mitchum earns the enmity of all red-blooded American kids because the target he and his cronies are aiming at is Hopalong Cassidy.

ROBERT MITCHUM

· · · · · ·

BORDER PATROL
(1942)

Robert Mitchum's early life was filled with hard times and ill winds. He was but a year and a half old when his father, a railroad switchman, was killed in a work accident. After his mother married for the third time, 10-year-old Robert was shipped off with his siblings to live with his grandparents. When he rejoined her, she was living in the rough-hewn Hell's Kitchen section of New York City, where he showed he could keep pace with his tough contemporaries by exulting in torturing his high school teachers with his peashooter.

His mother made a deal with the principal: If he wouldn't expel the boy, she'd force him to join the school band. But when her son dropped a firecracker into a trumpet some kid was playing, another reprieve was not forthcoming. Consequently, Mitchum started working at 14 in 1931 and the following year ran away from home, lying about his age to get a position on a salvage boat.

Given the boot when

Dead men don't wear hats.

CAST

WILLIAM BOYD, ANDY CLYDE, JAY KIRBY, RUSSELL SIMPSON, CLAUDIA DRAKE, CLIFF PARKINSON, BOB MITCHUM, GEORGE REEVES, DUNCAN RENALDO

· · · · · ·

UNITED ARTISTS
DIRECTED BY LESLEY SELANDER
WRITTEN BY MICHAEL WILSON
PRODUCED BY HARRY SHERMAN
CINEMATOGRAPHY BY RUSSELL HARLAN

his true age was discovered, Mitchum joined the hordes of Depression-era kids who hit the road and slept in boxcars. Like Paul Muni in the movies, he did time on a Georgia chain gang, having been picked up for vagrancy. But whereas Muni received an Academy Award nomination for his incarceration, all Mitchum got was gangrene in his leg from the shackles. The enterprising teenager turned that to his advantage, however: The guards let him do his road work without the chains, so he managed to amble off into the Georgia backwoods. For the next few years he continued his peregrine existence, wandering from Pennsylvania and Delaware to California and Nevada, stopping periodically for gainful employment digging ditches or mining coal before moving on.

Finally, in 1936, the rambling boy settled down in Long Beach, California, where his sister Julie and other family members were living. Julie had been nearly as peripatetic as Robert because, having embarked on a show-biz career at age 14, she had to go where the nightclubs would have her; in Southern California she was intimately involved with the Players Guild of Long Beach and secured a position for her younger brother as a stagehand. His proximity to the footlights encouraged him to try out for small roles with the company. "I'd never had so much fun before," he gushed. "I got sort of hooked on it right there and then." He branched out from acting to write children's plays and create material for his sister's nightclub act, revealing such a flair for risqué songs that other cabaret performers sought out his material. Most unexpected of all Mitchum's endeavors—given his hard-edged, cynical screen persona—is that he composed an oratorio detailing the plight of European Jewish refugees that was performed as part of a fund-raiser put on by Orson Welles at the Hollywood Bowl.

Despite his fecundity, Mitchum's creative efforts weren't enough to live on, so he got a position as handyman for Hollywood costume designer Orry-Kelly and

then served as an assistant for one Carroll Righter, the leading astrologer of the 1930s, who was then working over the rubes on a lecture tour of Florida. After getting married in 1940, Mitchum knew the jig was up—he'd have to find something more than temporary and odd jobs. He was utterly miserable laboring as a sheet-metal worker for Lockheed on the graveyard shift, staying awake through a unique mixture of "No-Doz and chewing tobacco with hot sauce sprinkled on it." One night he went blind. Concluding that there was nothing physically wrong with him, a doctor advised him that his temporary loss of sight sprang from the pressures of working on a job he hated. Mitchum was delighted to follow doctor's orders and found employment as a shoe salesman.

· · · · · ·

B ut this is a book about movie stars, not purveyors of footwear. Mitchum's mother told him, "You love acting, and if all those other idiots can get away with it, why not you?" A mother's love is nice, but interest from an agent is even better. One such creature had seen Mitchum onstage in Long Beach, thought he had potential and began introducing him to producers and casting agents. Unfortunately, the agent was a small-timer, so instead of the likes of David O. Selznick, he presented Mitchum to Harry "Pops" Sherman, who ground out half a dozen *Hopalong Cassidy* Westerns a year. The aspiring actor lied that he was a master of the equestrian arts, so producer Sherman, figuring he could always use another extra, told Mitchum he'd be hearing from him. He did, a mere three days later. Mitchum had a sanguine introduction to filmmaking: It wasn't as an extra that his services were needed, but as a replacement for a featured actor who earlier in the day had been trampled to death by a horse and wagon on the set. Arriving on location, Mitchum was given his gear and noticed that his cowboy hat was sticky. The costumer explained that it was

Once he had become successful, Mitchum could laugh about an incident that occurred when he was attempting to break into movies. A producer contemplating hiring the actor was giving him a careful look-over. Finally he concluded, "You look too much like Bing Crosby. Your ears stick out like his, too. Let's see your profile. My God, man, your nose is broken." Growled a disgusted Mitchum, "Yours will be, too, when I get through with you." Studio security guards whisked him out.

merely blood from the head of Mitchum's predecessor, methodically scraped it off with a penknife and handed it back.

Silver-haired William Boyd, who played Hopalong Cassidy, was probably the best actor among the cowboy stars, and taken on their own modest terms his films are quite enjoyable. In *Border Patrol,* Hoppy and his sidekicks, comic geezer Andy Clyde and dashing (sort of) young Jay Kirby, are members of the Texas Rangers guarding the border between Texas and Mexico. The film was written by Michael Wilson, who in the 1950s became a *cause célèbre* when the Motion Picture Academy refused to acknowledge his Oscar nomination for *Friendly Persuasion* because of alleged ties to the Communist Party.

Border Patrol clearly has the mark of a man concerned about social injustice: The evil that Hoppy is battling isn't cattle rustling or bank robbing but the exploitation of the working man. Mexicans are disappearing, crossing into Texas and never being heard from again. The villain of the piece is Orestes Krebs (great name), the self-declared potentate of the "Kingdom of Silver Bullet"—home only to him and his henchmen—and owner of a local mine. Krebs advertises for workers in Mexico and then enslaves the applicants. Because his philosophy is "I don't recognize the laws of Texas; I am the law here," Krebs conducts a kangaroo court in which the three rangers are convicted of horse thieving, murder, robbery, trespassing and anything else that crosses his mind. Sentenced to hang, our heroes escape only through the intercession of a young Mexican woman who risks her life to smuggle guns to them in a pot of beans (writer Wilson was a feminist as well as a leftist) and, after the requisite shootout, good triumphs. The film certainly moves, and it's nice to know that young Saturday matinee audiences of 1943 were taught the evils of peonage. The critics even liked *Border Patrol.* The *New York Daily News* marveled that it was "not a slipshod west-

ern but one that has first-rate acting and a believable story," while the *Hollywood Reporter* declared, "the 43rd Hopalong Cassidy adventure is one of the most entertaining in the series," citing its "admixture of fast action and stunning scenic effects."

Billed ninth as Bob Mitchum, the newcomer wasted no time making his presence felt. In the first few seconds of the film he is part of a duo that chases and then shoots a man racing to get back across the Mexican border. Making sure his prey is dead, he utters his first screen dialogue: "C'mon, let's get out of here." Twenty minutes later he's back, exchanging gunfire with the three Texas Rangers, and later serves as foreman on the jury that convicts them, announcing "Guilty" with his characteristic laconic nonchalance. He gets his in the end. The closest Mitchum came to being reviewed was in *Daily Variety,* which wrote, "Remainder of cast is highly commendable."

Over the next two years Mitchum turned up in seven more Hopalong Cassidy movies, and appeared in small roles ranging from MGM's big-budgeted *The Human Comedy* and *Thirty Seconds Over Tokyo* to Laurel and Hardy's *The Dancing Masters.* He says he turned nothing down, but after 1945 he could start being more selective. That's when he played a hard-nosed commanding officer in the hit film about war correspondent Ernie Pyle, *The Story of G.I. Joe,* for which he received a Supporting Actor Oscar nomination and which made him a star. In a span of less than three years, it was Mitchum's 23rd movie.

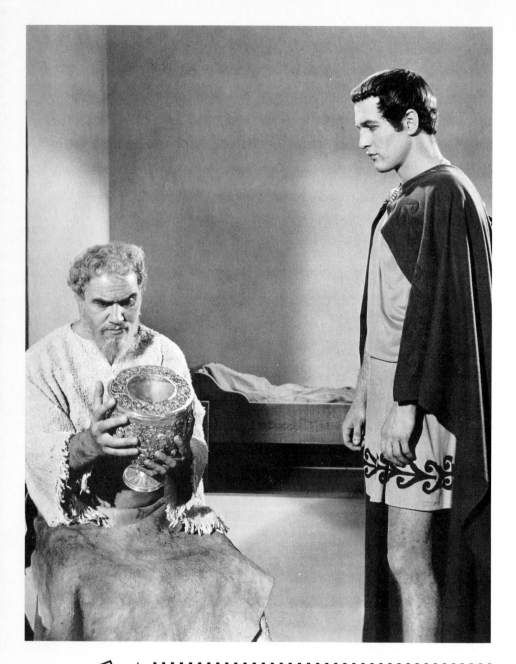

Let's face it, Paul Newman does not look great in a toga. It didn't help that he was miserable with the way *The Silver Chalice* was turning out. The sagacious-looking St. Peter next to him would find fame five years later as Pa Cartwright on *Bonanza*. (Yes, it's Lorne Greene.)

PAUL NEWMAN

······

THE SILVER CHALICE
(1954)

With his father the owner of a very successful sporting goods store, the future superstar led a conventional upper-middle-class childhood in the Cleveland suburb of Shaker Heights. Having left Kenyon College to enlist in World War II, Newman resumed his school career on the GI Bill in 1946. Although he had been part of a local children's theater group (the Curtain Pullers) while in grammar school, it was the playing field, not plays, that held his interest in his early 20s. That all changed during junior year when a barroom brawl landed him in jail overnight and knocking him off the Kenyon football team. To fill up the time that he would have been spending with the pigskin, he slapped on the greasepaint and ultimately appeared in 10 school productions, this despite his later claim, "I was probably one of the worst college actors in history."

After college—his yearbook announced that he graduated "magnum cum

CAST

VIRGINIA MAYO, PIER ANGELI,
JACK PALANCE, PAUL NEWMAN,
WALTER HAMPDEN,
JOSEPH WISEMAN,
ALEXANDER SCOURBY,
LORNE GREENE, E.G. MARSHALL,
NATALIE WOOD

······

WARNER BROTHERS
DIRECTED AND PRODUCED BY
VICTOR SAVILLE
SCREENPLAY BY LESSER SAMUELS
CINEMATOGRAPHY BY WILLIAM V. SKALL

Paul Newman felt such disdain for his first movie that when it was shown on television he took out a newspaper ad apologizing.

As a young new-comer to movies, Newman dutifully followed Hollywood protocol and made nice to journalists who ambled onto the set. Here's what he told one reporter:

"Sometimes when I see the work of really good people I get hopeless and wonder if I should go back to the sporting goods business.

"But I know now that what I want is to be an actor the rest of my life. I don't want to be a big success for just a year or two—and then hear people saying: 'Newman? Oh, I remember him. Whatever became of him?'"

lager"—Newman spent a season in Wisconsin summer stock and then several months in an Illinois repertory company, where he met his first wife. His growth as an actor was temporarily stunted when his father died and he had to go back home and manage the family store. Two years later when his brother agreed to take charge of the business, Newman got the hell out of Cleveland and landed at the Yale Drama School ("out of no burning desire to act, but to flee from the store"), intending to get a master's degree and then return to Kenyon to teach. He spent his summer break in New York, figuring that if things didn't pan out there he'd hop back on the train to New Haven.

When the fall semester began his classmates continued to see Newman, not on campus, but on a television set—he had one-shot roles on a number of series. TV was still the bastard son of the arts, but Newman soon after went legitimate: Joshua Logan cast him as the phlegmatic male second lead in William Inge's *Picnic*. With its sexually repressed Midwesterners filling the stage with angst-ridden heavy breathing, the play became one of the big hits of the 1952–53 season, and it brought Newman several rewards: a Theater World award as one of the year's most promising new-comers; enough money to study with Lee Strasberg and Elia Kazan at the Actors Studio; and the opportunity to become acquainted with a young understudy in the show, Joanne Woodward.

Picnic also brought Newman to the attention of a talent scout from Warner Brothers, and with long-term contract in hand, the actor headed out west. Around this time an acquaintance from the Actors Studio also struck a deal with Warners: James Dean. Newman and Dean were the finalists for the lead role in Elia Kazan's film version of Steinbeck's *East of Eden*. Kazan hemmed and hawed over which of the two brooding young actors could best express teenage discontent before finally picking the 23-year-old Dean. The consolation prize for Newman, 29, was a film that

actually had a much bigger budget than the Kazan production—but remember, money isn't everything.

Biblical movies, first popularized in the 1920s and early '30s by Cecil B. DeMille, had been enjoying a renaissance since DeMille's 1949 release *Samson and Delilah* proved a box-office bonanza. The most commercially successful of the early '50s brood was *The Robe,* about a Roman centurion who gets that old-time religion after he dresses up in one of Jesus's frocks; the movie not only had the usual dollop of mild sex and violence to accompany the inspiration and reverence, but was the first film shot in the CinemaScope widescreen process and at the time was considered quite a show. Along came independent producer-director Victor Saville, who convinced Jack Warner that the public was hankering for another widescreen adaptation of a best-seller centered on a material possession that Jesus had left behind and that the early Christians had held in reverence. The object of their affection in *The Silver Chalice* is the cup Jesus used at the Last Supper. Newman was cast as Basil, a pagan slave who, because he is the best whittler in all Jerusalem, is bought by Christians who want him to fashion a chalice that will be positively *recherché.*

For theological conflict, Jack Palance is on hand as Simon, a magician who wears what looks to be a dunce cap and who actually does the hoary rabbit-out-of-a-hat bit. His other feats of prestidigitation, such as the Pentecostal routine of causing tongues of fire to dance on people's heads, would not have been possible without the Warner Brothers special-effects department. His sleight of hand convinces many that he is the real Messiah and, after having been content to be a successful charlatan, Simon deludes himself into believing he really is God. This is too bad for him, because he attempts to prove his divinity by doing something even Jesus never deigned to try—flying. Once Simon steps off a tall tower, that's all she wrote.

For romance, there's Natalie Wood as Helena, a

The world premiere of *The Silver Chalice* was held not in Hollywood or New York City, but in Saranac Lake, New York. The town had captured the honor by winning a nationwide sales contest for Christmas Seals.

• • • • • • • • • • •

Was there really a similarity in the looks of Brando and Newman in the '50s? And what about four decades later?

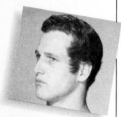

Newman in *The Silver Chalice* . . .

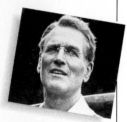

. . . and in *Mr. & Mrs. Bridge.*

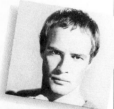

Brando in *Julius Caesar* . . .

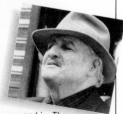

. . . and in *The Freshman.*

A Poor Man's Brando?

Getting a look at Paul Newman for the first time, reviewers, almost to a person, mentioned the same thing, something that years later seems quite surprising:

"Paul Newman's performance as the hero, who fashions the chalice, is no Marlon Brando, although he reminds you of Brando."
—*Hollywood Citizen-News*

". . . bears a striking resemblance to Marlon Brando, but his contribution is hardly outstanding."
—*New York Times*

"Newman—a poor man's Marlon Brando." —*Saturday Review*

"a new boy, Jack [sic] Newman . . . bears an astonishing resemblance to Marlon Brando, an excessively sullen Marlon."
—*New York World-Telegram*

"Paul Newman, a lad who resembles Marlon Brando, delivers his lines with the emotional fervor of a Putnam Division conductor announcing local stops."
—*The New Yorker*

slave girl loved by the young Basil, who grows up to be Virginia Mayo. Helena is Simon's pleasure-loving assistant, but as embodied by Mayo, with dyed platinum hair, harem outfits and eyebrows plucked to a 45-degree angle, she looks as if she'd be more at home as part of a Vegas revue than running around ancient Jerusalem and Rome. Her competition for Basil's favor is the dully Christian Deborah (Pier Angeli), whose idea of a good time is a spell of proselytizing. Of course, according to the conventions of this genre, her sancti-

mony becomes a real turn-on for Basil, and by the time the movie's over he's her dutiful Christian husband. To add verisimilitude, there are guest appearances by such New Testament favorites as St. Luke, Joseph of Arimathea and St. Peter (in the person of no less than Lorne Greene, making *his* debut). And in a pitch for Cold War relevance, Peter closes the film by saying that although the cup may be missing in 54 A.D., he is sure it will show up at a time when it is really needed, in "a world of evil and long, bitter wars . . . when man holds lightning in his hands."

Newman hated making *The Silver Chalice,* partly because of the script, but largely because it wasn't *East of Eden.* To make things worse, the Kazan film was shooting on the soundstage next door, a constant reminder of the part that got away. On top of that, James Dean was dating Pier Angeli, so during his free time he'd hang around on Newman's set; Newman's lack of commitment to the project shows in his listless performance. Posters proclaimed it "The Mightiest Story of Good and Evil Ever Told, Ever Lived, Ever Made into a Motion Picture," but critics and audiences, starting to get their fill of these movies, were as dismissive of *The Silver Chalice* as Newman was, and the movie didn't come close to making back its $4-million price tag. About the most positive review of the film came from the *Los Angeles Times,* which allowed, "It is colorful at times, rather tedious in others." Nevertheless, the movie did receive two Academy Award nominations: for Franz Waxman's score and William V. Skall's cinematography.

Actually, thanks to its unique visual scheme, *The Silver Chalice* is less unwatchable than most entries in the inherently dopey biblical genre. Rather than going for the typical, lavishly hokey reproductions of ancient columned buildings with bas-reliefs and friezes all over the place, production designer Rolf Gerard created a strikingly stylized world of abstract structures shown in unexpected shadows, off-putting angles and odd depths

Victor Saville, producer-director of *The Silver Chalice,* tried to convince the world that if Newman resembled another movie star it was someone who had achieved greatness even before Marlon Brando was born. In a prerelease spiel, Saville gushed, "Here is a young man who is destined for screen greatness. He has an intensity and a strange sense of brooding that comes over on the screen with impact and reminds one of the Latin lover, Rudolph Valentino."

PAUL NEWMAN ON *THE SILVER CHALICE*

"The worst film made in the entirety of the 1950s—the worst American film in the entire decade."

"To have the honor of being in the worst picture of the fifties and to have survived is no mean feat."

of field. The "look" of *The Silver Chalice* is a De Chirico painting come to life, and you might think that this was an experimental, avant-garde film if only the actors didn't open their mouths and recite the inane dialogue.

Fortunately for his career, Newman had sent an urgent telegram to his East Coast agents while working on *The Silver Chalice*. "Get me back on Broadway!" it pleaded. They provided him with *The Desperate Hours*, in which he played a thug who holds a family hostage in their home; the melodrama opened several weeks after *The Silver Chalice* and brought Newman the sterling reviews he didn't receive for his movie debut. Those and a couple of television programs (including a drama in which he was a last-minute replacement for the newly dead James Dean) convinced Hollywood to give him another chance, and MGM borrowed the actor from Warners. After his third film, playing a prettified Rocky Graziano in 1956's *Somebody Up There Likes Me* (and again replacing James Dean), Paul Newman finally became a movie star.

His later success did not ameliorate his hard feelings toward that first film, however. In 1975, when Newman and his wife, Joanne Woodward, were honored by the Film Society of Lincoln Center, the actor requested that the persons putting together a film montage of his career pretend that *The Silver Chalice* didn't exist. And when he got wind of a Los Angeles television station's plan to show the movie daily over the course of a week, the actor took out a newspaper ad with a funereal black border. It said, "Paul Newman apologizes every night this week—Channel 9."

JACK NICHOLSON

·······

CRY BABY KILLER
(1958)

A son of Neptune, New Jersey, Jack Nicholson was the kind of chameleon who could be voted both class clown *and* vice president of the senior class at Manasquan High School, a pool hustler who also had Study Club listed as one of his activities in his yearbook biography. In addition, Nicholson was president of the Rules Club, an amusingly incongruous distinction given his iconoclastic screen persona and, specifically, the chicken salad sandwich scene in *Five Easy Pieces*. He did perform in school theatrical productions, but that was only because "I got sort of talked into it by a teacher. And all the chicks that I liked were doing plays." Nicholson received a chemical engineering scholarship from the University of Delaware, but, because he had skipped a year of school along the line and was only 17, he decided to defer for a year; he headed out to California to stay with his sister (who, he

CAST

HARRY LAUTER, JACK NICHOLSON, CAROLYN MITCHELL, BRETT HALSEY, LYNN CARTWRIGHT, RALPH REED, JOHN SHAY, BARBARA KNUDSON, JORDAN WHITFIELD

······

ALLIED ARTISTS
DIRECTED BY JUS ADDISS
SCREENPLAY BY LEO GORDON AND
MELVIN LEVY, STORY BY LEO GORDON
PRODUCED BY DAVID KRAMARSKY
AND DAVID MARCH
EXECUTIVE PRODUCER: ROGER CORMAN
CINEMATOGRAPHY BY FLOYD CROSBY

············

Long before he put on his shades and became the coolest man in the history of the world, Jack Nicholson answered fan mail for Tom and Jerry.

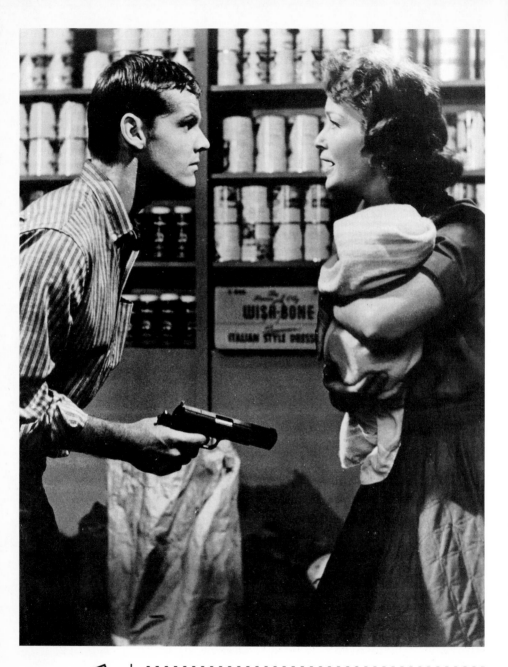

Jack Nicholson probably made more money for two seconds of *Batman* than he earned for all of *Cry Baby Killer*. Nevertheless, three decades before playing the Joker, he was indulging in the same sort of antisocial behavior, such as terrorizing a young mother (Barbara Knudson) and her infant.

discovered two decades later—after her death—was actually his mother). He never did get to Delaware.

Because "I wanted to see some movie stars," Nicholson pestered the employment offices of various movie studios until MGM relented and made him an office boy in the cartoon department; among other responsibilities, he handled correspondence for the studio's cartoon cat and mouse stars. Walking by a veteran producer on the lot, Nicholson said, "How ya doin', Joe?" Startled by such familiarity from someone he didn't know, Joe Pasternak thought this pluckiness might translate well on screen. The producer of *The Student Prince* and *Skirts Ahoy!* asked Nicholson if he'd like to make a screen test. More interested in becoming a screenwriter than in appearing onscreen, Nicholson turned him down. To Pasternak, this was lunacy; he'd been around since the 1930s and had never known a young person who didn't want to be a movie star. Pasternak was so discombobulated that he told Nicholson's boss, Bill Hanna (as in Hanna-Barbera), to talk some sense into the crazy kid. The cartoonist used his connections to arrange an apprenticeship at the Players Ring Theater, a petri dish for young Hollywood hopefuls at the time. The acting bug got to him, and after the Players Ring folded, Nicholson began taking classes with blacklisted actor Jeff Corey; his classmates included some people with whom he would continue to intersect personally and professionally: Robert Towne (later the writer of *The Last Detail, Chinatown* and *The Two Jakes*) and Carol Eastman (author of *The Shooting, Five Easy Pieces,* and *The Fortune*). And Roger Corman.

Corman, in his mid-20s at the time, was already the producer of minuscule-budgeted movies that went by such titles as *The Monster from the Ocean Floor, Apache Woman, Oklahoma Woman* and *Swamp Woman.* His reason for signing up with Jeff Corey was twofold. First, he wanted a better understanding of the actor's mind, so that if he had problems with performers on the set, he could speak their own language. Second,

- - - - - - - - - -

Having given Jack Nicholson his first screen role, producer-director Roger Corman remained an important force in the actor's life. Other Corman projects in which Nicholson has been involved:

The Little Shop of Horrors (1960)— bit part as a masochist at the dentist's office.

The Wild Ride (1960)— top-billed and playing a biker for the first time.

The Broken Land (1962)— fifth-billed as another alienated teen in his initial cowboy movie.

The Terror (above; 1963)— second-billed; more Edgar Allan Poe, again with Karloff and again directed by Corman.

acting classes were filled with young talent so hungry for work that they wouldn't mind the paltry paychecks and wretched working conditions that Corman had to offer. Even though Jeff Corey complained to Nicholson that his acting lacked "poetry," Corman saw some Lawrence Ferlinghetti there. He signed the 21-year-old for a movie, and he'd be playing the lead. Corman would later say, "I thought he was an intelligent and exciting actor who could bring more to the role than what was written in the script. I thought he had a youthful energy and at the same time a certain amount of control over that energy."

- - - - - -

True to form, executive producer Corman made *Cry Baby Killer* in 10 days, bringing it in for $7,000. Nicholson plays Jimmy Walker, a low-rent variation of James Dean's Jim Stark in *Rebel Without a Cause*. Jimmy is basically a nice kid, not some thug who's mad at the world; his particular case of adolescent alienation stems from his girlfriend's leaving him to run around with a fast crowd, one ornery hood Manny (Brett Halsey) in particular. The film opens with Manny and his gang beating up Nicholson for having taken exception to her new taste in boyfriends. Nicholson can't understand how his good girl has gone bad, and as he says to a buddy, "Carol was a swell girl till Manny got his hands on her." His pal deflates him with, "You mean till she wanted Manny's hands on her." (A female friend of Carol's warns her in the matchless parlance of 1950s teen movies, "You'll wind up in the gutter before you're old enough to vote!") When Jimmy goes to the Hut, the drive-in restaurant where Manny's crowd hangs out, he gets a second helping. In the midst of being beat up again, Jimmy pulls a gun out from the pants of one of Manny's boys and shoots Manny and another goon. Having been a good boy all his life, he's unaccustomed to this kind of predicament, so he runs into the storeroom of the Hut, picking up a woman (Barbara

Knudson) and her infant along the way. The rest of the 61-minute film focuses on the hostage situation—besides mother and child, there's Sam, an employee. Panic-stricken, Jimmy alternatively meditates on his scary plight and growls threats, the latter causing the mother to scream back, "You're a mad beast, an animal." When the obeisant Sam (because Jordan Whitfield, the actor playing Sam, is black, this personality trait makes the viewer a bit queasy) admonishes her to watch her tongue, the churlish woman snaps back at him, "What's the matter with you? Are you afraid of hurting his feelings, this monster with a gun! Murderer! Degenerate!" Jimmy's snappy comeback: "Shut up!" Meanwhile, people have gathered outside, hoping for a little excitement, and *Cry Baby Killer* takes a passing swipe at mob violence. A television reporter tells those who couldn't make it in person, "The crowd is going crazy and the police can't hold them back!"—a wildly hyperbolic statement given that Corman hired only about a dozen extras to constitute this throng. Although fearful of what might befall him, Jimmy heeds Carol's pleas after she professes her love, and he gives himself up. *Cry Baby Killer* is what it is, a straightforward, two-bit movie whose only distinction—besides Nicholson's presence—is that its antihero is more vulnerable than you'd expect for someone who's holding an infant hostage.

The film does prove that Nicholson was not a natural actor. His work here is uncharacteristically wooden, and his voice has an adenoidal quality that makes you giggle in direct proportion to how tough he's trying to sound at a given moment. He does have an appropriate look of bewilderment at times, but whether that's part of his characterization or an end result of trying to get a handle on movie acting is hard to say. *Variety* wrote, "Young Nicholson is handicapped by having a character of only one dimension to play." A typical comment about the movie came from the *Hollywood Reporter*: "While no epic, *Cry Baby Killer* quali-

The Raven (1963)—sixth-billed under the likes of Vincent Price, Peter Lorre and Boris Karloff; this marked the first occasion when Nicholson was *directed* by Corman.

The Shooting (1966)—fourth-billed; a Western coproduced by Nicholson.

The St. Valentine's Day Massacre (1967)—Corman directed and Nicholson had a single line: As a gangster who is rubbing his bullets, he comments, "It's garlic. The bullets don't kill you. You die of blood poisoning."

The Trip (1967)—Nicholson's not in it, he just wrote it; Corman directed the thing.

fies as a fair 'slice of life' picture," and the *Los Angeles Times* lamented that "with a better-planned story, this could have been a more interesting motion picture." Although *Cry Baby Killer* opened in L.A. as the bottom half of a double bill with *Hot Car Girl,* Nicholson was sure he had arrived. He got a bitter lesson when no additional film offers came his way, so he bided his time making numerous appearances on the seamy television series *Divorce Court.* Finally, two years later, Roger Corman tossed him a role, although this one wasn't a lead. In *The Little Shop of Horrors*—a movie which purportedly took two days to complete—Nicholson has only a few minutes in a funny but irrelevant turn as Wilbur Force, a masochistic dental patient who refuses all offers of Novocain. To think this is the same actor who would one day pocket an estimated $60 million from *Batman* alone! What a long, strange trip it's been.

NICK NOLTE

······

RETURN TO MACON COUNTY
(1975)

efore he ever considered acting as a vocation, Nick Nolte had a nice little career going as a scam artist. While in college in the early 1960s, he sold fake draft cards to beer-seeking under-21s, but had to give up that racket for a simple reason: The Feds nabbed him and he was given 75 years in prison with a $45,000 fine to boot. The sentence was reduced to five years on probation, but still, a thing like that can really shake up a person, and Nolte retreated to his divorced mother's home for a year of heavy-duty meditation. His conclusion was that he should return to school, thus making Pasadena City his fifth college in four years. Taking a breather from the books, he went to a production at the Pasadena Playhouse and had a revelation. "I said 'Boy, this is something I want to get involved in.' Not only did I understand that this play was about human relations, but there was also something there that I knew I had to discover for myself." Having been a letterman in five

CAST

NICK NOLTE, DON JOHNSON,
ROBIN MATTSON, ROBERT VIHARO,
EUGENE DANIELS, MATT GREENE,
DEVON ERICSON

······

AMERICAN INTERNATIONAL PICTURES
DIRECTED AND WRITTEN BY
RICHARD COMPTON
PRODUCED BY ELLIOT SCHICK
EXECUTIVE PRODUCER: SAMUEL Z. ARKOFF
CINEMATOGRAPHY BY JACQUES MARQUETTE

············

People who saw Nick Nolte's first film wouldn't get a clear fix on how accomplished an actor he was, but they sure would know he could drive a car.

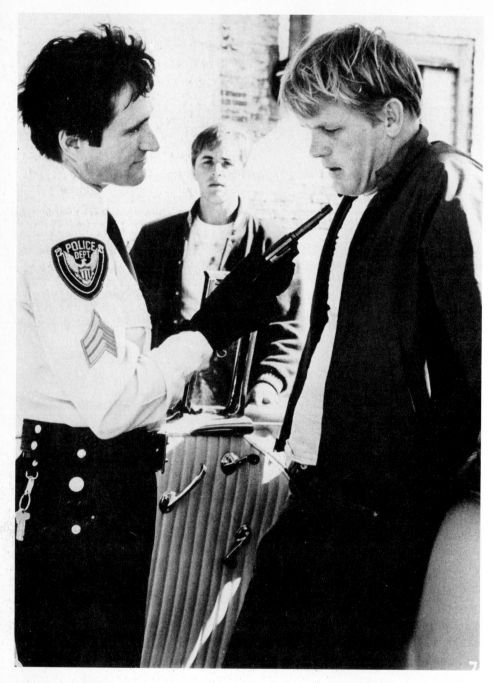

 As Don Johnson watches, Nick Nolte is hassled by redneck cop Robert Viharo—which is essentially the entire plot of *Return to Macon County*.

different sports in high school, Nolte knew something about competition and realized that because of the glut of would-be Brandos, the odds of his getting onstage in New York were not great. As for the other coast, with its surfeit of second comings of Troy Donahue, "Hollywood seemed like a dying place." Better to be in the boondocks where the pool of aspiring actors was much smaller.

He transferred to school number six, Phoenix City College, and studied acting with a group called the Actors Inner Circle. In the summertime he appeared with another repertory company in Denver. Three years later when the Inner Circle folded, Nolte reckoned that perhaps he was seasoned enough to give New York a shot and ended up at the East Village's avant-garde Cafe La Mama, which in 1968 was at the apex of its fashionableness and influence. In Nolte's estimation the production was "awful": "My mother was a big black man wearing an innertube, a diaper and Venetian blinds on his head with ping-pong balls suspended from it. It was *that* kind of play."

The actor's taste ran to the more traditional, and he headed back to the world of Arthur Miller and Tennessee Williams at Minneapolis's Log Cabin Theatre, where he remained for three years. An old friend was producing a new William Inge play and invited Nolte to return to Phoenix to star in it. With Inge's encouragement, the production moved to Los Angeles, but then, right before the show opened, the playwright committed suicide. That's the kind of publicity that money can't buy, and even in the Big Orange where resident theater was still a quaint idea, people took notice. Casting directors came to see Nolte's acclaimed turn as a death row inmate, and the actor was soon a fixture on bad early-1970s television: *Medical Center, Emergency, Barnaby Jones* and made-for-TV movies about which you can glean all you need to know from the titles: *The Treasure Chest Murder, Death Sentence, The Runaway Barge*. They were a far cry from the works of

NICK NOLTE'S FIRST SCREEN DIALOGUE

"Hey, that sounds like sweet music" (referring to the purr of the Chevy's motor).

Eugene O'Neill that Nolte favored as a stage actor, and similarly, when the movies came calling it wasn't to do *A Touch of the Poet.*

· · · · · ·

The 1974 film *Macon County Line* was written and produced by former Beverly Hillbilly Max Baer, Jr., who also starred as a redneck sheriff terrorizing the wrong two guys after his family is killed. It became the highest-grossing release in the 21-year history of American International Pictures, and there was no way that the studio, the undisputed champ of the exploitation film, was not going to make a follow-up. The only trouble was that when *Macon County Line* was over, practically the entire cast ended up dead. AIP worked around the problem. *Return to Macon County* was not so much a sequel as a redux. The original had two likably rowdy young men and a female pickup pursued by a crazed lawman in 1957, so the second film would have two likably rowdy young men and a female pickup pursued by a crazed lawman in 1958.

Nolte and Don Johnson (who had appeared together in an episode of the cop series *The Rookies*) play brothers Bo and Harley. The former is a driver, the latter a mechanic, and they're on their way to California to enter their bright yellow souped-up Chevy in the Grand National drag race. Unfortunately for them, you can't get there from here without passing through Macon County, Georgia. Their travails begin when they start a fight in a diner defending the honor of waitress Junell (Robin Mattson), who is promptly fired. She insists on joining the boys and although—because?—she's unabashedly dim-witted, she wants to be their manager. Their next bit of trouble occurs when Harley accepts a challenge from some local greasers who not only don't pay up their 50 bucks when they lose the race, but also beat up and rob Harley. Junell retrieves the cash by holding a gun on the hoods, but as they're being chased, our heroes crash into policeman Wit-

taker's (Robert Viharo's) car, a bad situation that Bo exacerbates by punching out the peace officer. And then the rest of the movie has Bo, Harley and Junell being pursued both by the greasers and Wittaker, who grows increasingly obsessed with capturing them, to the point of madness. The only other thing going on is that Bo and Junell fall for each other, which causes some friction between the brothers, though Harley has a romance along the way himself. In the climax, the thugs have tracked down the trio to a farmhouse and steal the Chevy. You've guessed it: Wittaker shows up just then, sees that damned yellow car and sprays it with bullets. The end result is two dead villains and a cop who's turned into a blubbering mess as he faces life in the hoosegow if he's lucky. Junell decides its time to irritate someone else and thumbs a ride to Miami. Bo and Harley go off on their way to a second sequel that never occurred.

Return to Macon County is really shabby. Where the original *Macon County Line* had a raw vitality, this movie, despite having the same director, Richard Compton, is silly and tedious. One of the main problems was noted by *Variety:* "There seems to be miles of driving footage—not so much action, crash footage, just scenic driving shots—inserted between the periodic personal encounters." Another major flaw is that we are supposed to find the brothers a couple of rollicking cutups. They're obstreperous boors. Nolte and Johnson at least come across as professional actors, which cannot be said for the remainder of the cast; the problem is with how the characters are written, not in the way the two leads play them.

Almost exactly a year after Nolte began filming *Return to Macon County,* the television miniseries *Rich Man, Poor Man* premiered; his performance as the rebellious Tom Jordache turned him into one of the most sought-after actors in the business.

THE CRITICS ON NICK NOLTE

"Blond, blue-eyed and deep-voiced, Nolte is one of the most charismatic actors to emerge in recent seasons. He could be on the brink of a major career—even though here he comes dangerously close to overdoing the amblin', shamblin', good ole boy bit."
—Kevin Thomas, *Los Angeles Times*

"Both the young men, played by Nick Nolte and Don Johnson, are very good. Mr. Nolte, in particular, conveys exuberance, a reasonable but not excessive violence and vulnerability."
—Richard Eder, *New York Times*

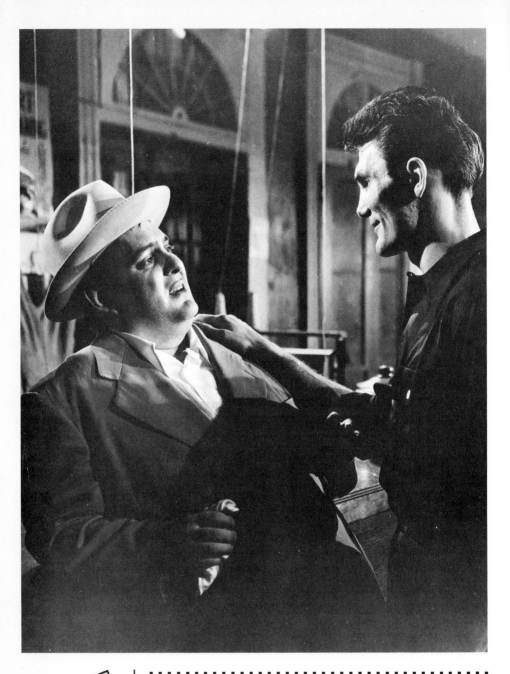

It started early with Jack Palance. The beatings. The shootings. The murders. Having killed a fellow card player in the opening minutes of *Panic in the Streets*, he spends much of the rest of the movie giving poor Zero Mostel a hard time before disposing of him, too—and Mostel was one of his closest friends!

JACK PALANCE

······

PANIC IN THE STREETS
(1950)

L ike Richard Burton, Jack Palance (born Walter Palahnuik) came from coal mining stock, but it was sports, not theatrics, that kept him above ground. He said, "I admire miners. They're a loyal, sturdy, wonderful breed of men. But I decided to leave their limited world. I wanted something more." An athletic scholarship took this son of Ukrainian immigrants from the quarries of Pennsylvania to the University of North Carolina, where he boxed and played football and basketball. But school made Walter antsy and, after sophomore year, he left for the greener pastures of house painting and short order cooking. He also pursued a career as a professional boxer but gave it up despite an 18–1–1 record because "I didn't have a real fighter's heart." That's not literally true, because he enrolled in the Air Force when the World War II broke out, serving as a bomber pilot. He went down in a hit, sustaining extensive burns

Jack Palance got on with his malevolent ways right at the beginning.

CAST

RICHARD WIDMARK,
PAUL DOUGLAS,
BARBARA BEL GEDDES,
WALTER JACK PALANCE,
ZERO MOSTEL, DAN RISS,
ALEXIS MINOTIS

······

20TH CENTUURY-FOX
DIRECTED BY ELIA KAZAN
SCREENPLAY BY RICHARD MURPHY
STORY BY EDNA ANHALT AND
EDWARD ANHALT
ADAPTATION BY DANIEL FUCHS
PRODUCED BY SOL C. SIEGEL
CINEMATOGRAPHY BY JOE MACDONALD

· · · · · · · · · · ·

An obscure actor
named Lewis
Charles has a
cinematic distinc-
tion: He was the
first person ever
murdered by Jack
Palance in a movie.
Over the years,
Palance's celluloid
stock in trade has
been wreaking
havoc. Some of the
actors who have
subsequently felt the
wrath of Jack are:

Joan Crawford,
Sudden Fear (1952)

Alan Ladd, *Shane*
(1953)

Robert Mitchum and
Linda Darnell, *Second
Chance* (1953)

Charlton Heston,
Arrowhead (1953)

Constance Smith,
Isabel Jewell and
Frances Bavier, *Man
in the Attic* (1953)—
Palance played Jack
the Ripper

Jeff Chandler, *Sign of
the Pagan* (1954)—
Palance was Attila
the Hun

Anthony Quinn,
Barabbas (1962)

Claudia Cardinale,
The Professionals
(1966)

and other injuries; the resulting plastic surgery gave him his uniquely taut face and striking, intense features.

After leaving the hospital, he cogitated on the types of jobs he had had after leaving school and decided to return to higher learning. Taking advantage of the GI Bill of Rights, Palance enrolled at Stanford (which he jokingly referred to as a "rich man's school"), majoring in English and intending to pursue a career in journalism when he finished. But then he joined the school's drama club, and that was it. "I knew that everything else I had done during life was just a preparation for my real career. I would become an actor." For the second time in his life, Palance bade adieu to college, this time to move to New York and the world of legitimate theater. His first Broadway appearance was in a bit part as a Russian soldier in a romantic comedy set in the Soviet-occupied zone of Vienna; directed by actor Robert Montgomery, the play was appropriately titled *The Big Two*—it only lasted two weeks. Two other unsuccessful plays followed, but then director Elia Kazan selected him to be the understudy for Anthony Quinn in the road company of *A Streetcar Named Desire*. Back in New York, Palance also did on-call duty for the original Stanley Kowalski, Marlon Brando, going on after he broke Brando's nose while showing him the fine points of pugilism.

· · · · · ·

K azan was preparing a new movie, and as was his wont, he intended to populate the film with "actors who were known only to New York theater people." Jack Palance was one such actor, so he landed in *Panic in the Streets*. Palance points out, however, that it wasn't Kazan who chose him to play the villain of the piece: "He offered me a small part. I read it and did not like it, so I turned it down. Next day I was called back and offered a bigger part, which I took. But recalling me was not Kazan's doing. That was due to Joe Pincus, a 20th Century-Fox executive who had been trying

to get me a break for a long time."

Filmed on location in New Orleans, *Panic in the Streets* is a crime drama with a twist: The murderer the good guys are tracking down is infected with the highly contagious pneumonic plague and is therefore much more potentially dangerous than all your Al Capones and John Dillingers put together. (This may very well be the only movie whose hero [Richard Widmark] is a civil servant from the United States Public Health Service.) At this point in his career, Elia Kazan was a fairly conventional filmmaker, and *Panic in the Streets* unfolds as a straightforward narrative. Still, the movie possesses several notable attributes, chief among them Joe MacDonald's photography, which has a gritty, documentary feeling. MacDonald's camera renders vividly the underside of the Big Easy's waterfront, with its bleak dives, forlorn fleabag hotels and hard-living, hard-luck denizens. Moreover, the individuals populating the background of the film have dispirited faces you just didn't see in movie theaters at the time, unless you were in an art house for a dose of Italian neorealism.

Billed as Walter Jack Palance and playing a small-time hood named Blackie, Palance embodies barely controlled rage. He is deceptively soft-spoken and possesses a nice touch of irony, his intensity making an innocuous line like "What would you do if you were in my shoes and a friend double-crossed you?" come across as a death sentence. He's like a Stanislavskian Sheldon Leonard. Blackie has a cool demeanor that can snap in a moment: He starts off the film by murdering an acquaintance for bowing out of a poker game without giving him a chance to recoup his losses; he wasn't aware that his victim, Kochak (Lewis Charles), had the plague and would have been dead in a matter of hours even without his interference. Blackie spends the rest of the movie hunting the dead man's cousin, Poldi (Guy Thomajan), one of his henchmen who he thinks is holding out with smuggled goods. With the entire New Orleans police force investigating Kochak's mur-

Peter Cushing, *Torture Garden* (1967)

Franco Nero, *The Mercenary* (1969)

Charles Bronson, *Chato's Land* (1971)

Faye Dunaway, *Oklahoma Crude* (1973)

Bo Svenson, *Portrait of a Hitman* (1977)

Sylvester Stallone and Kurt Russell, *Tango and Cash* (1989)

THE CRITICS ON JACK PALANCE

"Walter Jack Palance, as the gang leader, gives a sharp performance often bordering on the macabre."

—*Variety*

"A newcomer to films, Mr. Palance is a tall, rugged man with deep-set, piercing eyes and a granite-like face that commands attention."

—Thomas Pryor,
New York Times

"Walter Palance wonderfully gets across, as the murderer, the craft and stupidity that adds up to his particular quality of evil."

—Hollis Alpert,
Saturday Review

der, Blackie is convinced the dead man must have been involved in something big, and he wants a piece of it. What the cops are really trying to do is locate anyone who came in contact with Kochak, and is thereby a likely carrier of the disease.

The symbiotic interaction between the pitiless Blackie and his sweaty, nervous flunky, Fitch (Zero Mostel, in another of the film's marvelous performances), is especially fascinating: a casebook sadomasochistic relationship presented for your enjoyment at a time when the majority of moviegoers had no inkling of such things. Blackie seizes on Fitch's pathetic obsequiousness and uses it to demean and ridicule him every chance he gets. When Fitch yells at Poldi because he thinks it's what Blackie would do under the circumstances, he is told—in the distinctive, icily sardonic Palance fashion—"Don't be objectionable, Fitch." At the end of the film, the two men flee to the city's wharves and, even with the law closing in on them, a disgusted Blackie takes time out to shoot Fitch for suggesting they turn themselves in. Finally Blackie metamorphoses into a rat: Hoping to escape, he climbs up the mooring of a ship. But exhausted from his illness, he falls into the Mississippi and the waiting authorities. Palance has only five scenes, but his is such a potent piece of acting that anyone who sees it is unlikely to shake off his chillingly calm venom.

Under contract to 20th Century-Fox, the actor followed *Panic in the Streets* by again costarring with Richard Widmark and playing a marine—albeit a punch-drunk one—in the World War II film *Halls of Montezuma*. After Elia Kazan revisited New Orleans for the film version of *Streetcar*, Palance was scheduled to be reunited with the director by starring as the eponymous Mexican revolutionary in *Viva Zapata!* When Marlon Brando became available, Palance was asked to take the role of Zapata's brother. This was unacceptable. The disagreement led to Palance's agreeing with the studio to rip up his contract, and Eufemio Zapata

was played by Anthony Quinn, the actor Palance had understudied a few years earlier. Quinn went on to win a Supporting Actor Academy Award for *Viva Zapata!*; ironically, one of the people he beat was Jack Palance, who had Joan Crawford cowering in *Sudden Fear*. Palance's turn would come 39 years later with *City Slickers* and one of the most memorable Oscar acceptance speeches ever, one-armed push-ups and all.

Despite already being typecast as a villain, Jack Palance, in 1953, showed up on the year's list of the "Stars of Tomorrow." The 10 actors deemed likely to be big draws during the Eisenhower era were:

1. Janet Leigh
2. Gloria Grahame
3. Tony Curtis
4. Terry Moore
5. Rosemary Clooney
6. Julie Adams
7. Robert Wagner
8. Scott Brady
9. Pier Angeli
10. Jack Palance

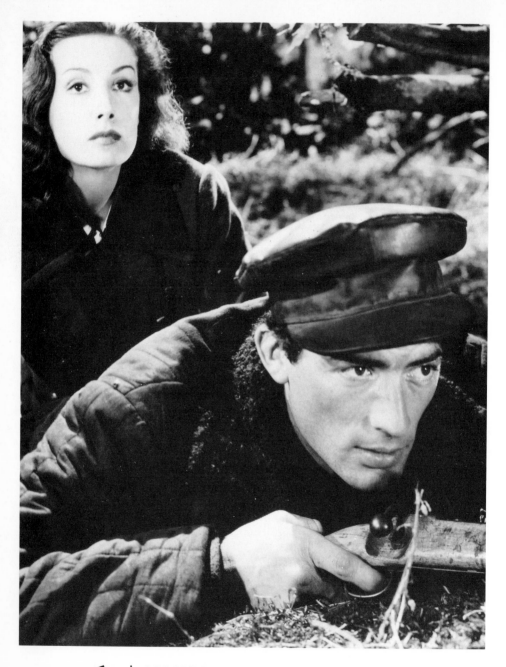

Handsome, dignified Gregory Peck certainly *looks* the part of the leader of a band of Russian guerrillas fighting the Nazis. But then he opens his mouth and sounds not at all like a Comrade but exactly like Gregory Peck. Tamara Toumanova at least peppered her English with a Slavic accent.

GREGORY PECK

······

DAYS OF GLORY
(1943)

Born in La Jolla, California, in 1916, the man christened Eldred Gregory Peck later said, "I'm glad I had a middle name to run to." Acceding to the wishes of his pharmacist father, who looked forward to bragging about "my son the doctor," Peck took premed courses at San Diego State. But studying to be an M.D. brought about ennui, so he went to where the action was—he took a job as a night watchman for an oil company. This, too, was an aborted endeavor because someone in middle management enthused that if Eldred kept up the good work, in 10 or 15 years he could be making $300 bucks a month. He was outta there and into a more prestigious school than before, but the hallowed halls of Berkeley didn't inspire him to become a scholar; running track and rowing with the crew team kept him too busy to crack the books. Even a severe back injury that forced Peck to forgo athletics didn't get him

CAST

TAMARA TOUMANOVA,
GREGORY PECK, ALAN REED,
MARIA PALMER,
LOWELL GILMORE, HUGO HAAS,
DENA PENN, GLENN VERNON,
IGOR DOLGORUKI,
EDWARD L. DURST, LOU CROSBY

······

RKO
DIRECTED BY JACQUES TOURNEUR
SCREENPLAY BY CASEY ROBINSON
STORY BY MELCHIOR LENGYEL
PRODUCED BY CASEY ROBINSON
CINEMATOGRAPHY BY TONY GAUDIO

··············

Gregory Peck started off in a movie nobody wanted to see and still became a star.

Over the years, Gregory Peck would prove himself a "man's man" in a variety of Westerns, war movies and other action films. His initial appeal, however, was overwhelmingly to women, who went wild over his combination of brooding good looks, strength of character and soulful sensitivity. Members of the press weren't immune from his charms either. A newspaper in Havana, of all places, cooed that he was a "new menace to feminine hearts," and a reporter for the Associated Press, Rosalind Shaffer, expressed her feelings thus:

"Gregory Peck is a real pulse accelerator. He is what Maria Montez would enviously describe as sensational.

into the library. (It would later keep him out of World War II, which did wonders for his career.) Years later, Peck hypothesized that going to Mass every Sunday as a youngster had instilled in him a fascination with pageantry and, not seized with any inclination to join the Newman Club, he latched onto the campus activity that came closest to Catholic pomp and circumstance: He joined the Berkeley Drama Club.

This acting business accorded Peck a sense of fulfillment he hadn't previously experienced. He wanted more and he wanted to be paid for it, so, after graduation in 1939, he traveled 3,000 miles to offer his thespian services to New York audiences. The good news was that shortly after his arrival he was indeed earning money with his mellifluous voice; the bad news was, that he wasn't performing on the stage but at the New York World's Fair, encouraging patrons to take a whirl on the nausea-inducing Meteor Speedway ride. The constant barking left him hoarse at the end of every day, so he switched to a more *sotto voce* endeavor, tour guide at Radio City (where 10 of his films would eventually play). A scholarship at the Neighborhood Playhouse School extricated him from hobnobbing with the tourists, and when the school year ended, Peck performed in summer stock. His career accelerated when he hit the road for a small role (eight lines) with grande dame Katharine Cornell in a revival of Shaw's *The Doctor's Dilemma*, then appeared in three Broadway productions in 1942 and 1943 (Peck received excellent reviews, the plays did not) and, in 1943, landed a Hollywood contract.

The prolific Casey Robinson was one of the premier screenwriters at Warner Brothers, having worked on *Captain Blood, Dark Victory* and *Now, Voyager*. But even the best scripters got no respect in Hollywood, and the literate, Ivy League–educated Robinson was fed up with being bossed around by the uncouth philistines who occupied the majority of producers' offices. He was determined to succeed at the producing game, he

was going to do it by making "artistic" rather than commercial films, and he would even forgo having movie stars in them.

Robinson knew a thing or two about hucksterism. In preparation for *Days of Glory,* his account of a small band of Soviet guerrillas battling the Nazis, the neophyte producer behaved as if he were David O. Selznick looking for his Scarlett O'Hara. To drum up interest in his production, Robinson had an artist draw the various Russian characters in the story and sent the sketches not only to agents, casting directors and theatrical producers, but to entertainment editors of newspapers across the country who reprinted the drawings. Thousands of people wrote to Robinson saying that the older peasant looked just like Uncle Joe or the teenage freedom fighter had an uncanny resemblance to my neighbor Sadie's nephew. When all was said and done, however, the cast was made up of actors from radio, the theater and, in the case of the leading lady, ballet. As for Peck, Robinson had spotted him in one of the actor's Broadway flops and signed him up.

■ ■ ■ ■ ■ ■

I n *Days of Glory,* Peck received second billing to the Modigliani-faced Tamara Toumanova, a well-known ballerina who also happened to be engaged to Robinson. The film was intended as a tribute to the "simple people" around the world who had risen to heroic stature in the face of war (or as the pompous-voiced Robinson puts it in the film's introductory narration: "A true story of a little group of free people who lived, loved and fought to drive the invaders from their native soil"). Robinson also introduces the actors, intoning, "Presenting the motion picture debut of a cast of new personalities." He described Gregory Peck as a "distinguished star of the New York stage"— a bit of an exaggeration considering that none of Peck's Broadway shows lasted more than a month.

"He's handsome, in the way any woman likes a man to be handsome. Six feet two and a half, he is rather spare, just enough to give him interesting wrinkles in his dark strong face. He has black hair with a slight natural wave, large dark eyes—a dreamboat, girls— and a certain engaging awkwardness so often characteristic of tall men. And he's only 28."

As a Russian guerrilla in *Days of Glory* (1944).

Although he was
cast as a Russian in
Days of Glory,
Gregory Peck did
not even attempt a
Slavic accent.
Throughout his
career, the actor
would enact charac-
ters of different
nationalities or dis-
tinct areas of the
United States, but
no matter who he
was playing, he
always sounded like
Gregory Peck. Even
when he won an
Oscar for portraying
Atticus Finch in *To
Kill a Mockingbird,*
he did not give the
Alabama lawyer a
Southern drawl.
Among the other
accents and dialects
Gregory Peck has
avoided:

Scottish (*The Keys of
the Kingdom*)

Backwoods Southern
(*The Yearling* and
I Walk the Line)

New England (*The
World in His Arms* and
Moby Dick)

Canadian (*The Purple
Plain*)

Director Jacques Tourneur is justly celebrated for his moody, low-key horror films, such as *The Cat People* and *I Walked with a Zombie.* Like those esteemed thrillers, *Days of Glory* is steeped in atmosphere; but because it mostly takes place in a hidden fortress, what Tourneur accomplishes is to convey the claustrophobia of the bunker, which does not make for great enter-tainment. And it doesn't help that the persons populat-ing the movie are not simply stock characters (a stoic peasant woman, a brash adolescent who defiantly curses the Nazis right before being executed, a middle-aged bumbler who soars to heights of bravery), but inordinately dull ones at that.

Critics in 1944 complained that the events por-trayed in *Days of Glory* had occurred three years earlier, which in the time span of the War was a lifetime ago, and found it hard to get worked up over yesterday's news. A half century later that objection seems irrelevant, but the other common beef still resonates: The war aspect of *Days of Glory* is nudged out by a ludicrous romance between Peck and Toumanova, cast as a ballerina who was entertaining the troops "at Comrade Stalin's be-hest" when a battle broke out. She has taken refuge with Peck's merry band and, after initially having no stomach for their violence, becomes one of the gang by shooting a German soldier. Before you know it, as the two of them hide from the Nazis after blowing up a train, instead of keeping vigilant watch for the enemy, they're busy engaging in romantic clinches. Peck has a pinched speaking style and a gloomy mien throughout the film, so it's absolutely ridiculous when his somber demeanor collides with a florid sentiment like "Nina, Ninotchka, where do you come from? Your eyes are as wonderful as a forgotten dream." Charles Boyer he ain't.

Filmgoers weren't interested in meeting the "Bril-liant Cast of Broadway Stage Personalities" promised in the ads, and *Days of Glory* was not a success. Those who did see the movie, however, were impressed by its leading man, especially distaff audiences, who theater

Spanish (*Behold a Pale Horse*)

British (*Captain Horatio Hornblower*)

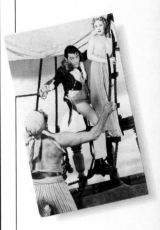

THE CRITICS ON GREGORY PECK

"Gregory Peck comes recommended with a Gary Cooper angularity and a face somewhat like that modest gentleman's, but his acting is equally stiff."

—Bosley Crowther, *New York Times*

Peck "has made a name for himself on the New York stage and is destined for screen stardom, provided his next vehicle is an improvement on his first."

—Wanda Hale, *New York Daily News*

"There is something of the 'strong and silent' in this Mr. Peck. He reflects in his work the grim, unrelenting spirit of the story. At least we hope it's the story and not Mr. Peck's natural disposition to glum and stalk."

—Sara Hamilton, *Los Angeles Examiner*

"The guerrilla chief, as played by Mr. Peck, is too frail-looking to be as dangerous as described."

—*The New Yorker*

managers swore were sighing when Peck was on the screen; this reaction did not escape the notice of the Hollywood hierarchy at a time when the war was still responsible for a dearth of young leading men for the movies. (The under-35 men who were appearing on screen were real lightweights: Tom Drake, Frank Lattimore, James Craig, Dennis Morgan, Richard Travis. No wonder Peck caused a sensation.)

Several months after *Days of Glory* had come and gone, Hedda Hopper declared, "Gregory Peck is the hottest thing in town," an estimation borne out by the bidding war that erupted for his services and resulted in a situation unprecedented in the days of the studio system: The actor signed three separate, concurrent con-

tracts, with 20th Century-Fox, MGM and Selznick. He then starred in three of 1945's biggest hits: *The Keys of the Kingdom, The Valley of Decision* and *Spellbound,* garnering an Oscar nomination for playing a missionary priest in the first. Gregory Peck was the number one male star to emerge in Hollywood during the war years, and his appeal was strong enough that even when Tyrone Power and Clark Gable and James Stewart returned from the service, Peck remained as big as any of them.

ROBERT PRESTON

·····

KING OF ALCATRAZ
(1938)

Music came early into Robert Preston Meservey's life. His mother didn't make things easy for the kid by insisting that he spend his time learning piano and trumpet in a rough Los Angeles neighborhood where most young fingers were used to form fists, not perform Chopin études. He first acted as a high school student and was so enamored of the craft that in 1934, at age 16, he dropped out of school to join a Shakespearean troupe run by one Patia Power, whose son Tyrone was just getting started in movies. The Power company went belly-up six months later, but Preston landed on his feet with a fellowship at the theatrical school attached to the Pasadena Playhouse. There he appeared in more than three dozen productions in two years; among his fellow students were William Holden, Dana Andrews and—not exactly a ringing endorsement for the teaching prowess of the playhouse—Victor Mature.

CAST

GAIL PATRICK, LLOYD NOLAN, HARRY CAREY, J. CARROL NAISH, ROBERT PRESTON, ANTHONY QUINN, RICHARD STANLEY (DENNIS MORGAN), EMORY PARNELL, PORTER HALL, RICHARD DENNING

······

PARAMOUNT
DIRECTED BY ROBERT FLOREY
SCREENPLAY BY IRVING REIS
PRODUCED BY WILLIAM C. THOMAS
CINEMATOGRAPHY BY HARRY FISCHBECK

The quintessential Broadway song-and-dance man began by mixing it up with gangsters.

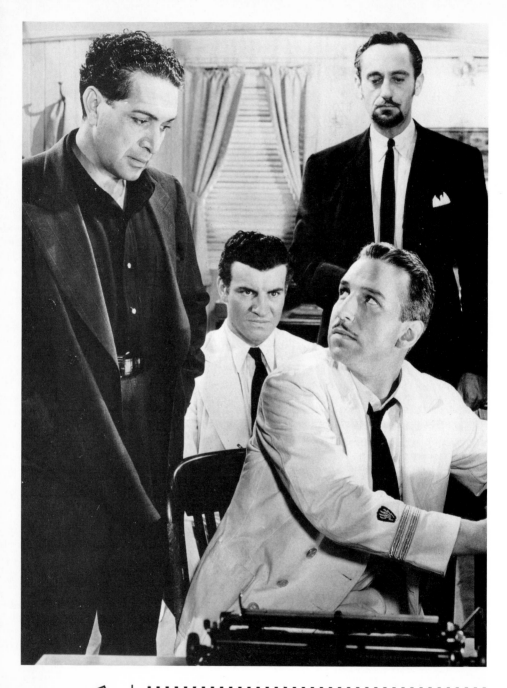

Grim-faced Robert Preston doesn't look like a song-and-dance man. But no wonder—bad guy J. Carrol Naish is threatening both him and his pal Lloyd Nolan.

Because Pasadena is just a few miles outside Los Angeles, it was much easier for people in the film industry to partake of the *theatuh* there rather than traveling all the way to Broadway. And so it came to pass that Preston, appearing in Robert Sherwood's *Idiot's Delight,* caught the fancy of a lawyer who worked for Paramount. He suggested an immediate screen test, after which the studio signed the 20-year-old for a mere $100 a week and told him to drop the Meservey, which was much too dandified for a virile young actor. Although Preston had played a hoofer in *Idiot's Delight,* the studio saw him more as a tough guy, and his first assignment was a second lead in a B movie called *King of Alcatraz.*

Thanks to such directors as Ernst Lubitsch, Josef von Sternberg and Frank Borzage, and the presence of Marlene Dietrich, Claudette Colbert and Ray Milland, the Paramount of the 1930s conjures an air of Continental sophistication and an urbane flair in dealing with the ways of love. But the studio also did a series of extremely well-crafted, taut little crime films with titles like *Night Club Scandal, Tip-Off Girls* and *Hunted Men.* Although Warner Brothers is justifiably remembered as *the* studio for gangster movies, Paramount's entries are not far behind in terms of verve and excitement, even if its array of bad guys (Akim Tamiroff, Lloyd Nolan, J. Carroll Naish) wasn't quite as menacing as Cagney, Robinson and Bogart.

· · · · · ·

Naish has the title role in *King of Alcatraz,* although the title, designed to cash in on the popularity of prison films at the time, was misleading; the character busts out of jail at the beginning of the picture and the prison in the Bay is not seen again. Most of the movie takes place on a tramp steamer, where Naish, amusingly disguised as an old lady, books passage and meets up with the remaining members of that old gang of his. The radio operators on the ship are

To hype its new contractee, the Paramount publicity department made available for newspapers a cartoon drawing of the actor with pertinent "facts": "Dark-haired, gray-eyed Robert Preston named as the greatest star discovery since Gable!"—which, even for Hollywood is rather extreme—and "He'll only play 'He-Man' parts, and has turned down many offers of 'Slick-haired' roles!" (Fortunately, he didn't always adhere to this last prescriptive or he would never have given his matchless performance as Toddy in *Victor/Victoria*.)

Preston and Lloyd Nolan (playing a good guy for a change), who enact a variation on the old Quirt and Flagg bickering buddies routine and compete for the affections of the boat's nurse, Gail Patrick.

The mobsters take control of the ship, and when the two radiomen refuse to do their bidding, they throw Nolan down a hatch and do a number on Preston. Stuck in the hold, Nolan manages to put together a crude radio device and calls for aid. Overhearing him, Naish's people get ticked off and shoot him in the abdomen. Unless the bullet is removed, Nolan will die, but, unfortunately for him, Nurse Patrick has never gone beyond taking temperatures. Preston has a brainstorm: He'll agree to send out the gang's messages if they let him contact a doctor on another ship. And so, listening to instructions over the radio, Gail Patrick successfully performs the delicate surgery on Nolan, as hilariously improbable an overachievement as stewardess Karen Black's piloting a plane in *Airport 1975*. Sounds like a happy ending, but, right after the medical procedure, the rest of the crew overpowers the gangsters and Naish is killed. This seems like a happy ending, too, except that Preston is shot in the crossfire and dies, enabling Nolan to get the girl. (That was inevitable anyway, since Nolan was second-billed—after Patrick—and Preston was down in fifth place; back in the '30s love always followed billing.)

This is all a lot of nonsense, of course, but as directed by Robert Florey, whose rat-a-tat style made him perhaps the best B-movie helmer of his day, *King of Alcatraz* is tremendously enjoyable. Even contemporary critics, who generally had little patience for low-budget pulp movies, took notice. Howard S. Barnes of the *New York Herald-Tribune* commented that "Although it has no stars and skimps along on a B budget, *King of Alcatraz* is a singularly exciting screen melodrama." And Frank S. Nugent of the *New York Times* wrote, "Surprise, Surprise! It's a trim little melodrama, tightly written and logically contrived, and Paramount's

Robert Florey deserves a round of applause for keeping it spinning so furiously. It just goes to show you can't tell by the title . . . a fresh and remarkably diverting film."

Most of the reviews mentioned Preston in tandem with his onscreen buddy: "Nolan and Preston team nicely and turn in convincing performances" (*Variety*); "Nolan and Robert Preston, who makes his film debut in the film, are a well matched pair of boisterous, scrappy seamen" (*New York Daily News*). Looking much older than his 20 years, Preston does a thoroughly competent job within the confines of a one-dimensional role; the only hint that this broad-shouldered, somewhat bulky actor would become the leading male musical comedy star of his generation is a certain jauntiness that occasionally emanates from his eyes amid the histrionics.

Preston settled in for a less than distinguished career at Paramount, playing leads in B movies (*The Night of January 16th, Night Plane from Chungking*) and featured roles in A productions (*Beau Geste, Reap the Wild Wind*). He volunteered for the Air Force in 1942, and when his postwar film career proved as unexceptional as his early days, he packed up and headed east in 1951. A series of Broadway plays—some successful, some not so, although his reviews were almost always exemplary—and summer stock followed. A week before Christmas 1957, he appeared in a musical for the first time. As "Professor" Harold Hill in *The Music Man*, Preston made Broadway history, revealing heretofore unsuspected talents. With his work onstage and in movies over the next three decades until his death, this formerly run-of-the-mill, likable film actor would achieve the rarefied status of a legend.

In the first ever "Stars of Tomorrow," in which American film exhibitors named the most promising screen newcomers, Robert Preston came in fourth, the highest showing for a male. This was even though the poll was taken in 1941, three years after his debut. The complete results:

1. Laraine Day
2. Rita Hayworth
3. Ruth Hussey
4. Robert Preston
5. Ronald Reagan
6. John Payne
7. Jeffrey Lynn
8. Ann Rutherford
9. Dennis Morgan
10. Jackie Cooper (who made his first movie 17 years before the poll and was a Best Actor Academy Award nominee in 1931)

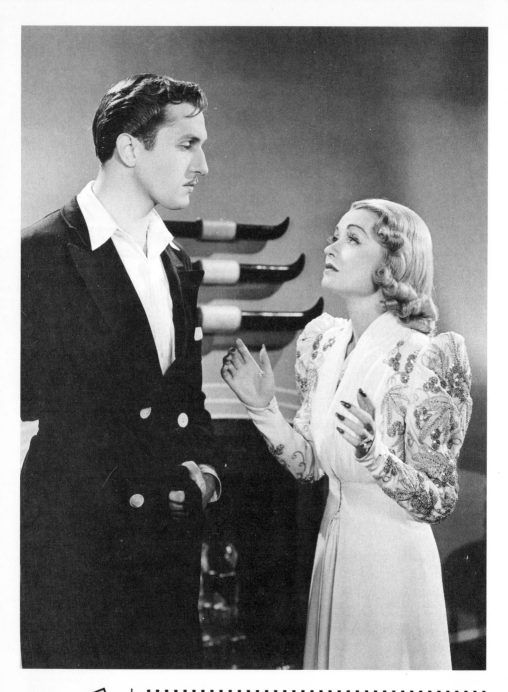

Introducing the new Cary Grant. It didn't quite pan out that way, as playing screwball comedy opposite Constance Bennett proved a less suitable métier for Vincent Price than portraying neurotic weaklings and, later, off-the-wall madmen.

Vincent Price

······

Service de Luxe
(1938)

Vincent Price, the scion of an upper-class St. Louis family, graduated from Yale in 1933 and, at the height of the Depression, landed a job teaching art and drama to scions of upper-class New York families at the Riverdale School. After a year of that, he moved to England to study for an M.F.A. at the University of London, focusing on the history of German art. While at Yale, Price had not joined the drama club and, in fact, recalled, "Except for one appearance as an angel in a nativity play at the age of five—I forgot all my lines—and one as Sir Galahad at sixteen—we shot craps behind the scenes—I didn't participate in amateur dramatics at all." Nevertheless, he maintained an interest in the theater—before landing at the Riverdale School, he had tried to crack the New York stage. While in London, as a 1935 profile in the *Brooklyn Eagle* put it, he "purely for the fun of it, applied at the small experimental Gate Thea-

CAST

CONSTANCE BENNETT,
VINCENT PRICE,
CHARLIE RUGGLES,
HELEN BRODERICK, MISCHA AUER,
JOY HODGES, HALLIWELL HOBBES,
CHESTER CLUTE

······

UNIVERSAL
DIRECTED BY ROWLAND V. LEE
SCREENPLAY BY GERTRUDE PURCELL
AND LEONARD SPIGELGASS, STORY BY
BRUCE MANNING AND VERA CASPARY
PRODUCED BY EDMUND GRAINGER
CINEMATOGRAPHY BY GEORGE ROBINSON

The star of *House of Wax, The Pit and the Pendulum* and *The Abominable Dr. Phibes* was presented to movie audiences as a heartthrob.

THE CRITICS ON VINCENT PRICE

"He is a lean, lanky young man of the Joel McCrea type and has all the assurance and charm necessary for a click on the screen."
—Kate Cameron,
New York Daily News

"In Vincent Price, Universal has found a promising leading man, assured, a competent actor with an excellent voice, clean cut, well-mannered and tall above the average."
—*Daily Variety*

"An excellent dramatic actor, Mr. Price is somewhat less than happily cast as a flippant romantic."
—Rose Pelswick,
New York Journal-American

tre for a walk-on. Producer Norman Marshall needed a tall man with an American accent to play a policeman," and Price fit the bill very nicely.

It was *auf Wiedersehen* to Dürer and those other Teutonic artists; Vincent Price was now officially an actor. And a charmed one at that. Producer Marshall's next presentation was to be *Victoria Regina*, a biography of Queen Victoria, and it just so happened that Price bore an uncanny resemblance to her Majesty's husband. London theatergoers didn't mind that a Yank was playing their beloved Prince Albert, and they took Price to their collective heart.

When *Victoria Regina* came to Broadway, Price crossed the Atlantic with it. The New York production of the show was considered a special triumph for star Helen Hayes, but Price came in for his share of praise and was dubbed a new matinee idol. Brooks Atkinson of the *Times* wrote that his "gentleness of manner as an actor is completely winning," while the *Post* raved, "Newcomer though he is, Mr. Price has an astonishing ease, genuine presence; an ingratiating manner, great dignity, a rich singing, as well as an effective speaking voice, and shows in this first real opportunity which has come to him exceptional promise as an actor." Accordingly, Hollywood sent out its siren song for Price's services, but he resisted the temptation, preferring to remain on the stage in New York. After a year and a half as Prince Albert, he appeared in a less successful play and in two of Orson Welles's Mercury Theatre productions. And he finally agreed to a movie contract. Universal, circa 1937, might not have seemed the place for an East Coast stage actor with artistic aspirations; the studio's big prestige item that year was the Deanna Durbin vehicle *100 Men and a Girl*, and its handful of other A movies had titles like *Wings Over Honolulu*, *You're a Sweetheart* and *Merry Go-Round of 1938*. But Universal offered Price an unusual and irresistible deal: He was under obligation to make movies only six months a year; the rest of the time he was free to pursue his stage career.

The studio didn't call on Price for nearly a year, finally assigning him to a screwball comedy in which he was second-billed to Constance Bennett. After a career slip in the mid-1930s, the actress, who several years earlier had been the highest paid woman in Hollywood ($35,000 a week), was again a hot commodity thanks to the success of *Topper*. In *Service De Luxe*, Bennett is a dynamo who runs a personal service bureau, serving as a factotum for rich clients—she takes care of any chores with which they don't want to be bothered (filling out tax forms, walking the dog) and steps in during emergencies (helping out a chap who wakes up on his wedding day with a monumental hangover). Her latest customer is a man whose nephew (Price), a tractor inventor (!), is planning to visit him in New York; not wanting to be bothered by the young man, the curmudgeon assigns Bennett to prevent his trip. Naturally, the fellow she has kept off the boat from Albany is someone else altogether, and the stranger she socializes with and develops a crush on during the trip downriver is none other than Price.

Bennett only learns of Price's identity when Uncle hires her to be his chaperone in the Big Town, a service the independent-minded Price refuses. The usual screwball personages are then trotted out as Bennett convinces another client, eccentric millionaire Charlie Ruggles, to finance Price's experimental tractors. Meanwhile, Ruggles's ditzy daughter (Joy Hodges) fancies herself in love with Price, much to Bennett's chagrin. He inadvertently becomes engaged to the daughter, then tries to extricate himself until he learns that Bennett, who he thought was a helpless young thing, is actually a working woman; he becomes enraged and wants nothing further to do with her. But we know better, and luckily there's an eccentric Russian on hand (who else but Mischa Auer?), the eccentric millionaire's chef, who gets culinary advice by talking with his

"While moderately good at the romance, he is quite baffled by the extraneous antics."
—Howard Barnes, *New York Herald-Tribune*

"Universal has a player who may go rapidly into the top brackets. . . . He uncovers a screen personality that carries a zing for the femmes."
—*Variety*

"An impressive recruit from the stage, Vincent Price . . . is about the tallest leading man in pictures as of now, and serves a new and substantial kind of romantic performance."
—*Motion Picture Herald*

dead ancestors. Price discovers that the chef is really a nobleman and, knowing that the ditzy daughter has a thing for royalty, plays Cupid for the two of them and graciously agrees to break off his engagement. He and Bennett are now free to marry, once she gives up her life as a career woman—which, naturally, is what she wanted all along.

A movie like *Service De Luxe* makes you realize why a select few screwball comedies such as *My Man Godfrey, The Awful Truth* and *Twentieth Century* are so fondly remembered: It's difficult to make all the elements in this type of film coalesce, and when they don't the result can be nearly unbearable. The situations and characters in *Service De Luxe* have all been seen before, in far better circumstances, and while Rowland V. Lee (*Zoo in Budapest, The Count of Monte Cristo*) was not an untalented director, his touch is not light enough to offset the heavy-handed material. Although having a heroine renounce her vocation is difficult for viewers of the post–*Feminine Mystique* age to stomach, this was a standard theme, emblematic of its time. Even so, a startled critic for the *New York Telegram* observed, "To be sure, men have resented brilliant career women on the screen before, but seldom have they turned on them with such ferocity . . . it is done so seriously that one can't help wondering if it might not be satire in disguise." (We haven't completely rid ourselves of this noisome plot resolution—as recently as 1990, in *Pretty Woman*, Julia Roberts willingly gave up her job for the love of Richard Gere.)

By this point, Constance Bennett could do a comedy like *Service De Luxe* in her sleep, but an uncomfortable Price does not have an easy time balancing the romantic and priggish sides of his character; a scene in which he gets to show that he, too, can be an eccentric by singing about toothpaste in a drugstore is painfully stilted. The movie was almost unanimously dismissed, and, recalling the raspberries thrown at it, Price wrote in his memoirs, "One of the kindest things that the

critics said about the film was that it was a 'pathetically unfunny farce.'" One reviewer who praised *Service De Luxe* was, of all people, the guy from the *Daily Worker,* mouthpiece of the American Communist Party. I assume the reason he went for the movie is that Price's character is "an idealist who refuses excessive profits on his revolutionary tractor because he wants to keep its price within the reach of poor farmers." As for Vincent Price, the critical consensus was that he was very tall (6'4") and showed promise, but would probably do better with more inspired material. And the tepid reaction of the film pretty much wiped out the goodwill Constance Bennett had engendered for herself with *Topper.*

Having finished *Service De Luxe,* Price fled back to New York and the theater. For his next film, Universal lent the actor out to Warner Brothers, where he went all the way down to sixth billing as Sir Walter Raleigh in the Bette Davis–Errol Flynn vehicle *The Private Lives of Elizabeth and Essex.* A harbinger of things to come: In 1940, Universal assigned Price the title role in *The Invisible Man Returns,* his first horror film, after which he left the studio. Back on the Broadway stage, he won raves as the evil husband in the hit suspense thriller *Angel Street,* a role that would be played by Charles Boyer when the play was filmed as *Gaslight.* Following that, Price returned to motion pictures, settling in as a slightly sinister character actor and, later, a fright specialist. It was a long and honorable career, but one that could not have been divined from the ads for *Service De Luxe,* which trumpeted, "YOU'LL GET THE THRILL OF YOUR LIFE when gorgeous Connie fits Broadway's latest romantic idol close in her arms."

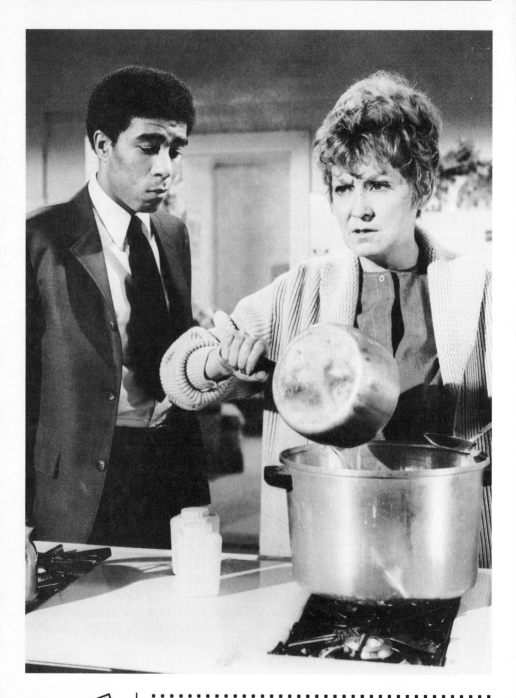

If Richard Pryor doesn't appear particularly funny in this scene, it's because he's not. Seeking information in a murder investigation from Kay Medford, Pryor is as straightforward as Jack Webb doing Joe Friday. And not even as amusing.

RICHARD PRYOR

······

THE BUSY BODY
(1966)

Suppose they took a comedian and gave him nothing funny to do.

CAST

SID CAESAR, ROBERT RYAN,
ANNE BAXTER, KAY MEDFORD,
JAN MURRAY, RICHARD PRYOR,
ARLENE GOLONKA,
CHARLES MCGRAW, BEN BLUE,
DOM DELUISE, BILL DANA,
GODFREY CAMBRIDGE,
MARTY INGELS, GEORGE JESSEL,
MICKEY DEEMS

······

PARAMOUNT
DIRECTED AND PRODUCED BY
WILLIAM CASTLE
SCREENPLAY BY BEN STARR
CINEMATOGRAPHY BY HAL STINE

Born in Peoria in 1940, Richard Pryor had his first brush with show business when, at the age of seven, he amused patrons at a local nightspot by sitting in on drums, but that was it for another decade and a half. Because he was surrounded by poverty, joining the Army seemed like a good idea at the time, and he spent 18 months in West Germany. The racism he encountered from his fellow defenders of liberty in the late 1950s, however, was a shocking wake-up call and fueled some of the anger that later found an outlet in his comedy.

Several years earlier, a high school teacher had planted in his mind the idea of becoming a comedian and, on his return to the States, Pryor played in Peoria. Other venues followed, but they weren't exactly elite engagements, unless you think it's a kick to be young, gifted and black and performing in East St. Louis. Still, Pryor

plugged away on the Chitlin' Circuit, eventually playing to crossover audiences and then, in 1963, heading for New York. Like many successful—and unsuccessful—comics before and after him, Pryor performed in dreary little Manhattan *boîtes de nuit* whose owners felt no remorse at paying the talent a pittance on the grounds that they were magnanimously offering the acts an opportunity to hone their craft. That was just a temporary situation, though, and eventually Pryor was booked into some of the better clubs, such as the Cafe Wha?

Pryor has said that his primary role model in the mid-1960s was Bill Cosby because a white agent advised him that the Cos was the type of black man with whom white audiences could feel comfortable. Indeed, while Pryor's early routines did a wry take on the ways of the world, they were all but bereft of the mordacious edge that propelled him into the top echelon in the 1970s. (A 1964 *Variety* review of his act said, "Colored comedian has strong and definite ideas on humor," but complained that "there is still much for him to learn. . . . He has the approach of an intellectual rather than an entertainer.") Show business is full of strange bedfellows, of course, but still it comes as a jolt to discover that Richard Pryor's ministering angel came in the person of Rudy Vallee. In 1964, the crooner invited the comic to appear on his show, *On Broadway Tonight,* a CBS summer series spotlighting young talent. (Among the other unknowns Vallee put on the air were Rodney Dangerfield, Rich Little and George Carlin.) From there, Pryor made it to the Catskills, Las Vegas and further exposure on the tube with Ed Sullivan, Johnny Carson, Merv Griffin and the *Kraft Summer Music Hall.*

As an emerging figure in the world of mainstream comedy, Pryor caught the attention of William Castle. A marginally talented B-movie director, Castle did have real flair in a related cinematic endeavor: He was a genius at coming up with gimmicks to ballyhoo lousy horror movies, turning them into gold mines. To drum

up interest in *Macabre,* he took out insurance policies with Lloyd's of London in case any audience members were scared to death, and for *The Tingler,* about a creature that stings people, he had theater seats rigged with electric buzzers. By the mid-1960s, moviegoers had grown too sophisticated for this kind of hokiness, so Castle was forced to rely on whatever filmmaking talent he had (as well as sticking such remnants of 1930s Hollywood as Joan Crawford, Barbara Stanwyck and Robert Taylor in cheesy thrillers).

For some reason, Castle decided there was a film audience for a television comedian from the 1950s who had never been a movie star, so he signed Sid Caesar to a two-picture deal. In the first of their collaborations, a gangland comedy called *The Busy Body,* Castle paired Caesar with two first-rate actors, Robert Ryan and Anne Baxter. He also sprinkled the movie with comedians who formed a smorgasbord of styles and eras, ranging from the fossilized vaudevillian George Jessel to the topical Godfery Cambridge, with Jan Murray, Marty Ingels, Bill Dana, Ben Blue, Kay Medford, Dom DeLuise and Pryor occupying various places in between.

• • • • • •

*T*he Busy Body has to do with Caesar's attempts to recover $1 million belonging to mob boss Ryan and buried in a suit worn by a corpse. As the title implies, the stiff disappears from its final resting place, and as he tracks it down Caesar encounters the aforementioned comics, giving them each the opportunity for a few minutes of shtick. The plot, which involves an insurance scam, is as convoluted as *The Big Sleep,* but without anything even approaching the payoff of the Howard Hawks film, and the laugh lines are on the order of "I swear on my mother's racing form" and (Sid Caesar to Anne Baxter after sex) "Anytime you're near my apartment, just drop in and use my swizzle stick." Castle's pacing is lugubrious, and Caesar, whose mama's

• • • • • • • • • • •

Minor though his role in *The Busy Body* was, Richard Pryor took it extremely seriously. He mused about his technique, "I did every actor that I'd ever seen in this one role. I walked in the door like Steve McQueen, I took my hat off like John Wayne, even did some Charlton Heston. I had all these things, I'd rehearsed them all. I was probably real rotten, but I thought I was great, then."

boy/gangland flunky character is extremely unappeal-
ing, seems to have forgotten everything he ever knew
about comic timing. Caesar overdoes a double take here;
Marty Ingels grates with his misplaced manic energy
there. *The Busy Body* is that pitiful creature, a comedy
without laughs.

Richard Pryor doesn't add to the movie's laugh
quotient, but it isn't really his fault. Cast as a police
lieutenant investigating the various killings, Pryor is
wasted in what is essentially a straight role. He does
get to trot out a stuffy British accent when imitating a
punctilious funeral director and, in a graveyard stake-
out, invokes some of his soon-to-be familiar bits of
business, running around frantically and hysterically
screaming, "Where is everybody?" Basically, though, there's
no reason why this cop had to be played by a comedian,
and Pryor gave the role little of the street-smart sass
that would later become a hallmark.

The unsuccessful comedy did nothing for Pryor's
career (but at least, since his role was small, it didn't do
any apparent damage either). He next appeared in a
small role in the dark satire about what happens when
14-year-olds get the vote, *Wild in the Streets,* and con-
tinued to rise in popularity as a comedian. In 1970,
however, Pryor, as he described it, "went crazy" and
walked offstage in front of a full house at the El Alad-
din Hotel in Vegas. Something snapped and the comic
decided he could no longer dichotomize his stage per-
sona and his true feelings. There'd be no more genteel
humor as he moved into his "Crazy Nigger" mode,
shaking audiences with his profane takes on life as a
black man. Pryor caused uneasiness in some onlook-
ers—early supporter Merv Griffin didn't know what to
make of the frequent use of a word he thought black
people hated to hear—and initially lost some bookings.
But at a time when Richard Nixon was President of the
United States, Pryor was able to tap into the anger and
anxieties of young audiences no matter what their race.
The transformation seemed to liberate him, and his

supporting performance as a drug addict in 1972's *Lady Sings the Blues* had a vitality and intensity previously lacking in his screen work. By the mid-1970s he was not only the country's most popular black comedian, he was arguably the most popular comedian, period. And by the end of the decade he was so big a movie star that Billy Wilder would quip that the only four words movie executives knew were "Get me Richard Pryor!"

THE CRITICS ON RICHARD PRYOR

Pryor's few notices were as bland as his role. The *Motion Picture Herald* didn't critique Pryor's performance, it simply referred to him as "the young comedian who always appears to have just been slapped in the face." Charles Champlin of the *Los Angeles Times* remarked, "The young Negro comedian is too young but amusing," while the *Hollywood Citizen-News* thought he managed to "register . . . as a murdered mortician's assistant"— unfortunately, that was Dom DeLuise's role.

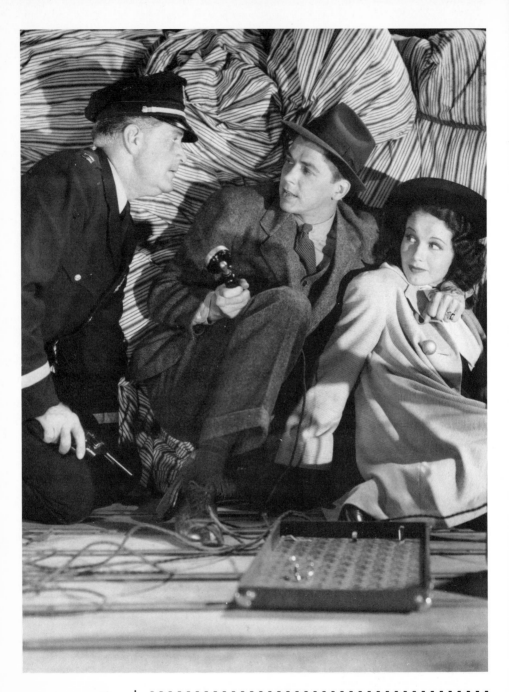

 Ladies and gentleman, the President of the United States. With radio transmitter in tow, Ronald Reagan, 26, is already doing his Great Communicator bit in *Love Is on the Air*. His fellow citizens are Cliff Saum and June Travis.

RONALD REAGAN

······

LOVE IS ON THE AIR
(1937)

A nyone who lived through the 1980s undoubt-edly heard all the folksy anecdotes about young Ronald Reagan: How he got the nick-name "Dutch" because when his father first saw him, he said he looked like a "fat little Dutchman." His strength in coping with his father's alcoholism and life close to the poverty line. The "uncanny" imitations of announcers he had just heard on the radio. His stint as a campus radical when he led the struggle to get rid of the despotic president of Eureka College, who was threatening to end the school's sports program. And the hoariest, most-repeated tale of them all: his job as a sportscaster, in which he broadcast Chi-cago Cubs games, pre-tending to be at Wrigley Field when he was actu-ally sitting in the Des Moines radio station and receiving the plays over a telegraph. It was Ronald Reagan's first time lying to the public over the air-waves.

The way Reagan saw

····

Who could have known?

CAST

RONALD REAGAN, JUNE TRAVIS, EDDIE ACUFF, GEORGE E. STONE, ROBERT BARRAT, ADDISON RICHARDS, RAYMOND HATTON, TOMMY BUPP, DICKIE JONES, SPEC O'DONNELL, WILLIAM HOPPER

······

WARNER BROTHERS
DIRECTED BY NICK GRINDE
SCREENPLAY BY MORTON GRANT
PRODUCED BY BRYAN FOY
CINEMATOGRAPHY BY JAMES VAN TREES

■ ■ ■ ■ ■ ■ ■ ■ ■ ■

Ronald Reagan was the most prominent politician to emerge from the ranks of the performing arts. Other actors and actresses who sought a career in politics include:

Edward Arnold— unsuccessful candidate for Republican nomination for U.S. senator from California (lost to Richard Nixon)

Rex Bell—lieutenant governor of Nevada; unsuccessful candidate for governor

Sonny Bono—mayor of Palm Springs, California; unsuccessful in bid for Republican U.S. Senate nomination

Wendell Corey—city councilman, Santa Monica, California; unsuccessful in bid to become Republican nominee for Congress

Helen Gahagan (Douglas)— Democratic congresswoman from California; unsuccessful candidate for U.S. Senate (defeated by Richard Nixon)

Clint Eastwood— mayor of Carmel, California

it, the public was missing out by only hearing his mellifluous voice and not getting the rest of him. Unless they happened to see him at a local restaurant or had a look at his publicity photos, they wouldn't know about his all-American boyish handsomeness. But if he were in the movies. . . . And besides, Hollywood could provide him with a lot more money and prestige than a radio station in Iowa. Plus, Dutch had joined the Drama Club when he was at Eureka, so this was not just some impetuous whim. Reagan hatched a scheme and convinced the station's general manager that it would be quite a coup if he accompanied the Cubs to their spring training camp on Santa Catalina Island. After covering the baseball team long enough to assuage his conscience, Dutch swung into his real agenda: He phoned singer Joy Hodges, a Des Moines native whom Reagan had interviewed on the radio and who now was under contract to RKO. Because she found him oh so attractive, she agreed to have him meet her agent, who thought the 26-year-old had an appealing natural quality and arranged two screen tests, swearing to studio casting agents, "I have another Robert Taylor sitting in my office." Reagan stormed off the Paramount lot before stepping in front of the cameras, roiled that the casting director had kept him waiting for hours. Things went better at Warner Brothers. A few days after returning home, Regan received a telegram from the agent. Warners wanted him for a seven-year contract, starting at $200 a week. So long, Des Moines. Hello, Hollywood.

It was typical of Jack Warner's sweatshop of a studio that Reagan arrived in Hollywood on May 31, 1937, and was scheduled to start shooting his first movie on June 7. Warner had a simple philosophy: If you're paying a guy big bucks to make movies, you're wasting good money unless you have him start right away. It wasn't going to be easy for the untrained new contract player because he wasn't being given a slow buildup; rather, in his first time out in front of the

cameras he was going to be the star of the film. And even though *Love Is on the Air* would be a cheap, 61-minute programmer shot in three weeks, Reagan would be in almost every scene. As the actor recalled in his autobiography, "I didn't know at the time that studios made two kinds of pictures: A's and B's. Needless to say, this was a B—but I didn't know it. All I knew was I was starring in my first movie, and that seemed to make a great deal of sense." The film was a remake of *Hi, Nellie*, an unsuccessful Paul Muni movie from only three years earlier, with the original newspaper milieu being transferred to a radio station—a setting that would at least give the actor a feeling of familiarity in this new medium.

■ ■ ■ ■ ■ ■

L ove Is on the Air was originally intended as a musical, but when murder and racketeers started getting thrown into the mix, it was decided that maybe the ditties would be out of place, so the title song was actually sung by Dick Powell in another movie. Reagan played a radio news commentator who, in his hard-hitting condemnations of political corruption, tarnishes the reputation of his sponsor. (That he would attack the person who pays the bills pretty much throws away any credibility right off the bat.) When he balks at being ordered to can the political commentary, Reagan gets his comeuppance—he has to host the "Children's Hour" program and deal with a bunch of snot-nosed kids. Inexorably cheerful, he makes the best of the situation and organizes bicycle races and boxing matches for the children, and he takes the show out on the road, broadcasting from such exciting locales as playgrounds and sandlot baseball diamonds. Winning the trust of the youngsters in town, he is privy to information from a kid about a missing businessman. Reagan then helps the police find the man's kidnappers and broadcasts the resultant shootout over his shortwave radio, making him the most popular personality on the

Helen Gahagan in *She* (1935).

Fred Grandy—Republican congressman from Iowa

Nancy Kulp—unsuccessful Democratic nominee for Congress from Pennsylvania

John Lodge—Republican U.S. senator from Connecticut

Melina Mercouri—Socialist member of the Greek parliament

Gary Merrill—unsuccessful Republican nominee for Congress from Maine

Karen Morley—unsuccessful American Labor Party candidate for lieutenant governor of New York

George Murphy—Republican U.S. senator from California

Martin Sheen—mayor of Malibu, California

Ralph Waite—unsuccessful Democratic nominee for Congress from California

· · · · · · · · · · ·

INTRODUCING RONALD REAGAN

The Warner Brothers publicity department alerted theater owners:

"It's a pleasure to meet Ronald Reagan!

"We think our new film find will click O.K. because he has an informal, refreshing and engaging manner. He knows how to sell himself and his first picture, too!"

air. As for the titular "Love," he wins the fair hand of the woman he replaced on the kiddie show, June Travis.

Reagan handles his one-dimensional role with somewhat more aplomb than you'd expect from a first-time actor, although he does have his awkward moments, as if from time to time he was suddenly startled to find himself on a soundstage. He is uncomfortable in the romantic clinches with leading lady Travis and recollected three decades later that the experience taught him that "work is work, and fun is fun, and kissing was more fun at the high school picnic." The movie, an overly melodramatic time-filler, doesn't call for much histrionics on his part, but he has an amicable presence. In fact, Ronald Reagan is not nearly deserving of the Terrible Actor label revisionist history has tagged on him; throughout his career he was a perfectly serviceable performer. In New York, *Love Is on the Air* premiered in Brooklyn; a month later, it finally made it to Manhattan as the bottom part of a triple bill at the Palace, listed beneath a second-run showing of *Stage Door* and Mickey Mouse in *Hawaiian Holiday*.

Reviewers were less than thrilled with the enterprise. *Variety* allowed that while it's "certainly not for the fastidious, the nabe patrons who don't seek too much credibility and who don't mind an overdone plot formula will like the pic's rapid-prancing pace and pleasant characters." Despite all the kids in *Love Is on the Air,* an early proponent of "family values," the American Legion Auxiliary, advised that a "murder and its accompanying horror make the picture unsuitable for any but adults." And the National Council of Jewish Women warned, "Fraught with gang war, and political graft, this obviously mistitled social drama flounders in a welter of blood and bullets." Certainly the ads for the film seemed to promise a romantic comedy: A cartoon Cupid stands in front of a radio microphone with the call letters "WUV" (cute, huh?), accompanied by such copy as "At the Stroke of the Chime—It Will Be Exactly . . . Love Time!"

Love Is on the Air was just another B movie that quickly came and went, and Reagan was kept busy starring in more of the same and taking on supporting roles in major movies. (Bette Davis said that around the Warners lot, the actor was referred to as "Little Ronnie Reagan.") Finally, in 1941, he got a lead in a big-budget film, *Kings Row,* the dark flip side of *Our Town,* in which he had his legs cut off by a demonic doctor and uttered, memorably, "Where's the rest of me?" Unfortunately for his career, World War II came along and he was drafted into making documentary films for the Air Force. After 1945, the moviegoing public had, by and large, lost interest in uncomplicated, wholesome types—Give us Burt Lancaster!—and Reagan's career never regained its lost momentum. It's impossible not to reflect that had Ronald Reagan been a little more talented and forceful an actor, if he had possessed a little more of that indefinable star power, he might have remained a major movie star. And American history might have been very different.

THE CRITICS ON RONALD REAGAN

"Run, don't walk to the nearest entrance and beg, borrow or steal a look at Ronald Reagan in *Love Is on the Air.* What he has done to one gal (an adamant critic, at that) he can do to millions of others by restoring their faith in Santa Claus and making them ardent Reagan fans in one sitting . . . young Reagan's debut takes on sensational proportions. . . . Making the jump from sports announcing to movies is simple, providing one has bumped into a talent scout, has poise, a voice, personality and a face the camera loves."
—Dorothy Masters, *New York Daily News*

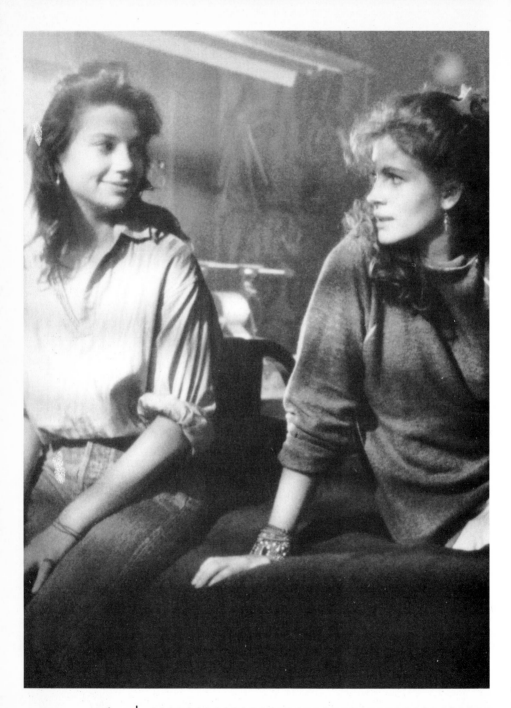

Justine Bateman smiles benignly on Julia Roberts, who was a mere newcomer while she was a star.

JULIA ROBERTS

......

SATISFACTION
(1987)

Because her parents ran an actors' and play-wrights' workshop outside Atlanta, you might assume that, through osmosis, Julia Roberts developed a desire to be a theatrical light at an early age. You would be wrong. "For as long as I can remember, I wanted to be a veterinarian," she said. "I thought I was Dr. Dolittle, convinced I could talk to the animals." But the field of study that has wrought havoc on the grade point averages of many artistic people over the years got in the way of her dream: "I went to school and discovered science, which I hated, so that went out the window." Could it have been seeing, at age 10, all the attention lav-ished on her brother Eric when he was given a huge publicity buildup as the star of *King of the Gypsies* in 1978? No, that wasn't it either. In actuality, Roberts's acting career just sort of happened.

After graduating from high school in 1985, Julia, unlike many of her class-mates, figured she didn't want to go to college and she didn't want to devote

......

Julia Roberts played second fiddle—or second guitar—to a TV star.

CAST

JUSTINE BATEMAN,
LIAM NEESON, TRINI ALVARADO,
SCOTT COFFEY, BRITTA PHILLIPS,
JULIA ROBERTS, DEBBIE HARRY

......

20TH CENTURY-FOX
DIRECTED BY JOAN FREEMAN
WRITTEN BY CHARLES PURPURA
PRODUCED BY AARON SPELLING AND
ALAN GREISMAN
CINEMATOGRAPHY BY THOMAS DEL RUTH

........

When she was
starting out in films,
Julia Roberts was
routinely referred to
as Eric Roberts's
sister. No one has
called her this in a
long while. Other
siblings who have
had successful
acting careers
include:

Dana Andrews and
Steve Forrest

Ethel Barrymore,
John Barrymore and
Lionel Barrymore

Warren Beatty and
Shirley MacLaine

Noah Beery and
Wallace Beery

Jim Belushi and
John Belushi

Constance Bennett and
Joan Bennett

Sally Blane and
Loretta Young

Scott Brady and
Lawrence Tierney

Angela Cartwright and
Veronica Cartwright

Tom Conway and
George Sanders

Olivia de Havilland
and Joan Fontaine

Catherine Deneuve
and Françoise Dorléac

Joanne Dru and
John Ireland

her energies to landing herself a husband. Therefore, she went with the *That Girl* option: moving to New York to live with her sister Lisa and aping her status as an aspiring actress. Julia worked as a sales clerk, and one day, while strolling down Columbus Avenue, someone took a look at her, liked what he saw, and put her in touch with a man named Bob McGowan who became her manager. McGowan's first bit of advice was that she shuck off the Southern accent; there weren't enough Tennessee Williams revivals around to make it an asset. Her first acting work came about in 1986 when brother Eric—who had proven too intense an actor to achieve the stardom that had been forecast for him—told the producers of the cheap movie he was about to do that his sister would be ideal in the role of his sister. A recent Oscar nomination as Best Supporting Actor for *Runaway Train* had not served to adrenalize Eric's career, so the film, *Blood Red,* became that dreaded commodity, a straight-to-video movie, only getting exposure in 1990 as a result of Julia's success.

While Julia Roberts was attending high school, Justine Bateman went through her adolescence on television, playing daughter Mallory on *Family Ties.* Seeing that her sitcom brother, Michael J. Fox, had made it big in movies, some money men (including Aaron Spelling and Sally Field's husband) looked to Bateman for a repeat performance. Bateman's would-be ticket to movie stardom saw her cast as the leader of a rock group who, as teenagers in movies had for more than half a century, comes of age during one eventful summer. Although *Satisfaction* was to be a Justine Bateman vehicle, she needed a band to back her up, and that's where Roberts came in. Bob McGowan told the film's casting director that his client was a musician and made Roberts take a crash course in percussion because "drums are the easiest instrument to learn." Sometimes in this business you've gotta lie if you want results, and Roberts was cast in *Satisfaction*— as the bass guitarist.

· · · · · ·

Although the writer of *Satisfaction*, Charlie Pur-
pura, had scripted the wonderful, highly original
Catholic boys' school comedy *Heaven Help Us*,
all he could come up with here is a sea of clichés un-
folding at a mid-Atlantic resort. Each member of
Justine's band, Jenny Lee and Mystery, has a single
salient trait: lead guitarist Trini Alvarado is the leather-
clad tough street kid whose swaggering masks her in-
security; drummer Britta Phillips does little in the movie
besides popping pills; and keyboardist and sole male
member Scott Coffey blossoms from classical-music
nerd to rock-and-roll animal. As for Julia Roberts, who
received sixth billing, a subsidiary character comments
that her lascivious Daryle "on good days, is a slut." All
the band members are given a histrionic moment or
two before having to clear space for Justine Bateman to
strut her stuff as the star. (She worries about keeping the
band together, must make a decision whether to accept
a college scholarship or take "Mystery" on a European
tour, and gets her heart broken by burnt-out song-
writer Liam Neeson.) As for the band, Mystery is a
relatively cleaned-up bar band, and it's hard to believe
it'd make much of an impression on anyone other
than a bunch of kids who've had a few too many Bud-
weisers. The group's repertoire consists almost exclu-
sively of covers of old songs ("Knock on Wood," "C'mon
Everybody"), and even the name of Bateman's charac-
ter is a cover version: "Jenny Lee" was a 1958 hit by Jan
and Arnie.

Roberts's first scene comes during high school
graduation when she turns down an engagement ring
from her boyfriend: Flashing that smile that doesn't
quit, she insists "Frankie . . . Frankie, I want to go."
Her tour de force comes when a lunkhead law student
she's dating tries to rape her. "You want me just to lay
here and be quiet while you ball me?" she defiantly
asks, and when he answers in the affirmative, she hits

Emilio Estevez and
Charlie Sheen

Mia Farrow and
Tisa Farrow

Jane Fonda and
Peter Fonda

Dorothy Gish and
Lillian Gish

June Havoc and
Gypsy Rose Lee

Dennis Quaid and
Randy Quaid (below)

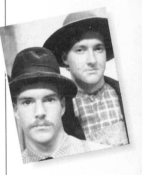

Lynn Redgrave and
Vanessa Redgrave

Catherine Schell and
Maximilian Schell

Constance Talmadge
and Norma Talmadge

Dick Van Dyke and
Jerry Van Dyke

him on the head with a duck decoy. Lest her character
be pegged as a woman of the '80s, however, when her
Frankie later comes down, trying to persuade her to
come home and stop parading as a "piece of meat" on
stage, she initially squawks but then gives in to her sex
drive. There follows a series of quick dissolves covering
a 24-hour period in which the parked van she and her
boyfriend have bunked down in incessantly rocks up
and down and back and forth, to the accompaniment
of their moans and screams.

As a young woman more interested in lust and ro-
mance than music, Roberts turns in a sprightly comic
performance, with a winking self-awareness giving a
spirited edge to her character. Her joyful verve is in
sharp contrast to the listless Bateman, wooden Phillips,
bland Coffey and hammy Alvarado, and if she isn't
overly convincing playing bass, well, none of the other
band members is especially lively as a musician either. I
saw *Satisfaction* back in 1988 and I'd be lying if I said
I foresaw Roberts's impending stardom, but watching
her charming performance now, you can clearly pick
up on the vivaciousness that would set her apart from
most of her contemporaries.

Opined Michael Wilmington of the *Los Angeles
Times,* "Watching *Satisfaction* sometimes feels like being
dropped into a time-warping Vegematic. This is a mo-
vie—supposedly about an '80s rock band—where the
songs date from the '60s, the language and sexual atti-
tudes suggest the '70s and the plot is pure '50s." His
colleagues concurred. Julia Roberts was scarcely com-
mented on by critics, and, luckily for her, she segued
from *Satisfaction* to another, slightly better saga of teen-
age girls on the brink of womanhood, *Mystic Pizza,*
which brought her her first approbatory attention. Poor
Justine Bateman, on the other hand. Rather than repli-
cating Michael J. Fox's success, her subsequent career
more closely approximated the third *Family Ties* sib-
ling, Tina Yothers.

WINONA RYDER

······

LUCAS
(1985)

Ryder was born Winona Horowitz in 1971; her first name came from her place of birth, Winona, Minnesota, although she grew up in Northern California. Her parents, Michael and Cindy, were very much in tune with the 1960s, even in the 1970s, and for a while lived on a farm cooperative—*not* a commune, Ryder insists—in Mendocino, California. The senior Horowitzes were not your garden-variety hippies, however; with their passion for literary scholarship, they acted more like counterculture Lionel Trillings. Winona's parents wrote an in-depth study of Aldous Huxley and another book asserting that Louisa May Alcott wrote *Little Women* while under the influence of opium. They also served as archivists for the papers of LSD proponent Timothy Leary and created a bibliography of his works. Leary said that while he was exiled in Switzerland in the early '70s, Michael Horowitz showed him a photograph of the newborn Winona and "I wrote an inscrip-

Winona Ryder showed that a nerd can be beautiful, too.

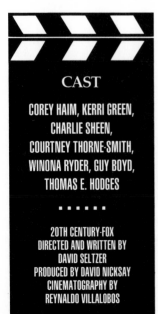

CAST

COREY HAIM, KERRI GREEN, CHARLIE SHEEN, COURTNEY THORNE-SMITH, WINONA RYDER, GUY BOYD, THOMAS E. HODGES

······

20TH CENTURY-FOX
DIRECTED AND WRITTEN BY
DAVID SELTZER
PRODUCED BY DAVID NICKSAY
CINEMATOGRAPHY BY
REYNALDO VILLALOBOS

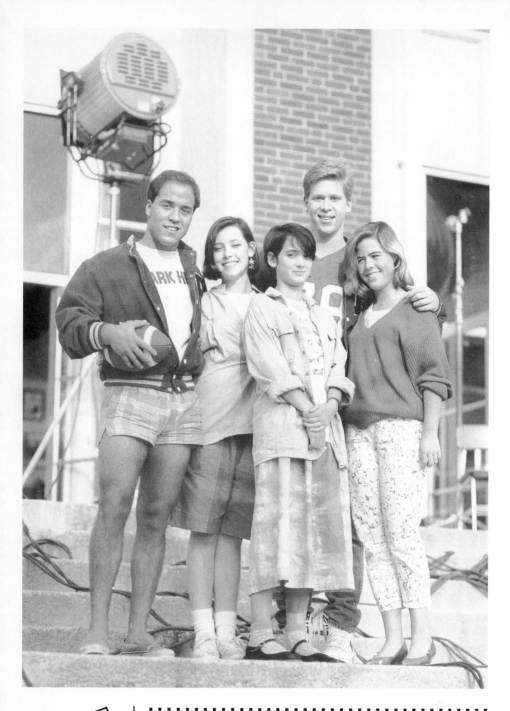

Winona Ryder, center, poses for a candid shot with her fellow unknown actors while the stars of *Lucas* are off doing something else.

tion on the picture welcoming a new Buddha to planet Earth"; when she was a teenager, Winona in turn asked Leary to be her godfather. Michael Horowitz's field of expertise is the Beat writers of the 1950s, and Allen Ginsberg was another family pal. Winona's was not exactly a *Leave It to Beaver* or *Brady Bunch* upbringing.

Starting at a new school, Winona showed up for the first day of seventh grade with a crew cut and boy's clothing; given the level of open-mindedness most junior high kids have, it's not surprising she got beaten up. Her analysis of the incident: "I think they thought I was a gay boy." They also figured her for some kind of weirdo because of her background, and because her musical taste ran to the Sex Pistols at a time when, if you wanted to be accepted, you listened to Van Halen. Somewhat of an anomaly, Cindy Horowitz was an earth mother who also happened to be a fervent movie buff, a passion she instilled in her daughter. "My mom used to keep me home from school whenever there was a good old movie on TV," recalled Winona, whose favorite star was the "completely exquisite" Greer Garson.

Partly to counterbalance her educational situation but also as an opportunity to do her best Greer Garson, Winona joined the junior division of the American Conservatory Theater in San Francisco. Impressed by her performance in Tennessee Williams's *This Property Is Condemned* at ACT, a talent scout arranged a screen test for *Desert Bloom;* the role of a girl coming of age against the backdrop of nuclear testing in early 1950s Nevada went to Annabeth Gish, but a casting agent got a look at the test and signed Winona for her first movie.

Winona filmed *Lucas* in the summer of 1985 after finishing eighth grade. She changed her name to Winona October, although during filming she reverted to Horowitz. Somewhere between filming and post-production, she heard a Mitch Ryder record and her screen name came to be Wynona Ryder.

• • • • • •

Had Winona Ryder remained Winona Horowitz, she may have doomed her career to ethnic roles. Among the indiviuals who for various reasons—changed their monikers for the betterment of their performing careers are:

Frederick Austerlitz—
Fred Astaire

Ernest Bickel—
Fredric March

Spangle Arlington Brough—
Robert Taylor

Charles Carter—
Charlton Heston

Lilly Chauchoin—
Claudette Colbert

Aaron Chwatt—
Red Buttons

Mary Cathleen Collins—Bo Derek

Alphonso Giuseppe Giovanni Roberto D'Abruzzo—
Robert Alda

Issur Danielovitch—
Kirk Douglas

Estelle Egglestone—
Stella Stevens

Tula Finklea—
Cyd Charisse

Samille Friesen—
Dyan Cannon

Lucas is a well-intentioned but rather uncomfortable movie to sit through because it's basically just a nonstop series of humiliations inflicted on a teenage boy. It is memorable, however, for one reason: Winona Ryder made a truly extraordinary debut. The title character, played by Corey Haim, is a brilliant but geeky 14-year-old who is in an accelerated program in high school. He's forever being taunted by the school's jocks (during a pep rally they use him as a "football"), and when 16-year-old Maggie (Kerri Green) befriends him he falls in love with her, but she sure as hell doesn't want to *date* him. To get back at her for going out with the captain of the football team (Charlie Sheen), Lucas tries out for the team himself. In the showers, the other players make fun of the size of his penis, and when the ballsy kid responds in kind, he ends up with a crotch full of deep-heating ointment; as a further indignity they then lock him outside wearing only a towel as, in excruciating pain, he weaves wildly among other students before cooling himself off by sitting in a drinking fountain. If you believe studio production notes, writer-director David Seltzer shot this scene in the very shower where he had been similarly bullied when he was a kid.

When it's the first game of the season, Lucas, naturally, gets the chance to be the hero. Seltzer, however, wouldn't even afford the character the movie cliché of saving the day; the poor thing doesn't just drop the ball, he ends up seriously injured and in the hospital. And if that isn't enough, Maggie finds out he's not the wealthy kid he claimed to be but actually lives with his alcoholic father in a trailer camp so run-down even a tornado wouldn't bother with it. But the football players, admiring his grit for going on the field, buy him a varsity jacket. That's what passes for an upbeat resolution; never mind that he remains a misfit, doesn't get the girl of his dreams and still has to live in that crummy trailer.

Fifth-billed Winona Ryder played Rina, another of

the school's outcasts, a bookish, sensitive girl in love from afar with Lucas, who is so preoccupied with Maggie he never notices. Showing up some 15 minutes into the film and appearing in eight scenes, Ryder doesn't have a lot of dialogue, and her character doesn't figure prominently in the proceedings, yet she is astonishingly good. Rarely have adolescent longing and hurt been so subtly conveyed as by Ryder's liquid eyes, quiet gestures and slight facial changes. Her expressiveness is akin to that of a great silent film actress—Garbo or Lillian Gish. When Ryder speaks, her somewhat raspy voice is tinged with a world-weary sadness that seems preternatural. That first day of seventh grade must have really had an effect. Given her achievement in the film, it's almost shocking that most critics didn't even mention Ryder in their reviews, concentrating instead on praising Kerri Green (who is very sweet and genuinely appealing in a more conventional way). Two who did take notice were *Variety*'s Todd McCarthy, who observed, "Winona Ryder quietly steals all her scenes," and Kirk Honeycutt of the *Los Angeles Daily News*, who wrote, "Dark-haired Winona Ryder has an almost ethereal quality."

The mid-1980s were a dismal time in film history, with the majority of films targeted for the Clearasil set. (Remember *Weird Science* and *My Science Project*?) David Seltzer intended *Lucas* as an antidote to the portrayals of teenagers in other films. "Teenagers have no advocates," he harrumphed. "I think any other minority so maligned by Hollywood would have pickets around the theater saying, 'We are not just idiots.'" The director had also promised that *Lucas* would have "no bare breasts, no dope and no rock'n'roll." That didn't exactly sound like a day at the beach, so nobody showed up to see the movie. It also didn't help that as overplayed by a mannered Corey Haim, Lucas seems to be less an endearing eccentric than a mental deficient. Haim himself took pains while publicizing the movie to make sure nobody confused him for the

Emma Matzo—
Lizabeth Scott

Maurice
Micklewhite, Jr.—
Michael Caine

Peggy Middleton—
Yvonne DeCarlo

Marion Morrison—
John Wayne

Betty Joan Perske—
Lauren Bacall

Vera Ralston—
Vera Miles

Lyova Rosenthal—
Lee Grant

Shirley Schrift —
Shelley Winters

Bernard Schwartz—
Tony Curtis

Michael Shalhoub—
Omar Sharif

Gail Shikles, Jr.—
Craig Stevens

Ruby Stevens—
Barbara Stanwyck

James Stewart—
Stewart Granger

Bernard Zanville—
Dane Clark

Alexandra Zuck—
Sandra Dee

· · · · · · · · · ·

Director David
Seltzer on the
actress: "Winona
is immensely open,
vulnerable and
whimsical in a
Disneyesque way.
There is something
wistful and angelic
about her that
ultimately is
reflected in her
performance."

weirdo he was playing: "We're nothing alike. No way
I'm like him. Not at all."

Ryder followed *Lucas* with another "sensitive" small
film that nobody saw, *Square Dance*, but then in 1988
had a showy role in a hit movie when she played the
maladjusted daughter in *Beetlejuice*, a role that was
essentially a comic variation on *Lucas*'s Rina. *Heathers*
followed a year later, and suddenly Winona Ryder was
the hottest actress in her age group, the Molly Ring-
wald of her generation.

SUSAN SARANDON

······

JOE
(1969)

Born Susan Tomalin in Edison, New Jersey, in 1946, she got her new last name by way of marriage to aspiring actor Chris Sarandon while they were in college. ("I attended Catholic University, and it was certainly the way to become a lapsed Catholic," she once told an interviewer.) Although she majored in drama at school (and minored in military strategy!), Sarandon had no particular intention of becoming an actress. But when she did a scene with Chris when he was auditioning for an agent, the 10-percenter was so impressed he took on both halves of the couple as clients. After graduation, they stayed in Washington, D.C., to do summer stock and then, like so many young actors before them, went on to New York. There the improbable happened: Within weeks of arriving in the city, Susan got cast in a film. And even if it was a cheap movie starring and made by unknowns for Cannon, a company whose forte was sexploitation, it sure beat working as a waitress or proofreading for a law firm.

CAST

PETER BOYLE, DENNIS PATRICK,
AUDREY CAIRE,
SUSAN SARANDON, K. CALLAN,
PATRICK MCDERMOTT

······

CANNON
DIRECTED BY JOHN G. AVILDSEN
SCREENPLAY BY NORMAN WEXLER
PRODUCED BY DAVID GIL
CINEMATOGRAPHY BY JOHN G. AVILDSEN

·············

Two decades before personifying disillusioned womanhood in *Thelma and Louise*, Susan Sarandon kicked off her film career by embodying the disillusioned youth of the Vietnam era.

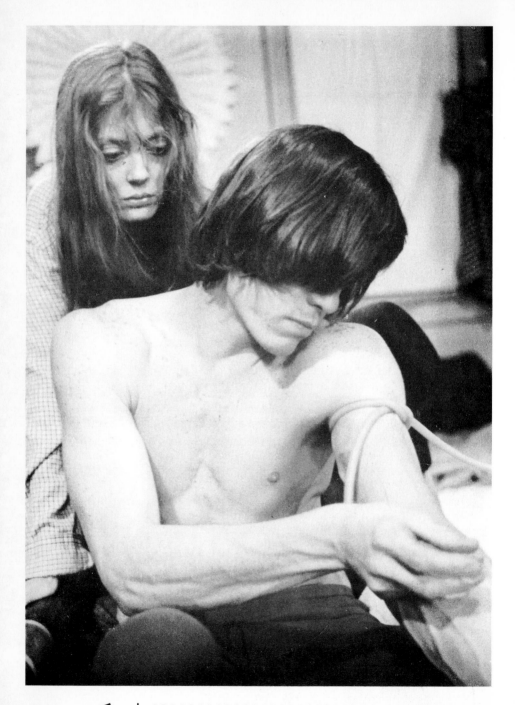

Looking like poster children for Nancy Reagan's "Just Say No" campaign, Susan
Sarandon and Patrick McDermott get set to freak out.

· · · · · ·

*T*he *Gap* began production in December 1969 and was intended to show both sides of the so-called Generation Gap objectively, focusing on the inability of a father and daughter to comprehend each other. The 23-year-old Sarandon played Melissa, a teenager who leaves her upper-middle-class family to "drop out" and live in an East Village tenement, where she does a wide variety of drugs with her "old man," a small-time pusher. When she lands in a hospital strung out on speed, her uncomprehending father accidentally kills her beloved in a blind rage. This makes the daughter even more exasperated with her folks. All terribly contemporary. Oh yes, along the way the father strikes up a friendship with a bigoted factory worker from Astoria.

In May 1970, after filming on *The Gap* was completed, a violent confrontation occurred on Wall Street in which angry construction workers physically attacked antiwar demonstrators. Suddenly hard hats became the loud-mouthed media spokespersons for Nixon and Agnew's supposed Silent Majority, blue-collar bullies standing up for American values by railing against radicals and liberals and permissiveness and LSD and students and the news media and intellectuals and rock music and whatever else they could think of. Somebody at Cannon realized that these lightning rods of controversy had more than a passing resemblance to that factory worker played by Peter Boyle in *The Gap,* and a company that specialized in soft-core porn certainly knew how to exploit a situation for maximum effect. The movie was reedited to emphasize his character, and his name became the title: *Joe.* Ads for the film carried a picture of Boyle, a rifle in one hand, an American flag in the other, and a picture of a hippie superimposed on a target. Thus the publicity department cleverly attracted both young people, going to have their worst fears confirmed, and reactionaries, who wanted to see a little ass kicked.

· · · · · · · · · ·

In *Joe,* Susan Sarandon is a teenager who brings all sorts of grief to her parents. A mere eight years later, in *Pretty Baby,* it's she who's the parent—although as a mother raising her daughter in a New Orleans bordello, she's not too far removed from the antisocial tendencies she evinced as Melissa in *Joe.*

As Brooke Shields's mother in *Pretty Baby* (1978).

Back in the summer of 1970, *Joe* was cutting-edge cinema and caused a minor sensation. "It's not a film people can really love," averred its producer, David Gil, "but it's one that perhaps America deserves at this point." Judith Crist proclaimed *Joe* "a movie truly of our times and demanding to be seen at this very minute," and *Time* raved, "It is a film of Freudian anguish, biblical savagery and immense social and cinematic importance." Gossip queen Rona Barrett checked out the movie and had this reaction: "*Joe* is a mind blower!"

Today, shorn of its topicality, *Joe* stands naked as the mess it is. The central conceit of the friendship between Peter Boyle's Joe Curran and Dennis Patrick's Bill Compton is a cute notion but never rings true. And when, tracking down Melissa, who has run away again, they are sidetracked at such prototypical East Village hangouts as a macrobiotic restaurant and a drugged-out "love-in," the film squanders what little credibility it has. The movie is peopled by caricatures rather than characters, and there's more than a hint of misogyny in the film's treatment of the men's wives. Because of the reediting of the film, scenes with Sarandon and Patrick occasionally veer toward an Oedipus-like relationship between father and daughter, and then stop short; somewhere on the cutting-room floor was an elaboration on this theme.

John G. Avildsen, arguably the least talented director ever to win an Oscar (for *Rocky*), employs a crude scattershot approach here, indiscriminately treating some scenes as broad comedy, others as over-the-top melodrama and still others as if he were attempting a paradigm of social realism. An example of the Avildsen touch: When Compton kills his daughter's lover, the incident is shown not just in groovy double exposure, but in fast motion to boot. Most ludicrous of all is the film's climax: Having had their wallets ripped off at the aforementioned sex party, the two men track down the thieves at a Rockland County commune. Joe shoots a couple of the residents, and when his pal tries to stop

him, he retorts that the problem with kids today is that "they shit on your life. . . . They shit on everything you believe in." That makes sense to Compton, who joins in the gunfire. And wouldn't you know it, the young woman he shoots in the back is none other than his daughter, Melissa. Bummer, man.

Sarandon's first appearance on celluloid comes even before the actual movie; the opening credits for *Joe* roll over scenes of her wandering up Fifth Avenue. She also gets the first line, entering her apartment and remarking to her boyfriend, "You didn't go to Boston." (He had second thoughts about a drug deal there.) In what may be a record—apart from perhaps Seka or Traci Lords—Sarandon bares her breasts 28 seconds after showing up, and a few moments later she's completely in the buff and in the bathtub with Lover Boy. Her role consists mostly of her being petulant, and her tour-de-force scene occurs when, looking like hell, she has a drug-induced breakdown in a convenience store, smears lipstick on her face and knocks merchandise off the shelves. "We have a young girl here who's flipped out," the proprietor tells the cops in a bit of understatement. Sarandon, who here has a passing resemblance to the Raggedy Ann doll on her bed as well as—oddly enough—to Goldie Hawn, is affecting in the role, although there was no indication she would develop into one of the most distinctive of all actresses.

Between the time Sarandon filmed *Joe* and the film's premiere, she had become a regular on a soap opera, *A World Apart*, and had made her Broadway debut in Gore Vidal's *An Evening with Richard Nixon*. *Joe* did not become a career-defining movie for Sarandon, but she kept on plugging. A couple of small film roles came her way, and then in 1974 she appeared in Billy Wilder's remake of *The Front Page* with Jack Lemmon and Walter Matthau, followed by leading-lady duties to Robert Redford in *The Great Waldo Pepper*. She had arrived.

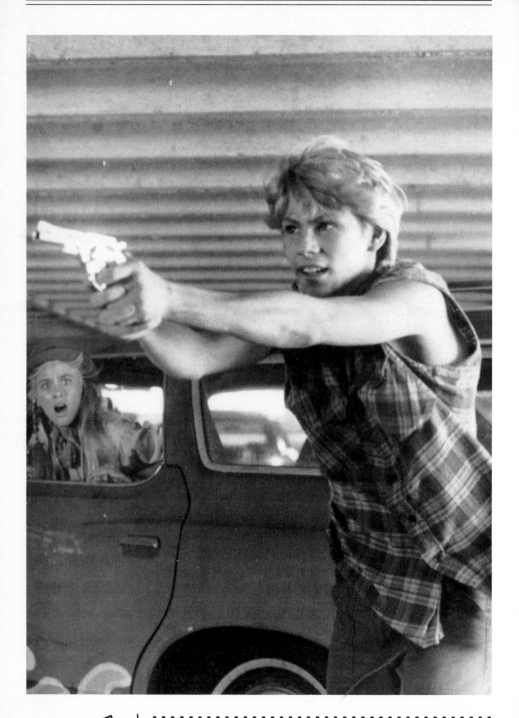

From the beginning, Christian Slater was the embodiment of bravado—the gun he's brandishing here is actually a toy.

CHRISTIAN SLATER

·······

THE LEGEND OF BILLIE JEAN
(1984)

Like Barbra Streisand, Christian Slater kicked off his show-business career as a guest on *The Joe Franklin Show*. Since the dawn of television, the surrealistically hyperbolic, non-sequituring New York talk-show host invited total unknowns onto his program, a Beulah Land where everyone's a superstar and where a third-rate comedian booked at some fourth-rate club in Bayside will most assuredly be introduced as "the world's favorite funnyman." One day, a casting agent was booked as a guest and Joe, seeing her son with her in the green room—it wasn't technically a green room, but rather some folding chairs set up on the adjacent *Romper Room* set—invited the lad on, too. This was nine-year-old Christian Slater's first time in front of the cameras.

Fortuitously, choreographer Michael Kidd happened to see the program and thought young Slater would make a boffo Win-

Somehow, playing a character named Binx doesn't seem the most propitious way to start off in movies.

CAST

HELEN SLATER, KEITH GORDON,
CHRISTIAN SLATER,
RICHARD BRADFORD,
PETER COYOTE, MARTHA GEHMAN,
YEARDLEY SMITH, BARRY TUBB,
DEAN STOCKWELL

······

TRI-STAR
DIRECTED BY MATTHEW ROBBINS
SCREENPLAY BY MARK ROSENTHAL AND
LAWRENCE KONNER
PRODUCED BY ROB COHEN
EXECUTIVE PRODUCERS: JON PETERS
AND PETER GUBER
CINEMATOGRAPHY BY
JEFFREY L. KIMBALL

In *The Legend of Billie Jean*, Christian Slater portrayed a kid named Binx. Throughout the history of the cinema, there have been a lot of boys and young men stuck with totally goofy monickers.

Oogie Pringle
(Scotty Beckett in *A Date With Judy*, 1948)

Stickin' Plaster
(Terry Kilburn in *Andy Hardy Gets Spring Fever*, 1939)

Neptune
(Onest Conley in *Grand Old Girl*, 1935)

Scruno
(Sunshine Sammy Morrison in various East Side Kids films)

Squimpy
(Billy Benedict in *King of the Newsboys*, 1938)

Boomer
(Tommy Menzies in *Angels' Alley*, 1948)

Whizzer
(Jimmy Hunt in *The All-American*, 1953)

Dizzy
(Charles Smith in various Henry Aldrich films)

throp Paroo in the revival of *The Music Man* Kidd was preparing for a national tour. Although—or perhaps because—doing the show would mean nine months away from home, Christian pleaded with his mom to let him do it, for the simple reason that being on the road with Dick van Dyke would get him out of school. His critique of his *Music Man* performance: "I was terrible. I kept waving at people in the audience." Among the other endeavors of his early career were the soap opera *One Life to Live* (for which his mother was in charge of casting), several Broadway shows, including *Macbeth* starring Nicol Williamson and a musicalization of *David Copperfield*—it was no *Oliver!*—and the "Living Nativity" tableau in the Radio City Music Hall Christmas Show, which "was *absurd*. Five times a day me with my staff and my goat walking on stage and kneeling for 20 minutes while this guy narrates it. There's no reason for it to be 'Living'—nobody's moving."

later got his first film role the old-fashioned way— he auditioned for it. You can only shake your head over the fact that *The Legend of Billie Jean* was ever made, as you contemplate that first a couple of studio readers had to recommend the script, and then various levels of management at Guber-Peters and Tri-Star approved the project as it made its way up to the final green light. It's not that the film is any more terrible than dozens of others, it's just so remarkably pointless. The 15-year-old Slater portrays Binx, a happy-go-lucky kid in Corpus Christi, Texas, whose beloved Honda motorbike is trashed by a local bully. His older sister, Billie Jean (Helen Slater), is not one to let this heinous crime go unpunished, so she visits Mr. Pyatt (Richard Bradford), father of the bully, and demands the $608 it will take to repair the scooter. Well, acorns don't fall far from the tree, because Pyatt turns out simply to be a larger version of his Neanderthal son. After agreeing to make amends for the bike, he tries to have his way with

Billie Jean, calling it a "layaway plan." When Binx sees the brute manhandling his sister, he accidentally shoots him, which gives Pyatt the opportunity to cover up his sexual assault. He intends to tell the police that the kids were committing a robbery and, knowing that the authorities always take the word of adults over kids, Billie Jean and Binx hightail it out of there. A sympathetic police lieutenant (the Lincolnesque Peter Coyote) suspects the truth and makes a deal with them to turn themselves in, in exchange for the $608 from Pyatt. But Pyatt double-crosses them, and brother and sister, along with their friends Ophelia (Martha Gehmen) and Putter (Yeardley Smith, later the voice of Lisa Simpson), go on the lam.

The Legend of Billie Jean tried to win over youthful moviegoers by taking the side of the angels and exposing the hypocrisy of grown-ups. But that conceit is so murkily presented that when all is said and done this is still a movie about a damaged motorbike and, let's face it, the problems of a boy and his scooter don't add up to a hill of beans. Director Matthew Robbins (*Corvette Summer, Dragonslayer*), who, despite an association with Steven Spielberg, has had tough going in the hit department, is a competent director of action scenes but he is understandably unable to make any sense of this material.

Most reviewers mentioned Christian Slater only to explain that he's no relation to Helen Slater (who probably would have become a major star if movies like this one and *Supergirl* had not gotten in her way). Paul Attanasio of the *Washington Post* did declare that the young actor "has a goofy hell-raisin' steal-the-picture charm," though the one word that best describes Christian's first film performance is "spirited." He was also cute enough to be a pinup for *16* and *Bop!*, but there is little in his work in *The Legend of Billie Jean* to suggest the wry, sardonic screen presence who would emerge a few years later in such films as *Heathers* and *Pump Up the Volume*.

Dink
(Jackie Cooper in *The Champ*, 1931)

Beezy
(George Breakston in various Andy Hardy films)

Happy
(Cameron Mitchell in *Death of a Salesman*, 1951)

Deadhead
(Jody McCrea in *Beach Party*, 1963)

Pighead
(David Gorcey in *Juvenile Court*, 1938)

Piggie
(Thomas Andrisano in *Teenage Gang Debs*, 1966)

Horse
(James McLarty in *Meatballs*, 1979)

Chimp
(Tommy Bond in The *Gas House Kids Go West*, 1948)

Dog
(Jimmie Komack in *Senior Prom*, 1958)

Ox
(Rod McKuen in *Rock, Pretty Baby*, 1956)

Crab
(Huntz Hall in *Angels With Dirty Faces*, 1938)

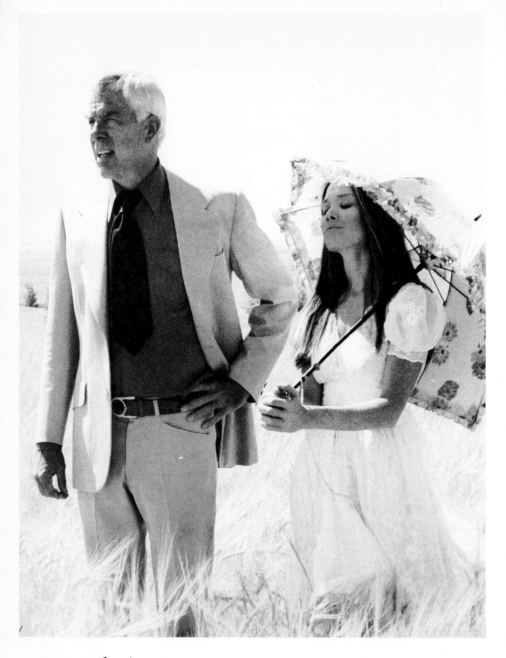

Talk about an odd couple. Sissy Spacek strolls with her Sir Galahad—Lee Marvin, who is 25 years her senior. A mob hitman might seem an unlikely white knight, but that's the type of movie *Prime Cut* is, and after all, Marvin did rescue Spacek from life as an enslaved, drugged-up prostitute.

SISSY SPACEK

······

PRIME CUT
(1971)

Sissy Spacek was a Christmas Day baby, 1949 vintage. She "always loved to perform. And I seemed to have no fear of doing it. When I was just a little bitty kid, I had a little top hat and cane and tails, and could do a soft shoe to 'Sunny Side of the Street.' And at church I'd always sing solos." By age six, Spacek was also a first-class baton twirler, which to you or me may be no great shakes, but in the tiny East Texas town where she grew up it was something to shout about. During her high school years, she lived life in the fast lane, insofar as that was possible in Quitman: majorette, homecoming queen, Choral Club singer, guitar teacher, cartoonist for the school paper, Methodist Youth Fellowship member, and singer at the Rotary and Lions' clubs. The idyllic quality of Spacek's life was shattered when she was 16 and one of her brothers was diagnosed with leukemia. To help her "get out from underneath" her brother's illness, she spent the summer in New York with her cousin, actor Rip Torn, and his wife, Geraldine Page.

You've gotta start someplace, but in a pigsty?

CAST

LEE MARVIN, GENE HACKMAN,
ANGEL TOMPKINS,
GREGORY WALCOTT,
SISSY SPACEK, JANIT BALDWIN,

······

CINEMA CENTER
DIRECTED BY MICHAEL RITCHIE
SCREENPLAY BY ROBERT DILLON
PRODUCED BY JOE WIZAN
CINEMATOGRAPHY BY GENE POLITO

Torn's Chelsea block probably had more people living on it than all of Quitman, Texas, but Sissy thrived in her new urban environment, so much so that rather than going to college, she returned to the Apple after high school. At the time, singing, not acting, preoccupied her, and Torn arranged a meeting for her at the William Morris Agency: "A lot of men filed into a room, and I started to sing my heart out. Then they all filed out, and they filed in again, and they told me to keep on plugging and come back in a few years." The following year, she actually cut a record. Using the name Rainbo, she recorded, "John, You've Gone Too Far This Time," a tongue-in-cheek chastisement of John Lennon for posing nude with Yoko on an album cover. Spacek performed in coffeehouses, made money extolling the virtues of bubble gum in commercial jingles and, even though she was only 5'3", had a fairly successful modeling career. An agent suggested that with her career not going great guns, she might want to consider taking acting lessons. She dutifully did a six-month spell at the Lee Strasberg institute, but was never sold on the whole Method concept, which she admitted was "pretty much Greek to me."

One day her manager informed her that film director Michael Ritchie was two floors above him interviewing actresses to play a teenager in a new movie. Spacek was 21, but her wide eyes and freckles took years off her age, and he told her to get herself up there. She claims she was literally shaking with trepidation when her turn came but, fortuitously, "Just before I began they told me the girl was to be portrayed with a Southern drawl and as being scared. That was perfect because my accent is strictly Texas and I *was* scared." Impressed but not completely convinced, Ritchie and his casting director sent Spacek to Hollywood for a screen test. Three days later she got the part. Unfortunately, it was a part in *Prime Cut.*

• • • • • •

esthetically, *Prime Cut* is a movie without the slightest *raison d'être*. Lee Marvin plays a Chicago mob enforcer hired to go to Kansas City (Kansas, not Missouri, although the movie was actually shot in Calgary) and straighten out Gene Hackman, another gangster who's been ripping off the Windy City boys and who, for no apparent reason, is named Mary Ann. Hackman's cover operation is a slaughterhouse and meat packaging plant, and when Marvin shows up to collect the missing 500 grand, he walks in on what looks like a livestock auction, but on closer examination what's being sold is naked teenage girls. Introducing Sissy Spacek. The first celluloid image of her is a close-up as she and another young woman lie on a bed of hay in a pigpen. Spacek's eyes are open but blank. To Marvin's disgusted inquiries, Hackman says, "Cow flesh, girl flesh, it's all the same to me." Spacek whispers, "Help me, please," and Marvin gathers her up and takes her to his hotel, leaving the other enslaved girls behind. The remainder of the film consists of Hackman refusing to pay up, which results in him and his henchmen having it out with Marvin and his cronies. No gradual shadings of the characters. No surprise plot twists. Just a movie that manages to be totally incoherent even though only the expected happens. There's a shootout at a county fair. Marvin and Spacek are chased through a wheatfield by a large grain reaper. (Director Ritchie apparently had visions of Cary Grant and the cropduster. Delusions of grandeur.) Sissy is kidnapped. Marvin rescues her. Another shootout, this time at the slaughterhouse. Hackman is left to die. Marvin and Spacek liberate the girls of the orphanage where she was raised and which was actually just a holding pen for the children until they were old enough to be sold by Hackman. There's a great deal of carnage. As Andrew Sarris wrote in the *Village Voice*, it's "simply ridiculous bang-bang stuff."

I admire Sissy Spacek's work as an actress enormously, but there's no getting around the fact that in

"As late as two years ago, the story of her 'discovery' alone, would have guaranteed Sissy Spacek 'instant stardom': a young girl arrives in New York from Texas, studies briefly with Lee Strasberg, and then, before she can compile a sheet-long résumé of acting credits, lands a role opposite Lee Marvin. (They used to *make* movies about this.)"

For the record, Sissy Spacek did not become a "star" until the end of 1976, when *Carrie* was released.

As for the "death of . . . studios," Cinema Center Films shut down shortly after *Prime Cut* was released.

THE CRITICS ON SISSY SPACEK

"A young and resplendently unpromising actress."

—Jay Cocks, *Time*

"A striking, sensitive youngster, Sissy Spacek pays off with likeable vulnerability."

—Rex Reed

"The film's sole virtue is Sissy Spacek, a lovely twenty-year-old with an exquisitely appealing face, who, alas, makes her debut herein as the nymphet."

—Judith Crist, *New York*

"Sissy Spacek overdoes the innocence bit."

—Norma McLain Stoop, *After Dark*.

her film debut she is dreadful. Granted, her character makes no sense at all, but I have no idea whether the singsong vocals and blank expression she employs here were intended to express innocence or a wounded psyche or the ingestion of too many drugs. A few years later, in such films as *Badlands, Carrie* and *Welcome to L.A.*, Spacek would play characters whose eccentricities would make her Poppy in *Prime Cut* seem positively normal, and those she handled with aplomb. Her first film performance was an aberration.

SYLVESTER STALLONE

······

BANANAS
(1970)

S ylvester Stallone's hard-knock life became common knowledge back in 1976. As part of the promotional campaign that made *Rocky* the most shamelessly calculated "sleeper" in film history (other than, perhaps, *Marty*), the actor had more tales of woe and inspiration than five years' worth of *Ma Perkins* episodes. Tirelessly he prattled on about the poverty-stricken boyhood in Hell's Kitchen; the time spent in foster homes because his parents couldn't provide for him and his brother; the cruel teasing from the other children about his name and speech impediment; the facial paralysis acquired at birth; the endless running away from home; the steady succession of school dismissals. A quintessential Stallone quote from the *Rocky* tour: "I was not an attractive child. I was sickly and even had rickets. My personality was abhorrent to other children, so I enjoyed my own company and did a lot of fantasizing."

············

J'accuse,
Woody Allen.

CAST

WOODY ALLEN, LOUISE LASSER,
CARLOS MONTALBAN,
NATIVIDAD ABASCAL,
JACOBO MORALES,
RENE ENRIQUEZ, HOWARD COSELL,
ROGER GRIMSBY, CHARLOTTE RAE

······

UNITED ARTISTS
DIRECTED BY WOODY ALLEN Y
SCREENPLAY BY WOODY ALLEN
AND MICKEY ROSE
PRODUCED BY JACK GROSSBERG
EXECUTIVE PRODUCER:
CHARLES H. JOFFEE
CINEMATOGRAPHY BY
ANDREW M. COSTIKYAN

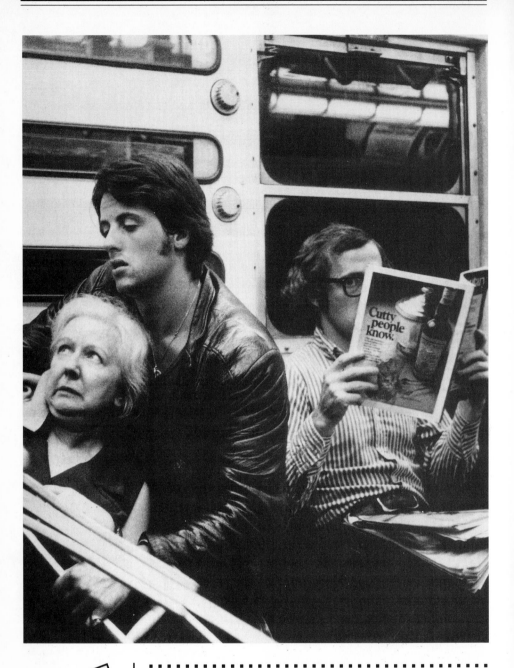

Half a dozen years later, he would somehow manage to capture America's heart in *Rocky,* but in 1970 Sylvester Stallone was an unknown actor terrorizing a subway car for comic effect. The juxtaposition of New York-based, Jewish left-wing intellectual Woody Allen and Stallone, who is none of these things, shows that it takes all kinds to make movies.

Then the saga turns inspirational. The fantasizing leads him to become interested in acting. He makes his stage debut at the college he's attending in Switzerland—where the future Rambo conveniently sits out the Vietnam war. Feeling upbeat about himself for the first time in his lousy life, he studies acting at the University of Miami, where those stuck-up professors tell him he has no business trying to act. Screw 'em. He'll conquer Broadway and show them. But instead of welcoming him with open arms, New York relegates him to working in a deli and ushering at a movie theater. The only acting he does is in showcase productions, hoping that some agent might drop in and recognize his genius. Things get so bad that he's sleeping at the Port Authority. Finally a movie producer offers him a movie role in the porno movie, *Party at Kitty and Stud's*. Stallone takes the part because—get out your handkerchiefs—he was "cold and sick and broke."

From the depths of degradation, the actor is visited by the Angel of Mercy—in the person of Woody Allen. It's only a bit part, but Sly's gotta have it. And when Allen turns down the struggling actor, saying he doesn't look tough enough to play a mugger, the enterprising Stallone is undaunted. He covers his face and hands with dirt and returns to the casting call. Allen is convinced. Even though he won't receive billing for the part, Stallone, at age 24, has at last achieved legitimacy.

■ ■ ■ ■ ■ ■

Stallone's scene comes early in *Bananas*. The first part of the film consists of episodes from the life of a nebbish, Fielding Mellish (Woody Allen, naturally). Fielding surreptitiously tries to buy a porno magazine, only to have the newsdealer yell out a price check for *Orgasm*. It's Woody Allen back in his silly period, when he fashioned himself as a put-upon Everyman—or at least Every Jewish New York Intellectual—and before he retooled himself as a romantic lead in front of the camera and a serious artist behind it.

Sylvester Stallone's participation occurs in a subway car, where he first grabs a hat off a woman's head. He and a colleague then attack an old lady sitting next to Fielding, crushing her with one of her crutches and taking her pocketbook. Fielding doesn't glance up from his magazine and, in fact, pushes one of her crutches away from him. Then, in a sudden burst of valor, he bolts up and pushes the two miscreants out the door, which closes behind them. Gloating over his heroism, he mocks them through the window—only to have the door reopen. Back on the train, the pair menaces Fielding, who takes off down the car with them in hot pursuit. We don't see the end result, but in the next scene our hero is all in one piece; the woman who was mugged is left reading *Orgasm*. The entire business takes a minute and 35 seconds, and Stallone is onscreen for all but 15 seconds of it. He has no dialogue—the scene is silent except for Marvin Hamlisch's sprightly stride piano music—but Stallone manages to be convincingly threatening.

The post-Stallone remainder of *Bananas* follows Fielding to the strife-torn Latin American country of San Marcos, where he goes to forget a failed love affair. He gets involved with rebels who eventually overthrow the government, but when their leader becomes as corrupt as the old regime, another coup installs Fielding—with a fake Castro beard—as the new president. Coming to New York for fund-raising purposes, Fielding is recognized and arrested by the FBI for fraud and subversive activities. There follows what might well be the funniest courtroom scene on film (1936's *Disorder in the Court* with the Three Stooges is the only other legitimate contender), with J. Edgar Hoover in disguise as a large black woman and Fielding bound and gagged for contempt but continuing to serve as his own counsel just the same. All's well at film's end, as Fielding lands the woman of his dreams (Louise Lasser), and the play-by-play of the consummation of their marriage is handled by Howard Cosell on *Wide World of Sports*.

After shooting his scene in *Bananas*, Sylvester Stallone went back to the sex trade, appearing in *Score*, an Off-Broadway show about the then hot topic of wife-swapping; there were months' worth of previews, but once the critics got a look at it, the show lasted only three more weeks. The actor then had another dry spell, which ended in 1973 when he headed to Hollywood hoping to sell a script and instead landed a lead role in the 1950s nostalgia comedy *The Lords of Flatbush*. He again played a mugger in *The Prisoner of Second Avenue* and, beginning to work steadily, was very good as gangsters in the not-very-good films *Farewell, My Lovely* and *Capone*. He also made a memorable comic heavy in Paul Bartel's off-the-wall live-action cartoon, *Death Race 2000*. Stallone might well have continued on his way as a Mike Mazurki for the '70s, but then Irwin Winkler and Robert Charnoff had to go and accede to his wishes and have him star in the script they bought from him. Even that wouldn't have been too bad, except that the publicity department at United Artists turned the shoddy and maudlin *Rocky* into a phenomenon and the actor's third-rate Brando imitation into an acclaimed performance. Suddenly the charming character actor was a not so charming, self-important movie star. Several years later, when his stock had fallen and the public didn't want to see Stallone in anything except another *Rocky* rehash, it looked as if he was headed for the small screen. Along came the odious *Rambo* films, in which he embodied right-wing wet dreams, and he was hot again.

Now, I'm not saying that Woody Allen is entirely responsible for the infliction of Sylvester Stallone on America—after all, the unknown who played Stallone's fellow mugger in *Bananas* remains an unknown. But when Stallone came back for his second *Bananas* try-out, if only Woody Allen had told him he had already been turned down, then maybe he would have gotten discouraged and gone into another line of work and we could have been spared all that.

In addition to Sylvester Stallone, a number of other prominent actors had small parts in Woody Allen films when they were unknowns:

Conrad Bain—*Bananas*

Beverly D'Angelo—*Annie Hall*

Allen Garfield—*Bananas*

Cindy Gibb—*Stardust Memories*

John Glover—*Annie Hall*

Michael Jeter—*Zelig*

Louise Lasser—*Take the Money and Run*

Mark Linn-Baker—*Manhattan*

David Rasche—*Manhattan*

Mercedes Ruehl—*Radio Days*

Sharon Stone—*Stardust Memories*

Michael Tucker—*The Purple Rose of Cairo*

John Turturro—*Hannah and Her Sisters*

Robert Walden—*Everything You Always Wanted to Know About Sex*

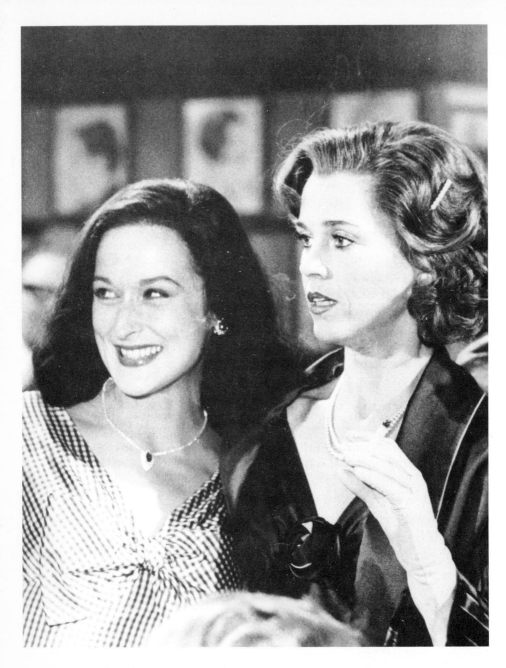

In a few years Meryl Streep would supplant Jane Fonda as America's most admired film actress, but here she's strictly filler, making coolly nasty comments to Fonda's Lillian Hellman as a nabob of New York high society. Streep hated having her hair darkened for the film, and with good reason.

MERYL STREEP

••••••

JULIA
(1976)

Mary Louise Streep was born in 1949 and raised in well-to-do areas of New Jersey and, by her own account, grew up "mousey and unmotivated." Or, put another way, "I was ugly. With my glasses and permanented hair, I looked like a mini-adult. I had the same face I have today . . . the effect wasn't cute or endearing." Even one of her brothers has chimed in that Mary Louise was "pretty ghastly." But for her, adolescence did not constitute the horrifying "awkward years" that most kids go through. Off came the braces, out went the glasses and on went the peroxide and lemon juice (for that natural-blonde look). "It was my first real characterization," Streep laughs, and she didn't just look the part, she also became a cheerleader and homecoming queen. And when she played Marian the Librarian in the school production of *The Music*

Already with the accent.

CAST

JANE FONDA,
VANESSA REDGRAVE,
JASON ROBARDS,
MAXIMILLIAN SCHELL,
HAL HOLBROOK,
ROSEMARY MURPHY,
MERYL STREEP, DORA DOLL,
JOHN GLOVER, LISA PELIKAN,
SUSAN JONES,
CATHLEEN NESBITT

••••••

20TH CENTURY-FOX
DIRECTED BY FRED ZINNEMANN
SCREENPLAY BY ALVIN SARGENT
PRODUCED BY RICHARD ROTH
CINEMATOGRAPHY BY
DOUGLAS SLOCOMBE

Man she knew that it was the actor's life for her. At Vassar, Streep regularly trod the boards, and the normally jaded head of the drama department was so impressed by his student that he invited her to spend spring break of senior year with him in New York—not for an affair, but to appear in an Off-Off-Broadway play he was directing in which Michael Moriarty, improbably, had the title role: *The Playboy of Seville.*

After a year with a Vermont stock company that traveled to lodges to present Shakespeare and Chekhov to ski bums, Streep went to the Yale Drama School. There she had the instructors eating out of her hand, and practically any role she wanted was hers. She also learned about some of the unhappier trappings of success: The jealousy of other actresses at the school made her "crazy, nervous, on my way to an ulcer." New York was the logical next step, and Streep was a veritable comet, appearing in six major productions in less than a year. Within a week of coming to the city, she had really arrived—Joseph Papp signed her for ingenue duties in the Victorian-era *Trelawney of the "Wells"* at Lincoln Center. In a Broadway revival of Tennessee Williams's *27 Wagons Full of Cotton,* the petite actress pulled a Shelley Winters by playing a 170-pound floozy and received a Tony nomination. She spent the summer of 1976 in two of Papp's Shakespeare in the Park productions, and that August the *New York Times* profiled the newcomer, explicating, "Her name is Meryl Streep, as in streak. As in streaking to the top, as she has been doing ever since she hit New York last summer." Streep's own explanation for her success: "I've been shot with luck since I came to the city." The *Daily News* had taken notice of the actress even earlier, and in a February article she fretted, "It seems all too easy. When it's that easy there could be trouble around the corner."

· · · · · ·

What was waiting for her was a movie role. In September she went off to England to make *Julia*, an adaptation of one of the stories in *Pentimento*, playwright Lillian Hellman's book of memoirs. Directed by Fred Zinnemann, *Julia* recounts the relationship between Hellman (Jane Fonda) and the childhood friend (Vanessa Redgrave) who grew up to turn away from her privileged background and fight fascism in Europe, ultimately being killed by the Nazis. The stately movie is a remarkable testament to friendship and to courage, commitment and the creative spirit, but it also succeeds as an unusually taut suspense tale, thanks to a long sequence in which Hellman smuggles $50,000 to Germany for an anti-Hitler group.

Meryl Streep had ninth billing for her two scenes as Anne Marie Travers, a member of the New York smart set of the 1930s and ostensibly a friend of Hellman and Julia. Her first brief bit takes place at Sardi's, where Hellman receives an opening-night standing ovation for *The Children's Hour*. As Hellman walks by her table, Anne Marie stands, grabs the playwright's hand and says something inaudible, followed by "Congratulations." She then introduces her companion: "This is Max. I made him come down." Lillian espies her good friends Dorothy Parker and Alan Campbell (Rosemary Murphy and Hal Holbrook) and leaves Anne Marie behind, giving Meryl Streep a mere 15 seconds of screen time. Four minutes later, Streep's Anne Marie is back in another restaurant, smiling icily in a big close-up, and says to Hellman, "Now you've been invited to Moscow? What is that, some sort of political thing?" After Hellman assures her it's a theater festival, Streep's character begins exasperating Hellman by mentioning an acquaintance killed in the Spanish Civil War and lamenting for his sister: "Imagine having your brother die a Communist." She then riles Lillian by saying, "I tried to see Julia in Vienna, but she wouldn't see me. She's leading a strange life, pretending not to be rich,

When Meryl Streep arrived on the set of *Julia* in England, she immediately broke out in hives. "It was just being in the presence of Jane Fonda, Vanessa Redgrave and Jason Robards," she explained, even though she had no scenes with the latter two.

∎ ∎ ∎ ∎ ∎ ∎ ∎ ∎ ∎ ∎ ∎

She was also critical about her own performance: "I wasn't terribly happy with my work in *Julia*. Maybe it was the black wig I had to wear. But I took the part because the film was about intolerance." Nor was she happy with what costume designer Anthea Sylbert had whipped up for her. "I wear red in every scene," Streep lamented, "and I look bizarre."

doing something called anti-fa, uhhh, anti-fascist work." The scene ends with Anne Marie leaving and muttering more or less to herself, "Imagine. Russia of all places." The exchange between the two women takes just under a minute; Streep is onscreen 42 seconds, though sometimes with her back to the camera. We don't see her again, but John Glover later has a moment as her brother, who drunkenly tells Hellman that he and Anne Marie have had sex and then intimates it's commonly assumed Julia and Lillian were lovers. Hellman slugs him.

Streep was made to wear an extremely unflattering black wig, which did not complement her fair complexion. Playing an unpleasant, snobbish society woman, Streep accordingly goes for her first screen accent. Her version of Larchmont Lockjaw is effective but doesn't even begin to approach Joanna Barnes's glorious and definitive rendition as Gloria Upson in *Auntie Mame*. Streep's role was too small to receive much notice from the critics, but the two stars had kind words. Jane Fonda told *Ms.*, "She's a much better actress than I am. I can't do what she does," and, after filming a scene with Streep, commented to Fred Zinnemann, "This one will go far." Vanessa Redgrave said of Streep and John Glover, "Their scenes carry great conviction and a great evocation of their society, a society that tries to buy famous authors, famous people, and which didn't succeed in buying Lillian." Redgrave would receive an Oscar for Best Supporting Actress for her work in *Julia*. A year later, this newcomer Streep herself would be nominated for that award (for *The Deer Hunter*) and a year after that, her work in *Kramer vs. Kramer* would win her the prize.

DONALD SUTHERLAND

······

CASTLE OF THE LIVING DEAD
(1963)

Donald Sutherland hails from New Brunswick, Canada, and was a sickly child, enduring bouts of polio and rheumatic fever. The physical ailments were nasty, but far worse for the boy were the emotional wounds inflicted by his schoolmates. Zeroing in on his rather unusual features, the children yelled "Goofus," or for a change of pace concentrated on his protruding ears and hit him with "Dumbo" (not the most original group of kids). And young Donald's schoolteacher mother was no help either. "Mama, am I good-looking?" he asked. "Well, no," she tearfully answered, "but your face has a lot of character." Fortunately, a pretty face wasn't necessary to be on the radio, and Sutherland started spinning records for a Nova Scotia station at the age of 14 in 1948.

Very shy while growing up, Sutherland has said that he never set foot inside a legitimate theater until he attended the University of Toronto. There,

CAST

CHRISTOPHER LEE,
GAIA GERMANI, PHILLIPE LEROY,
JACQUES STANISLAWSKI,
MIRKO VALENTIN,
DONALD SUTHERLAND,
ENNIO ANTONELLI

······

SERENA FILMS
DIRECTED BY LUCIANO RICCI
SCREENPLAY BY WARREN KIEFER AND
MICHAEL REEVES, STORY BY
PAUL MASLANSKY AND WARREN KIEFER
PRODUCED BY PAUL MASALANSKY
CINEMATOGRAPHY BY ALDO TONTI

·············

Donald Sutherland started with two roles in a movie in which most actors would not even want one.

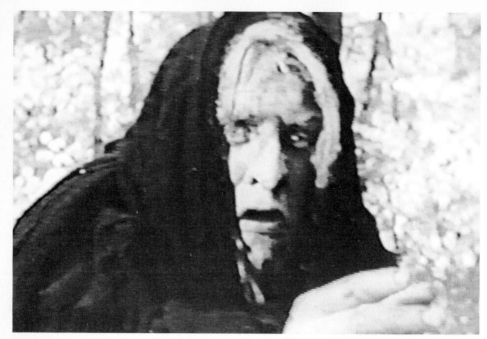

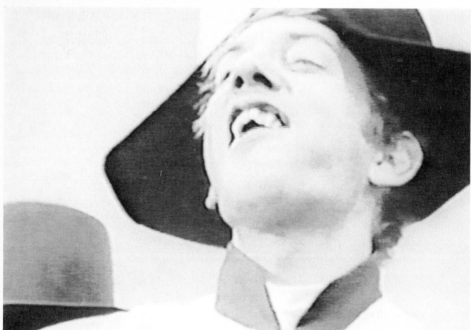

The two faces of Donald Sutherland: in drag as a bitter old hag and as a rip-off of Dogberry, the inept constable from *Much Ado About Nothing*.

accepting a friend's dare, he auditioned for and was cast in a production of James Thurber's college comedy, *The Male Animal.* He had started out intending to get an engineering degree, but being in this and subsequent plays convinced him that words were more interesting than numbers, so English became his major. All it took to make Sutherland decide to pursue acting as his life's work was a glowing review of his performance in *The Tempest* from a local drama critic; after graduation he packed off to England, where he studied at the London Academy of Music and Dramatic Art. Having completed his studies, Sutherland lived a hand-to-mouth existence as a repertory actor out in the provinces, subsequently obtaining a slightly better standard of living by appearing on the London stage and on episodes of such TV series as *The Avengers* and *The Saint.* Four years after Sutherland arrived in London, an Italian movie director caught his performance in a West End production of *Spoon River Anthology* and thought he might be able to use this gangly 6'4" actor with offbeat looks. Of course, this filmmaker specialized in horror films.

.

Director Luciano Ricci thought Sutherland's talent was so nice, he cast him twice. In *Castle of the Living Dead,* which is set in post-Napoleonic France, the sixth-billed Sutherland plays both a bumbling police officer and, no kidding, a hideous old crone. The film, one of the innumerable low-budget horror movies Christopher Lee starred in on the Continent, is unmitigatedly dull stuff, with none of the cheap thrills you hope for in a film with a title like this. Lee (in a surprisingly lifeless performance) is Count Draco, who invites a traveling theatrical troupe to his castle. Obviously, he's not interested in their lame comedy act, but merely needs more specimens for his iniquitous experiments; his specialty is turning living creatures into waxlike figures, forever suspended in time. He ex-

.

Canada has provided Hollywood with a mother lode of actors, including:

Dan Aykroyd
Ben Blue
Genevieve Bujold
Raymond Burr
Rod Cameron
John Candy
Hume Cronyn
Lolita Davidovich
Yvonne DeCarlo
Collen Dewhurst
Marie Dressler
Deanna Durbin
Glenn Ford
Lorne Greene
Arthur Hill
Walter Huston
Ruby Keeler
Margot Kidder
Gene Lockhart
Rick Moranis
Kate Nelligan
Leslie Nielsen
Mary Pickford
Walter Pidgeon
Christopher Plummer
William Shatner
Norma Shearer
Martin Short
Fay Wray

plains the *Weltanschauung* behind his research to the film's ingenue (whose beehive hairdo is 140 years ahead of its time): "You're a very beautiful woman, Laura. You should never grow old. You should stay like this . . . forever! . . . Eternal beauty can become a reality!" Count Draco accomplishes his rigor-mortis stunt with an embalming chemical; the filmmakers do it through the magic of the freeze frame. The film moves along like molasses as Draco and his Igor methodically knock off troupe members, until he gets stiffed himself. The supposedly big shock scene, in which we see a room of frozen humans, is no more exciting than a stop at a second-rate wax museum.

Donald Sutherland appears in 10 scenes: in four as the constable, in five as the witch, and in the finale in both guises. His initial screen line comes after he sees the acting company engage in a spot of gallows humor in its act: "Hey, how's that fellow do that hanging trick?" he asks, sounding, frankly, rather stupid. As it develops, the character *is* a dolt, a man who doesn't have the slightest clue that something odd might be going on in that nice Count Draco's castle. A remarkably pop-eyed Sutherland, who speaks with a slight lisp, plays the role with tongue firmly in cheek, but he overdoes it; the hammy, slack-jawed manner in which he portrays the man's misplaced pomposity and lack of self-awareness is as monotonous as the movie overall. He does have one (relatively) funny line. At the end of the film, after the count has been disposed of and his collection of corpses discovered, Sutherland's character, previously a toady for Draco, says to an underling, "My suspicions about the count were confirmed." "Suspicions?" "Yes. I kept them to myself until I was certain."

The actor does somewhat better as the beldam, doing an adequate job by talking in the standard creaky witch's voice. The hag has a weakness for speaking in rhymes, such as "Some will live/And some will die/Before tomorrow's/Sun is high." She's not much of a poet or too impressive a prophet—the title of the movie

tells you as much as her verse does. Another piece of versemongering: "The harlequin who eats my bread/Will soon be dead." Sutherland's crone has a chip on her shoulder about the count: "I was the first to suffer from his hands. He failed, I escaped to roam the land like this. . . . May he burn in hell's everlasting fire." She gets her revenge, too, because she's the one who stabs him in the end with a hook dipped in his serum. This is when Sutherland gets to talk to himself. The peace officer asks the witch, "Are you all right? You could've got hurt." The female Sutherland shrugs, "He made me sore."

The cast of *Castle of the Living Dead* is a hodge-podge of Italians, French, Englishmen and the Canadian Sutherland. the *Lancashire Evening News* chortled, "The dubbing will probably horrify more than the plot." Cinematographer Aldo Tonti had worked with Fellini, Rossellini and Visconti, but this movie looks as if it was shot with a Brownie camera. Reflecting on his career, Christopher Lee said, "*Castle of the Living Dead* was special to me because it was the first time I ever met Donald Sutherland." They'd meet again the next year when they made *Dr. Terror's House of Horrors*. That was the state of Sutherland's career at the time.

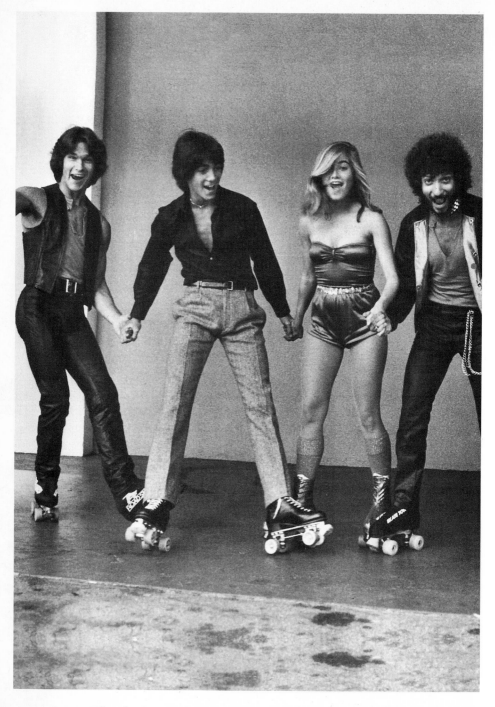

Patrick Swayze goofs off with Chachi, Marcia Brady and Horshack.

PATRICK SWAYZE

······

SKATETOWN, U.S.A.
(1979)

Born in Houston in 1952, Swayze was the son of an oil company engineer and a dance school operator, and he took a shine to his mom's vocation at an early age. The thing is, though, in Texas real men don't dance—except for the Cotton-Eye Joe. "People thought I must be gay," Swayze once said to *Dance* magazine. Lest anyone get the wrong idea, he pumped iron. He played on the high school football team, gymnastics team, track team and swimming team (well, maybe that one wasn't such a great public relations move). He also learned how to fight. He waited for someone to yell "Fag," and then *pow!* Guys learned to think twice about questioning his orientation just because he enjoyed a good *pas de deux*.

Swayze attended San Jacinto College in Pasadena, Texas, on a gymnastics scholarship, but he

CAST

SCOTT BAIO, FLIP WILSON, RON PALILLO, RUTH BUZZI, DAVE MASON, GREG BRADFORD, MAUREEN MCCORMICK, PATRICK SWAYZE, BILLY BARTY, KELLY LANG, DAVID LANDSBERG, THE UNKNOWN COMIC (MURRAY LANGSTON), DOROTHY STRATTEN

······

COLUMBIA
DIRECTED AND PRODUCED BY
WILLIAM A. LEVEY
SCREENPLAY BY NICK CASTLE,
STORY BY NICK CASTLE,
WILLIAM A. LEVEY AND LORIN DREYFUSS
EXECUTIVE PRODUCER: RAY STARK
CINEMATOGRAPHY BY
DONALD M. MORGAN

············

Many of us roller skated to disco music at a particular time in history. But we weren't captured on celluloid while we were doing it, so, unlike Patrick Swayze, we can deny everything.

left that when he got a better offer—playing Prince
Charming in *Disney on Parade*. He offered his interpre-
tation of Snow White's hero to audiences in arenas
throughout the United States, Canada and Central
America. He then got a scholarship with the Harkness
Ballet, and it's incredible that he didn't become the
biggest sensation in Gotham right then and there
because "When I came to New York, I was unique in
that I looked like a man onstage. I had nineteen-inch
arms." He moved over to the second company of the
Joffrey and then became a dancer in the Eliot Feld
Dance Company. There all that high school macho
stuff came back to haunt him: A bad knee from a grid-
iron injury made tripping the light fantastic just too
excruciating. And it had to happen "right at the point
where I was about to realize my dreams with Eliot
Feld, with him about to choreograph *Americana* for
me and Baryshnikov." Still, don't dare get the idea that
he had wimped out—years later, when he again injured
himself during a movie, he bragged, "The doctors were
amazed at the level my pain threshold was at." He also
underwent a number of operations on the knee, and
although his joint wasn't strong enough for ballet moves,
he figured he could still manage musical comedy steps.
So he got on line with the other boys of the chorus in
an unsuccessful Joel Grey musical, *Goodtime Charley*.

Taking over the lead in a musical that's been around
for six years doesn't sound like a great career break, but
Swayze happened to be starring in *Grease* when that show
became—temporarily—Broadway's longest-running, and
he basked in publicity as it hit its record-breaking
3,343rd performance. Besides, the role of Danny Zuco
seemed to be a talisman for a successful career: Richard
Gere had played the role of the clean-cut hood in Lon-
don and so, too, in various productions, had Barry Bost-
wick, Peter Gallagher, Treat Williams, Ted Wass and
Jeff Conaway. Swayze figured maybe it was time for
Hollywood.

• • • • • •

Patrick Swayze had a movie deal within months of arriving on the West Coast, signing up for what somebody apparently thought the world needed now: the first-ever roller-disco movie, *Skatetown, U.S.A.* Swayze joined a—mercifully—once-in-a-lifetime cast: Scott Baio (Chachi from *Happy Days*), Flip Wilson, Ruth Buzzi (of *Laugh-In*), Maureen McCormick (Marcia Brady from the *Bunch*), Joe E. Ross (late of *Car 54, Where Are You?*), Ron Palillo (*Welcome Back Kotter*'s Horshack), little person Billy Barty, the Unknown Comic and somebody named Greg Bradford, whose moves as a dancer in the film version of *Grease* so captivated that movie's coproducer, Allan Carr, that, in his capacity as a personal manager, he took on the youngster as a client.

Skatetown, U.S.A. takes place over the course of one evening in an L.A. roller rink, a night on which a new roller-disco champ will be crowned. Greg Bradford stars as a nice down-to-earth kid from the Valley, who practices his art on the street because the cost of admission to a genuine, professional rink is *trop cher*. His adversary is Patrick Swayze as Ace, a mean-spirited bully from the West Side who gives the light-hearted sport a bad name. There's no way, though, that a good kid like our hero is going to be psyched out by the threats and dirty tricks of a lowlife, and not only does he refuse to back out of the contest, he puts the moves on Swayze's sister. Guess who wins? Guess with whom he ends up romantically?

People going around a rink can't take up the entirety of a 98-minute movie, despite the fact that some of the routines are by specialty roller groups such as the Hot Wheelers and Jerry Nista's Disco Rollers (who, even in 1979 when roller disco didn't necessarily seem like a completely ridiculous concept, were hardly household names). *Skatetown, U.S.A.* is therefore padded with musical numbers by 1960s rocker Dave Mason and "comedy relief" from stand-up comics. How funny

"Not since John Travolta took the disco floor in *Saturday Night Fever*—no, not since Valentino did his tango in *The Four Horsemen of the Apocalypse*—has there been such a confident display of male sexuality," gushed Kevin Thomas of the *Los Angeles Times*, feasting his eyes on Patrick Swayze for the first time. Thomas added that Swayze "drew gasps" from the "rowdy" first-day audience at Hollywood Boulevard's Paramount Theatre.

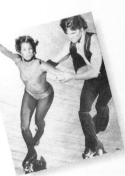

With April Allen in *Skatetown, U.S.A.*

is it? Well, the level of humor in the film is having white midget Billy Barty play black comedian Flip Wilson's father (and also the husband of Wilson's tired female character, Geraldine). As for the direction, all you have to know is that William A. Levey was previously the *auteur* of *Slumber Party '57* and *The Happy Hooker Goes to Washington*. The movie doesn't even work on an unintentionally funny level, because a crucial element of camp is missing—the filmmakers themselves weren't taking this seriously, except perhaps as a means of making some fast cash from unsuspecting patrons.

Dolled up in tight-fitting leather pants and vest, Swayze looks like the missing seventh member of the Village People. There's no mistaking who he is, though; you can't miss those trademark blank eyes. (If the eyes are the window to the soul, he's got an expanse in there as wide open as Montana.) Somehow, even though he's in constant motion, whirling around the rink, dipping and sashaying, Swayze still comes across as the least mobile man in America. He has one acting trick to convince you he's a bad guy, a sneer, which makes him reek not of menace, but of churlishness.

By the time *Skatetown, U.S.A.* opened in late 1979, the roller-disco "craze" was petering out, and the film did nothing to revive interest in it. The one amusing thing about *Skatetown, U.S.A.* is that a few months after it was released, the Academy of Motion Picture Arts and Sciences saw fit to give Ray Stark, whose production company made the film, the Irving G. Thalberg Award for his "distinguished" output as a movie producer. Patrick Swayze spent the next few years in television and didn't return to the screen until 1983's *The Outsiders*. He's been known to bristle at the mention of *Skatetown, U.S.A.* "It's a piece of garbage," says the star of *Road House*, *Steel Dawn* and *Tiger Warsaw*.

The Three Stooges

······

Soup to Nuts
(1930)

The Solomon and Jennie Horowitz household in Ulmer Park, Brooklyn, contained five boys: Irving was the eldest, followed by Jack, Samuel, Harry and the baby, Jerome. Irving became a businessman and Jack sold insurance, so they need not concern us. Harry (who went by the name Morris, go figure) was the first Horowitz to manifest symptoms of show business in the blood. He regularly played hooky from school to attend theatrical matinees and dropped out of Erasmus High School (a half century later Barbra Streisand's alma mater) to run errands at Brooklyn's Vitaphone movie studio. In 1909 Morris Horowitz stepped in front of the cameras for the first time; he was 12 years old and made numerous additional film appearances over the next five years. In 1911, he tried to please his parents by enrolling in the Baron DeHirsch Trade

CAST

TED HEALY, FRANCES MCCOY,
STANLEY SMITH, LUCILLE BROWNE,
CHARLES WINNINGER,
HALLAM COOLEY, GEORGE BICKEL,
WILLIAM H. TOOKER,
HARRY (MOE) HOWARD,
SHEMP HOWARD, LARRY FINE,
FRED SANBORN, HEINIE CONKLIN,
MACK SWAIN, BILLY BARTY,
ROSCOE ATES, RUBE GOLDBERG

······

FOX
DIRECTED BY BENJAMIN STOLOFF
SCREENPLAY BY RUBE GOLDBERG·
CONTINUITY BY HOWARD J. GREEN
ASSOCIATE PRODUCER: A.L. ROCKETT
CINEMATOGRAPHY BY JOSEPH VALENTINE

············

Before they were stooges, they were racketeers.

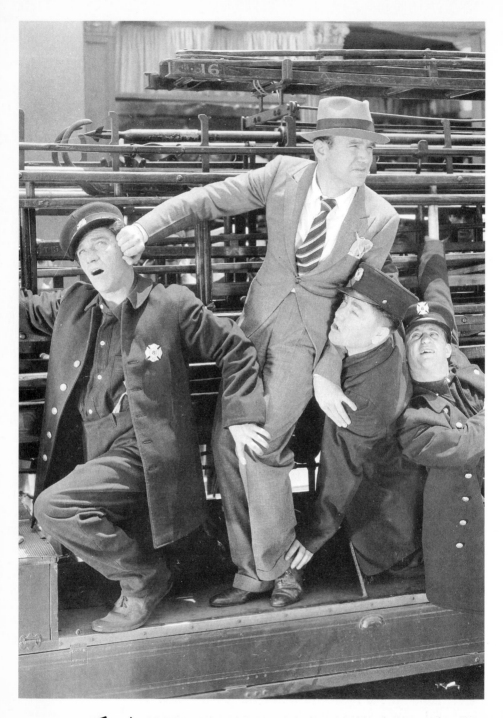

Shemp, Moe and Larry doing what comes naturally with their boss Ted Healy.

School, but studying to be an electrician bored him and soon he was back in the flickers. Morris's brother Samuel (two years his senior) was at the same school at the same time; his field of endeavor was plumbing, his interest in it practically nil. (Given the image we have from their comedies of their aptitude as handymen, the very idea of the Horowitz brothers at a trade school is pretty terrifying; but since nothing you learn is ever wasted, I'm sure they looked back to the experience for pointers on such comedies as *A-Plumbing We Will Go.*) Moe and Shemp Howard, as they were now known, joined a barbershop quartet until their father found out, and then, in 1914, Moe headed to the Deep South to become the resident juvenile actor on the *Sunflower,* a Mississippi River showboat. He had to double as an usher and clean up the auditorium after each night's performance. He and Shemp eventually linked up again to put together a vaudeville act that featured them harmonizing and engaging in nonsense patter in blackface (hence the name "Howard and Howard—A Study in Black"). This partnership lasted through 1922, except for Shemp's brief stopover in World War I, brief because he was discharged for chronic bed-wetting.

In 1922 Ted Healy, a leading comedian on the vaudeville circuit, needed a quick replacement as an onstage foil. He remembered that his childhood buddy Morris Horowitz was a pretty funny kid and gave him a call. In the midst of giving Healy a hard time on the stage of the Brooklyn Prospect Theatre—not really, it was part of the setup—Moe recognized a particular laugh emanating from the audience and brought up Shemp. The brothers' weisenheimer, off-the-cuff joking went over so well that Healy signed them on as a permanent part of his act, taking them with him on the road and having them join him in several Broadway revues. Three years later, Moe and Shemp were in a Chicago speakeasy and saw a funny-looking violinist with a wild mane of hair who told jokes while he played and en-

THE EVOLUTION OF THE THREE STOOGES

From their first film when they were four, the Three Stooges underwent a series of realignments in their 30-year movie career.

Top to bottom, Larry and Moe with Curly Howard, Shemp Howard, Joe Besso, and Joe De Rita.

gaged in a hebephrenic Cossack dance. An outrageous act like this was catnip to the brothers Howard, and they suggested that their boss sign him up. Healy agreed and, on the condition that he cease and desist the awful violin playing, Larry Fine became the comedians' third stooge.

Over the next few years, each one of the boys would temporarily drop out of the act for a spell—a seemingly better offer came his way, or a wife wanted her husband to spend more time at home—but by the time of Healy's 1929 hit Broadway show, *A Night in Venice*, directed by Busby Berkeley, all three had regrouped. Their name changed from show to show, town to town: they were known variously as "Ted Healy and His Gang," ". . . and His Racketeers," ". . . and his Laugh Racketeers," and, in *A Night in Venice*, ". . . and His Three Southern Gentlemen," but, curiously, never "Ted Healy and His Stooges." The success of this musical brought out the Hollywood talent scouts, who, besides searching the Broadway stage for practitioners of proper diction, were on the lookout for verbal comedians, suitable replacements for those strictly visual clowns whom sound had rendered obsolete. Healy and his sidekicks signed a deal with Fox. Healy was to be paid $1,250 a week, each of his Southern Gentlemen a mere C-spot. Moe recalled, "The salary was not up to what vaudeville paid at the time, but we were dying to see the palm-lined streets of Hollywood." Also joining the act was someone named Freddie Sanborn, a comedian whose shtick consisted of whispering in an allegedly funny fashion and playing the xylophone; the scout who had signed Healy and company insisted Sanborn would be a boffo Southern Gentleman. Thus the Three Stooges started off their film work as a quartet.

• • • • • •

Because the cast of *Soup to Nuts* was generally unknown to moviegoers (unless they happened to be regulars at the local vaudeville house), the movie's selling point was that a household name *had*

concocted the screenplay—such as it was. Rube Goldberg was the cartoonist who specialized in devising crazy, labyrinthine inventions, in which common household items were interconnected so that a simple task could be completed in the most convoluted manner possible. *Soup to Nuts* had a number of such creations—"mechanical marvels," a press release called the gizmos, one of which was a gravy mopper-upper for lapels—and the slightest of plots to connect the old vaudeville routines and slapstick sequences.

The story concerns the owner of a costume shop, Charles Winninger, who spends too much time on his inventions and loses his business to creditors. An actor I've never heard of named Stanley Smith plays the finance man who falls in love with Winninger's niece, an equally obscure actress called Lucille Browne. Ted Healy is Winninger's assistant, who doubles as a fireman along with the Racketeers (as Moe, Larry, Shemp and Sanborn were billed, although Moe's name was given as Harry). Winninger gets a job as a waiter in a restaurant. A fire destroys the costume shop, but not before Healy and the boys rescue Smith and Browne. Winninger learns to his surprise that the place was insured and he's in the money, and Browne decides to return Smith's affections.

The Racketeers reportedly ad-libbed almost all of their material, which is replete with wisecracks and putdowns; they have only a handful of scenes, the highlights involving their crossing up Healy when he heroically puts out the climactic fire, destroying a society party by answering an alarm and going to the wrong house, and a surrealistic bit in which they turn up as Mexican revolutionaries. To say that *Soup to Nuts* is primitive is putting it mildly. Studio publicity promised, "Ted Healy and His Racketeers bring a comedy style to *Soup to Nuts* as entirely new and original in its way as Will Rogers' witticisms," but the personalities of the Racketeers are undefined, and while their scenes are the only interesting ones in the film,

Howard, Howard and Fine clearly hadn't yet hit their stride. *Variety* beefed that *Soup to Nuts* was nothing more than "a two-reel Keystone of the silent days, padded six reels with dialogue," and it wasn't funny because although "the cast is full of comedians they are all straight men excepting Ted Healy's stooges." The ads sold the movie as "Rube Goldberg's Girly, Goofy Mirthquake" but Fox had overrated the appeal the cartoonist had for picturegoers, which, as it turned out, was nearly non-existent. Nor was there much rapport among Freddie Sanborn and the others, so he went back to New York, inaudible voice and xylophone in tow.

In his memoirs, Moe Howard wrote, "I can remember how Ted told us before we started filming, 'Boys, one of us or all of us may click in films, so it's the best of luck to anyone who makes it.'" Three of them made it: Winfield Sheehan, the head of Fox, offered Moe, Larry and Shemp a seven-year contract, only to have the studio renege on the deal a few days later. Moe explained that a friend "told me that he was in Sheehan's office when Ted came in and said, 'You know, Mr. Sheehan, you're ruining my act by signing the boys for a contract. I didn't think that one Irishman would do this to another Irishman.' Sheehan told him, 'Don't be concerned, Ted. I'll take care of this.'" They were so furious that they left Healy immediately, billing their new act as Howard, Fine and Howard—Three Lost Souls.

The trio did nicely for themselves, despite constant legal haggling from Healy, whose new stooges were making him realize how valuable his old ones were. Eventually Healy switched from threatening to imploring and a deal was worked out, part of which was that Healy would give up drinking—a long-running source of friction. Shemp, however, never again trusted the boss and, after another dispute, left the group. Moe then recruited his youngest brother, Jerry, never mind that his experience in show biz was minimal. Just as he had set a condition on Larry's entry into the act, Healy would take

Jerry only if he agreed to shave his long locks. He did and soon after began going by the name Curly, and the rest is history. An MGM contract ensued for Ted Healy and His Stooges (their latest appellation). They starred in short subjects in Culver City as well as showing up in features, including the major release *Dancing Lady*, which top-lined Gable and Crawford and introduced Fred Astaire. The Stooges finally ventured out on their own in 1934 when they signed a one-picture deal with Columbia, with an option for more. In the course of 25 years, there were 189 more, and in 1983 the Three Stooges received a posthumous star on the Hollywood Walk of Fame. Was it deserved? Soitenly!

Five decades after their film debut, the Stooges, who had been fervid supporters of Franklin Roosevelt, again made the rounds in politics. A bumper sticker contained pictures of Moe, Larry and Curly, as well as President Ronald Reagan.

FIND THE DUMMY

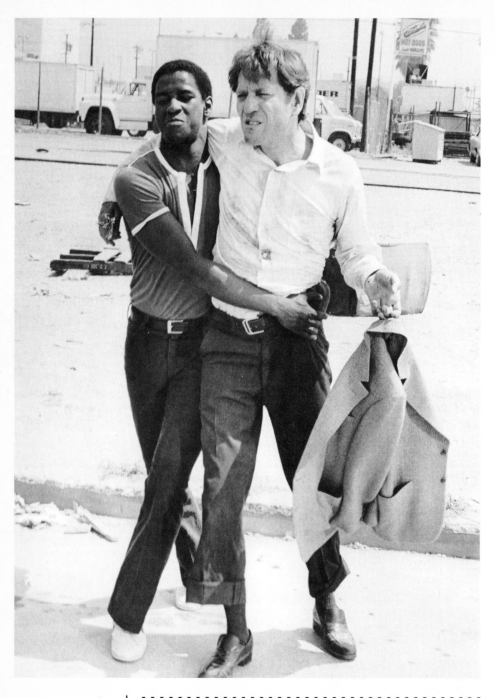

Denzel Washington is the son George Segal didn't know he had. A white man with a black son—get it?

DENZEL WASHINGTON
······
CARBON COPY
(1980)

T he saga of Denzel Washington, actor, begins in 1974. Having finished his sophomore year at Fordham University, Washington was spending the summer as a counselor at a YMCA camp in Connecticut. Thinking that their campers would get a kick out of seeing the counselors make fools of themselves, the staff presented a talent show. Hey, whaddya know, everyone thought Counselor Washington was pretty good. Come September, he realized that when the autumn weather turns the leaves to flame, one hasn't got time for the waiting game, so, encouraged by the accolades he received at camp, the journalism major quickly signed up for an acting class at Fordham. After being bowled over watching him play the leads in school productions of *The Emperor Jones* and *Othello*, Washington's professor not only encouraged him to consider a career in acting, he also "dragged several agents to come and see him" perform. The teacher recol-

Does Denzel Washington look like George Segal's son to you?

CAST

GEORGE SEGAL,
SUSAN SAINT JAMES,
JACK WARDEN,
DENZEL WASHINGTON,
PAUL WINFIELD, DICK MARTIN,
VICKY DAWSON, TOM POSTON

······

AVCO-EMBASSY
DIRECTED BY MICHAEL SCHULTZ
SCREENPLAY BY STANLEY SHAPIRO
PRODUCED BY CARTER DEHAVEN III AND
STANLEY SHAPIRO
CINEMATOGRAPHY BY FRED KOENEKAMP

Denzel Washington has a good deal of unfortunate dialogue in *Carbon Copy*. That much of it is intended to be ironic doesn't make it any less unsavory. Three examples:

"Mom never got married. You know how it is with us colored folks, we ain't much for marrying."

To his newfound father, "You can teach me how to build a model airplane. I'll show you how to pick a lock."

Again to his dad, "You can rub my head for good luck."

lected that he also rounded up José Ferrer, who had played Iago to Paul Robeson's Othello, to take a look and "he and I agreed that Denzel had a brilliant career ahead of him." One of the 10-percenters who been hauled in concurred, and Washington now had someone representing him.

The best this agent could do for him was a supporting role in an undistinguished TV biography of three-time Olympic gold medalist Wilma Rudolph, so Washington decided that more training might be in order. After just a year at the American Conservatory Theatre, however, he wanted to be in the thick of things; heading back to New York, he began working fairly steadily Off Broadway, Off Off Broadway, and in Joseph Papp's Shakespeare in the Park. He also did a television adaptation of *Flesh and Blood*, writer Pete Hamill's typically overwrought mélange of boxing and incest.

W ashington says that in the late 1970s and early 1980s he turned down a number of film roles because of an aversion to black stereotypes. No pimps, no drug dealers, no shufflin', eye-poppin' scaredy-cats providing comic relief. The first part he did accept wasn't exactly a stereotype, but it was an unbelievable character in a truly stupid movie. *Carbon Copy*'s coproducer and writer Stanley Shapiro said that in their quest for just the right young actor for their film, he, fellow producer Carter De Haven and director Michael Schultz "saw something like 400 or 500 actors." Schultz, whose earlier works included the successful *Car Wash* and the fiasco *Sgt. Pepper's Lonely Hearts Club Band*, made several trips to New York, checking out plays with black actors as well as university theatrical productions. Washington was one person Schultz thought had potential, and he recommended that the producers have the actor videotape a scene from the script. Seeing this evidence, they were in accord with the director and flew Washington to Los Angeles for a screen test with

the star of the film, George Segal. Such a lot of bother for so paltry a result.

The premise of *Carbon Copy* is that wealthy white businessman Walter Whitney (Segal) discovers that he sired a son out of wedlock and—here's the beauty part—this Roger (Washington) is black. Not a mulatto, but black. There is no possible way that Denzel Washington could be George Segal's son, so the film can only operate on a pure fantasy level and not as any kind of serious social satire. That's okay for a while, when the movie is a broad comedy consisting of little more than Whitney's cartoonish family and friends having stereotypical—and not especially amusing—reactions to the news, but when the movie starts throwing out tired platitudes about racial harmony, it becomes a complete mishmash.

Carbon Copy has something of the air of a racist joke told by a good liberal who insists he means no harm. The movie apparently intends to skewer racism, yet its would-be facetiousness is so poorly realized that all the film manages to do is emphasize racial stereotypes. On a different, but not unrelated, subject, it's hard to believe that as recently as 1980, wife rape—which is how the film opens—was considered an appropriate subject for laughs; at least things have progressed beyond *that*. During production, Stanley Shapiro, who had won an Oscar for cowriting *Pillow Talk,* gloated, "A good comedy has to say something serious with laughter. Everyone feels this one is a winner. Even the crew is marvelous." Sorry, Stanley, but *Carbon Copy* was a box-office loser. While viewing it as a muddle, the press didn't come down on it as hard as it might have. The reason for the kid-gloves treatment may have been explicated by Seth Cagin in the *SoHo Weekly News:* "There are many things wrong with *Carbon Copy*—a hammy performance by George Segal, plot exposition that's as subtle as an architect's blueprint, and comic staging that's unworthy of a sitcom—but it's the only Hollywood movie in recent memory to deal unabash-

George Segal gets out some beauts, too:

"I have to be the father of the only black kid who can't play basketball."

"He's not black. He's what interior decorators call hickory bronze."

"I don't mind living in Watts, but do we have to live in the poor section?"

edly with racism in America, and with that, director Michael Schultz earns himself the right to a good deal of indulgence."

Denzel Washington did not become a star with *Carbon Copy,* nor did he deserve to. He cloaks his performance in a smug coyness, as if he were trying to distance himself from material he felt superior to and yet still pander for the audience's approval. He also jumps on his dialogue, throwing his lines out in a clipped style, but considering the intellectual level of what his character has to say, you can't blame him for trying to get through it quickly. Nor does the 25-year-old actor make a convincing teenager. Nevertheless Billy Graham (no, not that one), in the black newspaper the *New York Amsterdam News,* wrote, "Although *Carbon Copy* may receive poor reviews and adverse criticisms from discerning audiences, check out Denzel Washington's performance and watch the beginning of what promises to be the debut of a rising star in other major movie films—hopefully."

It would take a few years for Washington's star to rise in motion pictures but, happily for him, there was theater. The Negro Ensemble Company's award-winning production of *A Soldier's Play* opened a few months after *Carbon Copy* had arrived and departed, and Washington won an Obie award as a destructively prideful Army man during World War II; Norman Jewison's 1984 film version put the actor back on track in movies. There was also television, and a featured role in the hospital dramedy *St. Elsewhere,* which premiered in 1982, made Denzel Washington a household name. *Glory* (1989) made him an Academy Award winner. How disappointing then that after he became a star, Washington chose to make *Heart Condition,* a comedy in which his heart is transplanted into racist cop Bob Hoskins, and which was no more enlightened than *Carbon Copy* had been 10 years earlier.

SIGOURNEY WEAVER

······

ANNIE HALL
(1977)

While attending the Ethel Walker School, Susan Weaver read *The Great Gatsby* and, because when you're age 14 the more unexpected the more romantic, Susan coopted not "Daisy" or "Myrtle" or even "Jordan," but the cognomen of Jordan Baker's unseen aunt: "I was so tall and lanky, and Susan was such a short name. I thought Sigourney was such a musical name. It fit." Her background was anything but prosaic. Weaver's father, Pat, was the president of NBC, and one video innovation is so frequently ascribed to him that at times it seems "The Father of the Television Talk Show" is part of his given name. In fact, Sigourney's first contact with celebrityhood occurred when J. Fred Muggs, the *Today* show's resident chimpanzee during the Dave Garroway days, attacked the six-year-old, ripping her dress and hat. (Despite this traumatic experience,

············

Her real name is more prosaic.

CAST

WOODY ALLEN, DIANE KEATON,
TONY ROBERTS, CAROL KANE,
PAUL SIMON, SHELLEY DUVALL,
JANET MARGOLIN,
COLLEEN DEWHURST,
CHRISTOPHER WALKEN,
JOHNNY HAYMER, JEFF GOLDBLUM

······

UNITED ARTISTS
DIRECTED BY WOODY ALLEN
SCREENPLAY BY WOODY ALLEN AND
MARSHALL BRICKMAN
PRODUCED BY CHARLES H. JOFFEE
EXECUTIVE PRODUCER:
ROBERT GREENHUT
CINEMATOGRAPHY BY GORDON WILLIS

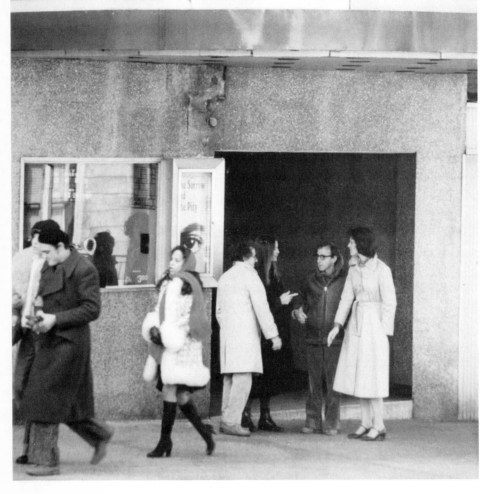

Sigourney Weaver towers over Woody Allen as a woman he dates while trying to forget Diane Keaton, who's got a new man of her own. Weaver would become a star after she appeared with someone who towered over *her*—the title character in *Alien.*

she went on to make *Gorillas in the Mist*.) Her British mother, Elizabeth Inglis, was an actress who as a child appeared in Hitchcock's *The 39 Steps*. And then there was Uncle Doodles. Having started out as a vocalist with Spike Jones's screwball orchestra, Doodles Weaver was a slapstick comedian whose short subjects were intended to have juvenile appeal but which, because of his odd looks and demented behavior, actually scared small children. I speak from personal experience.

After Ethel Walker, Sigourney hit Stanford, an exhilarating pandemonic hub of antiwar activity in 1967. Her studies took a back seat to "guerrilla theater," through which she set out to change Lyndon Johnson's opinion on Vietnam by participating in angry free-form plays on the Northern California campus. She also did more traditional stage work with a San Francisco Shakespeare company. These thespian experiences led the English major to ditch her plans of working for a Ph.D. and becoming a literature professor, and on a whim she instead applied to the Yale Drama School. Her acceptance letter was addressed to Mr. Sigourney Weaver. It should have been a tip-off. Weaver was miserable in New Haven: "I didn't get a lot of encouragement from the top people there, and I left with no confidence at all." And whereas Meryl Streep, who was a year ahead of Weaver at Yale, seemed to land the lead role in every single production, Sigourney "thought I'd have the opportunity to play a variety of different roles at Yale, but my teachers never cast me as anything except little old ladies."

Three years later Weaver was in New York and initially, in terms of fulfillment and happiness, the locale was little better. No agent wanted to represent her because, at 5′11″, she was deemed too Olympian. But gradually the work came. First she understudied in a 1975 revival of Somerset Maugham's *The Constant Wife,* directed by John Gielgud and starring another long drink of water, Ingrid Bergman. Then she appeared in a couple of plays by two of her buddies from Yale:

Sigourney Weaver received her formal training at the Yale School of Drama. Also possessing diplomas from the school (or its predecessor, the Yale University Department of Drama of the Yale University School of the Fine Arts) are:

Amy Aquino

Angela Bassett

Kate Burton

Charles S. Dutton

Jill Eikenberry

Julie Harris

Van Heflin

Ken Howard

Stacy Keach

Frances McDormand

James Naughton

Barbara O'Neill

John Shea

Talia Shire

Meryl Streep

John Turturro

Diane Venora

Henry Winkler

••••••••••

When she made
her second film
two years later,
Sigourney Weaver
went from 76th
billing to first. As
Ripley in *Alien*—
one of the most
puissant women
ever to show up on-
screen—Weaver
became a household
name. Arthur Bell of
the *Village Voice*
prophesied, "Ten to
one, in a month's
time, Sigourney will
be getting carbon
copies of the scripts
they send to Jane
Fonda. In a year,
she'll be getting the
originals." The
columnist Liz Smith
pontificated that the
actress "would make
a perfect 'intelligent'
replacement for
Kate Jackson on
Charlie's Angels."
Not likely.

Christopher Durang's Off-Broadway double bill of *Titanic*—an absurdist comedy in which she essayed a homicidal maniac—and *Das Lusitania Songspiel*, which ran all of one week; and, in repertory, Albert Innaurato's *Gemini*, although she didn't go with the play for its long, successful Broadway run. There was also the soap opera *Somerset*.

Sigourney Weaver made her film debut in 1976 between these two plays. She would be working for Woody Allen, but the downside was that her role was not much to speak of—she had no dialogue. Weaver is in one of the last scenes of *Annie Hall*, showing up after Woody Allen and Diane Keaton have broken up. On the soundtrack, Allen says, "Interestingly, however, I did run into Annie again. It was on the Upper West Side of Manhattan [at this moment Weaver makes her appearance]. She had moved back to New York. She was living in SoHo with some guy and when I met her she was, of all things, dragging him in to see *The Sorrow and the Pity*, which I counted as a personal triumph." Wearing a raincoat, her face a bit of a blur in this long shot, Weaver stands outside the Thalia, shaking hands with Keaton and her date (Walter Bernstein, who wrote *The Front*) and towering over Woody Allen. And then she's out of the movie, her scene leading into the montage of moments between Allen and Keaton that finishes the film. The funny thing about Woody Allen's movies—besides the comedy—is that despite the fact that they are so perfectly cast and (generally) so well acted, when you scan the cast credits, there are, apart from the top stars, very few names you recognize. If you get through reading 75 other names like Joan Newman, Russell Horton and Bob Maroff (as well as Jeff Goldblum, Beverly D'Angelo and Shelley Hack, all of whom have small roles), you'll see "Sigourney Weaver" opposite "Alvy's Date Outside Theater."

DEBRA WINGER

······

SLUMBER PARTY '57
(1975)

Mary Debra Winger was born in Cleveland, but her family moved to the San Fernando Valley in 1961 when she was six. The spelling of her middle name was inspired by 1950s ingenue Debra Paget, and while growing up she harbored fantasies about becoming an actress. Her Orthodox Jewish parents rolled their eyes at such nonsense, although her father did introduce her to a business acquaintance, septuagenarian director George Cukor. He had no interest in the 14-year-old girl, reportedly barking at her, "You've got no class!" At age 16, Winger again moved, this time without her family. She took off for Israel "totally out of curiosity after hearing so much about the country when I was growing up." The reason for the relocation: She had graduated from high school and "I just wanted to get out of the house. The Middle East

> Maybe it was part of a Faustian deal in which Mephistopheles agreed to give her a major film career if he could first sit in a sleazy movie theater and watch her bare her breasts.

CAST

JANET WOOD, NOELLE NORTH,
DEBRA WINGER,
BRIDGET HOLLOMAN,
RAINBEAUX SMITH,
MARY ANN APPLESETH,
R.L. ARMSTRONG,
JOYCE JILLSON, RAFAEL CAMPOS,
JOE E. ROSS, LARRY GELMAN,
WILL HUTCHINS

······

CANNON
DIRECTED BY WILLIAM A. LEVEY
SCREENPLAY BY FRANK FARMER
STORY BY WILLIAM A. LEVEY
PRODUCED BY JOHN IRELAND
CINEMATOGRAPHY BY ROBERT CARAMICO

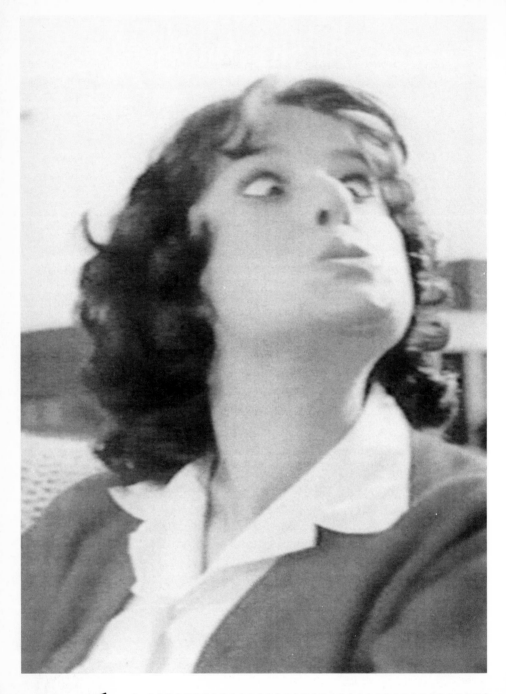

Even when not participating in soft-core sex scenes, Debra Winger managed to look extremely foolish in *Slumber Party '57*.

seemed an acceptable place to go." She lived on a kib-butz, applied for citizenship and spent three months in basic training with the Israeli Army. This arduous last experience convinced Winger that, for her, Israel was no Promised Land, and she was back stateside. At home, she again talked about a show-business career, but her folks told her to get real. Reality dawned in the form of California State University, Northridge, where she lackadaisically took classes in sociology and criminology.

While at school, Winger kept one foot in the world of show business: She performed as a troll, furry costume and all, at the Magic Mountain amusement park, doubling as a tour guide. Then, on December 31, 1973, . . . disaster! Riding on the back of a truck at the park, Winger fell off and got a severe knock on the head. Suffering a cerebral hemorrhage and a damaged optical nerve, Winger nearly died, going through peri-odic bouts of blindness and paralysis on one side of her body. The yearlong recovery gave her plenty of time for contemplation, and she decided that if she did recover, with God as her witness, she would defy the skeptics (i.e., Mom and Dad Winger) and do what she wanted to do: pursue a career in acting—seriously and with deter-mination. Such newfound resolve caused her later to say, "Poetically, I look at my accident as a huge hunk of grace."

The first thing Winger did after leaving the hospi-tal was to get herself an acting teacher (Michael V. Gazzo), and she participated in showcase productions around the Valley. She soon had paying acting roles: commercials for McDonald's and Burger King, a guest shot on *Police Woman*, even a recurring role on a televi-sion series, portraying Drusilla, the younger sister of Lynda Carter, for 14 episodes of *Wonder Woman*. By the time she was first seen as Wonder Girl in March 1976, Debra Winger also had a movie in the can, although her fast-food commercials constituted a greater artistic success.

Presumably Winger's first movie was set in 1957 to differentiate it from the countless other soft-core sex films that were on the market, as well as to capitalize on *Happy Days,* the country's most popular tele-vision series at the time. This change of eras in such a shoddy film makes for a plethora of anachronisms rang-ing from hearing such songs as "Running Bear" and "My Boyfriend's Back" emanate from the radio several years before they were recorded, to a reference to the "new Rock Hudson/ Doris Day" movie, although the first, *Pillow Talk,* hadn't been made yet.

In any soft-core sex film, the actors have to speak utterly ridiculous lines. *Slumber Party '57* exacerbated matters by trying—and not even coming close—to re-create the lingo of the Eisenhower era. Among Winger's choice pieces of dialogue are:

"I bet that dumb coach is a fairy. I mean how can sex hurt a basketball player? Isolate them like they had some kind of a bug?" [She is told that the players will be back on Sunday.] "Yeah, just enough time for a 'wham, bam, thank you, Ma'am.' "

"Hey, you guys. I've got a super-neat idea. What about if we all tell about the first time we ever did it."

"You did make it with James Dean, did you not?"

Slumber Party '57 is definitely in the running as the worst film described in this book. It is soft-core porn at its most jejune and dispiriting. The premise is that in 1957, six high school girls, blue because their boyfriends have gone away for a weekend basketball tournament, gather for a slumber party. There, each girl recounts how and where she lost her virginity. Debra Winger plays Debbie, and in her episode she's given a ride in a Thunderbird by a college boy named Bud. When they're pursued by a gang of bikers who have designs on Debbie, he vanquishes them all in a fistfight, as Debbie watches while slowly and suggestively eating a banana. The girl is so impressed by Bud's valor that she willingly submits to him in the woods. Scenes of their lovemaking are accompanied by Phil Phillips's "Sea of Love" on the soundtrack and by flashbacks of what we've seen just two minutes earlier, Bud battling the bikers, the thought of which apparently continues to stir her for she dreamily allows her beau to remove her blouse. The "surprise twist" in *Slumber Party '57* is that after Sherry (played by somebody calling herself Rainbeaux Smith) admits that she is still a virgin and then invites six boys over to deflower her, the other girls acknowledge that none of them have ever "gone all the way" and that their tales were just fantasies.

The overwhelming tone of *Slumber Party '57* is out-and-out smuttiness—the camera greedily searches for breasts, buttocks and thighs to linger on and leer over. Much of the film consists of gratuitous scenes of the girls' showers in gym, a pair of young things fighting and ripping off each other's clothes and the six heroines taking a topless dip in the pool, where a camera is strategically placed (Esther Williams's underwater shots were never like this). These sequences at least pass muster for truth-in-advertising laws, for they are exactly what the title implies you're going to get; the movie was intended for an audience seeking a specific

content, and the necessary quota of exposed breasts—including Debra Winger's—is met. *Slumber Party '57* is also stuffed with lots of footage that is pure padding (the sextet driving around town, walking around the house and dealing with a burglar), as well as some pathetic stabs at humor.

Debra Winger smirks her way through the film—it would have been hard not to with this dialogue and these situations. Her performance is in keeping with the indecorous tone of the entire movie, which is to say she seems intent on proving correct George Cukor's estimation of her. Winger's most memorable moment isn't even in the script: She steps on top of an unsteady coffee table and comes close to landing on her face. The only reviews *Slumber Party '57* received were from a couple of trade papers, and they were exactly what you'd expect. *Variety* reported that "Levey's dirty-old-man direction virtually drools over the screen" and noted that the screenplay, direction and makeup "vulgarize the six principal actresses and make them look more like contemporary hookers than nymphets from a more innocent era." The reviewer from *Box-Office* commented "the actresses are obviously not ingenues," although Winger was just 20 when she made the film.

I realize we should walk a mile in another person's shoes—in the film Winger's are saddle oxfords—before we criticize . . . but what *was* she thinking? I guess when she resolved to be an actress she meant it, and didn't care about the venue. Appearing in a movie like this was certainly not the most obvious way to go about achieving a serious acting career, and more power to her for having accomplished it. Winger understandably omits *Slumber Party '57* from her official biography. That begins with minor roles in two other bad but not nearly as disreputable films, the disco comedy *Thank God It's Friday* and the travel comedy *French Postcards*. And then came *Urban Cowboy*, and the young woman who had frolicked in *Slumber Party '57* was officially Debra Winger, movie star.

"Violence makes me hotter than a pistol. . . . I mean even the thought of it makes me feel kinda weird."

"He picked me up in his super-tough 'bird.'"

"You sure got a bitchin' car."

"Dig that, you goof-off."

"My dad used to spank me. It kind of hurt but it kind of felt good, you know what I mean?"

Natalie Wood looks exactly like who she is—not a professional actress, but five-year-old Natasha Gurdin, a cute little girl from Santa Rosa, California.

Natalie Wood

······

HAPPY LAND
(1943)

N atasha Gurdin was born in San Francisco in 1938, the daughter of a Russian-born carpenter and a ballerina who fled the motherland after the revolution. Early on, she moved to Santa Rosa, which, for one bright shining moment in 1942 and '43, must have seemed like Hollywood North. First, Alfred Hitchcock, needing a quintessential American small town, filmed *Shadow of a Doubt* in the scenic village. The citizens barely had time to come down from the two-pronged high of seeing Joseph Cotten and Teresa Wright on their streets and themselves being cast as extras when another movie unit invaded. Don Ameche! Frances Dee! Harry Carey! There was one difference this time, however; whereas in the Hitchcock film Santa Rosa played itself, for *Happy Land* it would be passing as a town in Iowa.

Picturesque though outsiders may have found Santa Rosa, to the Gurdins, who lived unprosperously on the poor side of town, it was anything

Every aspiring actor should have it as easy as Natalie Wood.

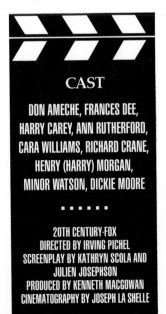

CAST

DON AMECHE, FRANCES DEE,
HARRY CAREY, ANN RUTHERFORD,
CARA WILLIAMS, RICHARD CRANE,
HENRY (HARRY) MORGAN,
MINOR WATSON, DICKIE MOORE

■ ■ ■ ■ ■ ■

20TH CENTURY-FOX
DIRECTED BY IRVING PICHEL
SCREENPLAY BY KATHRYN SCOLA AND
JULIEN JOSEPHSON
PRODUCED BY KENNETH MACGOWAN
CINEMATOGRAPHY BY JOSEPH LA SHELLE

• • • • • • • • • •

Natalie Wood spent practically her entire life in the movies, with her debut film coming at age four and her drowning death at 43 while she was still filming her final movie. In between, she grew up before us.

Miracle on 34th Street (1947)

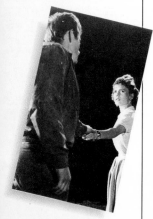

Rebel Without a Cause (1955)

but. Still Mrs. Gurdin could dream, couldn't she, so when word came that the locals were needed as extras, she gathered up five-year-old Natasha and brought her downtown. With her strikingly large, liquid eyes and vivacious personality, Natasha, her mother reasoned, was a natural for the movies; who could resist such an angel? The scene at the casting call was chaotic, and spotting a man sitting on a director's chair, Mrs. Gurdin instructed the girl to go over and do her stuff. Natasha climbed onto Irving Pichel's lap and sang a song. Rather than being horrified by this assertive child, Pichel was delighted, agreeing with her mother that, yes, she was a beautiful girl. But, he advised the mother, looks weren't enough to make it in movies; Natasha must also possess acting ability. The part he had in mind would necessitate her crying on cue. A snap, Mrs. Gurdin assured him.

Although it sounds as if it might be a Betty Grable musical, *Happy Land* is actually a bathetic piece of wartime Americana. Don Ameche portrays a druggist bitterly mourning his 21-year-old son, killed in the South Pacific. This attitude won't do, not when we all have to pull together to beat the Axis powers, so who should come to straighten Ameche out but the ghost of his dead father, Harry Carey.

Three years before Clarence the Angel would take James Stewart down Memory Lane, Gramps shows Ameche that it's a wonderful life in a two-decade tour of the boy's time on earth. Here's Rusty playing in the cornfields, going to kindergarten, working in the drugstore and falling in love. Better to have 21 years as an American than live to be an octogenarian under fascist tyranny. Just in case Ameche (and slower members of the audience) still doesn't get it, Carey spells it out that the sacrifices of this war are being made for the children of future generations: "As long as they can play Indian, as long as they can join the Boy Scouts, as long as they can go on picnics in Briggs' Woods, it'll be worthwhile."

The movie is treacly and manipulative as all get-out, but it sure does get to you; as the *New York Sun* put it, "*Happy Land* takes its spectators on an emotional jag." Many observers noted the similarities between *Happy Land*, written by MacKinlay Kantor, and the earlier small-town slice of life *The Human Comedy*, scripted by William Saroyan, generally finding this movie pat and contrived in comparison. Nor did *Happy Land* pack 'em in, but what can you expect when the advertising tag line was "A Picture As American As An Ice Cream Soda At The Corner Drug Store!"

Ice cream also played a part in Natasha's big scene. Portraying a nursery school classmate of the dead kid, she bites into a cone only to have the ice cream fall onto the ground. As promised, the tears come. Director Pichel was thrilled with his discovery. Natalie Wood remembered that he "took a liking to me and spoke to my mother about adopting me. My mother thought he was joking, of course, and said, 'Oh, sure! You can have her whenever you please!' Several weeks later, Pichel turned up at the house with a couple of attorneys and had adoption papers drawn up. My mother was mortified and my father was furious. Pichel really expected to take me home." No hard feelings, though, and he became her mentor. Three years later, when he needed a girl to play Claudette Colbert's daughter in *Tomorrow Is Forever*, he eschewed the local Hollywood talent and summoned Natasha to come down the coast. In *Happy Land*, she was not among the 42 cast members receiving credit for the film; the second time around she was given costarring status under her new name. And when Irving Pichel's next movie, *The Bride Wore Boots*, also had a part for a preteen girl, I don't have to tell you whom he cast.

Bob & Carol & Ted & Alice (1969)

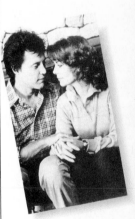

Brainstorm (1983)

In *The Visitors*, a couple of Vietnam vets seek revenge on the soldier who turned them in for raping a girl. Although he looks a little scary here, James Woods is not one of the titular creeps. Rather, he's the good guy who is paid a call and whose marriage is turned into a raging shambles.

JAMES WOODS

······

THE VISITORS
(1971)

James Woods had intended to emulate his deceased father and spend a life in the military, but that plan hit a snag when the teenage Jimmy went through a glass door and severed all the tendons in his arm; he spent 10 months in a hospital bed. Although his bum arm precluded him from going into battle, Woods was resolute about serving his country at the height of the Vietnam War. On a full scholarship, he attended MIT as a political science major, specializing in defense analysis. Woods later referred to this as his "fascistic period," saying he "wised up when some expert came back from Vietnam and said he'd been there 13 times and had never seen napalm." A perennial on the dean's list, he nevertheless left school shortly before graduation because "MIT was a complete apologist for the Vietnam War. I decided I didn't want a degree in how to murder people." Although his antiwar statements make for good copy—and Woods has always loved being eminently quotable—the likelier reason for his de-

Somehow it comes as no surprise to learn that James Woods's first film was peopled by mental cases. What is unexpected is that he didn't play one of them.

CAST

PATRICK MCVEY, PATRICIA JOYCE, JAMES WOODS, CHICO MARTINEZ, STEVE RAILSBACK

······

UNITED ARTISTS
DIRECTED BY ELIA KAZAN
SCREENPLAY BY CHRIS KAZAN
PRODUCED BY CHRIS KAZAN
AND NICK PROFERES
CINEMATOGRAPHY BY NICK PROFERES

■ ■ ■ ■ ■ ■ ■ ■ ■ ■

Over the years, James Woods has delighted in making unexpected, goading, often outrageous statements in interviews. Here are some of his best:

About working with Elia Kazan in *The Visitors:* "Well, I was pretty young, but his way of working is legendary by now. He felt that you should live the part. . . . So we all lived in this big house, and I was not allowed to talk to the two other guys—which I thought was just fucking horseshit. Finally, I started fighting Kazan. I said: 'I'm not going to work this way. I'm not like one of these football players you've got, or a comedian or somebody you're going to turn into a great actor so you can be the hero. I am a great actor.' I mean this is all 23 years and 115

parture from college was sheer boredom: "Since I never wanted to be an actor, I would have to say that the major influence on my life was a professor of differential equations," he averred. "The man was like Sominex every day and I felt there must be something more exciting to do with my life."

So he headed down I-95 to see what he could do on the New York stage. Woods wasn't bothered by the fact that, although he had appeared in MIT productions and at a small Boston theater company, he had no formal training. He didn't want any part of studying if it meant dealing with Method acting, which he derided as "a bunch of guys sitting around pretending to be radishes." Within a year of arriving in New York, he got his first role, although it meant having to travel to Long Island. At a time when *Hair, Oh! Calcutta!* and *Fortune and Men's Eyes* were all the rage in Manhattan, the Brobdingnagian theater at Jones Beach on Long Island continued to be the summer home of "family musicals"—preferably by Rogers and Hammerstein— and Woods found himself in a secondary role in *South Pacific,* starring Nancy Dussault; because the cavernous space was out of doors, actors learned to grin and bear it through sudden thunderstorms. In the fall, the actor landed a Broadway job, but the play in which he was understudying lasted less than a week and he never got to go on. Spring brought him a taste of success: By lying that he was from Liverpool, he won a small part in the year's Tony winner for Best Play, *Borstal Boy,* a biography of Irish writer Brendan Behan.

The following season he went native as a mess-hall headwaiter in the British mystery-melodrama, *Conduct Unbecoming,* set in Colonial-era India. Woods's agent nearly had a coronary when the actor announced he was giving up his weekly Broadway paycheck to do a three-week run at the Brooklyn Academy of Music, which, although only 20 minutes away from Broadway, might as well have been in Nebraska as far as the New York theatrical establishment was concerned. Besides,

the actor wasn't just going to an outer borough; he'd be appearing in a play that featured the stoning to death of a baby. Nice career move. But it turned out fine: *Saved* received some rapturous reviews and, as a good-hearted but inarticulate young Cockney, Woods's notices were even better; he won an Obie award for his performance.

Woods was gaining a reputation as a dynamic young actor, but he was a total unknown to Elia Kazan. In a casebook example of the you're-only-as-good-as-your-last-picture syndrome, the director of *A Streetcar Named Desire, East of Eden* and *On the Waterfront* was not finding much interest from Hollywood after the commercial failures of *America, America* (1963) and *The Arrangement* (1969). Kazan later recalled, "I thought the amount of money spent on *The Arrangement,* three times more than on any film I'd ever made, was absurd and I wished to return to the purity of poverty, in other words to show that filmmaking was basically a simple and most human endeavor and did not require an enormous structure of machinery and the overhead costs which that brings with it."

■ ■ ■ ■ ■ ■

To that end, Kazan's son Christopher came up with a screenplay called *The Visitors,* which sought to examine the effect of the Vietnam War on the folks back home. They didn't have to go far to scout locations—the movie would be shot on the Newtown, Connecticut, property where both Kazans had houses. And because money was tight, Kazan shot in super 16mm, used a skeletal, nonunion crew (the two-time Oscar winner carried his own tripod) and hired actors who were willing to work without contracts. He was going against the bylaws of all the film unions, "but it was the only way to make this film, and rather than be thwarted, I decided to go the illegal route." Although he didn't know who James Woods was, Kazan says he "just walked into my office and I liked him immedi-

pounds of me. I said, 'I can act this. You don't have to manipulate me.'"

On studio executives: "I'm cynical because I'm tired of second-rate assholes. I'm tired of schmucks in Hollywood sitting around with a gram of coke up their noses who think they know everything."

On his breakthrough film, 1979's *The Onion Field:* "Every penny that was spent is on the screen—not up some associate producer's nose."

Talking about Hollywood: "In the theater, you actually have writers. *Here,* if somebody writes *The Karate Kid,* they think they've got fucking Faulkner on their hands."

ately." Only one of the actors in *The Visitors* had ever appeared in a film before, but Patrick McVey was hardly a household name. The rest of the cast consisted of Steve Railsback (who later played Charles Manson in the TV movie *Helter Skelter*), Chico Martinez (a New York cabdriver) and Patricia Joyce (a senior at Yale who shot her scenes between classes). The finished product cost $170,000, which, the director wryly noted, was less money than Faye Dunaway's agent pocketed for getting his client into *The Arrangement*.

The Visitors deals with Bill (Woods), an unemployed Vietnam veteran who lives with his girlfriend, Martha (Joyce), and their baby in a farmhouse owned by Martha's father, Harry (McVey). They work as caretakers for Harry, who's in an adjacent house and is a hard-drinking writer of potboiler Westerns. One winter morning, two other vets, Mike (Railsback) and Tony (Martinez), arrive, and for Bill this is not going to be a happy reunion. He had turned them in for raping and then killing a Vietnamese girl; the two were court-martialed but are now out of prison on a technicality, and Bill can only imagine the worst of motives for their visit. In the course of the tension-filled day, Mike and Tony win the heart of the macho Harry after they help him kill a neighbor's pesky dog. Bill, whose Vietnam experiences have turned him into a pacifist, doesn't partake in the killing, and he cuts no currency with the blowhard Harry, who contemptuously says of him, "Christ, what a weirdo. I always thought he was half queer."

Harry gets very drunk watching a football game. Mike needles Bill about squealing on them, although he insists that there are no hard feelings. The two guests stay for dinner at Harry's behest. After the meal, Martha, who is both fascinated and repelled by Mike, dances with him even though he calls her "a real nutcutter." When Bill sees them cutting a rug he can no longer repress his anger and frustration; he hits Martha and punches Mike. After Mike baits him, the two

engage in a grueling fight that leaves Bill pummeled. Bill lies unconscious and Mike returns to Martha, whom he rapes, slapping her violently as he does so. Mike and Tony leave, and Bill and Martha stumble together to nurse their bodies and wounded psyches.

Although the narrative of *The Visitors* is relatively simple and unadorned, it serves as a springboard for a moving and mournful examination of the meaning of masculinity, machismo and honor, as well as a rumination on violence in America. Ever cagey, director Kazan makes the sociopathic Mike a cunningly charismatic figure and, although he is representing "forces of darkness," Steve Railsback uses his baby face and an aura of ingenuousness to manipulate the audience into caring about the character. Woods, too, contributes to the complexity of the film by playing Bill not as an innocent, but as a prickly individual whose mantle of virtue seems to stem from a neurotic cowardice rather than any innate goodness. In an extremely poignant performance, Woods conveys the edgy weariness of someone who has seen the worst the world has to offer and tries to live a normal life anyway. As always, Kazan is particularly effective in creating mood and atmosphere, and Bill and Martha's sepulchral existence serves as a somber reality check for the utopian lives dreamed of by many starry-eyed young people at the time.

Considering that it was made by a director of such high repute, *The Visitors* was given remarkably short shrift by most critics. *Variety* wrote, "There are occasional meritorious camera angles, but what's intended for suspense is merely static, and the work of the four younger principals adds nothing to the Kazan reputation as a superior director of actors." Judith Crist, who would put the picture on her yearly 10-Worst List, snidely commented that the cast was composed of "screen unknowns who will undoubtedly so remain." *Newsweek*, though, called James Woods "particularly effective." In February 1972, *The Visitors* opened in New York at an art theater next to Carnegie Hall. Nine days

later it was gone, having been replaced by a fill-in run of Woody Allen's *Bananas*. Kazan was hurt by the film's reception and angry at the studio for not standing behind it, but despite its commercial and critical failure, *The Visitors* remains a work of which he is justifiably proud.

The same month that *The Visitors* appeared in New York, Woods received great acclaim on Broadway in Michael Weller's account of 1960s radicals, *Moonchildren*, and received a Theatre World award. But he was becoming tired of the stage, and the next year he appeared in *The Way We Were*, playing the left-wing college student who loses Barbra Streisand to Robert Redford. The likes of Redford would be a continual bane to Woods, who throughout his career would complain that he was never offered romantic leads because of his offbeat looks. He continued to work in supporting roles in films and television, getting his breakthrough role as a cop killer in *The Onion Field*. Oscar pundits were sure he'd be a leading contender for Best Supporting Actor of 1979, but he ended up not even nominated (although eight-year-old Justin Henry was). Woods kept plugging along and then, in late 1986, when *Platoon* made Oliver Stone *the* hot filmmaker in town, people suddenly became interested in Stone's film from earlier that year. Thanks to video, Woods's terrific turn as a manic journalist investigating government atrocities in *Salvador* was belatedly but widely seen and earned him an Oscar nomination. He lost to Paul Newman, but he was now established as a star and began to get those leading-man assignments that had earlier eluded him. This despite his compulsion to put down everything about Hollywood and the people who ran the town. For example: "You mention *Swann's Way* to these people and they think it's a street in Brentwood."

PIA ZADORA

······

SANTA CLAUS CONQUERS THE MARTIANS
(1964)

Pia Zadora was born in Frank Sinatra's hometown, Hoboken, New Jersey. (They also share at least one other distinction: Each has appeared in some of the world's most truly awful movies. Sinatra's include *Johnny Concho, Sergeants 3, The Pride and the Passion* and *The Miracle of the Bells,* not to mention his cameos in such beauts as *Pepe* and *The Oscar.* For Zadora's contributions, read on.) Zadora's family crossed two rivers to move to Queens, and there she fell in with the good sisters of Our Lady Queen of Martyrs School. "As a child," she reminisced, "I was so painfully shy that I used to hide between the furniture when company came and I never got along with other children. So the nuns at my school suggested I take drama classes." This seemed perfectly natural to her parents—her father was a violinist for Broadway shows and her mother was a theatrical wardrobe supervisor. In 1961, Bur-

CAST

JOHN CALL, LEONARD HICKS, VINCENT BECK, VICTOR STILES, DONNA CONFORTI, BILL MCCUTCHEON, CHRISTOPHER MONTH, PIA ZADORA, LEILA MARTIN

······

EMBASSY
DIRECTED BY NICHOLAS WEBSTER
SCREENPLAY BY GLENVILLE MARETH, BASED ON AN IDEA BY PAUL L. JACOBSON
PRODUCED BY PAUL L. JACOBSON
CINEMATOGRAPHY BY DAVID QUAID

············

Pia Zadora started off in a movie that scared small children, and she was still one herself.

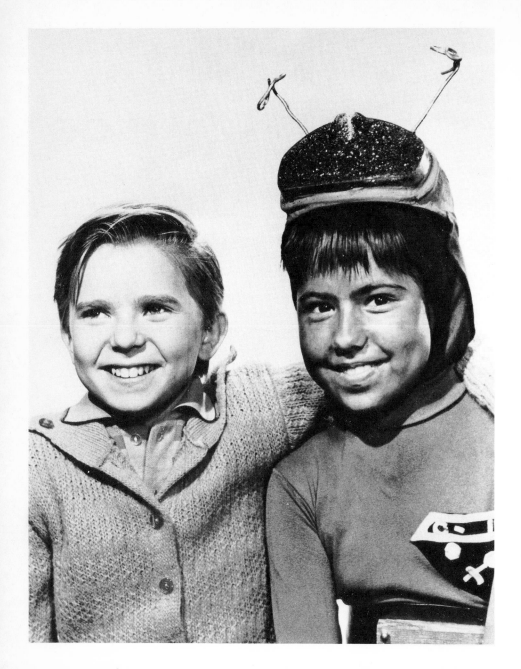

Portrait of the artist as a young girl. Pia Zadora would emerge as a camp icon in the 1980s, but her pal Victor Stiles would have to rest his cinematic reputation solely on his performance as kidnapped Earth boy, Billy, in *Santa Claus Conquers the Martians*.

gess Meredith plucked her, then six years old, from the American Academy of Dramatic Arts to put in a Broadway play starring Tallulah Bankhead that he was directing. Rather than being the terror of legend, Bankhead was kind to the child: "She said, 'Don't worry about what anybody else thinks, you just do what you have to do'"—advice that would come in handy through some of the rough spots of Zadora's career.

Three years later she made her first movie, but that didn't mean traveling to Hollywood, staying in the Beverly Hills Hotel and being driven to the studio in a limousine. Instead, she spent a few days on a Long Island soundstage. *Santa Claus Conquers the Martians* reportedly cost only $200,000, but it's such an amateur-night production that this price tag seems high. Then again, even a multimillion-dollar budget couldn't have saved a movie with such a chuckleheaded premise.

Two Martian children, Bomar and Girmar (the latter played by Zadora), watch a television program originating from Earth (consider how much backyard space that family's satellite dish must have taken up) transfixed by an interview with Santa Claus, who is joyfully expounding about Christmas toys. The nine-year-old Zadora speaks in a consistent monotone, and at first you think perhaps this is director Nicholas Webster's concept of the way a young Martian would talk, but later on you realize the performances of the Earth children are just as robotized. Bomar and Girmar's father, Kimar, is the president of Mars, and he's roiled that the youngsters are wasting their time checking out a markedly inferior civilization. Kimar's wife points out that the kids haven't been exhibiting much *joie de vivre* lately, so Kimar and his council go to see Chochem, the planet's 800-year-old wise man (who makes you wonder whether George Lucas had seen this movie and dredged up its memory when he conceived Jabba the Hutt).

The oracle observes, "We have no children on Mars. They have children's bodies but with adult minds.

The first lines to come out of Pia Zadora's mouth in a motion picture are "Bomar, what is a doll?"

They do not have a childhood." His solution: Santa Claus makes Earth children happy, so kidnap him and he'll make Martian children happy instead. Thus it's off to Earth to get Santa; in the film's closest approximation of wit, the aliens become confused when they see Santas on every street corner ringing bells and collecting money for charity. To find the genuine article, they ask two simpering children, Billy and Betty, where he lives and then, so they won't squeal to the authorities, abduct them, too.

Danger arises in the person of Voldar, a ruthless fascist who fears that this Christmas business will bring the gifted Martian children down to the mediocre level of Earthlings. ("Mediocre" is too generous a term for the Earthlings who made the movie.) To prevent this predicament, he sabotages the toy factory and then kidnaps Santa, as a prelude to a kill. Fortunately for children everywhere, Voldar's henchmen abduct not Santa but Dropo, Kimar's simpleton factotum, who is prancing about in Santa's clothes. In a rip-off from *Babes in Toyland,* the villains are eliminated with the help of toy soldiers. Knowing that Santa and the kids are homesick and seeing that Dropo did a pretty convincing Kris Kringle imitation, Kimar sends the Earthlings home in time for Christmas, handing the job of spreading Yuletide cheer on Mars to Dropo.

This synopsis, as ludicrous as it is, can only hint at the piquant preposterousness of *Santa Claus Conquers the Martians.* The film was produced by a fellow who had been a unit manager for *The Howdy Doody Show;* for behind-the-camera talent he used cronies from the world of local New York television, and it shows. Shoddiness reigns supreme: A killer robot resembles nothing so much as a garbage can stuck on top of an old stove, while a supposedly terrifying polar bear is all too obviously some guy in a cheap costume. And then there's the matter of the Martians, whose green makeup extends only to their chins; their necks and hands are white as virgin snow. The men's Jockey shorts are clearly

visible through their green tights, and on their heads are antennaed caps that seem to have been accessorized from a plumber's tool box. A nozzle extending from the top to the side is apparently a mark of having reached puberty, since the kids don't seem to have one.

The actors playing the adult aliens speak with the type of bombastic, overemphatic line readings you'd associate with a badly dubbed Italian gladiator movie. The usually amusing Bill McCutcheon shoots the works as the "comic relief" Dropo, indulging in an unbearable imitation of Danny Kaye (the fey original is hard enough to take). Young Zadora has nothing much to do other than be friendly to the Earth children and help around the workshop. She and the other three youngsters—all veterans of the Broadway stage, none of whom will ever have their likenesses hanging in Sardi's—perform with the wooden self-consciousness of children in a grammar school pageant, the difference being that in the school auditorium you'd forgive their ineptitude because you'd be related to one of them. There is also a song, performed by a bunch of young banshees, called "Hooray for Santa Claus," the lyrics to which—written out on the screen so that the audience can join in—set a terrible example to children by containing an appalling disdain for orthography: "You spell it S-A-N-T-A C-L-A-U-S/Hooray for Santy Claus!"

Independently produced, *Santa Claus Conquers the Martians* was picked up by producer Joseph E. Levine, a master at turning turkeys into golden geese by clever (i.e., false) and endless advertising. To be a child in December 1964 was to be constantly bombarded by TV commercials for *Santa Claus Conquers the Martians.* This game plan worked so well that the movie and the advertisements were trotted out every December throughout the 1960s. Reviewers at the time were amazingly benign. The critic from the *New York Herald-Tribune* somehow convinced himself that "the children in the film . . . are quite appealing," and Kathleen Carroll of the *Daily News* hailed "a gay, imaginative Christmas

When Pia Zadora won a Golden Globe in 1982, the subsequent hue and cry dogged her career for years. Was hers really such an outlandish victory? You be the judge. Her competitors for "New Star of the Year in a Motion Picture—Male or Female":

Elizabeth McGovern, *Ragtime*

Howard E. Rollins, Jr., *Ragtime*

Kathleen Turner, *Body Heat*

Rachel Ward, *Sharky's Machine*

Craig Wasson, *Four Friends*

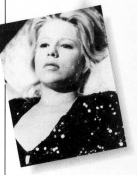

In *The Lonely Lady* (1983).

Pia Zadora on *Santa Claus Conquers the Martians:* "Well, my husband's five grandchildren love it."

gift for children." Many parents who got suckered into taking their little darlings to the movie strongly disagreed. Smaller children expecting cheery Christmas entertainment were deeply upset by seeing Santa Claus mistreated. They also couldn't handle the theme of two children being kidnapped or the scenes of Billy and Betty being tracked down by Voldar and his henchmen. You might as well take a four-year-old to *The Night of the Hunter.*

Pia Zadora continued to appear on Broadway through her late teens and then played nightclubs and Las Vegas, but she didn't enter the popular-culture landscape until she showed up as a singing television pitchwoman for Dubonnet aperitif in 1978; she happened to be married to Menahem Riklis, the billionaire owner of Dubonnet, who was 31 years her senior. Zadora didn't truly become part of the public consciousness, though, until she won a Golden Globe award for Best Newcomer, ostensibly for her 1981 movie *Butterfly,* but in actuality for the swelegant parties Riklis threw for the members of Hollywood foreign press. The notoriety radiating from getting an award for such a hilariously dreadful movie turned her into a national joke, a situation she bore with such grace and good humor that people eventually began to find her endearing. Emblematic of her unpretentiousness was the manner in which she publicized her 1983 film, *The Lonely Lady;* Zadora cheerfully acknowledged that it was trash, but emphasized it was *fun* trash. Although a great career as a thespian hasn't materialized, she has found redemption by establishing a career as a singer of pop standards. The dean of jazz critics, Leonard Feather of the *Los Angeles Times,* caught her act and raved, "She has it all: the range, expert intonation, a sensitive feeling for lyrics. The poor little rich girl has finally made it."

Photo Credits

PHOTOFEST—pages 2, 12, 21, 36, 42, 62, 122, 189 (top), 196, 208, 220, 246, 276, 285, 294, 306, 308, 309, 312, 332, 338, 358, 370, 378, 382

THE CLAUDE DAIGLE COLLECTION—pages 23, 32, 34, 45 (top and bottom), 48, 64, 72, 84, 87, 96, 112, 118, 130, 131, 134, 140, 142, 143, 146, 152, 155, 162, 167, 170, 186, 189 (bottom), 195, 202, 205, 211, 212, 214, 217, 226, 233, 234, 236, 237, 240, 245, 249, 258, 262, 266, 268, 272, 287, 292, 298, 315, 324, 327, 328, 355, 360, 363, 380, 381, 393

THE MUSEUM OF MODERN ART/FILM STILLS ARCHIVE—pages 18, 26, 45 (center), 78, 106, 164, 167, 192, 243, 282, 290, 326

TROMA, INC.—pages 66, 69

ACADEMY OF MOTION PICTURE ARTS AND SCIENCES—pages 252, 342

DAVID SELTZER—page 318

BILLY ROSE THEATRE COLLECTION, THE NEW YORK PUBLIC LIBRARY FOR THE PERFORMING ARTS, ASTOR, LENOX AND TILDEN FOUNDATIONS—pages 352, 390